Soul, Spirit, and Mountain

Soul, Spirit, and Mountain

Preoccupations of Contemporary Indonesian Painters

Astri Wright

Kuala Lumpur
Oxford University Press
Oxford Singapore New York
1994

Oxford University Press

Oxford New York Toronto
Delhi Bombay Calcutta Madras Karachi
Kuala Lumpur Singapore Hong Kong Tokyo
Nairobi Dar es Salaam Cape Town
Melbourne Auckland Madrid

and associated companies in
Berlin Ibadan

Oxford is a trade mark of Oxford University Press

Published in the United States
by Oxford University Press, New York

© Oxford University Press 1994
First published 1994

British Library Cataloguing in Publication Data
Data available

Library of Congress Cataloging-in-Publication Data

Wright, Astri, 1956–
Soul, spirit, and mountain: preoccupations of contemporary
 Indonesian painters/Astri Wright.
 p. cm.
Includes bibliographical references and index.
 ISBN 967 65 3042 5:
1. Painting, Indonesian. 2. Painting, Modern—20th century—Indonesia.
3. Mountains in art. 4. Spirituality in art. 5. Painters—Indonesia—Psychology.
I. Title.
ND 1026.W75 1994
759.9598'09'045—dc20
93-21550
CIP

Typeset by Indah Photosetting Centre Sdn. Bhd., Malaysia
Printed by Kyodo Printing Co. (S) Pte. Ltd., Singapore
Published by Oxford University Press,
19–25, Jalan Kuchai Lama, 58200 Kuala Lumpur, Malaysia

To my family:
three continents connected

The mountain is simply the 'pesangon' [the totality of cultural and personal baggage one is given during one's formative years], with its intenseness symbolized by the peaks; the temple is the knowledge, learning, intelligence and wisdom that could be abstracted from, formulated out of, the mountain, while the sun was the 'I', in its integrity. It is this sun that makes everything beneath visible or invisible, bright or dark. When all three are present in the mysticum, then the creative process has begun. The mountain and the temple are the tangible raw materials which only come to life when struck by the sun's rays. . . . And with the aid of this diagram literary criticism, and art criticism in general, can trace the mountain which makes possible the erection of the temple, and then the sun that illuminates it.

Pramoedya Ananta Toer, 1983: 36.

A picture is not thought out or settled beforehand. While it is being done it changes as one's thoughts change and when it is finished, it still goes on changing, according to the state of mind of whoever is looking at it. A picture lives a life like a living creature, undergoing the changes imposed on us by our life from day to day. This is natural enough, as the picture lives only through the man who is looking at it.

Picasso, quoted in *The Spanish Masters of Twentieth-Century Painting*, San Francisco: San Francisco Museum of Art, 1948: 52.

Foreword

THIS book traces the rise and spread within Indonesia of painting that breaks radically with the disciplines, materials, format, formal economy, and image content of the traditional court or popular arts. The remarkably diverse work illustrated in *Soul, Spirit, and Mountain: Preoccupations of Contemporary Indonesian Painters* participates in a visual culture that, while not unitary in style, is recognizably part of contemporary felt experience and self-interpretation. In many of these paintings, one is immediately struck by the gestural impetus and the idiosyncratic pushing about of paint, by the stridencies of unmodulated colour jostling side by side in a flattened space, by the strange displacement of objects from their appointed places and, equally, by the unanticipated coupling of things usually kept strictly apart. Above all, it is the unceremonious immediacy of address, the assertion of rampant subjectivity, that breaks with the reserve and the public quality of the traditional arts.

To paint in this way is to advance the proposition that life is in reality as unstable, disjunctive, arbitrary, and lacking in depth and social fixity as it is here represented to be. If the meaningful order of traditional art points to unity, balance, harmony, and hierarchy, then the quick takes, fragmentary views, and arbitrary relationships of parts in these works is a formal equivalent to the fluid, uncentred, agglomerative quality of a world now increasingly responsive to the energies and invisible hand of a globally interdependent economy.

Even those coolly impersonal, hard-edged paintings that rely on a grid or other geometric constraint and which also exhibit an abnegation of self in their prim facture, break sharply from the fluid structures of most traditional art and thought. They, too, would seem to participate in practices and beliefs that transcend the domain of the aesthetic and are rooted in a way of life increasingly responsive to both the logical calculi of modern science and an instrumental secular order dominated by routinized bureaucracy. What holds these works bound, despite their perceptual disparity, is a tacit grasp of principles that enable them to qualify as art: a theory governing an intelligible structure of value that is an art world.

In his art criticism written in Paris in the mid-nineteenth century, Charles Baudelaire celebrated modernity as a condition of life. He exalted the poetic and marvellous quality of the present, thus giving weight and value to a world reformulating itself by breaking traditional structures of custom and social order in response to the increasing application of technology in the practices of everyday life. Baudelaire was

nervously responsive to fluctuations of feeling and thought in what he recognized as a comprehensive alteration of experience, and he demanded an art that was adequate to the fluidity, randomness, and violence of its occasion. Oddly, he found it in the work of a minor, and now little noticed artist, Constantin Guys, whom he celebrated as 'The Painter of Modern Life'. While his effort to canonize Guys was doomed, Baudelaire's defence of the new-launched modernism was both a condition of mind and an epoch that breaks consciously with tradition.

The world of modernity now stretches far beyond Europe and America. The tensions and contradictions engendered by sharply altered circumstances mark much of the art being created in India, China, Japan, and South-East Asia. In Indonesia, an ever increasing part of the population is now participating in what Hildred Geertz has called 'a new metropolitan superculture'. Some segments of that group are now patrons and enthusiasts of the boldly innovative art presented in this book, art that is judged by a new criterion: originality.

In her book, *Art in Indonesia*, Claire Holt sketched with passion and lucidity the stirrings of this new species of art and artist. That was in 1967. Until now, that is until Astri Wright completed *Soul, Spirit, and Mountain*, there has been no publication of similar ambition on this important subject. Wright, however, goes far beyond the territory charted by Holt, writing not only a descriptive study of the institutions of the art world and a critical assessment of the diverse works, but also—from her extensive interviews—giving us lively, digressive, sharply rendered portraits of the artists, their lives, their cultural politics, and their aspirations. She picks up snatches of conversation and uses them to give both energy and vivid effect to her analysis.

To comment on art as it first appears without a settled account of its value, requires an ability to intuit significance as it emerges within the tumult and uncertainty of experience. Put more directly: to catch art on the wing takes art as well as scholarship. It will come as no surprise to learn that Wright is both a scholar and a novelist.

Foremost among the many excellences of this book, is the insight it offers on the relationship between regional tradition and the emergence of a global art world. As Wright demonstrates, the mastery of an esoteric visual language is put to work by Indonesian artists to discover local realities. Whether by ringing changes on the densely layered meaning of the mountain, a root symbol saturating a variety of contexts from prehistory until now, or through their effort to find meaning and value in contemporary social actualities, Indonesian artists chart their own specific paths into the present. While modern art seems to have a universal and inevitable destiny as it spreads far beyond the European locus of first industrialization, there is now no unitary narrative that will encompass the heterogeneity of work arising in the new centres of contemporary art production.

STANLEY J. O'CONNOR
Cornell University
June 1993

Preface

THIS is not a history of modern or contemporary Indonesian art. It is an introductory discussion of a specific form and a limited period of Indonesian art which has received little attention outside Indonesia.[1] It is an attempt by an outsider to capture in a language foreign to the subject something about how Indonesian painters perceive themselves in relation to their diverse cultural heritage and how they orient themselves in the present, with its contrasting ideas about economic and cultural development and about tradition and modernity. It is about painters living in a young nation, proclaimed independent in 1945, connected with an international market economy and communication networks that disseminate dominant images of Western culture world-wide. These images are variously received, rejected, and reshaped in marriage with indigenous ones, in the process by which local populations respond to cultural stimulae. In this way, local variations of modern life and art are created.

The book is structured around a metaphor which forms the centre of the text like the trunk of a tree. On either side of this trunk branches out an exploration of a grouping of artists. The whole represents two broad and interwoven patterns in modern Indonesian art which, though still relevant today, can be traced back to the late 1930s: artists and works that draw on spiritual experiences or established vocabularies in their art, and artists and works that locate their inspiration and meaning in some level of social engagement. When I discuss the importance of the spiritual dimension in the work of many Indonesian artists, it is not an attempt to classify 'all Asians' as 'only interested in the spiritual', as modern, educated Asians frequently criticize Western scholars of doing; the discussion of either group of artists, in the case of Indonesia, cannot be representative or meaningful without also discussing the other.

Not all trends in contemporary Indonesian art are discussed. The most glaring omission, for those who are looking for a comprehensive and historical treatment of the subject-matter, will be the absence of many individual senior artists who have played, and continue to play, important roles, and

[1] Until very recently, the only publication outside Indonesia on modern Indonesian art, artists, and accompanying institutions, was Part III, 'Modern Art', in Holt's history of Indonesian art (1967: 191–263). Holt's research was mainly done during 1955–6. The material gathered during her brief follow-up visit in 1969 was written up in an article published a few months before her death (Holt, 1970b). To this day, these writings remain the best introduction in any European language to the history of modern Indonesian art.

rightfully have a place in the history of modern Indonesian art.

The late 1980s can, from several perspectives, be seen as a turning-point in such a history, marked by the disappearance of some of the last direct links to the struggle for independence and the birth of the nation. September 1988 saw the death of Sultan Hamengkubuwono IX of Yogyakarta, an active patron of the arts and a man of great historical and political importance, both during the Revolution and after Independence. By this time, most of the seminal figures among the pioneers of modern Indonesian art were gone. Hendra Gunawan died in 1983, S. Sudjojono in 1986, and Ahmad Sadali in 1987. The same year, Affandi painted a work entitled *Dead* (see Plate 87)—a work intended as a comment on both his life and the era to which he belonged.[2] With Hendra, Sudjojono, and Affandi thus effectively 'gone', the Indonesian art world found itself without the strong presence of these independent, outspoken figures, all of whom had been active in the underground struggle in the 1940s. Variously criticized and respected within the art community, none of the three had ever been the object of indifference.

Affandi had managed to excite the imagination even of people who had no knowledge of, or interest in, painting. Perhaps more than any other single individual, he disseminated a non-traditional image of 'the modern artist' in a population. Thus, at the end of the 1980s, the era of the nationalist revolution, Sukarno's charismatic and turbulent leadership, and the central place given to modern artists, receded

one step further from living memory.

I arrived in Indonesia to do my research in August 1987 and stayed until March 1989 with an additional month in early 1991. In these twenty months, I photographed exhibitions and public and private collections. I interviewed artists,[3] collectors, gallery owners, and art officials in Yogyakarta, Bandung, Surakarta, Bali, and Jakarta. Besides recording interviews, seminar presentations, and formal speeches at exhibition openings, I produced around 3,500 colour prints and 1,500 colour slides. These represent paintings by around 200 painters; between 50 and 60 painters are represented by more than a couple of works. These documentary materials were essential in a situation as diverse and rapidly developing as the one in which I found myself involved. Finally, the more than 40 articles and reviews I wrote about artists and exhibitions in the *Jakarta Post* during the fieldwork period spurred discussions with members of the reading public and the art community. To the extent that these articles brought people to an exhibition which they otherwise would not have seen, something could be given back to the artists.

Since comparative terminology is all too often weighted in favour of the familiar, a culture-specific approach is chosen, in which individual and regional contributions to larger historical ideas or movements are acknowledged and investigated.[4] As a check against my own

[2]Kartika, Affandi's daughter, pers. com., 1988. Despite his increasing physical frailty and frequent stays in the hospital in critical condition, Affandi lived until 23 May 1990. Note that the title inscribed on the painting is not *Dead Chicken*, as translated in J. Fischer, 1990: 166, Pl. 105; it is merely *Dead*.

[3]In referring to artists, I use the name most commonly used in conversation, which is also that used by people who do not know the artist personally. Many people in Indonesia have only one name; where there are two, these are often not thought to consist of a surname and a personal name; both are considered personal names.

[4]The culture-specific approach arose as a reaction to the view that South-East Asian arts were less perfect reflections of Indian art, pioneered by scholars, mainly Dutch, trained in philology,

learned standards of aesthetic judgement, I focused on those painters, art works, collectors, art writers, art officials, and institutions whom I came to know based on their visibility on the exhibition circuit, in the Indonesian news media, or as a result of discussions with artists, art officials, and collectors. It is inevitable, however, that those works I choose to discuss most extensively are those that have also engaged *me*, without setting myself up as an arbiter of 'universal quality'.

My strategy was to discover, as far as possible to an outsider, the frameworks that informed the categories, values, concerns, and preoccupations of Indonesian artists and participants in the art world, without maintaining a strictly comparative approach. I wanted to attempt to meet the Indonesian art world on its own terms, in particular the artists, many of whom I got to know. Many of these contacts have continued since I left the field in early 1989, so I have been able to follow the work of some artists over a period of several years. I have tried to represent the situation as I saw it by re-creating a fabric of cultural and individual description and integrating this with iconographic and formal analysis, using the footnotes for more in-depth commentary and references for readers less familiar with Indonesian studies. The framework of the study itself, as well as the terminology used, arose from a combination of statements made by artists in conversation or in writing and my own reworking of the data.

Arising as much from personality as from gender, and central to this study is the conviction that an informal and descriptive style can capture situations better than a formal, discursive style. In cross-cultural research, situations are the essential contexts for ideas. Furthermore, when the 'voice' is close to the academic writer's own, rather than one formalized or contrived in such a way that seeming lack of presence can be construed as objectivity, the writer's biases (as well as mistakes) will emerge clearly and make the reader's task easier. It is possibly inevitable, coming from one who has been encouraged in interdisciplinary studies from the start and come of age in an era of academic pluralism, that this book at times will mirror the presence of the researcher in the midst of the material (Clifford and Marcus, 1986; Birth, 1990).

Contemporary landscapes always seem more complex than do those of past eras, which have been simplified by the passage of time and the extinction of factors which once commanded the attention of their contemporaries. It has none the less frequently been observed that never has the landscape of any 'present' been more complex than in the latter part of the twentieth century, where the mass of accessible information and visual, emotional, and intellectual stimulae are unprecedented in global scope and morphological variety. Focusing on a foreign culture caught in the throes of modernization and capitalist development, with the accompanying clash of old and new, local and global values, compounds problems of analysis immensely. Any analysis is, of necessity, bounded by personal style, approach, insight, and opportunity.

The aim of this study is to contribute to the opening up of an underdeveloped area of cultural history. Based on the view that no single approach or individual can hold the key to an attainable truth, it is my hope that future

history, and archaeology. Contributions to classical and pre-modern South-East Asian art history are numerous, in Indonesia starting with Dutch archaeologists like Krom, Bosch, Bernet Kempers, Stutterheim, and many others. The tradition continues with contemporary scholars like Stanley J. O'Connor and Jan Fontein and the first and second generation of Indonesian scholars, like Soekmono and the late Satyawati Suleiman.

studies by both Indonesian and foreign art historians will exhibit a number of different theoretical approaches. Most important of all, I hope that the disciplinary boundaries, methods, and languages that have kept non-Western contributions to modern art from being investigated more fully will be replaced by greater openness and experimentation. I offer this text as a homage to a multifaceted subject eminently worthy of study, as well as a challenge to art historians, wherever they be, to begin writing the chapters in the history of world art which will include all modern artists, wherever they be.

ASTRI WRIGHT
University of Victoria
British Columbia, Canada
April 1993

Acknowledgements

IT gives me great pleasure to pause and think back over the last few years and recall the people who, in various ways, have been central and meaningful to the process of writing this book. Whereas gratitude offered in person is often toned down by constraints of culture and personality, recalling their faces one by one before my inner eye is a personalized ritual of thanksgiving where feeling can be pure and unmediated by social norms.

This is the place to thank my Ph.D. committee at Cornell University: Professor Stanley J. O'Connor, whose poetic approach to teaching South-East Asian art history always made his lectures an aesthetic experience and whose reticence in imposing frameworks cannot be blamed for any lack of such here; Professor Milton L. Barnett, whose many years in anthropology and international development enabled him to ceaselessly insist that there were ways to bridge the academic world with the 'real', and whose great skill and patience for editing is largely responsible for those mistakes that are absent in this book; and Professor Benedict R. O'G. Anderson, whose unrivalled knowledge of Indonesia and commitment to creative scholarship and social justice has taught me what I could absorb about fluid thinking across disciplinary boundaries.

My gratitude also goes to Professors David Wyatt and Oliver Wolters, whose South-East Asian history classes were among the most enjoyable I experienced during graduate school; John Wolff, for his unconventional approach to grammar teaching and for advocating the importance of social dancing in university life, and Marina Roseman, who introduced me to the anthropology of art and, although not a formal committee member, guided me generously during the first stages of planning the dissertation research.

For financial support for the field research, I am grateful to Fulbright–Hays, the Social Science Research Council, and the Asian Cultural Council. For many kinds of support (including financial) during my years as a graduate student, I am grateful to Cornell University's Southeast Asia Program. For offering me a library assistantship which enabled me to pay for day care while writing the dissertation, I am grateful to John Badgely, Curator of the Echols Collection.

For offering the unusually generous number of plates for the book, I am grateful to Oxford University Press. For substantial financial assistance in preparing the plates for the book, I am deeply indebted to the University of Victoria: The Center for Asia Pacific Initiative and the Vice-President Academic Dr Sam Scully responded to this challenge with unexpected warmth

and generosity. For allowing me to publish several of Claire Holt's previously unpublished photographs, I am grateful to Cornell's Southeast Asia Program and the Kroch Library's Rare and Manuscript Collection, as well as the New York Public Library's Dance Collection at Lincoln Center. To the latter institution I am also indebted for giving me access to the uncatalogued part of the Claire Holt Collection pertaining to modern art and artists in Indonesia. I am also indebted to the Aga Khan Award for Architecture for generously supplying me with photographic materials. For preparing the plates, I am grateful to Dawn Partridge Wood and Sterling Wood of Lens and Shutter in Victoria, and their Vancouver Lab.

In Indonesia, I express my gratitude to my sponsor, Dr Umar Kayam, and the Centre for Cultural Research (Pusat Penelitian Kebudayaan) at Gadjah Mada University in Yogyakarta; to the staff at the Indonesian Academy of Sciences (Lembaga Ilmu Pengetahuan Indonesia or LIPI), Jakarta, and to all Indonesian officials, at the national as well as the local level (especially Immigration), who provided essential insights into the machinations of living in Indonesia.

The list of people in Indonesia whose generosity in time spent talking to me and insights shared throughout the fieldwork period is so long that they cannot all be listed individually; many of their names are to be found in the following pages. The Indonesian artists who are the subject of this study, along with many others, shared with me opinions, memories, anecdotes, clippings, photographs, and, most important of all, their work. In many cases, we came to share the kind of times out of which friendships emerge. Regretfully, due to the limitations of space and the necessities of choice, many Indonesian artists who generously assisted me during the field research will not find themselves in these pages. For this, I can only apologize and hope for their understanding.

Besides the artists themselves, many of the people in the art world gave me great help, doing what they could to increase my understanding of a topic which they felt had been ignored by foreign scholars for too long. Kusnadi, Sudarmadji, Wiyoso Yudhoseputera, Arsono, and Soelebar S., variously connected with Taman Ismail Marzuki (TIM), IKJ or the Department of Education in Culture in Jakarta; But Mochtar and Sudarso S. P. at the Institute of Art in Yogyakarta; A. D. Pirous and G. Sidharta at the Bandung Institute of Technology's Faculty of Fine Art and Design (FSRD-ITB), all gave me of their time on various occasions. Among the gallery owners must be mentioned Basuki Wibowo, owner of DUTA, and Didier Hamel, the gallery's manager; Gumilang of OET's Gallery, and Ibu Sri, the gallery's manager (Jakarta); Sutedja Neka of Ubud; Agung Rai of Peliatan; Rudana of Tegal; Putu Budiastra of Museum Denpasar (Bali); Kartika Affandi-Köberl of the Affandi Museum, and Mella Jaarsma and Nindityo Adipurnomo of CEMETI gallery (Yogyakarta). In addition, I would like to thank all the private collectors who enthusiastically showed me their collections: among these were Yussuf Wanandi, Ciputra, Lukas Mangindaan, Toenggoel Siagian, Ten Ham, and Raka Sumichan. For especially generous sharing of knowledge of the art world, as well as materials from their personal collections and/or libraries, I am indebted to Halim H. D., F. X. Harsono, John McGlynn, Margaret Agusta, and Nia Fliam.

In Yogyakarta, I want to acknowledge the invaluable support and friendship of Elisabeth Suprihatin, who freed me from the time-consuming work of daily maintenance so I could concentrate on the research, and Tuti Setianingsih, who

tackled the multifaceted work of assistant, which frequently demanded intensive cross-cultural intervention, with courage and perseverance. Priyana Jatmika and Hariyanto also aided me greatly with motor cycle transport, transcriptions, and intelligent commentary.

In Jakarta, I found homes and family feeling with many friends, old and new; I thank John and Retno Duewel, David and Molly Winder, Toenggoel and Millie Siagian, Alan Feinstein, Anne and Mike Greene, and Anita Kendrick and Ujjwal Pradhan.

For reading and commenting on parts of the manuscript, I am grateful to Gigi Weix, Suzanne Brenner, Mike Bosler, Jim Supangkat, F. X. Harsono, Hildawati Siddhartha, Joseph Fischer, and Kenneth Seidman. I have also enjoyed exchanging ideas with Helena Spanjaard of the History of Art Department, University of Amsterdam. In addition, I am grateful to my students at the University of Victoria (where modern Indonesian art is taught as a full semester-long course), whose commentary and involvement with the material have sharpened the focus in several areas.

For help in the logistics of writing, I am grateful to Audrey Kahin and Dolina Millar at 102 West Avenue, Ithaca, for providing office space and access to the Cornell Modern Indonesia Project's computer. For technical assistance, I am grateful to Charles Elliot and Joe Covert of Cornell Information Technologies, whose understanding of microchip terrorism enabled them to cure my hard-drive of sudden carnivorous urges. Dave Manning of University of Victoria's Fine Arts Computer Lab has also provided crucial assistance.

For providing support and inspiration in my study of modern Indonesian painting, I am grateful in particular to Claire Holt, whom I unfortunately never met outside the printed page, but whose interdisciplinary background and inspired attachment to Indonesian artists has provided a solid model. In addition, I am grateful for the support of Joseph Fischer and Clare Benedict Fischer while in Indonesia, and to Joe in particular for inviting me to be co-curator of the Festival of Indonesia exhibition of Modern Indonesian Art which toured the USA in 1990–1. This gave a welcome 'applied' sense to my research, as well as the joy of sharing directly with the public the experience of many of the art works I had lived so closely with in Indonesia.

On the home front, my indebtedness can only be expressed as a deep *hutang budi* (spiritual debt), for without the help of people close by I could never have finished. Loving gratitude goes to my mother who has thrived on being a teacher to me from the day I could talk (back) and has encouraged me to follow my curiosity, no matter where it would take me, and '*always* pay attention to the *details*'; to Ariel, who arrived into our lives in the middle of the writing to provide moments of play and laughter and general immersion in the non-rational; to Subi, for giving Ariel the concentrated mothering and love that freed me to write, and last, but by no means least, to Kenny, who mothered and fathered both Ariel and myself as the need (frequently) arose, and without whom I could not have attempted to approach the challenge of combining family life and dissertation. For the shortcomings, gaps, and mistakes in the text that follows, no one but myself is to blame.

MINTA MA'AF
LAHIR DAN BATIN

Contents

Colour Plates

Plates

Appendices

1 Introduction

ARTISTS are an important source of authority about a work of art—one which has often been ignored in the pages of art historical research. In attempting to understand the art of another culture, the inclusion of the artist is essential: like thought processes and behaviour patterns, aesthetic reactions and judgements are learned, and the artist's ideas and circumstances can give clues to perceptions and values surrounding art that would not be immediately apparent to an outsider from the art work itself. In so far as the culture concerned is a contemporary one, the artists are accessible to the researcher; thus, many of the answers which can only be surmised in regard to historical periods can be sought directly. In a place like Indonesia, where modern artists have been somewhat marginal to their broader culture and ignored by the international art world of which they themselves feel a part, there is a great receptivity, on the part of artists, art historians, and collectors, to sharing their life stories, works, and ideas.

The history of art remained Eurocentric for a long time, citing Greek art as the historical foundation and aesthetic standard for later developments. Unconsciously, these standards were often applied to the analysis of art, for example that of India. In modern times, art historians found it necessary to incorporate certain basic ideas from non-Western arts as these inspired artists and movements. However, it is only very recently that the other side of the coin—looking at non-Western arts and how they have been influenced by modern Western developments without dismissing them as 'derivative'—has begun to attract scholarly and curatorial attention.[1]

Since the more clearly defined schools of modernism began to give way to the

[1]Evidence of growing scholarly attention was the March 1991 conference at the Australian National University, Canberra, called 'Modernism and Post-modernism in Asian Art', the first conference fully devoted to modern Asian art; the inclusion in the April 1991 conference of the American Committee of South Asian Art (ACSAA) at the Sackler Gallery, Washington, DC, also for the first time, of a panel on concerns in contemporary South and South-East Asian art, in particular Indonesia; and the publication of the first volume in English completely devoted to the topic of modern Indonesian art (J. Fischer, 1990). This book, published in connection with one of the four major travelling exhibitions of Indonesian art in the USA, sponsored by the Festival of Indonesia, has a representative selection of high-quality colour reproductions (many of which overlap with those in the present volume, since as co-curator, I supplied many of the initial photographs of works to be included). On the curatorial side, Latin American painting, in general, and Mexican, in particular, have in recent years been embraced by previously resistant modern art 'centres' such as New York. See, for example, the exhibition catalogue, *Mexico: Splendors of Thirty Centuries*, resulting from an exhibition at the Metropolitan Museum of Art, 1990, in which modern painting was included as an integral part of the history of Mexican art (see Ashton, 1990).

pluralism of the late 1960s, by some labelled post-modern, the demands on art history and art criticism have also been changing. In the search for new perspectives from which to approach questions of aesthetics, style, and meaning, art historians have variously adopted ideas and methods from sociology, anthropology, and Marxist, feminist, and women's studies. Conversely, scholars from these disciplines have devoted efforts to writing about art. American scholarship, in particular, with its predilection for interdisciplinary methods of analysis, has added to the approaches of the German and British classical-humanist and later formalist schools of art history.

The orientalist critique of the study of other cultures, first applied in the fields of comparative literature and later in history, film studies, and ethnomusicology, has taken some time to reach the discipline of art history, but slowly art history has become more of a pluralistic discipline, mirroring broader intellectual developments and the structures and demands of modern life itself. However, the study of the modern art of non-Western societies—whether by indigenous or by foreign (Western) scholars—is still in its infancy. It is ignorance of the indigenous part of the marriage which produced modern Indonesian art on the part of those who only see the Western stylistic influences (also apparent to varying degrees), that gives rise to the orientalist notion that it is completely derivative and thus of no interest to the scholar of art.

Theoretical Dimensions

To write a text of this nature, several important points arise, not all of which are addressed directly in this study but which underlie many of the choices made and which require future research and discussion.

John Berger said of Cubism that it 'recreated the syntax of art so that it could accommodate modern experience' (1972). The same may be said about the Indonesian artists who, in the early decades of the twentieth century, began to work in new styles and media. They chose to shift away from either traditional artistic media or other options of livelihood because the new, foreign art form offered them tools and ideas which could better encompass and express the anatomy of modern experience.

The question of what 'modern' means must be defined in relation to each area, era, and field under investigation. Ultimately, the definition of 'Indonesian modernism' or 'modern art' must come from the Indonesian artists and art historians themselves.[2] In order not to limit one's understanding too closely to Western formulations while writing about Indonesian painters, it is essential to think of 'the modern' in the broadest of terms. In Berman's view, being modern entails 'Any attempt by modern men and women to become subjects as well as objects of modernization, to get a grip on the modern world and make themselves at home in it' (1988: 5).

In a description which recognizes cross-cultural perspectives in modern life, Berman writes:

To be modern is to find ourselves in an environment that promises us adventure, power, joy, growth, transformation of ourselves and the world—and, at the same time, that threatens to destroy everything we have, everything we know, everything we are. Modern environments and experiences cut across all boundaries of geography and ethnicity, of class and nationality, of religion and ideology: in this sense, modernity can be said to unite all mankind. But it is a paradoxical unity, a unity of disunity: it pours

[2]The complex question of whether terms like modernism and post-modernism can be used to discuss modern Indonesian art will not be dealt with here.

us all into a maelstrom of perpetual disintegration and renewal, of struggle and contradiction, of ambiguity and anguish. To be modern is to be part of a universe in which, as Marx said, 'All that is solid melts into air' (1988: 15).

To 'Indonesians' of the early years of this century, modern experience was shaped by an accelerating influx of new ideas about education, language, history, and identity. With the introduction of new technologies, in part triggered by foreign occupation and war, an unprecedented self-consciousness about one's place in relation to the past and a dramatically changing present began to develop.

This new awareness of other places, cultures, and histories, both past and in the making, created the need to question the structures and assumptions of one's own world. Triggered by and, in the end, addressing the Dutch colonial presence, the question of identity—national, ethnic, and individual—came to occupy a central position. This discussion, in Indonesia called the Culture Debate, is one of the main signifiers of the modern era in Indonesia. Self-conscious reconstructions of the past have accompanied the search for a definition of the present. Fuelled by an unprecedented urge to evaluate and compare weaknesses and strengths, Indonesians have attempted to create a better platform from which to meet the challenges of an increasingly complicated and anxiety-provoking future.

Thus, with the modern era, new ideas became attached to concrete circumstances. For a while, some groups involved with the formation of a new Indonesian society focused on foreign ideologies of nationalism and social dynamics, highlighting the struggle of classes and peoples newly defined as exploited and oppressed. Others focused on the idea of the individual, the necessity of redefining traditional values and behaviour, and capitalist models of economic growth were stressed. The energy of emerging groups of modern professions like educators, doctors, military, and political men, as well as new types of writers and artists, focused on giving institutional, literary, and visual form to emerging ideas and circumstances.

Indonesians arrived late into what can be called modernizing conditions— conditions which in the West had developed gradually from the age of Enlightenment and the Industrial Revolution. In many cases, Indonesians were introduced, quite suddenly and simultaneously, to phenomena that had evolved over a long time in Europe, *and* to their contemporary responses throughout the world. In the case of modern art, this meant that the pictorial problems which engaged Western impressionists, post-impressionists, and early modernists were introduced in Indonesia *along with* their various solutions. One illustration of this process is an exhibition hosted by the Dutch art societies in Jakarta in the late 1930s, which included original paintings by Utrillo, Gauguin, Chagall, Chirico, and Van Dongen, and lithographs by Daumier, Corot, Gavarni, Millet, Pissarro, Derain, Toulouse-Lautrec, Kandinsky, Rouault, Picasso, and Tooroop (Holt, 1967: 197–8). One might say that Indonesian painters, studying with individual foreign or indigenous teachers and with access to exhibitions of original works by the European modernists shown in the Dutch Kunstkringen in the late 1930s, were offered intricate problem-sets complete with multiple answers, to be interpreted at their pleasure.

The phenomenon of such a 'catalogue of ready-made styles' being received into an Asian context has a very different significance than in the West, where premium is placed on originality. It may

have reinforced cultural predispositions to emulate forms of behaviour from figures of authority, also in the realm of artistic production where the master's work was the model for the apprentices. Furthermore, the relative absence of references to purely formal pictorial problems in the conversations and writings of Indonesian painters may indicate that they have found it more significant to focus on problems of symbolic meaning, narrative content, and expressions of national and cultural identity. An attitude in which formal solutions are not seen as separate from the meanings of forms and colours also distinguishes pre-modern arts in South-East Asia. If this indeed is the case, such an attitude, then, would constitute a bridge between contemporary Indonesian artists and traditional or indigenous art-makers, past and present.

In anthropological research on Indonesia, the vogue in the last few years has been to demonstrate how what has been called Indonesian (or more specifically, Javanese) 'tradition' is, directly or indirectly, a product of the Dutch colonial order, beginning in the nineteenth century and continued in the last twenty-seven years. This is a process in which elements already present in pre-colonial societies were isolated, organized, reinforced, and ultimately changed (Pemberton, 1989; Anderson, 1990d). In this study, the genealogy of 'tradition' is not the central question. Tradition is discussed here in so far as what is perceived as such by individual artists is invoked as a backdrop to, a source of inspiration for, or a topic of contention in their own work. In their debates about modern art, Indonesian artists and art historians approach the question of tradition in different ways, and they attempt to define how the emergence of modern painting in Indonesia challenges older notions about art-makers and art works and causes new kinds of institutions and relationships to come into being.

Copying: Influence or Affinity?

In the writing of art histories, which overwhelmingly have been male-centric histories based on an established Euro-American definition of what constitutes 'fine' as opposed to 'applied' arts,[3] the tracing of influence from one artist to another, one school to another, one geographical and cultural region to another, has been an essential tool of analysis. This tool, however, has reduced certain artists to donors (the few) and others to recipients (the many), with lesser status given to the latter. The negative quality of being a 'recipient' has

[3]Although I am concentrating on artistic creativity as it manifests itself in modern Indonesian painting, I do not distinguish sharply between the forms or quality of creativity that go into the making of traditional arts, often labelled 'crafts', which in English carry unfortunate connotations of 'lesser' vis-à-vis the higher status of the 'fine arts'. The relationship between the two is an important topic for discussion, especially pertinent in Indonesia, where the idea of 'fine arts'—arts with no utilitarian function—was introduced only in the late nineteenth century, and, one could argue, only in recent years has gained something of an audience. Prior to this, all arts in Indonesia were created to fill certain roles in ceremony and ritual, both personal and communal. Since each skilfully wrought object was thought to contain some degree of power, and certain groups of artisans were respected for possessing spiritual powers, it might be argued that 'mere fine arts' had little to offer in Indonesia; hence, later art works created in modern fine arts media were often 'filled' with meanings related to the traditional ways of thinking about objects. Some artists in Indonesia today argue that the distinction between fine and applied arts is an importation of Western terminology, along with institutions such as art academies, modelled on the European ones, all of which have little to do with a distinctly Indonesian aesthetic. In any case, it is clear that modern Indonesian artists can choose to identify themselves with past models of creativity which they find more meaningful than modern, imported ones, and which can empower them, both in their own eyes and in the eyes of their audience.

been based on this actor's copying rather than creating formally and/or ideationally original works. Situations have been recorded in the literature as static rather than dynamic.

Baxandall points out that the negative quality given to the copier is a result of faulty logic:

'Influence' is a curse of art criticism primarily because of its wrong-headed grammatical prejudice about who is the agent and who the patient: it seems to reverse the active/passive relation which the historical actor experiences and the inferential beholder will wish to take into account. If one says that X influenced Y, it does seem that one is saying that X did something to Y rather than that Y did something to X. But in the consideration of good pictures and painters the second is always the more lively reality.... If we think of Y rather than X as the agent, the vocabulary is much richer and more attractively diversified: draw on, resort to, avail oneself of, appropriate from, have recourse to, adapt, misunderstand, refer to, pick up, take on, engage with.... To think in terms of influence blunts thought by impoverishing the means of differentiation (1989: 58–9).

This study does not attempt to connect individual Indonesian artists or art works closely with Western forerunners or art works which may have been inspirational. The absence here of this kind of 'genealogical tracking' is based on the sense, first of all, that this is a pitfall Western (-trained) art historians all too easily fall into as an end in itself. Lacking in such cases is an in-depth consideration of the subtleties involved in different perceptions of and approaches to 'copying', an act which all too easily gets summed up with the negatively laden word, 'derivative'. Secondly, the inspirations cited by most Indonesian artists interviewed were numerous and varied, drawn from both Western and non-Western sources.

Any question of influence must explore nuances of meaning, ranging from the 'wholesale, detail-by-detail copying' of one artist's work by another, including a discussion of the reasons for the copying and the context within which this was done. It may have been a study exercise, an act of forgery, an act of magical/ mystical recapturing of power, or an act of homage. On the other hand, it may have been a partial adaptation of foreign forms selected because of their affinity to pre-existing artistic categories and synthesized with a selection of these, or it may have been an instance of parallel, unconnected creation of similar forms and styles, stimulated by cultural/ psychological/artistic processes that are not fully explicable but that are observable in global histories of art.

It is the assumption of this study that modern Indonesian art comes about through a dynamic, complex interchange between the two models, by which different art works come to exhibit similarities that are based as much on what Kandinsky calls a convergence of 'inner mood', ideals, sympathies, and affinities as on direct copying (1947: 23). Furthermore, the enormous body of visual material available to everyone in this age of mechanical reproduction, whether passive recipients of the media's and the market environment's visual bombardment or, like artists, active students of visual form, makes the act of selection, passive or conscious, inevitable. Thus, it may be those ideas and forms that correspond to, or dynamically challenge, something already in the artist's psychological make-up which will register. The majority of forms will generally not register.

Modern Indonesian painters' acceptance of forms and ideas from the outside was, and is, a process of partial borrowings, of conscious and sometimes unconscious choosing and rejecting. Foreign borrowings on the level of formal qualities, 'styles', and 'schools', will

always be easier to identify than will borrowings—or the lack of—on the level of ideas, meaning, and artistic intent which have also been active in the formulation of the work. Colours, forms, proportions, volume, and other purely formal aspects of an art work do not speak for themselves. In the same way that certain ideas are attached to certain forms in one era, other ideas may attach to the same form in another context. Although some images and forms appear near universally—the image of a tree, a mountain, or certain geometric shapes—and some of their meanings overlap between different ages and places—the task of the art historian is to trace the particular dimensions of meanings unique to each culture.

A triangle, to choose an example central to this study, will to an educated twentieth-century Western observer elicit associations of, among other things, Pythagoras, the science of geometry, Egyptian and pre-Columbian pyramids, the Christian trinity, and diagrams of psychological relationships. The associations of an educated contemporary Indonesian may both overlap and differ. The association to the mountain will be strong, especially to volcanoes, and the thought of the mountain may trigger a whole set of associations related to spiritual practices, such as ceremonial offerings or magical diagrams. The thought of the triangle as mountain may also be associated with the upward-pointing triangle which holds the same symbolic references as the *lingga* (Hindu symbol representing the masculine principle, an image of cosmic ordering and spiritual growth) and the downward-pointing triangle as *yoni* (Hindu symbol representing the feminine principle, an image of chthonic forces and fertility). The process that may occur in an Indonesian mind, by which the contemplation of a triangle brings the association of a pair of complementary triangles, is significantly different from the course of associations in a Western mind.

Along with rethinking the meaning of forms, and their relationship to style, it becomes paramount to employ a broader definition of style than that bequeathed us by Wölfflin (1932).[4] Danto's definition is useful: style, he writes, is 'the means [a work] uses to represent its subject' and this 'is determined by what statement about that subject is meant' (1979: 11–12). This assumes, in a discussion of style, attention also to the content and intention of the work, a subject which Baxandall (1989) addresses at length.

In modern Indonesian art, it is on the level of ideas associated with the forms employed in an art work that indigenous, non-Western perspectives are most evident—meanings which, to the viewer who has the cultural vocabulary with which to 'read' these works, are rooted in a reality which has a different anatomy than that of modern Western art.

Furthermore, as demonstrated in the revisions of how pre-modern South-East Asian borrowings from India, China, or the Arab world are discussed, those formal qualities, which were adopted from Western art in many cases, had forerunners in Indonesian artistic traditions (indigenous or indigenized), to which these borrowings were then adapted. They were chosen because of pre-existing affinities of a philosophical, material, and visual nature— predispositions or affinities which had employed visual techniques compatible with the 'modern', 'Western' pursuit of two-dimensionality, stylization, and abstraction, whether geometric, decorative, or expressionist.

The cultural affinities which

[4]Although culture and personality are included in Wölfflin's classic treatise on style, based on European art of the fifteenth to seventeenth centuries, they are less emphasized than are the formal qualities he posits as universal analytical tools.

determined the choice of foreign borrowings were not only rooted in long-standing traditions, but also in new realities and needs arising from the accelerated changes taking place in the Dutch East Indies in the course of the late nineteenth and twentieth centuries. In considering the question of borrowings, it would be just as important to look at the elements which were rejected if these could be determined. There are many variations within what has been collectively labelled modern Western art which held little interest to modern Indonesian artists.

For a comparative South-East Asian perspective, it is interesting to look at a recent study which offers the most comprehensive history of modern Thai art to date (Apinan, 1992). It is instructive about the commonalities and differences between the Thai and Indonesian modern art worlds. In its emphasis on foreign and indigenous élite networks of teachers, inspiring artist-models, patrons, and person-led institutions, it illustrates the South-East Asian emphasis on networks of personal loyalties and authoritative models. These are central factors in the modern Indonesian art world as well.

However, despite the fact, so often emphasized, that Thailand in contrast to her South-East Asian neighbours never became a European colony, it is worth noting that the development of modern Indonesian art was never as dominated as modern Thai art appears to have been, either by centralized royal patronage or by the presence of a handful of foreign artists. Although the teachers of many of the first generation of Indonesian artists were foreigners, mostly Dutch, none of these achieved the dominant position of the Italian painter Corrado Feroci in Thailand.[5] Unlike modern Thai art,

during the first half of its genesis, modern Indonesian art was not confined to a royal capital or a single geographical region. With large numbers of Dutch citizens occupying important positions throughout the civil service, the military, and trade networks, in cities also outside Batavia (later Jakarta), the first generation of modern Indonesian artists could find teachers and patrons in a variety of regions. Although the first teachers at Bandung's art academy (founded at the Bandung Institute of Technology (FSRD-ITB) as a fine arts department in 1947 and as an academy in 1950) were Dutch, by the late 1950s or early 1960s the faculty was mostly Indonesian. The Yogyakarta art academy (founded in 1949) was fully staffed by Indonesians from its outset.

Inspirational Frameworks

In developing the framework for research on modern Indonesian painting, sociological approaches to art worlds and the anatomy of the creative process have been useful in providing a dialectic of correspondence and disagreement.

Michael Baxandall's *Painting and Experience in Fifteenth Century Italy* (1972) discusses the ways in which the patron–client relationship operated in the execution of commissioned art works, and his attempt to define the 'period eye' by looking at ways people were taught to think about colour, to visually estimate

[5]One possible parallel would be Walter Spies in Bali, but his influence was limited to the small number of local painters around Ubud; furthermore, other artists, like Rudolf Bonnet, played an equally important role over a much longer period of time (Holt, 1967: 176–81; Rhodius and Darling, 1980). Another foreign name that occurs in connection with the Faculty of Art at the Bandung Institute of Technology (ITB) in the late 1940s and 1950s, is the Dutch artist Ries Mulder (Holt, 1967: 234), whose influence is clearly felt in the early works of Ahmad Sadali, Popo Iskandar, But Mochtar, A. D. Pirous, and Srihadi Sudarsono.

shape, volume, and weight, and to approach perspective and pattern, as in the practice of social dancing, is masterfully argued, relevant to the study of art in any epoch, and never more so than in the study of art in a culture other than our own. Every time and place other than the present is, in essence, a foreign culture.

Of direct relevance to the writing of this book is Baxandall's formulation of inferential criticism, which seeks to elucidate the causes—cultural and personal—behind that 'purposeful activity' which results in works of art. While admitting that seeing an individual painting as 'the product of situated volition or intention' is an intellectually precarious act, Baxandall none the less argues for the validity of including a discussion of intention in the analysis of art (1989: v–vi). His definition of 'intention' does not, however, refer to 'an author's historical intention'. Baxandall de-emphasizes the importance, and even the integrity, of trying to understand what in particular was going on in the artist's mind during the conception and execution of the work (1989: 35). Instead, he searches for contemporary cultural documents which include references to matters of perception, form, and meaning, returning in his intellectual wanderings always to the work of art itself. He does not stress, as sociological models do, the relationships created between various individuals, groups, and circumstances by the creation and subsequent life of the art work.

In this study, greater emphasis is placed on the direct, personal formulation of intention and involvement in the process of creation than in Baxandall's. The attempt to gain access to something of the inner life of the artist, and the intent with which he or she created works of art must be tempered by a sense of paradox.

On the one hand is the realization that this is essentially impossible to do. Picasso, who, along with Van Gogh, is the artist most frequently cited as a source of inspiration by the first two generations of Indonesian artists, once said:

How can you expect an onlooker to live a picture of mine as I lived it? A picture comes to me from miles away: who is to say how far away I sensed it, saw it, painted it, and yet the next day I can't see what I've done myself. How can anyone enter into my dreams, my instincts, my desires, my thoughts, which have taken a long time to mature and to come out into the daylight, and above all grasp from them what I have been about—perhaps against my own will? (Chipp, 1968: 272).

When I quote Picasso, it is because his warnings about pat systems for interpreting art apply perfectly to cross-cultural contexts. Furthermore, it is possible that basic problems regarding the nature of creativity and meaning of an art work that art history and criticism on the whole fail to answer are equally complex and elusive, in whichever culture or media creative action is being analysed. On the other hand, despite the elusiveness of complete insight, I believe that the act of attempting such an understanding is inherently meaningful and does enhance knowledge.

Howard Becker defines an 'art world' as the complex 'cooperative network through which art happens'—a network involving all the 'people, whose cooperative activity, organized via their joint knowledge of conventional means of doing things, produces the kind of art works that the art world is noted for' (1982: x, 1). In his definition of art as a set of work patterns and relationships, Becker includes people who never directly touch the art work produced, but who in indirect and important ways facilitate its creation.

This definition is thought-provoking and suggests aspects of the artistic

process *in* its context, which has been paid but scant attention. In modern Indonesian art, where men are still more often the doers and creators and women and/or servants the maintainers and nourishers, making the production of art possible, this perspective is not only important but, it would seem, an essentially honest one, which stimulates the study of the mechanisms or institutions, personal as well as structural, that support or hamper an artist in his or her work.[6]

In contrast to Becker's approach, however, the art works and artists themselves remain the elements of greatest importance in this study. Whereas Becker, in analysing networks of co-operation surrounding art works, asks who is *really* the artist, unwilling to see any single individual as more important or central than others, I do define the artist as the main actor within a cast of supporting players. This choice arises in part from wanting to introduce the Indonesian artists to an international art public as of equal interest as modern artists in Europe or America. Furthermore, artists in Indonesia occupy various social positions, ranging from élite and wealthy to unknown and poor, but at each level they are perceived as different from other workers, doing a different kind of labour, to different ends. Unlike Becker also, I do make reference

to those extra-rational dimensions of individual art works and to artistic inspiration that remain elusive to social science investigation, in an attempt to discuss these as they appear to exist within Indonesian contexts and frames of mind.

Reacting to the Western view that 'the art product is conceptually, and in certain ways practically, separable from its cultural context', Alan P. Merriam—like Baxandall and Becker—sees the art work as resulting from certain forms of behaviour and structured by certain social relationships. What prompts the types of behaviour that produces art is a 'series of conceptualizations which concern the product' (1977: 335–6). He defines two steps as preliminary to the existence of the art work itself: (1) concept and (2) behaviour. These result in (3) the product, or the work of art. Significantly, Merriam adds a subsequent step to the analysis: (4) feedback from society (within this step is assumed the audience's experience of the art work which precipitates a response), which in turn takes us back to step (1): the feedback may influence, modify, and even change the original concept of the artist. This, in turn, leads to altered behaviour, which leads to a different product, and so on (1977: 337). To get a grip on culture-specific assumptions and attitudes about art works, I would insert into Merriam's model an additional step, between steps (3) and (4): (3.5) traditional and changing notions about the life of the art work—interpretation, function, criteria of quality, etc.—in society. In the modern era, in Indonesia as elsewhere, it is by no means certain that step (1)—the artist's concept—arises from the same ideas that inform the audience; hence, it is useful to separate these two in the analysis.

[6]It also made me painfully aware of the number of people involved in supporting my own project. Due to the large amount of time demanded by the need to collect and produce primary data, such as photographing collections and exhibitions and orienting myself in a virtually unexplored field, my portrait of Indonesia's modern art world is narrower than it might have been. The interviews were not as systematic, wide-ranging nor as in-depth as I would have liked. Apart from a few individual collectors, there are only accidental appearances in the following pages of non-artists involved in the creative process at a few steps removed, like wives, servants, and others with no art education or interest.

Review of the Literature

Several recent European-language studies have covered ground which is essential to a thorough understanding of the history of modern Indonesian art. Helena Spanjaard's dissertation, written in Dutch, covers the colonial background to, and the formative period of, modern Indonesian art from the mid-nineteenth century to Independence; a final chapter discusses the period 1950–88 (Spanjaard, forthcoming). Other studies on modern Indonesian art are more limited in chronological scope, focusing on single, seminal artists, such as Sanento Yuliman's doctoral dissertation in French on Sudjojono (1981), Bruce van Rijk's MA thesis in Dutch on Raden Saleh (1986), and Mirwan Yusuf's MA thesis in French on Islamic calligraphy and the painter A. D. Pirous (1986). Two of the most recent publications are the volume of essays edited by Joseph Fischer (1990) and Brita L. Miklouho-Maklai's book on Indonesian art since 1966 (1991).

Looking for similar studies on other areas of South-East Asia, no systematic histories of modern art exist for Singapore, Burma, or Malaysia.[7] The documentation of Philippine art, and most recently modern Thai art, is the most comprehensive.[8]

The Indonesian literature is discussed in the preface to an Indonesian publication called *Percakapan dari Hati ke Hati Pelukis Indonesia* [Heart to Heart Chats with Indonesian Painters] by Mustika (1983). Mustika writes: 'From 1956 to 1983 there are few books about Indonesian painting which can serve as a basis of understanding for art lovers, would-be painters or young painters who strongly desire to live as a painter.'

Starting with the life and work of Raden Saleh, documentation of which is mostly to be found in Dutch newspapers and art magazines, the history of painting between 1880 and 1930 is veiled in darkness. Only in the late 1930s, after the founding of PERSAGI (Union of Indonesian Painters; Holt, 1967: 197), did the pre-independence Indonesian press start to print articles about painting. Mustika reports that a book entitled *Berkelana ke Alam Keindahan* [Wandering to the World of Beauty] by Achdiat K. Mihardja was published by Balai Pustaka around 1950, but it cannot be found today. Then, in 1956, 1959,

[7]For Burma, no publication is known to exist. For Singapore, the catalogue for the National Museum's Centenary Art Exhibition in 1987 is possibly the most representative presentation, with reproductions of works in many media by 218 artists. Catalogues of individual artists or group exhibitions exist (see *Singapore Artists*, Singapore: Ministry of Culture, Singapore Cultural Foundation and Federal Publications, 1982. Of 48 artists, apart from one Malay and one Irishman, all are ethnically Chinese, born in the mainland, in either Indonesia or Singapore). For Malaysia, see Dolores Wharton, *Contemporary Artists of Malaysia: A Biographic Survey*, published for the Asia Society by the Union Cultural Organization, 1971; T. K. Sabapathy and Redza Piyadasa, *Modern Artists of Malaysia*, Kuala Lumpur: Ministry of Education, 1983; *Seni Lukis Malaysia 57–87*, Kuala Lumpur: Balai Seni Lukis Negara, 1987.

[8]See Manuel D. Duldulao, *Contemporary Philippine Art: From the Fifties to the Seventies*, Manila: Vera-Reyes Inc., 1972; *The Philippine Art Scene*, about the artists, the critics, the dealers, and Imelda Marcos's role in the establishment of the Cultural Center of the Philippines in 1969, Manila: Maber Books Inc., 1977, and *A Century of Realism in Philippine Art*, Manila: Fine Arts Corporation, 1982; Purita Kalaw-Ledesma and Amadi Ma. Guerrero, *The Struggle for Philippine Art*, Manila: The Art Association of the Philippines, 1974. For Thailand, see Silpa Bhirasri, *Modern Art in Thailand*, Bangkok: National Culture Institute, Thai Culture Series, 1954; Damrong Wong-Uparaj (ed.), *Contemporary Art in Thailand*, Korat: North-East Technical Institute, 1967; Piriya Krairiksh, *Art since 1932*, Bangkok: Thammasat University, 1982; and Apinan Poshyananda, *Modern Art in Thailand: Nineteenth and Twentieth Centuries*, Singapore: Oxford University Press, 1992.

and 1964, respectively, the four large volumes of President Sukarno's painting collection were published in Peking, The People's Republic of China, in co-operation with Gunung Agung, Jakarta. Due to its high cost, the set was inaccessible to the general public (Dullah, 1956, 1959). Likewise with the 1978 publication of selections from the Adam Malik Collection (Liem Tjoe Ing). A Jakarta municipal government publication, *Seni Lukis Jakarta dalam Sorotan* [Spotlight on Painting in Jakarta] (Sudarmadji, 1974) was not for sale to the public, nor was a Department of Education and Culture publication on modern Indonesian art (Kusnadi and Nyoman Tusan, 1978).[9]

According to Mustika, there was available to the public a series of small books published by the Jakarta Arts Council (Dewan Kesenian Jakarta): one about Raden Saleh (Baharuddin M. S.), one about Affandi (Popo Iskandar, 1977), and an introduction to the history of Indonesian painting (Sanento Yuliman, 1976). In 1975, a book about Balinese painting, in 1977, a book about Zaini, and in 1979, *Gerakan Seni Rupa Baru Indonesia* [The Indonesian New Art Movement] (Supangkat, 1979) were published. In the early 1980s, a luxury edition of Henk Ngantung's sketches (Baharuddin M. S., 1981), and *Gregorius Sidharta: Ditengah Seni Rupa Indonesia/Gregorius Sidharta: In the Center of Indonesian Art* were published (Supangkat and Sanento Yuliman, 1982).

The number of publications on modern Indonesian art was estimated by Mustika to be between twenty-five and thirty, all published in small editions of around 5,000 (in a population of around 170 million). Although some are still available to the public, the prices are prohibitive for the majority of art students and artists. In this context, Mustika's presentation of biographical essays and interviews with sixteen painters considered central to the development of modern Indonesian art, is an attempt to meet the demand for information. From the point of view of the present study, it is also interesting because it gives us the artists' voices directly—a methodological choice no doubt facilitated by the fact that Mustika is a practising artist himself.

There are a number of Indonesian publications not mentioned by Mustika.[10] These include writings by Drs Sudarmadji, former lecturer in art history at the Akademi Seni Rupa Indonesia (ASRI) in Yogyakarta, head of the Jakarta Arts Council, and until 1990, Director of the Balai Seni Rupa (BSR). Besides catalogues and books on individual artists, he has written textbooks for use in the teaching of history, art criticism, and art appreciation. A government-sponsored attempt at a comprehensive history of Indonesian art, which includes the modern era, was published by the Department of Education and Culture (Departemen Pendidikan dan Kebudayaan or DPK) in 1979. An example of a regional contribution to such a history is Rudi Isbandi's book on Surabaya artists (1975), valuable for its reproductions (albeit in black and white)

[9]Mustika did not identify the title of this last publication. This is also the case where incomplete references are given in the text below.

[10]This illustrates Mustika's point about the inaccessibility to a complete collection of published materials, despite the attempts of the Jakarta Arts Council at Taman Ismail Marzuki to keep up-to-date documentation in their library. One of the problems with libraries in Indonesia is that the underdeveloped habit of reading and the lack of a tradition of research based on written sources keep much of those library materials that do exist unused on the shelves. As Umar Kayam and others have frequently pointed out, Indonesia is still predominantly an oral culture.

and short biographies of artists, many of whom are still active today, and a government publication about the late Balinese artist, Lempad.[11]

In addition to the various writings discussed here, numerous undergraduate theses and a few MA theses are written by fine arts students at the art academies and institutes in Indonesia. Much data on modern and contemporary artists are deposited in this body of unpublished and largely unexamined writing, but the students' training in research methodology is often scant and the required format of their theses highly formalized.

Most of the writing concerning art has been printed in newspapers and journals. Along with Kusnadi, who remained active as an artist after becoming an art critic, curator, and art official, Sudarmadji was the most prolific art critic in the newspapers during the 1970s and 1980s. Other well-known names are Dan Suwarjono and Bambang Bujono. Since the late 1980s, Sanento Yuliman and Jim Supangkat have written frequently, as has Agus Dermawan T. The latest high-quality publication on the subject of Indonesian art is *Perjalanan Seni Rupa Indonesia/Streams of Indonesian Art*, a bilingual volume, with 154 reproductions and essays ranging from prehistory to the present.[12] From the last years of the 1980s and the beginning of the 1990s, a new trend in publishing is evident: individual artists, responding to the growing demands of the art market for information and modern art-related materials, are increasingly publishing books about their own work, commissioning local art writers to write the text. Despite such additions to the bookshelf, the need for a comprehensive history of modern Indonesian art has yet to be met.[13]

The Art World in the 1980s[14]

As in the fields of politics and culture in general, Java and, to a lesser extent, Bali, dominate the modern Indonesian art world today, with Jakarta as the hub of activity. Would-be modern artists from other islands migrate there. Although regional exhibitions are held, it is seen as crucial to the career of an artist to have a solo exhibition in Jakarta and to be represented in galleries there and in Bali.

In 1970, the nation's first art centre, Taman Ismail Marzuki (TIM), was established as the first formal show-space for exhibitions of modern painting, sculpture, theatre, and music. The Municipal Government's Jakarta Arts Council was behind it. The Balai Seni Rupa (BSR), Jakarta's Municipal Art Gallery, was established in 1976 as an attempt to fill the need for a national gallery (Plate 1). By the 1980s, however, both TIM and BSR, as well as the two or three existing galleries run by private foundations (for example, the Mitra Budaya), were no longer felt to adequately serve the needs of collectors, dealers, and the younger generation of artists. Hence, towards the end of the 1980s, the number of private galleries and corporate show-spaces for artists increased rapidly, notably in Jakarta and Bali, with a few new exhibition spaces appearing in Yogyakarta, Bandung, and

[11]Lempad, whose art and life were intimately rooted in his immediate culture, is extolled as a prominent national figure, one among many examples of official effort to create a national history above deep-seated regional and cultural differences and loyalties (Masjkuri, 1979/80).

[12]Bandung: KIAS and Festival of Indonesia, 1992.

[13]The sudden and premature passing away of Sanento Yuliman in June 1992 has been a serious set-back to the writing of modern Indonesian art history, in particular the preparation of a two-volume history of modern Indonesian art which was to be co-written with Jim Supangkat.

[14]For a list of major exhibition spaces in Jakarta, Bandung, Yogyakarta, and Bali, see Appendix 1.

1. Balai Seni Rupa, Jakarta.
(Photograph Sudarmadji.)

elsewhere. Foreign cultural centres in Jakarta, notably the Dutch, Japanese, French, and German, have come to play an increasingly important role in hosting both foreign and Indonesian exhibitions, as have bank lobbies and hotels.

By 1990, the collecting of modern Indonesian art had become a fashionable and status-enhancing activity among both the Indonesian and the foreign expatriate élite.[15] Collectors, previously anonymous, now figure in the media and give opening speeches at exhibitions, which both occur and are reviewed more frequently than a decade ago. Numerous articles in the Indonesian press have reported on the unprecedented level of activity of the Indonesian art market: in the last four years alone, the prices of paintings have generally tripled, and annual auctions have driven prices for works by the first generation painters up to fifteen times higher than they were only a few years back. This increase in commercial opportunity has caused more people to (re)turn to modern artistic vocations in Indonesia.

[15]For a discussion of the history and anatomy of collecting modern art in Indonesia, see Wright, 1991a.

Background to Contemporary Indonesian Painting

The roots of modern Indonesian painting date back to the nineteenth century, when a small number of Dutch and European artists were present in the Dutch East Indies. The Portuguese had noted a highly 'natural' style of painting in Java in the early sixteenth century, and an epic poem from the same century tells of the painting of royal portraits, so vivid that they captured the viewer's heart (Holt, 1967: 191). The Dutch gave inferior quality Dutch paintings as gifts to native rulers as early as the seventeenth century. However, it was only in the nineteenth century that the actual techniques of Western oil-painting were introduced into the Dutch East Indies.

The existence of older, indigenous

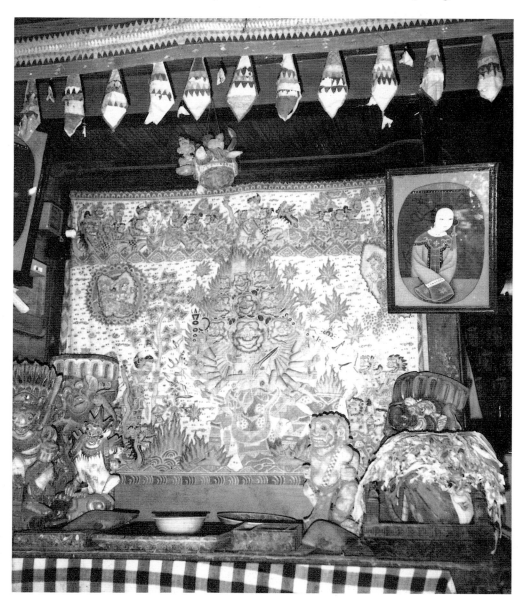

2. Traditional Balinese altar with Kamasan-style painting in background. (Photograph Astri Wright.)

painting traditions is still in evidence in painted scrolls depicting mythological narratives, used by story-tellers, and in manuscripts illustrated in Java and Bali, most often in *wayang* (shadow puppet) style.[16] Masks, puppets, and architectural details are still painted throughout present-day Indonesia (Plates 2 and 3).[17]

Prior to the introduction of Western oil-painting, however, it was the rich array of woven, appliquéd, embroidered, and resist-dyed textiles that constituted the most common two-dimensional indigenous art form in the archipelago (Plate 4) (Gittinger, 1979, 1980). This is especially true for the art of batik (Plate 5) (Tirtaamidjaja, n.d.; Elliot, 1984).

Indonesian historians count Raden Saleh, a nineteenth-century Javanese aristocrat as the first modern native painter in the Indies (Colour Plate 1).[18] He first studied with a Belgian painter in Batavia and later in Holland. During his twenty years in Europe, his talent was celebrated at German and Dutch royal courts (Holt, 1967: 192–8, 327–8). The first school of Western-style painting in the Indies, which followed in the wake of Raden Saleh, has been called the 'Beautiful Indies' school. Its naturalistic landscapes and portraiture dominated modern Indonesian art in the first decades of the twentieth century; the tradition continues to this day in the work of painters like Basuki Abdullah, Wahdi, and Dullah (Plate 6). This approach also informs folk artists and commercial painters working in Java (Plate 7).

3. Sagio, *wayang* puppet in classical Yogyakarta style of Gendeng Batara Guru, collection of University of British Columbia Museum of Anthropology. (Photograph Dominique Major.)

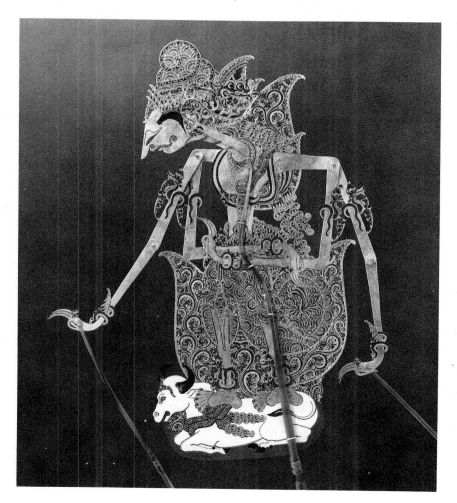

[16]See Chapter 2 for a fuller explanation of *wayang*.

[17]Illustrated manuscripts on various media from Sumatra, Madura, Lombok, Java, and Bali are discussed in Gallop and Arps, 1991; *wayang beber* narrative scrolls, Balinese Klungkung-style painting and *lontar* manuscripts, Javanese manuscripts with floral and geometric decor, masks and *wayang* puppets made both of buffalo hide and of wood, can be found throughout Jessup, 1990. Illustrations of architectural painting can be found in Holt, 1967, and in Barbier and Newton, 1988. Much more material about the development of painting in Indonesia could be gleaned from a study of the illustrations in Javanese manuscripts. Besides the traditional flat colour filling in of drawn outlines, some of these show the influence of European painting techniques, such as the attempt at realistic anatomy and shading in the painting of horses in the Javanese manuscript *Serat Bratayudha* from 1873 to 1883 (Jessup, 1990: Fig. 68).

[18]Here, Indonesian art historians use the word 'modern' to denote art which, in conception, technique, media, function, and meaning is new within the history of Indonesian art, drawing on non-indigenous artistic influences similar to the way modern European art in its genesis did, its native practitioners in the Dutch East Indies recruited and trained in ways entirely unlike the traditional social and educational institutions within which pre-modern Indonesian arts were produced.

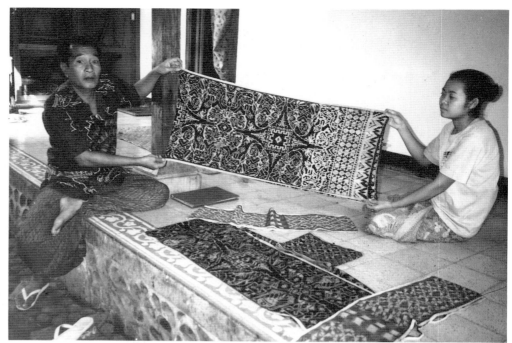

4. Tengganan villagers in Bali displaying 150-year-old *geringsing* double-*ikat*. (Photograph Astri Wright.)

5. Woman selling textiles from different parts of Java in Solo market. (Photograph Astri Wright.)

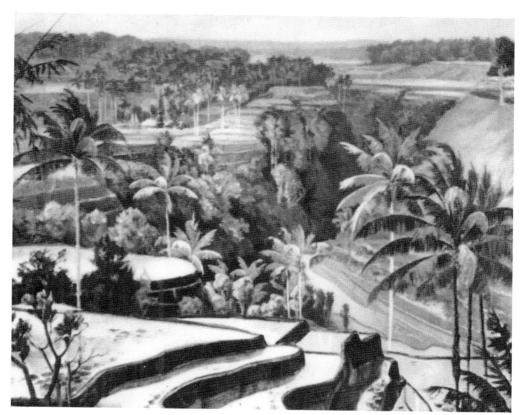

6. Dullah, *Rice-fields in Bali*, 1955, oil on masonite, 70.5 × 97.5 cm. (Sukarno Collection, Vol. II, No. 70.)

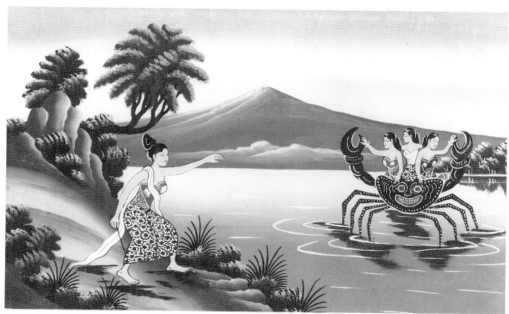

7. Tjitrowahyu, *Javanese Folktale*, 1988, gouache on cardboard, collection of Astri Wright. (Photograph Astri Wright.)

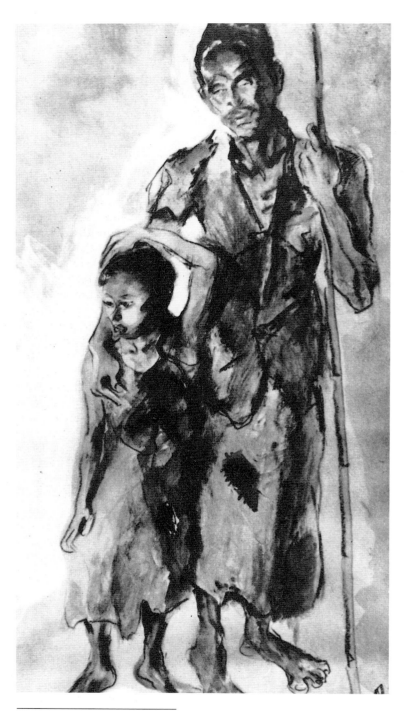

8. Affandi, *Child Leading His Blind Father*, 1944, water-colour on paper, 90.5 × 59.5 cm. (Sukarno Collection, Vol. II, No. 9).

In the late 1930s, inspired by the growing nationalist debate concerning education, language, identity, culture, and politics, painters like S. Sudjojono, Agus Djaya, Affandi, and Hendra Gunawan began to challenge the orthodoxy of this school and started experimenting with new approaches to painting (Plate 8). An intense debate ensued between the different factions of artists. The division between artists who believe that art belongs in the realm of personal involvement and vision, and those who believe it belongs in the realm of social and/or political involvement has triggered new rounds in the art debate in Indonesia periodically ever since. This has been one of the factors to inspire the pluralism in style and agenda which has characterized the last forty years of Indonesian art.

On 17 August 1945, two days after the Japanese surrender to the allied forces, Sukarno proclaimed Indonesian Independence (Plate 9). The Dutch, expecting to resume control in their colony as before the war, did not accept the declaration. For the next four years, Indonesians found themselves fighting for independence against heavy odds, in a war which was finally resolved by international pressure in 1949 (Kahin, 1952: 391–445). The involvement of many artists in the struggle is reflected in their art (Plate 10).

Soon after Indonesian Independence was a fact, the first two fine arts departments were established, later co-ordinated under the Ministry of Education and Culture and upgraded to art academies. Both were modelled on Dutch academies. Originally, their respective environments and methods of recruiting teachers and students gave rise to dramatically different approaches to modern art, the Faculty of Fine Art and Design at ITB in Bandung espousing aesthetic formalism and the Indonesian Academy of Fine Art (ASRI) in

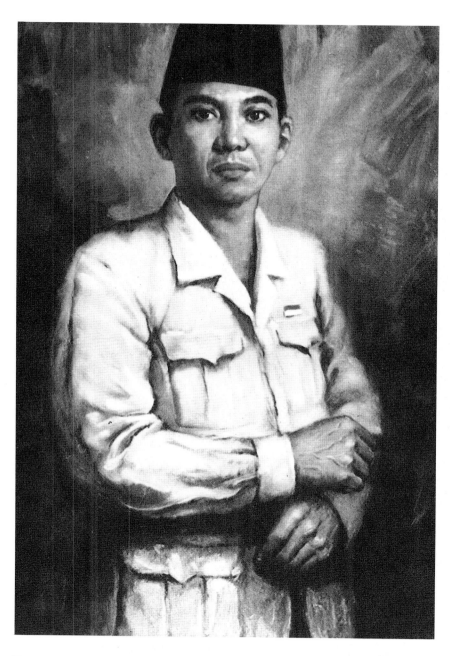

led to an inclusion of structural arts and design into the art department, as a balance to the emphasis on art for art's sake in the fine arts section. None the less, many of the works produced were only semi-abstract, with recognizable references made either visually or in the titles (Plate 11).[19]

Yogyakarta—commonly referred to as Yogya—the centre for the strongest surviving Javanese court culture and for batik, during the Revolution became the capital of the republican government and the centre for a dynamically evolving popular culture (Plate 12). Artists who believed in the active role of art in the nationalist struggle congregated there around the figure of Sukarno, and many of them stayed after the capital shifted to Jakarta in 1949. Hence, in the 1950s and early 1960s, the most active artist organizations were located in Yogyakarta, some connected with and others independent of ASRI. Some artists, like Batara Lubis, created highly stylized decorative work, drawing on his native Batak aesthetics and forms (Plate 13). Most, however, concentrated on depicting Indonesian life in representational forms of art, in a range of expressionistic styles (Plate 14).

The main point in the debate between the two schools has been the question of Indonesian identity, whether it was an essential question for artists to be concerned with, and if so, how this was best expressed aesthetically. ASRI

9. Basuki Abdullah, *President Sukarno*, early 1950s, oil on canvas, 111 × 75 cm. (Sukarno Collection, Vol. II, No. 1.)

Yogyakarta an art rooted in social realities.

The earliest teachers at the Bandung art department were Dutch. The emphasis on technical studies, such as engineering and architecture at ITB, along with the European teachers' focus on Western formalism and abstract art,

[19]Interestingly, although at ITB-Bandung Ries Mulder's choice of motifs may have contributed to launching themes which have later become common visual 'clichés' in the work of many Indonesian painters (fishing boats, landscapes, villagescapes), Mulder's work is stiffer than that of many of his students, a fact of which he was both aware and unhappy, as evident in a comment made to Holt (1955). Another Dutch painter who influenced artists, some still active today, was Gerard P. Adolfs, who lived in Surabaya most of his life, and who painted genre scenes in an impressionistic manner (Rudi Isbandi, 1975).

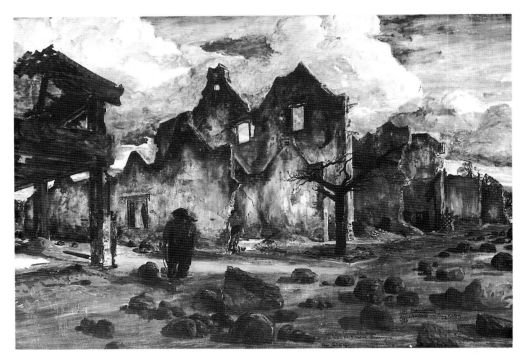

10. S. Sudjojono, *Shelled City*, 1949, oil on canvas, collection of Balai Seni Rupa. (Photograph Astri Wright.)

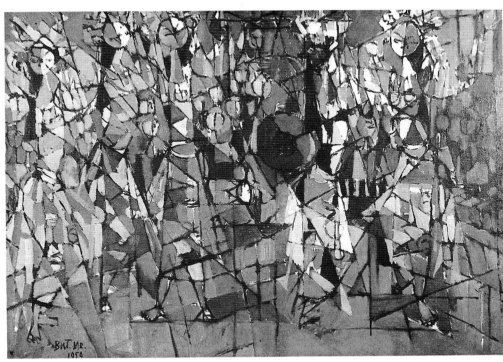

11. But Mochtar, *Dancers*, 1959, oil on canvas, 65 × 95 cm, Adam Malik Collection. (Photograph Astri Wright.)

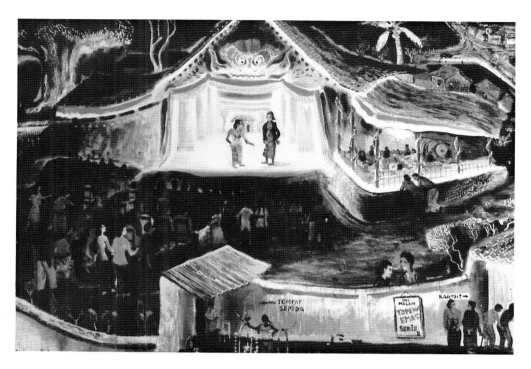

12. Surono, *Ketoprak* (*Popular Theatre*), 1950, oil on canvas, 82.5 × 122.0 cm. (Sukarno Collection, Vol. IV, No. 21.)

claimed that ITB, with its emphasis on formalism, was too Westernized, and ITB criticized ASRI for merely being Westernized in a more old-fashioned way, emphasizing narrative content which was clearly Indonesian, but none the less employing Western styles and media (Holt, 1967: 206).[20]

The existence, mainly in Yogya, of

sanggar—small artist groups, independent of the academies, centred around one or several senior artists—provided an alternative milieu in which artists could live, study, and work closely together. These *sanggar* were also the prime organizers of group exhibitions. It was only in the late 1950s and early 1960s that the first galleries appeared, laying the foundations for an institutionalized art market.

After the crack-down on leftist organizations and populist artistic expression in 1965,[21] the approaches of the two academies became less polarized. They are still the most important educational centres for artists in Indonesia. Since 1970, the non-government Jakarta Art Institute has played an important role in educating

[20]While acknowledging 'antagonistic undercurrents and rivalries', Holt emphasizes that both schools 'appeared to enjoy complete freedom in seeking and pursuing their own ways. There was no trace of a nationally prescribed ideology; there was no interference with or pressure on either staff or students in so far as subject or style was concerned. Consequently, in both schools one could find a great variety of conceptions in the work of both teachers and students' (1967: 206). Spanjaard (1990) goes so far as to argue that there was never a 'gap' between the Bandung and Yogya art academies. Both of these statements beg the question why it has seemed so important inside Indonesia, since 1966, to emphasize the need to 'narrow the polarities' and 'quell the antagonisms' which were perceived from official hold to exist between the two schools. Clearly, there are a number of different readings of the situation as well as diverse agendas. One of these is the Suharto era's

view of history and expression, which contrasts to the earlier period, when artists of all persuasions felt compelled to show their loyalty to their particular region and teacher, and to have *their* aesthetical-political stands reflected in their art.

[21]See Chapters 7, 8, and 10.

13. Batara Lubis, *Motif*, 1972,
oil on canvas, 74 × 74 cm,
Adam Malik Collection.
(Photograph Astri Wright.)

artists. There are also fine art departments at certain universities, such as Udayana University in Denpasar, Bali, and the University of March Eleventh (Universitas Sebelas Maret) in Solo. Finally, the art departments at regional teachers' training colleges (IKIP) across the nation must be mentioned. The prestige of holding a formal degree, and the importance of institutional affiliation, have today eclipsed both the reality and the previously powerful idea of the self-taught artist, prominent among the first generation of painters.[22]

[22]The subject of the 'self-taught' (*otodidak*) artist is discussed in Chapter 4.

In 1984, But Mochtar, a graduate of ITB and an early abstract artist, was appointed rector of ASRI in Yogyakarta, now renamed the Indonesian Institute of Art (Institut Seni Indonesia or ISI). During his tenure, which lasted until 1992, the curricula of the two art academies were standardized in ways that narrowed the original difference in approaches. Similarly, the artistic production in both places began to exhibit the full range of approaches, although the old characteristics of the two schools is still apparent when one looks at which art forms are given most emphasis. Long departed from their Mulderesque, cubist-inspired works of

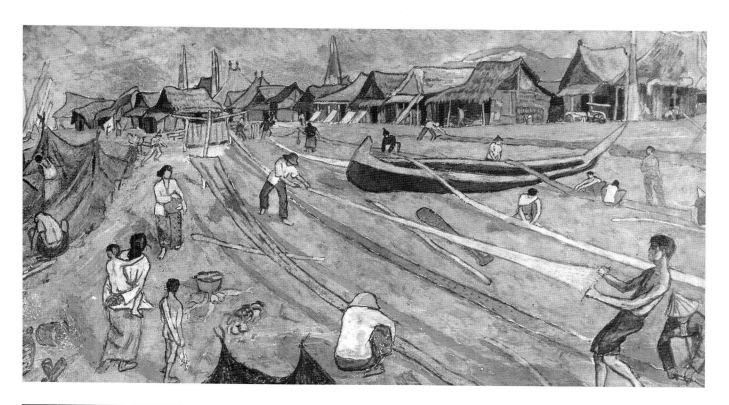

14. Tarmizi, *Fishing Village*, n.d., oil on canvas, 74.5 × 135.0 cm. (Photograph courtesy of the Adam Malik Collection.)

the 1950s, faculty members in Bandung in the 1970s began to self-consciously develop a modern 'national' visual vocabulary (Plate 15). Several artists formed the design group DECENTA, a forum for the study and collecting of Indonesian indigenous, tribal, and folk arts, including textiles. Abstracting designs from traditional arts representing belief systems ranging from animism to Islam, the DECENTA artists reformulated them into a modern idiom (Plate 16). The group has carried out numerous architectural and interior design projects on commission, especially in and around Jakarta (Plate 17). Finally, in this decade, modern Islamic painting emerged here as a new school (see Chapter 3).

Thus, while Bandung's academic artists in the 1970s began to explore Indonesian 'identity' through the reassembling of ethnic forms, abstract art, on the other hand, found a certain foothold in Yogyakarta. Some artists began to

explore hard-edged geometric abstraction, such as Handrio in his paintings inspired by music (Plate 18). In the 1980s, some art students began to experiment with abstract expressionism, as mature artists such as Nunung W. S. were already doing in Jakarta (Plate 19) (see Chapter 5).

Despite this merging of aims and practices in recent decades, however, many of the old ideas still influence artists' choices, which school art students decide to apply to, and the way people talk about Yogyakarta and Bandung. ITB-Bandung is today considered by many to be stronger in graphics and sculpture, while ISI-Yogyakarta is perceived to be stronger in painting. Although many young painters at ISI today work in abstract styles, the majority (evident even in the titles of their abstract works) still draw on local and tradition-based narratives. Besides pursuing interests in contemporary international art movements, many of

them are actively involved with *wayang* performance traditions and innovations, the mythology of Java and other islands, and classical dance (see Chapter 13).

The silencing of the voices calling for a socially engaged art after the cataclysmic change in regimes in 1965–6 lasted until the mid-1970s, when a group of young artists called the New Art Movement emerged to challenge the established order of the art world (see Chapter 12). Rebelling against the older artists in command of curricula and exhibitions, who defined art in terms which these younger artists found too conservative, Westernized, and remote from Indonesian realities, a group of young artists in the major cities sought to bring their art closer to the context of Indonesian life. For the first time in Indonesia, conceptual works were created and exhibited, causing the sharpest debate in the Indonesian press about the definition and function of art since the revolutionary decades of the 1930s and 1940s and the years leading up to 1965.

The 1980s in Indonesia were less polarized than the late 1970s. The New Art Movement was largely inactive although individual members exhibited occasionally. While conceptual art had attained a certain degree of legitimation,

17. Said Naum Mosque, interior, Jakarta. (Photograph Kamran Adle. Courtesy of the Aga Khan Award for Architecture.)

18. Handrio, *Painting VI*, 1988, acrylic on canvas, 84 × 54 cm, when photographed, collection of the artist. (Photograph Astri Wright.)

well as directly from the West, began once more to generate works that played with these established categories. Crossing the boundaries between two and three dimensions, between abstract, representational, and conceptual art, and between different media, these young artists incorporated movement and space into works that communicate on a more individual level, with personal and spiritual content or veiled socio-political commentary, often in caricaturistic, surrealistic, or other allegorical forms.

In the course of the decade, interesting developments in the 'socially engaged' tradition occurred: Hendra Gunawan (see Chapter 8), one of the best-known artists of the first generation, reappeared at the end of the 1970s after more than a decade in prison, and his voluptuous symbolic depictions of market women in dreamy landscapes, folk festivities, and itinerant performers quickly became the rage among Indonesian collectors. Sudjana Kerton (see Chapter 9), one of the many battlefield artists of the 1940s, returned from three decades abroad to enrich the Indonesian art world with his humorous sketches of village life. The intensity and originality of sculptor Amrus Natalsya, all but silenced after 1965, was again given limited public exposure through a private gallery owned by his major patron. The most recently emerged painter of popular hardship is Djoko Pekik, now exhibiting again after a hiatus of twenty-five years (see Chapter 10).

A younger artist, Dede Eri Supria (see Chapter 12), the first Indonesian urban photo-realist, who emerged into public attention with the New Art Movement, found his 'voice'. He increasingly incorporated surreal elements into his work, which juxtaposes poor labourers and villagers in the modern metropolis. With the subject-matter of social realities thus quietly gaining ground, more visually adamant artists like Semsar, with

in most artists' work its original political edge disappeared (Plate 20). The majority of Indonesian artists continued to work along the lines of established categories of style and content.

Some of the youngest generation of artists, however, picking up on ideas introduced by the New Art Movement, as

19. Nunung W. S., *Dialogue II*, 1989, gouache on canvas, 75 × 110 cm, when photographed, collection of the artist. (Photograph Astri Wright.)

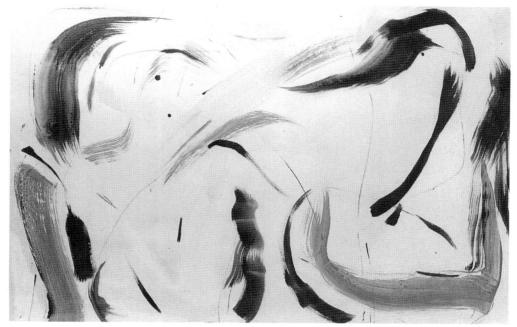

20. Nyoman Nuarta, *Rush Hour*, 1990, copper mesh, 120 × 140 cm. (Photograph courtesy of the artist.)

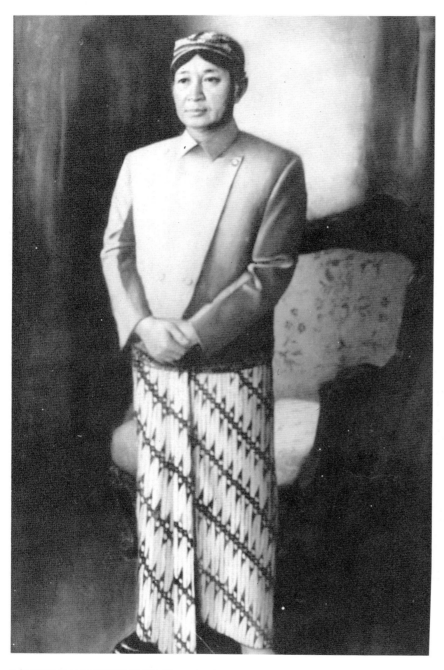

range of figurative, representational modes, echoing the sentiment of the revolutionary generation that their art must be accessible to everyone.[23]

It is within the larger group of artists, informed by their personally inspired visions, that the greatest stylistic variety is found, ranging from romantic-realist to abstract art. Among the romantic-naturalist landscape painters today, Wahdi in Bandung is one of the best, with a lyrical light and vision that is his own. Basuki Abdullah is the most famous, loved by the establishment for his nostalgia-ridden landscapes, flattering portraits, and melodramatic mythological scenes (Plate 21). A few sculptors also occasionally work in this vein, as illustrated by Nyoman Nuarta's *Ardjuna Victorious* (Plate 22) near the National Monument in the centre of Jakarta. Artists like Sudibio, whose art since the 1950s had fused spiritual and traditional motifs with personal psychological dimensions, experimented with combining imaginative visions with forms from Indonesian ethnic groups other than their own (Plate 23).

The father of abstract painting in Indonesia, the late Ahmad Sadali, was inspired by Islamic spirituality (see Chapter 3). Abstract or semi-abstract artists noted in exhibitions in the 1980s were, among others, Zaini, Srihadi Sudarsono, A. D. Pirous, Nashar, Bagong Kussudiardja, and female painters Farida Srihadi and Nunung W. S.

21. Basuki Abdullah, *President Suharto*, 1980, oil on canvas. (Photograph courtesy of the artist.)

his biting political caricatures, even found élite patronage.

Locating their inspiration and empathy in the everyday realities of the urban and rural poor, with whom they exhibit a certain identification, it is perhaps inevitable that these artists work in a

[23]It is still widely felt in Indonesia, as elsewhere, that abstract art is only 'understood' by the educated urban élite; indeed, modern Indonesian art predominantly mirrors the traditional cultural predisposition for viewing art works as embodiments of mystically or spiritually powerful symbolic texts, with the power to communicate to the people at large. It is perhaps from this perspective that certain works of art (such as those that establish an independent visual lexicon not immediately accessible to the unschooled eye) are viewed as potentially dangerous, demanding strict official control.

22. Nyoman Nuarta, *Ardjuna Victorious*, 1987, polyester resin, 4 × 25 m. (Photograph courtesy of the artist.)

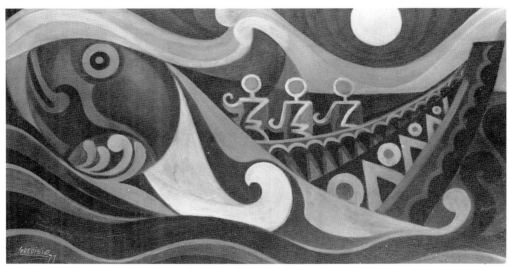

23. Sudibio, *Figures in Boat*, 1977, oil on canvas, 49.0 × 88.5 cm, collection of Toenggoel Siagian. (Photograph Astri Wright.)

Nindityo Adipurnomo (see Chapter 4) is one of the younger abstract artists to claim critical attention. Noted for their flat colour, geometric abstracts are Handrio and Mochtar Apin (Colour Plate 2). All of these artists use formal abstract methods to seek expression for their emotions, memories, sense experiences, or spiritual visions.[24] In

[24]Many Indonesian works which would be

abstract sculpture, Sunaryo, Arsono, Edith Ratna S. (Plate 24), and Untung must be noted; in addition, many sculptors who work in a range of styles, occasionally do abstract work, like Edhi Sunarso, Sidharta, and Nyoman Nuarta.

viewed as abstract by outsiders refer, however schematically, to traditional religious or mystical symbols, as evinced in the artist's vocabulary when talking about or naming the work.

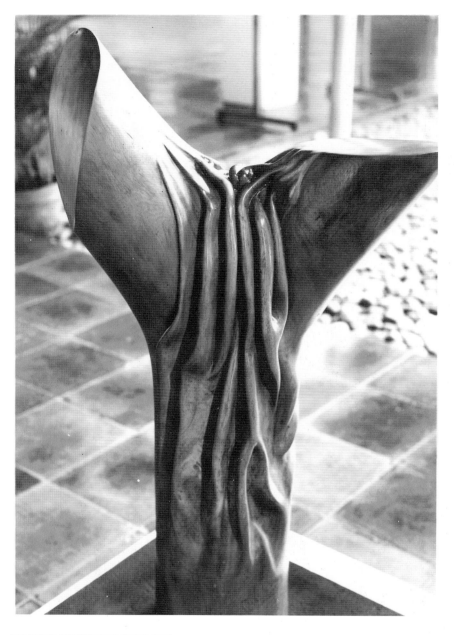

24. Edith Ratna S., *Dialogue IV*, 1987, wood. (Photograph Astri Wright.)

A decorative approach to sweet, innocuous, and highly familiar themes, in both painting and sculpture, holds great appeal to many Indonesian art lovers and collectors (and to many of the Pan-Asian collectors of Indonesian art, notably the Japanese). Hence, large numbers of older and younger artists contribute to this category, Irsam (Colour Plate 3), and Mulyadi W. (see Plate 72) being perhaps the most famous. This group includes many among the smaller group of active female artists (Colour Plate 4). Various degrees of representation are attained through a repetition of formal elements, contours, or patterns, usually composed of discrete, recognizable forms such as masks, human figures, animals, or traditional symbols derived from Indic, Islamic, or indigenous iconographies. It seems to be within this group that the most frequent copying of a well-known artist's style occurs. This, along with the repetition of similar elements and themes (often referents to tradition and to rural life) by large numbers of artists, places this group somewhere between a traditional Indonesian model of the art-maker and the modern artist whose work represents a new synthesis of tradition and individual originality.

Among those artists whose work is both decorative as well as original within modern Indonesian art is Widayat (see Chapter 5). He paints primordial, biblical, or Hindu–Buddhist themes in a style which has been called magic-decorative. Nyoman Gunarsa paints Balinese dancers in *wayang* puppet style, in broad, repetitive contour lines suggesting rhythmic movement (Plate 25).

A notable development which could be seen as bridging the gap between the groups inspired respectively by personal, individual vision and social vision was the emergence, in the mid-1980s, of a school of surrealism among young artists in Yogyakarta (Plate 26) (see Chapter 5).

Between the two stylistic extremes, romantic-realist and abstract, one large group inspired by personal vision is that which ranges from decorative to naïve.[25]

[25]Since there is in Indonesia a large body of art which is called 'primitive' or 'tribal', I prefer the term 'naïve' to 'primitive' in discussing Indonesian painting, though both terms carry unfortunate associations.

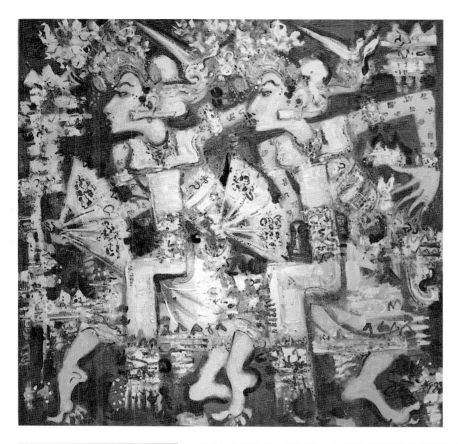

Depicting ruins, statuary, and puppets in metamorphosis or decay is one of many ways traditional art forms and symbols are skewed, twisted, or juxtaposed in shocking ways that create works of great psychological intensity. Although the painting technique and style are immediately recognizable to a Western audience, the discrete elements and forms derived from a traditional symbolic vocabulary can only be fully fathomed by someone familiar with Javanese and Indonesian culture—as, in the last resort, is the case with most of modern Indonesian art.

25. Nyoman Gunarsa, *Two Balinese Dancers*, 1988, oil on canvas, approx. 110 × 110 cm, when photographed, at Duta Fine Arts Gallery. (Photograph Astri Wright.)

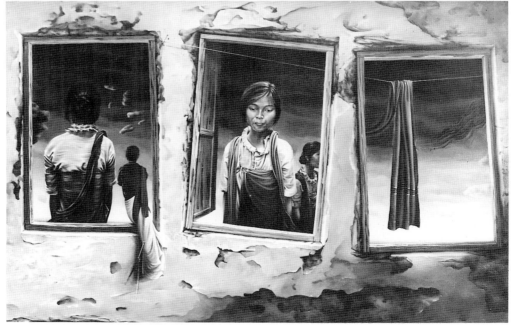

26. Ivan Sagito, *Yesterday, Today, Tomorrow*, 1986, oil on canvas, 100 × 150 cm. (Photograph courtesy of the artist.)

PART I
The Mountain as Metaphor
for the Spiritual

2 Soul, Spirit, and Mountain

The Symbol of the Mountain

THE perception of the mountain as a symbol of the universe, an idea familiar to many cultures world-wide, is pervasive throughout South-East Asia. Since the beginning of the historical period and probably long before, the thought that the structure of the cosmos was mirrored in the religio-political realm has repeatedly been illustrated in textual and visual imagery, where frequently the mountain, as the cosmic Mount Meru in Hindu–Buddhist mythology, is the chosen image of analogy between the macro and the micro perspectives.[1] The motif of the mountain continually recurs in modern Indonesian art as well. In the hope of highlighting, in both culturally accurate as well as poetically vivid ways, broader questions relating to perceptions of self, society, and artistic creativity, the symbol of the mountain will be the conceptual context for this discussion of modern Indonesian art and artists.

The ideas surrounding the image of the mountain in modern Indonesia resonate against millennia-old preoccupations with the soul and with spirit power, informed by indigenous animist, Buddhist, and Hindu ideas. These ideas have metamorphosed slowly during centuries of Islamization and colonization. Continuing into the modern era of nationalism and industrialization, they have changed but were never wholly lost.

Mountains have an acute objective reality in Indonesia, which is a chain of volcanic islands, both extinct and active. To many Indonesians, the sight of a smoking volcano is a familiar part of life (Plate 27); to some, the threat of an eruption still nourishes ancient beliefs in the need to pacify the destructive power of the spirit residing in the mountain. Until recently, the princes of Central Java still sent elaborate peace-offerings of textiles and other precious things to be thrown into the craters of the area's most active volcanoes (Holt, 1967: 28).[2] When Sultan Hamengkubuwono IX of Yogyakarta died in September 1988, many people in the region worried that Mount Merapi would now erupt. The Sultan had, it was said, with his superior spiritual prowess, extracted the obedience of the dragon that lives in the mountain; now that he had passed on, it was unclear whether the contract would still be honoured or whether his son would be spiritually powerful enough to renew it

[1] It would be redundant to cite all the sources discussing the importance of the mountain. For an introduction, see Holt, 1967: 11–93. For an updated review of contributions to the subject with bibliographic references, see Jessup, 1990: 49–71.

[2] Reports of such propitiary offerings can still occasionally be found in both the national and the regional press.

27. Mount Merapi, covered with daily emissions of volcanic smoke, behind modern houses in Salatiga, Central Java. (Photograph Astri Wright.)

(Plates 28 and 29). To help ensure the old Sultan's continued protection, it was deemed vital that offerings be made at his tomb at Imogiri.[3]

[3]As has been noted about another well-known sultan, 'The point here is not simply the glory of Sultan Agung's rule, but also the character of traditional Javanese thought, which makes no sharp distinction between the living and the dead' (Anderson, 1990b: 39).

Besides their topographical and occasionally dramatic reality, their agricultural and their mythological significance, mountains have been symbolically central to the Indonesian world-view since prehistoric times. Their importance was reinforced when Hindu and Buddhist religious systems were adopted in the archipelago in the early centuries of the Christian era.

What exactly the mountain meant in prehistoric days can only be guessed at within the framework of the animist world-views of nineteenth- and twentieth-century indigenous peoples. Given the persistence throughout Asia of ideas which attribute sacred qualities to mountains, and especially to their peaks, it is probable that Hindu–Buddhist views, as recorded in sacred texts and enacted in sacral arts and rituals, elaborated on earlier ideas rather than contradicted them.

Thus, throughout Indonesia, the mountain figures in local myths of origin are still told today, from Sumatra to Kalimantan, from Sulawesi to Timor and Maluku (Barbier and Newton, 1988: 72; Jessup, 1990: 51). The mountain as abstract sign—sometimes used consciously as symbol, sometimes as decorative form—is found in the lines of running triangles on prehistoric kettledrums and in the patterns of textiles, such as batik from Cirebon (Elliot, 1984: 90);[4] on supplementary

[4]This reading of the upright triangles on kettledrums as abstractions of the mountain is speculative, based on knowledge of Chinese bronzes and of other traditional arts and motifs in Indonesia. According to this reading, the central 'star' motif on the kettledrums would be, rather, the negative space of heaven left between the inward-pointing peaks of the chain of mountains running around the edges of the innermost circle. A paper which would support such a reading argues that the many-pointed representation of stars originated in the Mediterranean or Mesopotamian region and only migrated to Eastern Asia after the Dongson drums were created (Loofs, 1975). The triangles are

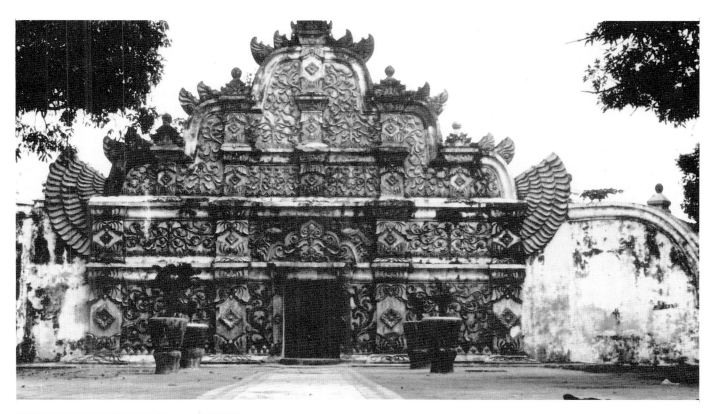

28. Gateway in the shape of a mountain, flanged with *garuda* wings, at Taman Sari, the royal Water Castle in Yogyakarta. (Photograph Astri Wright.)

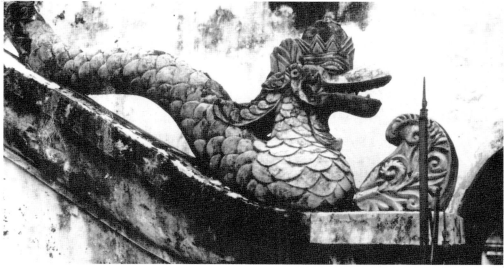

29. Dragon or *naga* on one of the railings at Taman Sari, Yogyakarta. (Photograph Astri Wright.)

interpreted as funerary- and fertility-related symbols. A connection between these and beliefs relating to mountain imagery as maps of the voyage of the soul is likely, especially in a realm where the meanings of individual symbols were not considered mutually exclusive.

weft cloth from Lampung; and on *songket* (supplementary weft pattern with use of gold-wrapped thread) cloth from Bali (Jessup, 1990: Cat. Nos. 77, 156b). The triangle is found on the miniature art of illuminated Javanese manuscripts and jewellery (Jessup, 1990: Cat. Nos. 99, 102). It is the main geometrical configuration that characterizes the upper elevations of monumental architecture, ranging from the Hindu or Buddhist stone temple to the wooden mosque (Plates 30 and 31);[5] from the steep, tapered roofs of Javanese village houses to the chief's house on South Nias, in South Sulawesi, Timor, and elsewhere (Plate 32) (Barbier and Newton, 1988: Figs. 42, 154). The first and last image to be shown on the screen of the *wayang* shadow puppet play is named *gunungan*—'like a mountain'. Even in a modern publication of photographs of Indonesia, the mountain frames the book's contents: not only the first photograph, but six of the first seven photographs, are of mountains—erupting volcanoes, deep trembling craters, and mist-shrouded peaks—and the last photograph in the book before the credits is a *gunungan* (Joop Ave, 1986).[6]

The mountain thus stands as a symbol both of this world and of the spiritual realm, and it mediates the likeness and communication between the two. This is not unique to Java: remains of the earliest religious sanctuaries known to mankind were located in mountain caves. Later religious structures were inspired by the form of the mountain, abstracted into an emblem. Hindu temples in India consciously duplicated the structure of the cosmic mountain, with the central vertical axis resting on its horizontal base, and all the structural and decorative details echoing the whole in the same way the microcosm was believed to mirror the macrocosm (Kramrisch, 1946). In South-East Asia, Hindu and Buddhist forms merged in different ways, creating local contributions to the history of Hindu and Buddhist architecture.

Central Java's Borobudur, the largest Buddhist monument in the world, is one of the most elaborate and enigmatic creations, combining elements of the Buddhist stupa with the idea of the cosmic mountain (Snodgrass, 1985: 226). Borobudur illustrates the point that the mountain is simultaneously an image of the universe and of the soul's journey towards Enlightenment. The devotee visiting Borobudur was supposed to ascend it, terrace by terrace, circling each clockwise, meditating on the reliefs at the lower levels, and later on the Bodhisattvas and Buddhas at the higher levels, finally reaching the top, where no decoration mars the pure abstraction of the central stupa itself (Plates 33 and 34).[7]

In studies of Indonesian art, most attention has been given to the classical

[5]Examples are the Hinduized type seen in the minaret at Kudus (Bernet Kempers, 1959: Pl. 34). The Great Mosque at Demak is an example of a later version still clearly Hindu- and mountain-inspired, in contrast to more modern mosques with clear Middle Eastern inspiration, such as the Istiqlal Mosque in Jakarta. Even modern mosques are built on the idiom of the mountain, however; see Masjid Said Naum in Jakarta, which in 1986 received honourable mention by Aga Khan's Swiss-based foundation (Tuti Indra Malaon, 1987).

[6]Published on the occasion of the fortieth anniversary of Indonesian Independence, this book has the work of eighty-eight photographers, mostly Indonesian, chosen among the work of 2,000 submitters.

[7]Krom's interpretation (1926) of Borobudur's three architecturely distinct levels as representing the spheres of *kammadhatu* (sphere of desire), *rupadhatu* (sphere of form), and *arupadhatu* (sphere of formlessness) has been challenged by John C. Huntington (forthcoming), who argues that the *arupadhatu* cannot, by its very nature, be depicted, architecturally or otherwise; thus, Borobudur should be read as representing levels of *kammadhatu* (lowest terrace) and *rupadhatu* (middle and upper terraces). It is within the latter sphere that Enlightenment takes place, during which the spiritual transition into the *arupadhatu* takes place.

30. This view of Besakih
 Temple in Bali, built on the
 slopes of Mount Agung,
 displays (from right to left)
 the squat triangular roof on
 an offering pavilion, the
 pagoda-like tower, the
 steeply tapering split gate,
 and the undivided gate.
 (Photograph Astri Wright.)

31. Mosque in Kudus, north
 Central Java, with a Hindu-
 style minaret and a Central
 Asian-style hall.
 (Photograph Astri Wright.)

Cat. Nos. 45, 60);[8] from the shape of the Hindu priest's head-dress in Bali, and Ganesha's head-dress at Candi Sukuh, to the triangular Kala head-dress from Borobudur (Fontein, 1990: Cat. Nos. 11A, 33); from the split gates of Balinese temples to the triangular composition frequently used in sculpture, echoes of the mountain are everywhere.[9]

In the Hindu–Buddhist view, the mountain stabilizes the universe, holding sky and earth in place, pacifying the 'demonic forces of disruption, instability and disorder'. Symbol of the Supreme Being, the mountain is like 'the unshakeable and firm hub of the universe' (Snodgrass, 1985: 187).[10]

Out of the hub of the wheel—imagined horizontally, the sacred diagram of the terrestrial plane—the mountain rises like an axis. The importance of the axis is that it was

... ritually set up as a line of communication with other planes of existence and as a way of return to their common source. It is a pathway of ascent, leading upward through the confining carapace of the physical world, passing beyond its limits and bounds to the unlimited and the unbounded. The axial pillar leads to the realm where the shackles of space

[8]Although Sri Soejatmi Satari's interpretation of these terracottas as purely decorative items devoid of any earlier magic-religious function does not answer the question why they were found near a mosque, embedded in the debris of other offerings, this essay is a contribution to the much neglected study of traditional ceramic sculptural arts.

[9]The triangle was a common principle of composition in classical Javanese art, where the device of two smaller figures symmetrically flanking a larger central one, or three figures of equal size, the one in the middle placed above the two flanking ones, is commonly employed (Holt, 1967: 63).

[10]This volume is a brilliant exposition of the symbolism of Hindu and Buddhist cosmologies and their reflection in the horizontal and vertical elements of the stupa as well as in its details. Here, Snodgrass has done for the stupa what Kramrisch (1946) did for the Hindu temple; in addition, his lucid comparison of the unity and occasional divergence between Hindu and Buddhist symbolism fills an important gap in the scholarship.

32. Traditional Melayu house, Taman Mini, Jakarta. (Photograph Astri Wright.)

era, and hence the Hindu–Buddhist iconography of the mountain repeatedly claims our attention. Also, in this part of the Indonesian heritage, the iconography of the mountain is embedded in stone, wood, metal, and cloth. From the composition of the monument as a whole to the small cave-like niches containing meditating Buddhas at Borobudur; from the cosmic mountain of the three-part Hindu temple of Prambanan (Plate 35) to the abstract peaked outline of the mandorlas framing bronze Bodhisattvas, to miniature terracottas depicting mountains, used as offerings and probably also in private homes (Sri Soejatmi Satari, 1981; Fontein, 1990:

33. Borobudur, ninth-century Buddhist edifice, Central Java; view from the top terrace where perforated bell-shaped stupas containing hidden Buddhas circle the plain, central, stupa. (Photograph Astri Wright.)

34. Borobudur, emerging from early morning mist. (Photograph Astri Wright.)

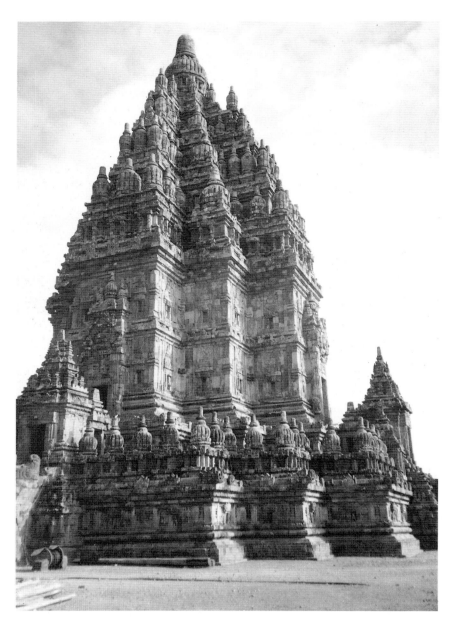

explanation for Mount Meru's frequent depiction like 'a pillar, a lotus or a tree' (Snodgrass, 1985: 178). From the form of the pillar, the step to the *lingga* is short; not surprisingly, the same axial ordering and therefore life-enhancing symbolism pertains.[11] It is this basic chain of ideas that accounts for the plethora of depictions of mountains, rising lotus stems, trees, and *lingga* throughout classical Indonesian art.

Rulers, Ancestor Spirits, and Gods

The importance of the axis in our context is that, as described in the above quote, it was thought to be a two-way channel which human souls could ascend and through which divine beneficence could descend. In Indonesia, mountains, especially their peaks, were believed to be the site where gods and ancestor spirits dwell and whence they take active part in human affairs.[12]

[11]The *lingga* (Jav.; Sanskrit *linga*) is the representation of Shiva's phallus, pillar, or axis of the world.

[12]The material cited pertains mostly to the Hinduized parts of Sumatra, Java, and Bali, with an emphasis on Java. Since this corresponds to the areas which have received the most intensive degree of modernization and where modern painting exists, the metaphor is appropriate. Ancestors are important actors in other parts of Indonesia as well, and intercourse with them gives rise to much ceremonial music and art, also two-dimensional: among the Dayak in Kalimantan, ancestors are believed to come to women in their dreams revealing new and meaningful patterns to be woven in *ikat* textiles (Vogelsanger, 1980).

These ancestors do not necessarily dwell on mountains; the ancestors of, for example, the Taliabu in Maluku can opt to live in one of the three levels of heaven located below the earth, or in one of the invisible palace cities located at certain points in the mountain ranges. A more modern notion of hierarchy has been imposed on the Taliabu cosmology, however, as their ancestors have been subordinated to the authority of Jesus, who in turn is seen as subordinate to the One God (David Baldwin, pers. com., January 1991).

That the idea that ancestors live on mountains also exists on the level of commercial clichés in

35. Prambanan, ninth-century Shiva temple, Central Java. (Photograph Astri Wright.)

and time are shaken loose. At the same time, it forms a channel for a downflowing of reality into the less-than-real world, an influx that imbues the world with meaning, opening up the finite to the Infinite and time to the Eternal (Snodgrass, 1985: 163).

The axial nature of the mountain is reflected in the myth of the Churning of the Milk Ocean; the mountain's use in this story as a churning rod is one

Daily life was directed by the souls of the departed ancestors who were supposed to be dwelling in the mountains. It was they who lived on at the hidden sources of the rivers, without whose waters no rice would grow. They were the founders of the village communities; they had established its customs and cared for its growth. These ancestors also disposed of the sources of magic life-power, the power which caused not only the life of man, but also that of animals and plants, even of the community of men—the mysterious fluidum without which no welfare was possible (Stutterheim, 1935: 2).

Although this passage is a description of religious themes in pre-Hinduistic Bali, the ideas remain relevant in the synthesis that is Hindu–Balinese religion, and illustrates the continuity of cosmological preoccupations from animist to later eras. Ancestor spirits and gods were thought to be the forces which determined the outcome of events in the world. Therefore, whoever wanted power would need their blessing or direct intervention and hence access to the axial lines of communication needed to be maintained. Hence, during the Hindu–Buddhist era, and possibly earlier, shrines and later temples to the ancestors were built on mountains.[13] One of the important acts carried out by contestants to the seat of power—would-be tribal chiefs, rajas, and later sultans—was to climb a mountain, to fast, and to meditate in caves, and in this way commune with the gods and spirits (Plate 36). The spiritual strength that was seen to accrue from such practice translated into worldly, political strength in a society where the two were seen as inseparably entwined (Anderson, 1990b). The material reality was believed to reflect the spiritual; inner virtue was made manifest in the world by outer wealth and the power to command; and the mountain symbolized this whole chain of ideas.

Among his subjects, the ruler was thus perceived as a superior being, one who dwelt simultaneously in both the earthly and the spiritual realms, a manifestation of spirit power beyond the reach of lesser mortals. Many of the classical sculptures of Central and East Java commemorate historical rulers. It is possible that some of these sculptures are posthumous 'portraits' of their royal patrons, depicted as the particular Hindu or Buddhist deity of which they were believed to have been the incarnation or with which they had personally identified during their lifetime. Among many examples is a sculpture believed to commemorate a thirteenth-century East Javanese king, Anushapati of Singhasari, as Shiva, and a fourteenth-century East Javanese sculpture believed to commemorate Queen Dedes as Prajñaparamita, the Buddhist Goddess of Perfect Wisdom (Bernet Kempers, 1959: Pls. 216, 222).[14]

After his or her death, the ruler, it was thought, crossed over from the visible world to the invisible realm of gods and ancestors on the mountain. Later generations seeking spirit power could approach them, either on the mountain or at the foot of their divine portrait, with prayers and offerings invoking the spirit to descend from invisible into visible form.

Indonesia today is illustrated in the following sentence in the introduction to a glossy brochure published by the Republic of Indonesia's National Development Information Office in 1990 for the Festival of Indonesia: 'From atop her mighty volcanic peaks have ruled Buddha, Brahma, Allah and the God of the Christians—and to this day, their spirits still walk.'

[13] One such example is Candi Sukuh, where the 'art-program' has been interpreted as a visual aid to guide the soul towards final liberation after death (O'Connor, 1985).

[14] Many examples of such statuary exist; the discussion has centred around to what degree they are believed to be portraits of individual kings and queens, placed in funerary monuments, or whether they are deity statues erected in the names of royal patrons, to commemorate them. For more examples, see Fontein, 1990: 53, Cat. Nos. 27, 29, 30.

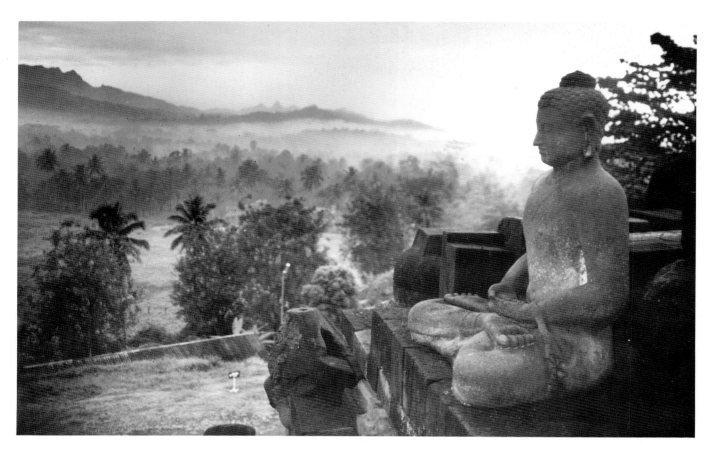

36. Borobudur, Buddha in
 meditation posture
 overlooking a landscape of
 coconut palms and fields.
 (Photograph Astri Wright.)

In the image of the mountain, then, from its broad horizontal base up to the narrow point of the peak, we have an image of cosmic and terrestrial order. This order, by its upwards and increasingly narrow thrust, is an image of a hierarchical ordering of souls and spirits according to levels of spiritual/wordly attainment. Concurrent with this ordered hierarchy, is the idea of movement: the progress of the soul struggling up the physical/symbolic mountain as it hones itself into a higher, more refined instrument (Plate 37). In this way, the soul hastens towards its own enlightenment and gains the legitimacy to rule over other, less-refined mortals. In the ascent of the mountain lies, therefore, the possibility for metamorphosis—from lower and cruder towards higher and more refined; from material and worldly towards the immaterial and spiritual; from ruled to ruler; from human to divine.

The mountain is thus both a static and a dynamic image where the divine and the demonic are juxtaposed at the top and bottom of an axis, characterized by different forms of expression. In this world of expressive typologies, the spiritual hierarchy is mirrored in the ordering of the world; thus, rulers are located closer to the divine; common people closer to the demonic. Hence, the images on the reliefs of temples show village people or servants as less controlled, more active, more deluded by their senses, and driven by their desires than are the princes and princesses who are seated in passive, royal ease, wearing the ornaments and garb of Bodhisattvas, the Buddhas-to-be.

37. In the steep ascent by narrow stairways up Borobudur, the pilgrim's progress is presided over by monstrous *kirttimukha* masks over the gateways and other beings. (Photograph Astri Wright.)

universe, it is closely connected with the symbolism of the mountain. Like the mountain, it is also a symbol of transition, its roots firmly and deeply planted in the ground and its branches reaching into the sky, supporting birds, common symbols of the soul in its ascent upwards (see Maxwell, 1987, 1990). The tree may symbolically represent the total cosmos:

... its branches are the heavens; the lower branches or the surface of the ground whence it grows are the plane of earth; the roots, plunging into the subterranean levels, are the hells; and the trunk is the world axis that centers and supports these multiple worlds. Snakes lie coiled among its roots; birds sit among its branches: it connects the chthonic and uranian worlds. Its form embraces all existences, all the worlds, all the multiple states of manifestation, all life. It subsumes the Elements composing the Universe: 'its branches are Ether, Air, Fire, Water and Earth' (Snodgrass, 1985: 180).

By nature of its lithe branches which co-mingle with ether, the tree reaches closer into the realm of formlessness than solid mass can. In Hindu–Buddhist iconography, the Cosmic Tree is seen as the crowning element in the diagram of the Universe, representing Heaven, where Earth and Mid-space Heaven are represented by the turtle and the mountain. These three dimensions are represented geometrically by the square, the octagon, and the circle. These geometric forms are echoed in the cross-sections of the tripartite division of the stupa (base, dome, and spire) and the three parts of the *lingga* (base, middle, and top).

The Buddha, it is said, entered his mother in the form of a white elephant and was born under a tree, Queen Maya clasping its branches as the child emerged from her side. The Buddha practised meditation under trees, and it was under a tree that he reached Enlightenment. The Tree of Enlightenment 'whose branches

The Symbol of the Tree

The tree is another motif which has had wide appeal cross-culturally and through time. In Hindu–Buddhist cosmologies, the tree plays a central role. Since the tree can be seen as a diagrammatic visualization of the structure of the

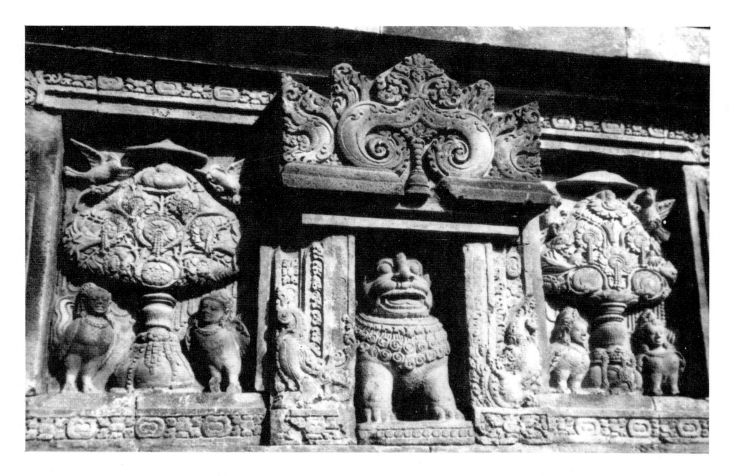

38. Prambanan, jewel-bedecked trees, topped with parasols and flanked by *kinnara*, in relief. (Photograph Astri Wright.)

are the layered heavens, corresponding to the states of consciousness attained in meditation, spreading one over the other in innumerable planes above the summit of Mt. Meru', is the equivalent of the Amalaka Tree of Hinduism, 'in whose branches Brahma, Vishnu and Shiva dwell' (Snodgrass, 1985: 327). Thus, the tree was seen as both the abode of the Hindu gods, as well as an appropriate substitute for the Buddha's presence, an idea that is attributed to the Buddha himself. On a less metaphysical level, the wish-granting tree became a favourite motif; depictions of such trees grace Borobudur (1985: 181). The classical version of the tree sprouts forth in curvaceous lines on the reliefs of Borobudur and Prambanan, and a later formulation of the tree vocabulary can be

seen on doors and panels decorating mosques and tombstones, carved in wood or stone (Plate 38).

It is likely that trees held an important place in prehistorical South-East Asian cosmologies. From historical times up to the present, the tree is a motif of central importance in Indonesian art. A stylized version is found on *ikat* textiles from around the archipelago; trees are also found on batik. One of the most indigenous in form and conception of all the tree forms found throughout the Indonesian archipelago is the *gunungan* or *kayon*, from *kayu*, tree (Plate 39) (Holt, 1967: 134). This is the flat leaf-shaped puppet of carved buffalo hide referred to above, which is placed in the centre of the screen to mark the beginning and the end of a *wayang*

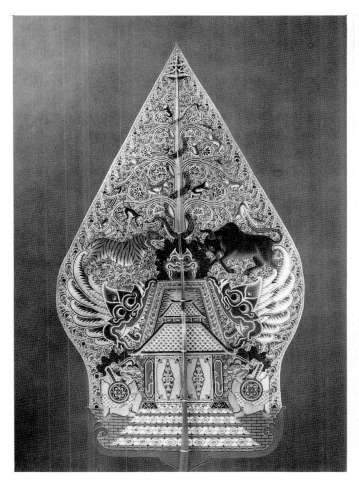

39. Sagio, *gunungan* or *kayon*, first and final puppet image in the *wayang*, collection of Dominique Major. (Photograph Dominique Major.)

40. Although the *lingga* can substitute for the tree/mountain in meaning, the composition of this *lingga–yoni*, an unusually naturalistic image in Java, duplicates the image of the tree even more closely, Candi Sukuh, fifteenth century, Central Java. (Photograph Astri Wright.)

performance. The very fact that this figure, in the shape of a tree with its branches supporting the teeming life of the forest, is also named 'like a mountain', indicates how in Indonesia the meanings of these two motifs overlap and mutually enrich each other.

Thus, in Java or Bali, the tree is not only the apex of a complex image—it may represent the whole thing; its potential as a symbol of totality is underlined. The meaning of the mountain in Indonesia has similarly expanded on that of its Indian prototype: it no longer designates Mid-space only, as it does in Indian iconography. In both the image of the tree and the mountain, it is the notion of *ascent* that is stressed, and the tree's

branches which infiltrate the pure element of ether become synonymous with the top of the mountain.

Such a merging of motifs seems to be a wider South-East Asian characteristic and a process that does not belong exclusively in the historical period. Snodgrass observes: 'For the Kampuchean sculptor, the mountain, lotus, pillar and tree were equivalent and interchangeable images of the world pivot' (1985: 178). In Java, the fact that the *lingga* is symbolically interchangeable with the mountain, or the tree, in different contexts, is illustrated in many ways, as in instances of *lingga* used as finials to top *candi* (Plate 40) (1985: 323).

The diagram of the world in ancient

Java, though hierarchical like the Indian model, thus appears somewhat less stratified: the mountain and the tree can represent the whole world, indeed the entire universe, and whether an individual element is located at the bottom, at the middle, or towards the top, they are partaking of the imagery of totality. This may provide a visual parallel to the relative blunting of the caste system that took place with the adaptation of Hindu ideas to indigenous Indonesian circumstances, a fact which can still be observed in Bali today (Geertz, 1973).

The Roles of Artists Historically

The role of the artist or art-maker working in various media in the Indonesian archipelago from ancient times up to the present can be glimpsed from oblique references in scattered historical sources.[15] The picture that emerges situates the artist within royal structures of patronage as well as at the village level, for the most part in the production of religious objects. Varying status would be given artists working in similar media, at different times and in different cultures in the archipelago. At times, the artist figured importantly in the creation of sacral spaces—miniature representations of the cosmological

order. Examples of this would be the architect-priests who led the construction of Hindu and Buddhist temples (Holt, 1967: 39). Sometimes the artist created ceremonial artefacts, imbued with spiritual powers and owned by both village and court-based élites (frequently these sacral objects remained in the families of those who created them). Examples are the kris daggers and a variety of gong instruments. Since metal in traditional cosmology represented the masculine aspect, these were made by men. Other examples are the elaborately dyed and woven textiles, such as the powerfully protective Iban *ikat* or the *geringsing* double-*ikat* cloth from Tengganan in Bali, made by women.

Looking for the artist of the past, we discern a figure whose creative powers at times are coupled with a highly sophisticated body of sacred, often secret knowledge, occasionally conferring the social status analogous to that of a priest. This case has been documented for certain metalsmiths who are believed to have been ranked above the Brahmin priest (O'Connor, 1985). In contrast, the status of the sculptors working on the monuments under the priest-architect's supervision, was low (Holt, 1967: 39). At the village level, the artist's status has at times been analogous to that of a *dukun*—healer and interceder with the spirits—a person whose occasionally eccentric behaviour was ascribable to his magical powers and who therefore held high status. Conversely, the makers of certain important and powerful art objects, such as the women who created the gold-thread embroidery from Aceh, are themselves accorded low social status.[16]

In the fourteenth-century poem *Nagarakertagama*, we find explicit

[15] To simplify matters and to avoid the Western-centrism of distinguishing between applied and fine arts, I will use the word 'artist' throughout. As any discussion outside of our own era and culture would necessitate a preliminary discussion of the meaning of the word 'art', another alternative might be 'art-maker'. Attempting a definition of the artist in a pre-modern, non-Western society, Gerbrands writes: 'When a creative member of a society personally interprets his society's values through matter, movement, or sound in such a way that the resultant forms comply with his society's standards of beauty, this creative process and the creations themselves are called art' (paraphrased in A. L. Kroeber (ed.), *Anthropology Today*, Del Mar, California: CRM Books, 1971).

[16] Barbara Leigh, 'Art in the Achehnese Wedding Ceremony: Old and New Design Forms', guest lecture at Cornell University, 30 January 1991.

mention of gold- and silversmiths (Pigeaud, 1962, III: can. 63). Smiths of various metals are also mentioned in tenth-century Central Javanese inscriptions as a privileged group, not subject to certain taxes; this contrasts to roof-makers and cloth dyers, who are ranked lowly and who do pay tax (Barrett Jones, 1984: 38–9).

The poet Prapañca himself writes at length about his role and the motivations behind his poetry (Pigeaud, 1962, III: can. 94–6). With his freedom to come and go, following the party of the prince closely, the status of this court poet was considerable. Other artists he described at length, who participated in the posthumous ceremony in honour of the Rajapatni in 1362, were singers, story-tellers, and dancers (III: 78).[17] Yet other artists, not mentioned explicitly, but who would have been involved in creating the ceremony, were the architects, stonemasons, and carpenters, both those who originally created the sanctuary itself and those who worked on the temporary structures for the ceremony (such as the tower-like structure carried on poles). Flower sculptors made the elaborate flower effigy, the place of visitation for the deceased queen's soul; basket sculptors made the plaited white bulls depicting Nandini, and wood-carvers made the groups of demons and deities for the platform. Skilled technicians engineered the constant streams of money and food which flowed from the mouths of the Nandinis and the revolving platform carrying the sculpture groups. Finally, textile artists created decorative cloths, metalsmiths created the musical instruments, and musicians performed on them, accompanying dancers (III: 75–7).[18]

In an earlier part of the poem, the works of ceramic sculptors are referred to, gracing the pillars of the houses in the royal compound; there is no mention of the sculptors themselves (III: can. 11). Likewise, in a later part of the poem, in the description of the annual Majapahit feast, the works of potters are referred to, both high-status jars holding the holy water prepared by Brahmins, and low-status jars and pots for drinking liquor. The former were possibly imports from China (III: can. 84, 90; IV: 510–11). The absence of any mention of potters elsewhere may indicate their low status.[19] Pigeaud's hypothesis is that the majority of these 'professionals' held low status, as clients of patrons who were responsible for their circumstances, possibly on a par with superior bondsmen (IV: 476; Zoetmulder, 1974: 156, 162, 187).

A single reference in a document contemporary to the *Nagarakertagama* is made to what might be seen, technically, as the ancestor of the modern painter. The passage refers to his low status: 'an *anglukis* (draughtsman), should not be called politely *empu* (Sir). That pollutes the (standing of the) *shaiwas* (priests)' (Pigeaud, 1962, III: 131). Two things are remarkable in this passage. One is the occurrence of a term which shares the same root as modern Indonesian words connected with the art of painting: the fourteenth-century *anglukis* is ancestor to the modern terms *pelukis* (painter), *melukis* (to paint), and *lukisan* (painting, drawing, portrayal).[20] The second thing

[17]The importance given to the performing arts, still evident in contemporary Indonesia, is also evident in this passage.

[18]All these objects and events are referred to without mention of the artists.

[19]It would seem that potters could have had higher status than other craftsmen, given that their materials combine earth, water, and fire, elements imbued with potentially dangerous forces which would require a certain level of spiritual power to master.

[20]According to Tirtaamidjaja (n.d.: 18), Rouffaer, a Dutch scholar, cites the use of the term *lukis* for batik-makers and *tulis* for their 'drawing' with wax and dyes in a *lontar* scroll from Galuh, South-west Java, dated to around AD 1520. The

is the warning against the inappropriate use of the reverential title *empu*. This is the exact term frequently used in the media about Affandi, prototypical modern Indonesian painter, both before and after his death in 1990.[21] Affandi, who insisted on calling himself by the older, more humble nomen of 'draughtsman' (*tukang gambar*) rather than the modern term painter (*pelukis*), in this way conceptually bridges the gap between his professional ancestors and today, and illustrates the elevation in status the Indonesian painter has experienced since then.[22]

Modern Indonesian Artists and the Spiritual

That traditional spiritual-religious symbols and experience have been an important source of inspiration for many Indonesian painters is evident in regard to content as well as style. In conversation or in the titles of their work, some artists refer to the workings of God (*Tuhan*; *Allah*; *Sang Hyang Widhi Wasa*) or to personal mystical experiences as the source of their spiritual life. Others speak of spirituality as the practice of maintaining good relations with the spirits of their ancestors, genealogical as well as cultural or mythical, and spirits which inhabit certain objects or places—beings which are commonly accepted as having the ability to act within the

dimension of people's everyday lives.[23] Many profess a world-view in which the material and psycho-spiritual aspects of the community are seen as mutually reflective and vitally important to maintain. This is done through ritual meals and ceremonies which accompany individual, social, and national rites of passage.[24]

Included in any working definition of contemporary Indonesian spirituality must be the mechanisms of the 'state-orchestrated civil religion' and the neo-Javanist revival of mysticism, whether in Islamic or Hindu–Buddhist garb (Geertz, 1990: 79). As Geertz points out, both are equally real: spirituality in Indonesia today thrives both in the realm of official propaganda and in the personal realm, whether on the individual level or in organizations that draw on traditions from Hinduism, Buddhism, Christianity (either Protestant or Catholic), or Islam.

Within this framework, we see that Indonesian painters use the image of the mountain or the tree in a number of different ways, with divergent meanings and intent, and aimed at different audiences. In the work of some artists,

terms batik and batik-maker only came into use later. Based on this sixteenth-century usage, it is possible that the early producers of batik originally held higher status than those who later practised outside the courts did.

[21] See 'Sang Empu Seni Lukis Berpulang', *KOMPAS*, 25 May 1990, p. 1.

[22] *Tukang* means 'artisan'; the type of artisan is qualified by a second word, such as *tukang kayu* (carpenter), etc. Gusti Nyoman Lempad, the original Balinese artist, also referred to himself as *tukang gambar*.

[23] Mochtar Lubis, in his call for a departure from what he calls mytho-mysticism in the Javanese world-view and a turn to rationality, wrote: 'Deep in the subconscious of the Indonesian—even in that of someone who is Western-educated and has attended a university in Europe or America—is a belief in mystical, supernatural powers, in spirits that possess the power to aid or hurt man. I can name more than eighty kinds of ghosts, more than fifty devils, and numerous other spirits' (Mochtar Lubis, 1969: 180). For a more recent discussion of the place of spirits and their human intermediaries, such as *dukun* and *dalang*, see Keeler, 1987: 109–34.

[24] This emphasis on communal well-being has become one of the clichés of official Indonesian discourse, in which such formulations are used as rhetorical devices designed to discourage any challenges to the existing order. This usage, however, should not obscure the sincerity which can also be found behind personal expressions of such ideas.

symbols with traditional spiritual content are consciously used as metaphors of spiritual power or as vehicles for ascent, symbols experienced in earnest by many as relevant to modern life. In other artists' work, however, such symbols are reproduced in a facile and repetitive way, frequently with great skill but without a sense of deeper, personal involvement. These artists are motivated because they see that the symbol communicates and its production is rewarded: the product sells.[25]

Twentieth-century art movements in Europe and North America caused much friction in the Christian Church, in both its Catholic and Protestant manifestations. The church clashed with individual artists, including seminal figures like Picasso and Pollock, who claimed the right to create religious art in new idioms (Dillenberger, 1990: 107, 169). Kandinsky wrote: 'To each spiritual epoch corresponds a new spiritual content, which that epoch expresses by forms that are new, unexpected, surprising and in this way aggressive' (1947: 11).[26]

In contrast to the clashes between artists and representatives of organized religion in Euro-America, there is little evidence of such controversy or iconoclasm in Indonesia. Whereas tension surrounds certain artists who are considered politically sensitive, artists whose inspiration is spiritual appear to adapt inherited art vocabularies in ways that do not offend political or religious leaders. With so many faiths, religious institutions, and spiritual practices coexisting in Indonesia, several major categories of spiritually inspired art exist side by side, in many cases exhibiting a co-mingling of iconographic elements.

That emphasis on the spiritual is central to much contemporary Indonesian painting, whether on the level of explicit statements or embedded in the choices and meanings of artistic form, is illustrated by the catalogue for the National Painting Biennial in 1989 (Dewan Kesenian Jakarta, 1989). Here, 46 artists (37 men and 9 women) each gave a statement about the sources of inspiration in their creative process. Keeping in mind the simplification that takes place in the process of labelling and the range such statements cover, from personal preoccupations to what is deemed acceptable or expected in public discourse, 27 artists gave statements which could be labelled 'spiritual'. Besides some cliché formulas of spirituality (2), they ranged from Javanese mystical and Bali-Hindu vocabularies (3 and 2) to a more general, nature-based transcendentalism (5, 4 of which were women), to more psychological interpretations of spirit (5). The rest of the statements in this group (10) fall within more neutral boundaries, referring to 'spirit', 'soul', or 'God' using

[25]As elsewhere in the world, the art market is an increasingly powerful force in the production of contemporary Indonesian painting. In the writing of this work it has been my choice to concentrate on painters whose preoccupations with their art do not appear to be stimulated mainly by the thought of marketability. A fascinating study in its own right would be to investigate the use of Pancasila-promoted symbolism in the work of a large number of contemporary Indonesian painters, ever more acute in the present 'art boom', with the mushrooming of supporting institutions, that has been taking place in the last four to five years.

[26]In the last ten years, European and American art historians have increasingly turned their attention to the spiritual roots evident also in the work of major pioneers of abstract art. A milestone in this respect was the exhibition, 'The Spiritual in Art: Abstract Painting 1890–1985', at the Los Angeles County Museum in 1986/7 (Weisberger, 1986). An illustration of the potency perceived universally, in certain combinations of visual marks, is the upward-pointing triangle which sandwiches

the voluminous exhibition catalogue, front and back, in the same way the triangular shape of the *gunungan* traditionally frames a *wayang* performance.

the Indonesian term *Tuhan*, not specific to either Islam, Hinduism, Buddhism, or Christianity.[27]

A. D. Pirous (b. 1933, Aceh) wrote: 'To create is to visualize the harmony between the ticking of nature's clock and the ticking of the heart in our body. It is a close recording of the life of the soul, in all its completeness, difficult to express in words and extremely private' (Dewan Kesenian Jakarta, 1989: 6). Amang Rachman Jubair (b. 1931, Surabaya) wrote: 'Painting is part of my worship' (1989: 10). Dwijo Sukatmo (b. 1950, Surabaya) wrote: 'Contemplation of Nature's Dynamism, both in the Macro and the Micro; to maintain the spirit (*semangat*) of both the intellect and the body' (1989: 28). Heyi Ma'mun (b. 1952, Bandung) wrote: 'To me, painting is an expression of self and an outpouring of Inspiration which is based on spiritual experience. Views of nature have become the subject of my paintings because nature is that part of life that is closest to its environment, closest to me; so it is also with the various mysteries nature contains. Rather than visualizing nature concretely, I choose to show it in forms which have undergone distortions: these are manifestations of the essence of nature. An atmosphere of intensity, as the language of the spirit, is emphasized' (1989: 38). The invocation poem submitted by Nyoman Erawan (b. 1958, Sukawati, Bali) expresses a Balinese spiritual view:

Formation and destruction are the processes
 of life
the old-fashioned the obsolete
the crisis-ridden, the cracked, the torn and
everything that wears the face of creation and
 destruction ...

and so also with us
who live towards the anticlimax of death
from organic form towards inorganic form
and this is transience
and this is the non-lasting nature of life
and this is our limitation
as for the rest ...
Oh, Almighty One ... protect us!!!
(1989: 68; author's translation)

Ancient Motifs in Modern Art: Mythology

Many examples of modern Indonesian painting illustrate the continuity in the tradition of artists preoccupied with mythological themes. Most of these works are straightforward translations into paint of classical themes, taken from the Buddhist, Hindu, or Javanese legends. Painted in neo-traditionalist or Javanese 'illustrated classics' styles, many such works refer directly to specific, identifiable Hindu–Buddhist temple reliefs (Plates 41 and 42) or the more stylized forms of *wayang* shadow puppet imagery (Colour Plate 5). Acclaimed by convention, mythological subject-matter is emotionally gratifying to both artist and public because it is familiar, politically safe, and potentially profitable. The preoccupation by modern painters with such themes also demonstrates the hold that the narratives and characters retain on their imaginations.

Wayang means 'shadow' and is used to denote dramatic performances of various kinds, with either human or puppet actors. On its own, the word stands for either a shadow play performance or for a *wayang* puppet, the latter being the most relevant to our context. The *wayang* shadow puppet performance complex has made stories from the Hindu and various Javanese folk-epics familiar to the Javanese for centuries.[28]

[27]Of the nineteen remaining artists in the catalogue, three submitted no statements; one delivered an aesthetic formalist statement; two bridged two or more categories; the rest cited a deity-less humanism (5), social realities (6), or Indonesian or national identity (3) as their main source of inspiration. Of the last group, two were born around 1940; one was born in 1950.

[28]The history of the *wayang* shadow puppet performance art form is unclear. It may have originated in India, where 'shadow play' is referred to in the Pali canon of the first century BC (Holt,

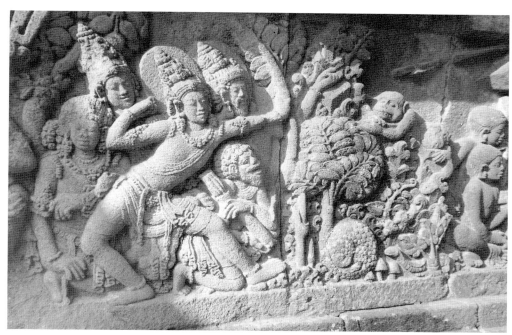

41. Prambanan, *Ramayana* relief. (Photograph Astri Wright.)

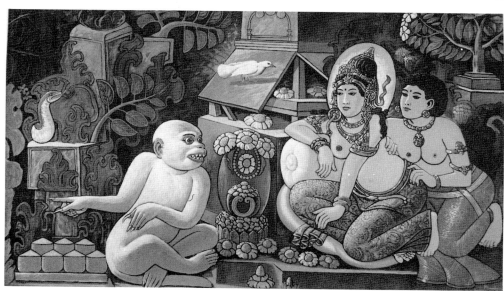

42. Ratmoyo, *Prambanan 1* (*Hanuman as Envoy*), 1979, 88 × 150 cm, oil on canvas. (Photograph courtesy of the artist.)

1967: 128–9). The earliest known mention of shadow puppet plays in China is during the Sung Dynasty, when in the eleventh century, stories from the Three Kingdoms were performed. The earliest known mention of Thai shadow puppet plays is AD 1458 (Holt, 1967: 130). In Java, *wayang* is first mentioned in an inscription found at Prambanan, issued by King Balitung in AD 907, where mention is also made of both the *Mahabharata* and the *Ramayana*. This inscription documents that the fascination with the Hindu epics in Javanese art, still apparent in the ongoing tradition of *wayang*, has survived over at least eleven hundred years. It is of interest that the historical prototypes for the *wayang* figures in modern art date from the same historically distant era which Javanese today see as their golden age, spiritually, culturally, and politically.

'In the *wayang* lies hidden the secret Javanese knowledge concerning the deepest significance of life ...' wrote Mangkunegara VII of Surakarta (1957: 1). To many people, the *wayang* is seen as the most elaborate and popular visual expression of Javanese mysticism.

The *wayang*—as art form, philosophy, and frame of reference—still has a variety of functions in Javanese culture: it is placed in the group of 'refined' art forms along with batik, *gamelan* music, the making of kris daggers, court-dances, and court poetry (Geertz, 1960: 261; Mulder, 1978: 81). Furthermore, it is still, although in changing form, one of the most popular types of village entertainment. A *wayang* performance is believed to have the power to protect, cure, and exorcize. It also lends to Javanese a vocabulary for the classification of personality, and provides cosmic analogies to the characters and doings within the realm of earthly politics.[29]

Every Javanese, except maybe the urban generation below thirty for whom television and movies have to a large extent taken the place of *wayang*, recognizes the figures of Ardjuna, Bima, Kreshna, Durna, and others, not to speak of the beloved figures of Semar and the clown retainers—Javanese additions to the Indian epic. Everyone recognizes Srikandhi as the beautiful and courageous but 'somewhat too active' female archer, second wife of Ardjuna—another Javanization of the original

Mahabharata (see Chapter 6). Javanese discourse is filled with references to *wayang* figures and their characters, likening people to this one or that one, or choosing one as a model to emulate. Asking people which is their favourite *wayang* figure is not a matter answered lightly and yet every major figure in Indonesian cultural or political life seems to have one.

Among artists who are inspired by *wayang* mythology, some paint more or less direct, traditionalist translations of specific characters or scenes from a *wayang* play (Plate 43) and are less central to questions of modernism in Indonesian art; others paint specific *wayang* characters but in more personally reconceived styles (Plates 44 and 45); a few take a non-traditional approach and envision a generic rather than a specific *wayang* figure. Affandi, who never had a studio and always painted outside, before his subject and never from memory, somehow came up with two *wayang* figures flying kites during the annual kite festival: Semar, central character in the Javanese *wayang kulit*, not found in the Indian *Mahabharata* epic, and Hanuman, central figure in the *Ramayana* stories performed in *wayang* (Plate 46). In the work of some artists, *wayang* figures appear in outline, recreated from their earlier mythological contexts into sequences of manipulated movement (see Plate 25).

The body of works by artists interested in the classical period as a source of imagery and meaning is more ambiguously constituted than the works dealing with *wayang* themes. The most famous of the senior painters to take classical Hindu–Buddhist deities as a major theme in his work is O. H. Supono (b. 1937, Surabaya; d. 1991). His semi-abstract and colouristically dense reinterpretations of the famous reliefs of the Borobudur and Prambanan temples

[29]See Anderson, 1965; Resink, 1975. See also Mulder, 1978: 32, for stories of how Sukarno used *wayang* for his political ends, and in turn was almost undone by the power of one of the stories which, according to the Javanese view, turned on him. See Hanna, 1967, for a discussion of how both Sukarno and Suharto have used *dukun* for advice and guidance and legitimation of their power, with sketches of some of the central mystics involved.

43. M. Roeslan, *Mantra of Inverted Fig-tree*, 1989, acrylic on paper, 62 × 92 cm. (Photograph courtesy of the artist.)

in Central Java form the core of both his 'breadline' work and his more serious work, which is less frequently sold.[30] Supono also painted dreamy depictions of *wayang* characters (see Plate 45) and portraits of sage-like men, such as Bali-Hindu priests (Colour Plate 6).

In the 1960s and 1970s, Supono painted expressionistic, tumultuous images, frequently horses, with Picasso-like distortions and fractured perspectives. He settled down to painting

his present subjects in the late 1970s and 1980s.[31] To Supono, who listed 'kejawen (Hindu–Buddha)' [*sic*] as his religion, the old carved stones of Borobudur were filled with mystery, enmeshed in historical, aesthetic, and philosophical values which begged to be (re-)expressed. He spent much quiet time at the temples, admiring the compositions of the reliefs which he felt were so perfect that nothing could be added. 'Even if you just copied them directly, the result would be good; how much better yet when you give your work spirit' (Saiff Bakham, n.d.: 4).

Unlike many other painters, he did not translate Borobudur directly and realistically on to the canvas.

[30]O. H. Supono's more rapidly executed canvases inspired by classical reliefs sold extremely well to tourists, both national and international, and could be considered an élite version of the postcard or mass-produced souvenir. His daughter, trained in painting at ISI-Yogya, helped in this production in his large studio-home in Bali. Supono was conscious and open about this split in his work; having a successful 'breadline' enabled him to pursue his serious work without the pressure of financial worries. In 1988, Supono wrote to me that he had sold around 6,500 paintings since 1960.

[31]In response to a questionnaire I sent to Indonesian painters in 1988, Supono lists as his favourite foreign painters Rembrandt, Van Gogh, Picasso, Chagall, Dali, Chirico, and Pollock. His favourite Indonesian painters are S. Sudjojono, Hendra Gunawan, and Sudibio.

44. Bagong Kussudiardja, *Three Kresnas*, 1987, oil on canvas, 144 × 150 cm, when photographed, collection of the artist. (Photograph Astri Wright.)

Borobudur—Rupadhatu (Colour Plate 7) is based on a relief from Borobudur, from the *rupadhatu* (sphere of form) galleries. The seven horizontal tiers of stones depicted in the painting, many of which are also separated vertically from their flanking stones, blur the outlines of the carved figures in a manner consistent with the erosion which has taken place over the centuries. Further adding to this natural process of abstraction are the patches of light and shadow represented by warm and cold colours, in part contrasting against, in part blending into, each other. The canvas is like a visual puzzle, formally challenging and colouristically lively, communicating the feeling of living rock. In his best works,

one feels that Supono is as fascinated with the abstract life of the forms themselves as with depicting something which can be labelled 'Borobudur', a monument now burdened with connotations of nationalist pride and touristic commercialization.

Though the painting of traditional mythological themes may communicate on the level of allegory, adding a layer of sarcasm to the work is more rarely seen. Tatang Ganar (b. 1936, near Bandung) has in recent years occasionally been blacklisted because of his political views and populist art. His painting *Three Classical Dancers* (Plate 47) could be interpreted as a sign of the artist finally conforming to what an artist in Suharto's

45. O. H. Supono, *Wayang*, 1985, oil on canvas. (Photograph courtesy of the artist.)

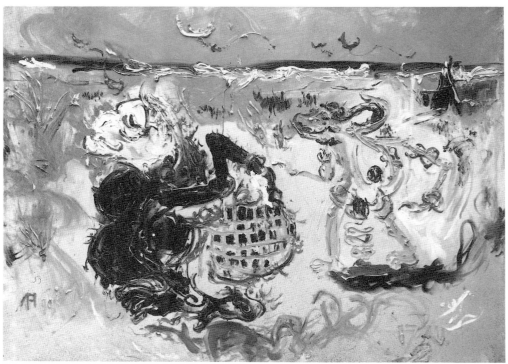

46. Affandi, *Flying Kites at Parangtritis*, 1987, oil on canvas, 100 × 130 cm, when photographed, collection of the artist. (Photograph Astri Wright.)

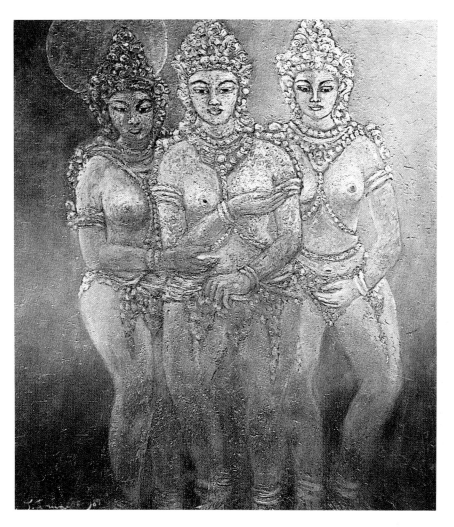

satisfying the human spirit.'[32]

Upon closer inspection, the goddesses in Tatang's work are not the sweet and timeless emblems of a golden age past in the service of contemporary nostalgia or propagandists. In spirit and composition, they resemble a group of three male Bodhisattvas from the balustrade on the Shiva temple at Prambanan (Krom, 1926: Pl. XIV). Tatang's solidly built goddesses have nothing of the yielding, passive/nostalgic or sex symbol qualities so often found in contemporary paintings of mythological themes involving women (see Chapter 6). Rather than inward, meditative gazes, they seem to be looking down at a crowd below, challenging them: the one on the right covers her vulva with one hand; the one in the centre cups her breast with one hand; the third supports the central one like a second in command, ready to move forward with her into action.[33]

The Mountain in Modern Painting

A few examples will suffice to illustrate the prevalence of the symbol of the mountain in the work of modern Indonesian painters, from the older generations to the younger. The mountain landscape in its most European, secular form was a common theme in late nineteenth-century and early twentieth-century Indonesian painting and remains so today, both among the famous salon painters as well as the popular street painters.[34]

47. Tatang Ganar, *Three Classical Dancers*, 1988–9, oil on canvas, 120 × 100 cm. (Reproduced with the permission of *Budaya*.)

era should be painting, as if saying: 'See, I can paint classical reliefs too, just like everyone else!' At the same time, it could be read as a veiled retort to the government's suppression of free expression.

The following statement accompanied the first published reproduction of *Three Classical Dancers*: 'While painting is an important aspect of life, Tatang does not consider art to be essential for living. First come food and clothing and shelter. Only after primary needs are met should we turn to art, for art is something we still need. Art is the expression of and the acknowledgement of the inner heart,

[32]*Budaya*, Vol. 1, No. 1, October 1990; cover. When the American editors commissioned this work for the first issue of the magazine in 1990, they did not know that the artist was prohibited from showing his work. It is not clear whether the statement originates with Tatang himself or with the editor; in any case, and for reasons that remain vague, the magazine's permit was suspended.
[33]For a discussion of historical precedents for women warriors, see Carey and Houben, 1987.
[34]See, for example, Basuki Abdullah's *Gunung* (*Mount*) *Merapi* in Dullah, 1956, II, No. 114.

In his *Mountain in Dardjili* (painted in the early 1950s), Affandi said he wanted to catch 'a mood of astonishment', because 'the big and high mountains appear to me like devils who will swallow all the little huts of the mountain people'.[35] Thus, to Affandi, the mountain was like a living, carnivorous organism. Trubus, in his Mount Merapi landscape, wanted to set the richness of the land against the destructive potential of the mountain, 'its anger terribly devastating, ruthless'. He was intrigued with how, out of its anger, the mountain offered fertility and creativity (Holt, 21 December 1955). In a small book by Rudi Isbandi about Surabaya painters, images of the mountain abound. Sudibio's *Cheerful, Lively Soul* (1970) shows an empowered peak thrusting up from a landscape of undulating, terraced rice-fields (1975: 55). The peak seems to be almost vibrating, dark against the light which shimmers intensely around its outline. The world below is well-ordered and fertile. Krishna Mustajab, in his abstract and conceptual *View of Mountain or Whatever* (1974), presents the essential 'rock', reductive symbol of the mountain, and depicts it hovering, weightlessly transcendent, against a luminous background (1975: 49).

In a conceptually construed image of ascension, Sulyadi Abraham's vertical canvas, *Hospital Corridor* (1975), shows a long hall in diminishing perspective on the left and an ascending staircase on the right (1975: 31). At the top of the staircase, a beam of light showers two vertical white pillars. To the left, an empty stretcher in the vaulted corridor and a white-draped body glimpsed at the far end evoke thoughts of sickness and death. Yet, the pull of the composition does not allow us to remain here in the low-roofed corridor (structurally and psycho-symbolically the

equivalent to the mountain cave or the womb chamber in Hindu temples): the ascending steps lead our eyes upwards to the beam of light and the pillars on the second level (the cosmic mountain, crowned by pillar/axis/*lingga*/tree).

The reduction of the mountain form to abstraction is found in the work of, among many others, Ahmad Sadali. His *Mountain Form on Grey Ground* (Colour Plate 8) consists of four triangles, their points meeting in the centre so they, together, form a square. The fact that the work is three-dimensional, the centre about 20 centimetres higher than the frame on all four sides, is not communicated in a reproductio... It adds a significant dimension to the experience of viewing the work at first hand. Because of the three-dimensional pyramidical structure, the bottom triangle appears more deeply shadowed than the others. In this way, the impression is created of a mountain of some material presence and weight, symbolizing a cosmos characterized by reflection and symmetry, where an essential form—the triangle—is echoed back and forth, each time recognizable but not identical. The specks of gold that hover around the tip of Sadali's 'mountain' give a feeling of lightness to the elevated part of the painting, highlighting the pinnacle in consonance with the idea of the spiritual power which resides at high altitudes. The gold also brings to mind the notion of *wahyu*, the radiance that was interpreted as a sign of the presence of power and which can be associated with mountain tops (Anderson, 1990b: 31, 38–9).

Both Bagong Kussudiardja's *The Monument to the Return of Yogya* (Plate 48) and Made Wianta's *Untitled* (Plate 49) employ the use of two triangles, one upward-pointing, one downward-pointing. Since the upward-pointing triangle in Hindu iconography is geometric shorthand for *lingga* and the

[35] Affandi in a speech to the 'Cercle Paul Valéry' at the Sorbonne in 1953 (Moerdowo, 1963: 84).

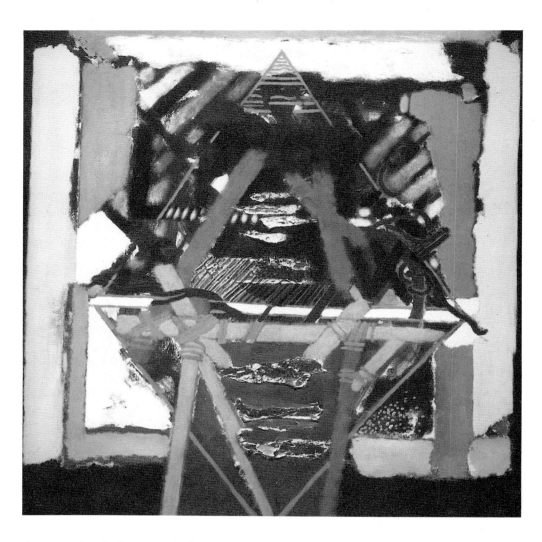

48. Bagong Kussudiardja, *The Monument to the Return of Yogya*, 1989, oil on canvas, 75 × 75 cm. (Photograph Astri Wright.)

downward-pointing triangle for *yoni* (compare with Plate 40 of *lingga–yoni*), both works evoke ideas about masculine/ feminine or oppositional elements in the universe. In both works, the two triangles are united, albeit through quite different means.

In Bagong's work, the triangle is frequently used in works referring to mountains and sites as expressions of Javanese cosmology. In *Mount Merapi*, for example, the triangle depicts the volcano which forms the northern backdrop to the city of Yogyakarta. In *The Court* (Colour Plate 9) the sultan's or raja's earthly domain is envisioned as a horizontal diagram of sacred proportions, reminiscent of Hindu– Buddhist mandalas. The triangle in *The Monument to the Return of Yogya*, along with the inclusion of the name of the city in its title, points us to a physical, geographical place with both metaphysical and nationalist overtones. Furthermore, the title refers to a monument created in commemoration of a historical event, and thus a temporal element is introduced as well. The event is the moment when Yogya, occupied by the Dutch, temporarily returned into Indonesian hands. This, the story goes, happened when forces led by Lieut. Col.

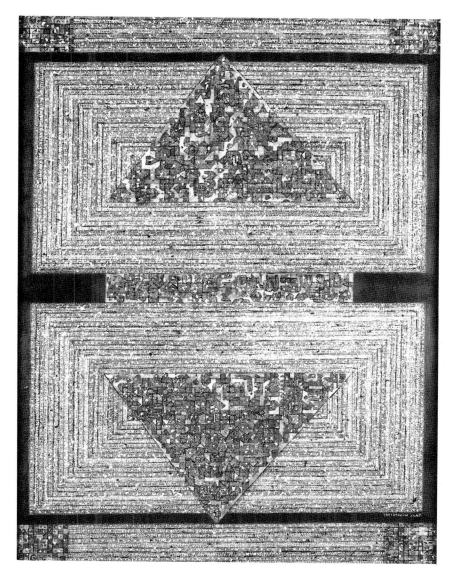

49. Made Wianta, *Untitled*, 1989, oil and mixed media on canvas, 150 x 100 cm. (Photograph courtesy of the artist.)

wider Indonesian public as a dancer and choreographer, is a Catholic who also professes to practising a combination of Javanese mysticism and martial arts. In his work he frequently combines Hindu-Javanese with Christian and occasional glimpses of Chinese symbolism (Wright, 1988d).

Made Wianta (b. 1949), since boyhood trained in the Balinese arts of dance, drumming, and traditional painting, is one of the most purely abstract, formalist artists working in Indonesia today. He sees the attempt to look for a national identity in modern Indonesian art as *passé*: contemporary art, he says, has no national or cultural boundaries. When asked what the triangle meant to him, he could not say: 'I have no idea why—but I have been obsessed with painting triangles for the last two years! Look here—all of these new paintings—all triangles!' (Colour Plate 10).[37] Although Made Wianta is fascinated with discussions of Hindu symbolism and appeared intrigued rather than threatened by the possibility of unconscious reference to Bali-Hindu symbolism, creating art, he says, is not an intellectual act. When he paints, Made Wianta is in a heightened emotional state, at times bordering on frenzy, which drives him to a great outpouring of physical energy. At times, jogging or jumping in place before a large-scale canvas, he stabs the paint on in moves reminiscent of martial arts.[38]

Made Wianta's *Untitled* signals something between pure abstraction and

Suharto in a surprise attack managed to hold the city for six hours in March 1946. Thus, Bagong's painting is not only about mountains and spirituality, it is also about history and politics and about how these in contemporary formulations are given mystical and mythical overtones.[36] Bagong, best known to the

[36]The monument is located in the north of Yogyakarta, in a direct line between the court and Mount Merapi. The event and the monument of *Yogya Kembali* is a significant iconographic example of the Suharto government's construction of historical legitimacy.

[37]Pers. com., Denpasar, March 1991. Two recent books have been published about Made Wianta (Couteau, 1990; Nyoman Arsana, 1990).

[38]The connection between modern painting and physical movement, whether in the vocabulary of dance or martial arts, is strong in Indonesia. This linkage to what appears to have been among the most important of all the arts—sacred/ceremonial dance and drama—merits further research.

blurred echoes of a traditional aesthetic; the canvas image hovers between flatness and illusions of depth. The two triangles, pointing up and down, are embedded in rectangles. A tension in perspective arises here: the rectangular areas look like horizontal colour fields seen from an aerial perspective; the triangles, with their upward pull, make us feel we share their baseline, viewing them from a vertical perspective.

This impression of the differing natures of triangles and rectangles is strengthened by their surface treatment. The repeat lines of the rectangles are patterned with minuscule dots in pale reds, greens, blues, and yellows, with an overlay of slightly larger dots in stronger hues of the same colours. The triangles are patterned with a maze-like interlocking and intertwining of ribbon forms which, along with the dots, reappear in much of Made Wianta's work, and take on the importance of signature. The colours here are the same as those used on the rectangles, but darker. The forms are larger, with a certain organic irregularity, and areas of gold-leaf distinguish the surface further. The rectangles, set against a black ground, are connected by a bridge which appears to be an extension of the triangles (its surface treatment being the same as the latter), holding together the various parts of the composition. This emerging and disappearing of a central form associates to weaving or plaiting, both of which are central techniques in Balinese ceremonial and vernacular arts.

The forms in Made Wianta's work—the largest of which is the shape of the canvas itself—can be broken down into a series of smaller units and sub-units, right down to the dots and other details of surface treatment so characteristic of his style. Besides constituting the smallest elements in a series of reductions which can be read as a progression from a macro to a micro perspective, these provide the unifying element in the work.

Added to the harmonious balance in composition and the treatment of the entire surface, typical of much of modern Indonesian painting and one of the bridges to traditional aesthetics, is the sense of light-catching, illuminating splendour that characterizes traditional Balinese arts, here offered in an unmistakably personal idiom.

Sutjipto Adi's (b. 1957, Jember) work is a consistent body of prismatically fractured photo-realist images set in space. *Reincarnation* (Colour Plate 11) is another composition based on triangles and other geometric configurations which transparently overlap. Weaving in and out of concentric circles, all the pictorial elements hover in a rarefied atmosphere of luminous blues and greens. Floating weightlessly among the circles are images of foetuses, human bodies, and spheres.

The central triangle that dominates the bottom half of the painting inscribes the image of the artist seated in meditation. The left half of his face is lit up, drawing our attention to his eye which looks up from below the knit brow. Rather than meditatively inverted, the gaze is piercing. The artist's quest demands looking outward as much as (if not more than) focusing inward—an ironic rewriting of the ancient idea of inner sight as insight. Different images emerge from or connect with points that bring to mind the *chakra*.[39] Above the head *chakra* a small luminous sphere provides one of several focuses in the work, another being the meditator's eye. A third major focus is the small circular void where all the compositional lines converge above the meditator's head. The forms in this extremely complex image are finely painted in repeated layers of thin oil glazes. As all of Sutjipto Adi's art, this

[39]The *chakra* are important points of psycho-spiritual energy located at various points in the body, as envisioned by various philosophies of yoga.

work stands as an evocative icon for one man's quest for a spiritual dimension in a nuclear space age (Plate 50).

Like Sutjipto Adi, Eddie Hara (b. 1957, Salatiga) inscribes his own image within a triangle (Colour Plate 12). However, the style is completely different. Drawn in a naïve, simplified manner and painted with broad brush strokes, the artist depicts himself as a wide-eyed, innocent being, surrounded by dreamlike or childlike forms. On his left shoulder stands an elephant, above which a small planet whirrs and two

snakes head towards his ear, all surrounded by stars and a moon. On his head perches a smiling angel who embraces the expressive face of the sun. A rooster, an airplane, and winged eyes hover above the artist's right shoulder. By (or on) his chest is a fish. Whether Eddie is being imaginatively playful or whether he attaches psychological or symbolic meanings to each of these forms, his art took shape under the influence of academic training and exposure to children's art and Indian folk art (Plate 51). In his work, the notion of self is represented in terms of elements of nature and the universe, the human self linked to other selves, none governed by terrestrial laws of gravity. Like Sutjipto Adi, one could say that Eddie Hara views inner space in terms of cosmic space, and the existential questions of self, place, and destiny are dressed in forms which link both past and present approaches to media, style, and meaning.

The Tree of Life in Modern Painting

Although beautiful, lush trees abound in the work of many Indonesian painters, it is the shape the tree of life takes in the *wayang* plays that retains the strongest hold on the imagination (Plate 52). Ahmad Sadali's abstract painting from 1969, *Ultramarine Triangle* (Plate 53), is a clear reference to the *gunungan* form, with its 'stem' rooted in a light rectangle at the bottom and the top overlapping with a light area at the top of the canvas, the middle of the 'tree' seen against darker ground. Amang Rachman Jubair's *Place of Origin* (1975) depicts a traditional Javanese village house with its steepled, square roof, a man on one side and a woman on the other, and three children in front (Rudi Isbandi, 1975: 35). The house is flanked by poles topped by birdcages; two doves face each other in the middle of the roof. Circumscribing it all is the outline of a *gunungan*, a

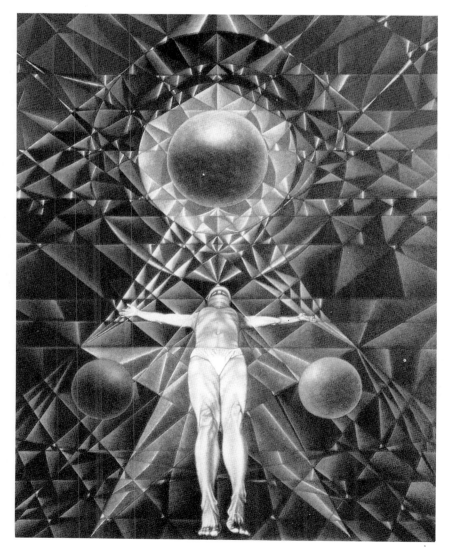

50. Sutjipto Adi, *Introspection III*, 1989, oil on canvas, 60.5 × 50.0 cm. (Photograph courtesy of the artist.)

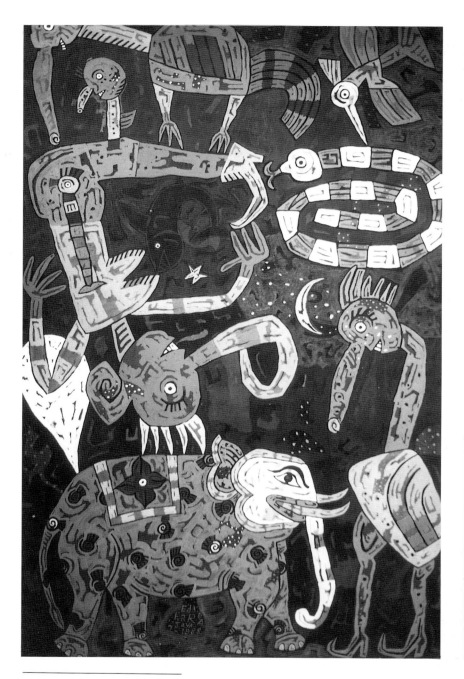

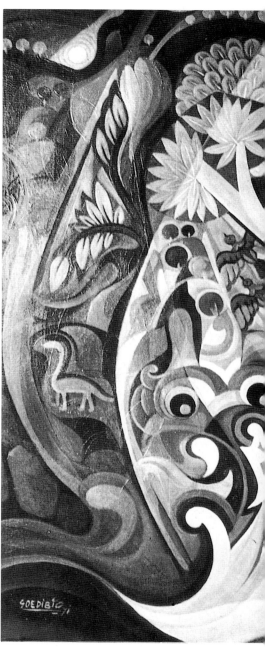

51. Eddie Hara, *Playing with an Elephant*, 1985, oil, acrylic, and charcoal on hardboard, 240 × 120 cm, when photographed, collection of the artist. (Photograph Astri Wright.)

52. Sudibio, *Tree of Life*, 1971, oil on canvas, 100 × 80 cm. (Photograph courtesy of the Adam Malik Collection.)

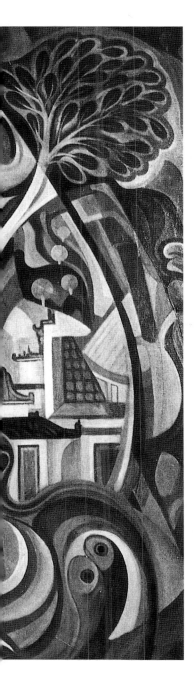

straightforward image of life and harmonious procreation, village style.

M. Sulebar Soekarman's (b. 1943, Bandung) *The Spirit of the Tree of Life* (Plate 54) builds up a triangular composition with fragments of newspapers with Chinese, Japanese, and roman scripts and superimposed layers of paints. The yellowed newspaper against the black ground forms a supporting structure to the lighter flights of superimposed colour. The torn and crumpled texts, perhaps symbolizing the ephemeral quality of everyday events, contrast with the energy of the red and white paint applied with a thick brush in unhesitating lines, swerves, and sharp angles. In Javanese and Hindu-Balinese thought, red and white symbolize the polarities in life, as do black and white. Red and white also symbolize the Indonesian flag, which refers not only to the nation but also to the idea of Indonesia being the sum of the blood and purity of its people. Whatever the appropriate reading here, the title aids in pointing the viewer towards thoughts about that which endures as opposed to that which does not.

About his work *Gunungan: Mountain Form* (Colour Plate 13) Nindityo Adipurnomo writes:

One thing that has made an impression on me and has become a driving obsession is the feeling I get when watching a shadow puppet performance—it becomes a period of wholeness, roundness, a time which must be mobilized with full autonomy by the puppeteer at the time of the opening and closing of the performance, when he places the *gunungan* in the middle of the screen! I still remember really clearly, when I started this painting, I started by building a tree of life in the middle of the canvas. Then I worked on the whole canvas until I knew it was time for me to return to the construction of the tree of life again, and then the painting was finished![40]

[40]Letter from the artist, April 1990; author's translation.

The process of creating the work of art here mirrors the structure of a *wayang* performance. Like the puppeteer, Nindityo started his work with the *gunungan*; then he created the canvas like the puppeteer would create the story, introducing the characters and the problem which, traditionally, would fill a whole night's peformance. Like the puppeteer who brings his story of divine and human characters in the battle of good versus evil to temporary resolution by dawn, closing the story by once more placing the *gunungan* in the middle of the screen, Nindityo finished the work by returning to his tree of life in the middle of the canvas, adding the final touches to it, and then stepping away from it. Thus, like the spiritually powerful *wayang* performances, the structure of Nindityo's work process forms a circle.

Whereas to Nindityo, the material symbols of traditional world-views are posited as viable sources of meaning to modern life, other young artists exhibit a more ambiguous approach. Nyoman Erawan, whose poem we encountered above, is preoccupied with death and physical destruction being integral parts, both of the life cycle and of all creative activity. These thoughts are embedded in the references in his work to the symbolic dimensions of the Balinese cremation ritual (Colour Plate 14). Although the work is replete with ambiguity, Nyoman Erawan is not necessarily challenging traditional views. However, he is, at the very least, insisting that material expressions of tradition—as all material things—are subject to decay.

Ign. Hening Swasono's *Cracks in the Tree of Life II* (Plate 55) is an example of the complete merging of the triangular form with the idea of the tree of life. One of a series of relief-like works made of painted plaster and other materials, this image challenges the contemporary potency of the traditional mountain/tree symbol. The triangle, in some places strongly delineated and colourful, is

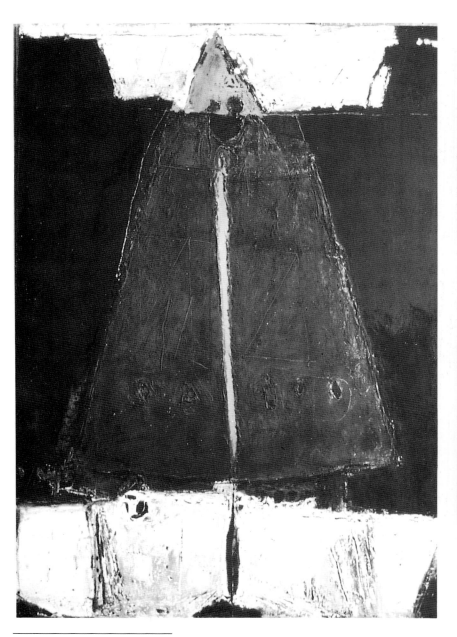

53. Ahmad Sadali, *Ultramarine Triangle*, 1969, oil on canvas, 100 × 70 cm. (Photograph Claire Holt. Courtesy of the Southeast Asia Program and the Carl A. Kroch Library, Rare and Manuscript Collections, Cornell University.)

54. M. Sulebar Soekarman, *The Spirit of the Tree of Life*, 1988, oil and paper collage on canvas, 95 × 85 cm, when photographed, collection of the artist. (Photograph Astri Wright.)

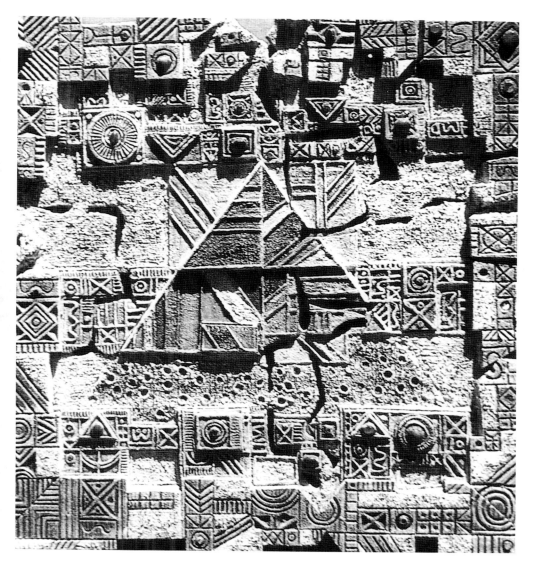

55. Ign. Hening Swasono, *Cracks in the Tree of Life II*, 1989, mixed media, 90 × 90 cm, when photographed, collection of the artist. (Photograph Astri Wright.)

elsewhere partly erased and encroached upon by other forms. Two squares on either side of the pinnacle tempt us to read that part as a rectangle; a band behind the main body of the triangle imposes on it the form of a cross. Most telling of all, the image is eroded and cracked in the same way as are the reliefs on the classical monuments. In Hening's work, as in Nyoman Erawan's, we find a comment on history and the present, in which the continuity of past ideas is neither taken for granted nor celebrated in the straightforward, uncomplicated, and unquestioned way so often evident in modern Indonesian painting. Hening and Nyoman Erawan, who are among the youngest Indonesian artists fully emerged as individuals with important contributions to make, exhibit a self-consciousness which pushes their work towards allegory of an acutely modern kind, offering an unprecedented form to an ancient South-East Asian theme.

3 The Spiritualization of Modern Indonesian Art

Islamic Painting

FOLLOWING the well-established international networks for sea trade, in which South-East Asia had been an active player along with China, India, North Africa, and the Roman Empire (Wolters, 1967; Miller, 1969), Islam began to make an impact on the archipelago from the twelfth century on, and increasingly in the fourteenth and fifteenth centuries. As Geertz writes, Islam's arrival in what is today Indonesia was not, as for example in Morocco, an entry into virgin territory: it arrived into a complex set of cultures, with 'true state organization, long-distance trade, sophisticated art, and universalist religion' (1968: 11). In contrast to the homogenizing force of Islam elsewhere, Geertz sees it as having tolerated, if not promoted, indigenous tendencies towards cultural diversification.

In the Outer Island enclaves it remained, or at least developed into, the sort of exclusivistic, undecorated and emphatic creed we associate with the main line of Muslim tradition, though even there the entanglement with Indian pantheism, in both the archipelago and the subcontinent, gave it a perceptibly theosophical tinge. In Java, however—where in the end, the overwhelming majority of Indonesian Muslims were to be found—the tinge became at once a great deal deeper and

much less evenly suffused.... The overall result is what can properly be called syncretism, but it was a syncretism the order of whose elements, the weight and meaning given to its various ingredients, differed markedly, and what is more important, increasingly, from one sector of the society to another (1968: 12–13).

The process described above is also reflected in the arts. Pre-Islamic art forms found ways to associate themselves with Islam, by developing minor variations or additions to their traditional forms. The adaptation of Hindu architectural forms in the building of mosques, such as evident at Kudus, and the invocation of Allah at the beginning of *wayang* performances, which then proceeded to tell the Javanese adaptation of a Hindu epic tale, are examples of this. In other instances, new art forms were introduced, such as carved tombstones, Middle Eastern, Indian, and Central Asian inspired mosque architecture, new patterns in batik cloth, and, most recently, modern painting.

In a nation which, according to government statistics, is 85 per cent Muslim,[1] one would expect a controversy to rage about the use of the human figure

[1] *Indonesia Facts 1990*, Jakarta: National Development Information Office.

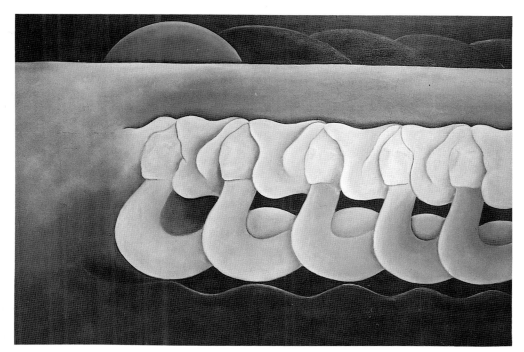

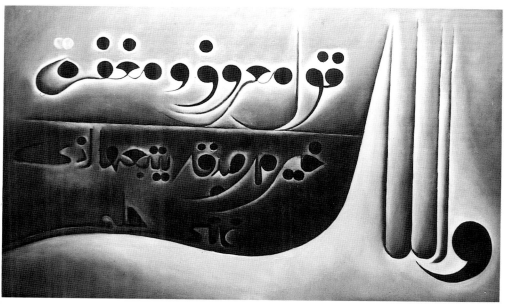

56. Amang Rachman Jubair, *Painting I*, 1980s, oil on canvas, 95 × 150 cm, when photographed, collection of the artist. (Photograph Astri Wright.)

57. Amang Rachman Jubair, *Painting III*, 1980s, oil on canvas, when photographed, collection of the artist. (Photograph Astri Wright.)

in art, especially art presented as having an Islamic context or pretext. But this debate—to the extent that it has taken place—has not been a loud one. A painter like Amang Rachman Jubair (b. 1931, Surabaya) is an example of an Islamic-oriented painter who is strongly influenced by mysticism. Amang Rachman works in a naïve mystical style of inner landscapes, where forms of Islamic calligraphy seem to come either mechanically or organically alive (Plates 56 and 57), and where human figures frequently appear. These are most

often female figures—such as the older woman in *Grandmother* (1974), seated in contemplation, or the three younger women in *Children Reaching for the Stars* (1989), having climbed a ladder, heading across a cloudscape towards a large glowing planet or sun (reproduced in Departemen Pendidikan dan Kebudayaan, 1988: 15).

It is possible that the conflict over figurative versus non-figurative Islamic art in Indonesia has been deflected, not only by the cultural disposition towards syncretism, but also by the fact that the most prominent of the Indonesian painters who most vocally identify with Islam have painted abstract works.

Ahmad Sadali

Ahmad Sadali (1924–87), from West Java, is considered the father of abstract painting in Indonesia.[2] In the discussion of universal versus local systems of aesthetic value, Sadali's paintings illustrate that while culture-specific insights can only enrich their reception, some works of art need no translation to be received cross-culturally. Often in brilliant colours and highly textural, playing with the shadows of geometric forms, Sadali painted vibratingly alive abstract works. According to other artists, it was he who introduced the notion of applying gold-leaf to certain areas of the canvas, a practice which clearly resonated with modern Indonesian artists and has been much adopted since (see Colour Plate 8 and Plate 53).[3]

In Indonesia, Sadali's paintings have been called 'vehicles for meditation', filled with 'mystery and religious quiverings' (Mustika, 1983: 38) (Plate 58). When asked how he would classify his work, he replied that he could not answer that question. He felt it was impossible for a painter who was deeply immersed in the process of painting to simultaneously analyse himself and relate himself to an 'ism'. Analysing, employing theoretical frameworks, and teaching, whether the history or philosophy or appreciation of art, he said, are completely different matters than painting.[4] Still, Sadali did teach in the Fine Arts Department at ITB-Bandung from 1953 on (1983: 34). He did not allow drawing from nude models in his own classes, an attitude that resonates both of Islam and of the reticence with which nudity is treated in Java.[5]

I cannot remember ever having decided to become a painter, even less having chosen that above anything else. I only know that there was a certainty that led me, simply and naturally, a certainty which I received with deep gratitude. Maybe this process felt natural because I was born in a family and in an

[2]Ahmad Sadali died a month after I arrived in Indonesia and no retrospective of his work was held while I was there. Most of his work having disappeared into private collections, I did not have the chance to give it the attention it undoubtedly deserves. A few of Sadali's paintings can be seen in the Neka Museum, in Agung Rai's collection, and in scattered reproductions in catalogues, mostly in black and white.

[3]For reproductions of two of Sadali's paintings

from 1959 and 1967, see Holt, 1970b: Pls. 3, 4. For two works from 1977 and 1984, see J. Fischer, 1990: Pls. 43, 44. It is to be hoped that Indonesian or other art historians will soon devote a monograph to Sadali's work.

[4]Emphasizing the importance of the non-rational mind in creating and appreciating art is often reiterated in the discourse of modern Indonesian painters, both the spiritually and the socially inspired. Affandi, in the memorable 1982 film by Yasir Marzuki, *Hungry to Paint*, talks about Picasso and Van Gogh, describing why it is that his affinity is with the latter. Picasso is too 'clever', his brain is too strong; Affandi, like Van Gogh, only has 'strong emotions'. It is only in the 1970s that certain younger Indonesian painters disclaim this tendency towards emphasizing the romantic and the lyrical.

[5]Ahmad Sadali did not, however, enforce this rule throughout the school, and drawing from the nude has intermittently been part of the curricula both in Bandung and in Yogya (pers. com. with But Mochtar, Rector of ISI, March 1991).

kalam[6] on parchment and whose products I admired highly. In short, my childhood environment was one that always paid attention to colours, form, comparing and evaluating what was suitable or not—maybe what is called 'aesthetic judgement' (1983: 30, 33; author's translation).

When asked what his main goal as a painter was, Sadali answered, 'To seek God's blessing. Maybe you laugh to hear me say that. But this is very serious for me. Truly, I do not know what the goal of living would be other than that' (1983: 33).

A. D. Pirous

Although Ahmad Sadali occasionally used Arabic calligraphy in his paintings, it was Abdul Djalil Pirous (b. 1933) who first exploited its expressive potential in calligraphic-abstract works, caught the attention of Indonesian artists and art lovers, and developed a new school in Indonesian painting (Machmud Buchari and Sanento Yuliman, 1985).

A. D. Pirous is from Meulaboh, Aceh, North Sumatra, a strongly Islamic region about which a Dutch scholar wrote at the turn of the century: 'The foreign civilization which has exercised the most lasting influence on the Acehnese, namely that of Islam, is but little favourable to the awakening or development of the artistic sense' (Hurgronje, 1906: 65). It has been pointed out that Hurgronje could not have been aware of the sensuous displays of exquisite silk and gold-embroidered textiles created for ceremonial occasions, especially the wedding ceremony (Leigh, 1988). It is also possible that these did not qualify in Hurgronje's mind as belonging with the class of objects that he labelled 'artistic'.

Pirous's mother was a devout Muslim who was skilled at gold-thread

58. Ahmad Sadali, *Horizon*, 1978, acrylic on hardboard, Agung Rai Collection. (Photograph Astri Wright.)

environment that supported it. For example, my grandmother had a batik studio, father had a printing press and a weaving workshop besides cultivating oranges, etc. An uncle of mine whom I often travelled around with and helped out, liked to paint landscapes while my great grandfather was a writer of the Holy Book (*Kitab Suci*), a calligrapher who used a

[6]A *kalam* is a pen made from the rib of a leaf.

embroidery and couching.[7] All the children helped in the mother's art work: 'One drew patterns, another one had to stretch the cloth on to a frame and Pirous mixed the ink' (Spanjaard, 1988: 124). At this time, he also studied Arabic letters at the religious school. His mother understood his desire to become an artist, and after serving in the republican student army Pirous enrolled in the Fine Arts Department in Bandung in 1955. Like his fellow students studying under Ries Mulder and Ahmad Sadali, his early works are exercises in cubist-inspired breaking up of the plane to depict fractured landscapes and figures. After graduating in 1964, Pirous became an instructor at ITB; in 1968 he was named the head of the graphics department; in 1988 he became Dean of the Faculty.

Unlike Ahmad Sadali, whose development appears to have been smooth and sure, Pirous had an experience which caused him to suddenly 'find himself'—to rediscover his cultural roots. In 1969, in the USA on a two-year scholarship, Pirous encountered the Islamic art collection in the Metropolitan Museum of Art:

Calligraphy, arabesques, and miniature paintings—it was something that didn't feel strange. It felt very close, very familiar, very intimate—*all* those things. Yes, of course! Because when I was still a child in my village in Aceh, all those things were scattered around me, on tombstones, in the mosque, in books, in my father's Arabic writing.... So then I realized, I can explore all these possibilities to find something that will be *myself*.... That was the first time I came into contact with Arabic calligraphy as a grown-up, and I am still doing it, until now.[8]

Pirous described the change his art took and the nature of his creative

process, then and now:

My paintings greatly changed, from something close to what you call abstract expressionism, or abstract—very easy, moving on the canvas, placing accents on the canvas, then you destroy it, then you build it again, you know.... At that time, I could work simultaneously on several paintings at the same time. But after 1970, I tried to make paintings with more concentration, planning them carefully: I had to choose the *surah*[9] that I wanted to paint, and then think, and try to interpret it—in my own way, you know—it takes a lot more preparation, that way. The technique was not spontaneous anymore.

When asked whether the act of painting had moved from being pure emotional expression to being more spiritually infused, Pirous answered:

You can say that. It's more—controlled, self-disciplined. I know from the beginning that this will be finished in this form and in a certain time. But before, I didn't know—I just started painting—and then suddenly I would say 'Nee! That is finished!'[10] Sometimes of course the painting turns out differently than what I plan. If this never happened, the work would merely be a very neat design and I don't like that, no. It must be something that, you know—you play around with, you feel, and then you express it—and you're quite absorbed. I still try to maintain that way of working.

In a work entitled *For the Sake of the Sparkling Morning Light* (Colour Plate 15), traces of Pirous's new awareness of the art infusing his childhood in Aceh are evident. Here, he combines abstract rectangular panels of colour with a tall, upward-thrusting triangle, filled with an inscription in Arabic script. The central background space of horizontal colour panels, against which the triangle is set, is symmetrically framed by vertical panels—a composition

[7]Examples of this kind of embroidery can be seen in Leigh, 1989: Figs. 5–11, 20–22, 41–46.

[8]This and following quotations are taken from an interview with the artist, June 1988.

[9]A *surah* is a verse from the Koran.

[10]The use of the Dutch word 'nee' for 'no' indicates Pirous's early educational history.

which is at once modern and evocative of Islamic textile arts from Sumatra. Traditional headcloths in batik employ the rectangular format and often use a triangle as a central motif; more directly relevant are the textile arts of Aceh themselves. The Acehnese penchant for symmetry is evident in the design of *tirei* wall-hangings used in the marriage chamber called 'Worldly Paradise', which consist of vertical colour panels in contrasting colours, and in the *maracu* wall-hanging dominated by a large triangle (Plate 59), which is also used in the wedding ceremony (Leigh, 1989: Figs. 20, 41). These are part of the aesthetic matrix into which Pirous was born.

Amidst shades of blue, mauve, and grey, the morning light referred to both in the title and in the *surah* depicted, is represented by a single golden line behind the tip of the triangle. The triangle itself is depicted as a chipped and cracking stone, a symbol of transience set against the timeless purity of abstract form. What is posited here as eternal is the return of daylight, and—presumably—the truth embedded in the calligraphy, which unlike the stone, is unblemished and, with its luminous turquoise colour, seems to derive its inner glow from the daylight itself.

Pirous is known in the artist community as someone who speaks well about art, both his own and that of others, historical as well as contemporary works. Questioned about what the hole-like shapes on a new painting on his easel might symbolize, Pirous said:

I just wanted to give a certain impression of antiquity, something from the past. In this way I want to convey a feeling that what I made here derived—not from *today*, but is something ... *eternal*. Like old stones with inscriptions on them, like the Ten Commandments, for example. Also, the theme of the calligraphy is taken from the first *surah* in the Koran, that says something like, 'Write it in the name of your God'. That indicates an important idea for us Muslims, that in the Muslim world, what is demanded today is to know how to read the Koran. That is the clue, the key to being educated. So this *surah* symbolizes knowledge. That's why I put it here, by the door—so [as] you enter this house, you are welcomed by this piece. But—this is if you *understand* it! If you don't understand it, that's all right too! You can get the aesthetic pleasure. But if you *do* understand it, you'll get *more* than that, not only pleasure. Something that can, you know, give a deeper meaning which is rooted in contemplation and meditation.... Because—all the *surah* say that writing originates from the *surah*, the Koran. So as a Muslim, you see and you enjoy, and you also feel something behind that enjoyment—the meaning of it all.

Pirous rejects the idea, however, that he preaches in paint. He is not, in his

59. *Pelaminan* (throne) for a bridal couple from Meulaboh, West Aceh. (Photograph N. Rieb.)

own mind, creating sermons visualized in paint, the way Borobudur can be conceived of as a series of sermons or teachings visualized in stone:

Don't look at this information as if I am doing these paintings for the purpose of religion. No! But given the reality of the religious-minded, I am honest about my way of working. I was sometimes triggered by the *surah* because of its meaning, because of its philosophy, because of its ethical value. Then I tried to interpret it into visual form. And then, if somebody can feel it, then I am *happy*, of course.... Some of my work can affect someone as more than merely aesthetics; I can't help it, that has happened. But I am not proselytizing—sometimes, [the *surah*] is not taken from the Koran—sometimes it is just a simple, beautiful sentence, a bit of poetry for example, that is all.

Clearly, the idea of proselytizing appears distasteful to Pirous, an attitude which points to a broader cultural value in Indonesia, often described as 'tolerance'. This does not mean that an art work is without message, but the message is not one to be loudly proclaimed and imposed upon others. Rather, it is there, inherent but meaningful, to the one who creates the work. It is also there, in the form it can be received, to the viewer who cares to approach the work and search with his or her 'heart/mind'.[11] Faced with a painting which consists predominantly of calligraphy, the idea that the writing means something cannot but impress itself on a Western mind.[12] There is, however, a tradition in Indonesia, especially in Java, of the text that is powerful precisely because it is not meant to be read. This is illustrated in Prince Yudhistira's magical weapon, a text known as the *Kalimasada*, which Anderson has called both powerful and incomprehensible: 'It is not what is "said" in the *Kalimasada* that is important, but that certain syllables are inscribed on it in a certain powerful order by a certain person at a certain time' (1990c: 128). Such a tradition might, at least in part, inform the way a calligraphic phrase in a painting is seen as well, not as something known or understood rationally, or even meant to be read, but as something inherently pregnant with meaning and power (see Florida, 1987).

Such an interpretation of how texts are approached might provide a clue to the way all types of texts are read, even in present-day Indonesia, also as regards symbols in art and art objects in their entirety. This would offer an explanation for why discussions of iconography, symbolism, or the meaning of specific works do not figure prominently in what Indonesian artists or critics write or say about art. Indonesian art writing more often consists of recounting the emotions or associations a work provoked in the writer, a narration of the theme of the work, and a discussion of individual artists and works in relation to their social and professional contexts and relationships.

However this may be, for the artist the emphasis is on the place the process of creating of art plays in his own life. For A. D. Pirous, painting approximates a spiritual discipline: after a full day at the office and a few evening hours spent with the family or in social engagements, he paints from 11 p.m. till 2 a.m. After two and a half hours' sleep, he rises for morning prayers, after which he may sleep another hour. He gets to the office by 8 a.m.

[11]This reading is compatible with views about 'sign' and 'meaning', where each text, in this case a painting, is thought of as an open-ended signifier, with no single correct interpretation, carrying traces of conflicting ideologies and shadows of intended and unintended meanings, as they are evoked in the mind of the interpreter.

[12]See, for example, Pirous's 1971 work entitled *Kaligrafi* (Departemen Pendidikan dan Kebudayaan, 1988: 7).

60. A. D. Pirous, *Thanks Be to God the Supreme*, 1984, modelling paste, acrylic, and gold on canvas, 46 × 46 cm. (Photograph courtesy of the artist.)

floating calligraphic shapes which are deformations of real Arabic letters and hence work on the level of imaginative reference. The work entitled *Prayer XII* (Colour Plate 16) uses text—a two-dimensional referent—as the texture to create the illusion of a three-dimensional landscape, above which a red sky in Japanese-inspired graded tones blazes behind the powerful calligraphic signs that hover above the firmament.

Graphic techniques have, in turn, influenced Pirous's painting, causing him to incorporate elements from prints, such as graded colours from dark to light: in his paintings, 'vertical coloured strips and ... brightly-coloured patches ... have the clarity of a serigraph, accentuated by the sharp outlines of the calligraphic motifs' (Spanjaard, 1988: 126).

Besides Islamic folk art motifs, such as the figure of Bouraq (Mohammed's mount—a winged horse with a female head) which frequently appears in Pirous's work (see J. Fischer, 1990: 73), he has also since his return from the USA been preoccupied with native and traditional Indonesian art motifs, such as early tombstones (Plate 60). In 1973, Pirous co-founded the design group and studio DECENTA with a group of ITB faculty members. The group systematically collected examples and photographs of indigenous, tribal, and folk art forms from around the archipelago, studied their designs and techniques, and built up a library for the use of DECENTA members and other interested parties.

In 1972, Pirous held his first solo exhibition in the Chase Manhattan Bank in Jakarta. Within a few years many other painters started painting calligraphy. In 1979, in connection with the national Koranic reading competition in Semarang, a large painting exhibition was held, with between thirty and forty painters represented, all showing

Besides oil-paintings, Pirous has worked prolifically in graphics (etching and serigraphy), often participating in international exhibitions (reproduced in Machmud Buchari and Sanento Yuliman, 1985). In developing graphics as a modern Indonesian medium of expression, Pirous has been a central figure.[13] His themes are mostly the same as in his oil-paintings: variations on geometric forms ranging from abstract to stylized fragments of stone monuments with calligraphic inscriptions, or plays on illuminated pages from the Koran. The more abstract works often have free-

[13]He is well-known among international graphic artists, having participated regularly at, for example, the International Biennial of Graphic Arts in Fredrikstad, Norway, and at other exhibitions in Holland, Taiwan, Yugoslavia, Germany, Great Britain, Australia, and the USA.

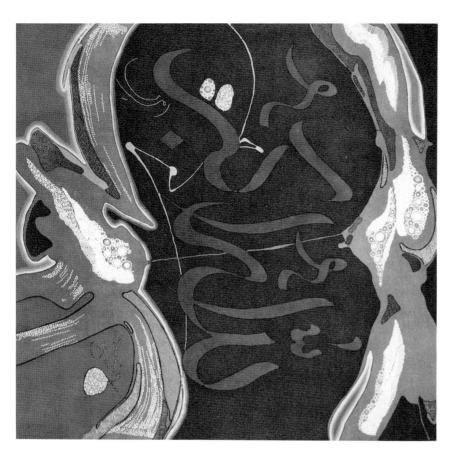

61. Amri Yahya, Untitled, 1985, batik-painting, when photographed, collection of the artist. (Photograph Astri Wright.)

senior artists paint a certain number of works which include Islamic calligraphy or references (Colour Plate 17 and Plate 61). A large number of younger painters concentrate on Islamic themes; among these can be mentioned Bambang Priyadi (b. 1959) of Malang whose work ranges from hyper-realistic depictions of calligraphically inscribed ruins, whether classical or primitive, to abstractions with hints of Islamic calligraphy (Colour Plate 18 and Plate 62).[16] Other artists raised in a strongly Muslim culture, such as Lian Sahar (b. 1933), originally from Aceh, do both traditional carvings and completely abstract modern paintings, without mixing influences from the two art forms on any discernible level (Plate 63).

In 1981, Pirous completed the circle which had been started in Meulaboh half a century earlier and reactivated in New York. He brought the new school of painting and his own art back to Aceh for a large exhibition he was instrumental in arranging in connection with the Twelfth National Koran Reading contest. In the exhibition entitled 'Painting, Calligraphy and Mosques in Aceh', A. D. Pirous, Ahmad Sadali, Sunaryo, and Srihadi Sudarsono, all well-known second-generation Bandung artists, joined with Amang Rachman Jubair, Amri Yahya, Lian Sahar, and twenty-five other painters from Java and Sumatra for the painting part of the exhibition (Museum Negeri Banda Aceh, 1981). Twelve well-known calligraphers, several of them from the Aceh area, showed works in traditional styles and media, and a photographic exhibition showed pictures of mosques and examples of wood- and stone-carving

calligraphic works on canvas![14] Seeing this, Pirous said he was surprised and happy.[15] Today, many of the well-known

[14]In the late 1980s, paintings of traditional-style Arabic calligraphy, chiselled into the stone of crumbling monuments often set in darkly lit, romantic landscapes became something of a craze among many young artists. This was evident in the large ASEAN Islamic Painting Exhibition in Yogyakarta in May 1988.

[15]Pirous's reaction indicates a different attitude towards creativity than one would expect to encounter in a Western painter whose style had inspired a large number of similar works. In the West, words like 'derivative' and 'copying' would have been brandished. In Pirous's conversation, ideas like 'school' and 'following' were invoked. This illustrates the more communal approach to creativity and originality in Indonesia, an attitude described in the development of twentieth-century Balinese painting and sculpture. (Holt, 1967, Ch. 7). This is one of the contexts which makes it so

hard to enforce copyright laws and the idea of intellectual property in Indonesia.

[16]Bambang Priyadi also occasionally paints in a surreal style with no direct Islamic reference, an illustration of the wide range that many Indonesian painters work in.

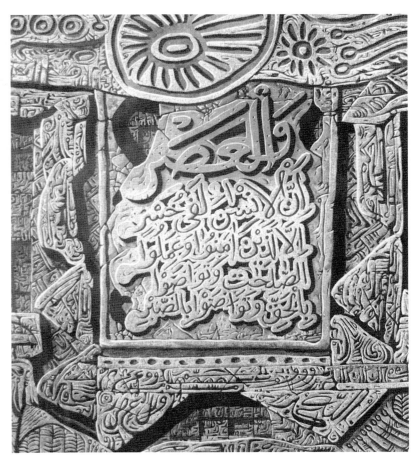

62. Bambang Priyadi,
Calligraphy, 1988, oil on
canvas, 130 × 110 cm,
when photographed,
collection of the artist.
(Photograph Astri Wright.)

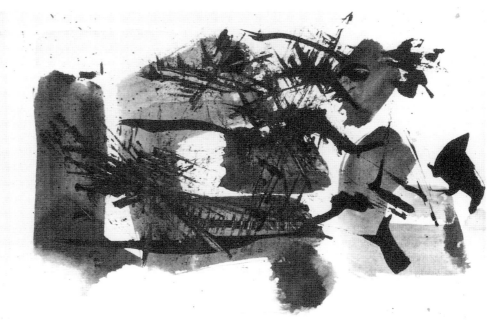

63. Lian Sahar, Untitled, 1980s.
(Photograph courtesy of the
artist.)

from the province. In 1984, Pirous, Ahmad Sadali, and three other Indonesian painters participated in an exhibition in Kuala Lumpur, which also featured works by Islamic artists from Lebanon, Bangladesh, and Malaysia. The catalogue contained an essay on the nature of Islamic aesthetics and art (Balai Seni Lukis Negara, 1984).

Besides his role as a teacher and in developing abstract painting in Indonesia, Pirous's most important contribution lies in his developing a vocabulary and style for a modern school of art with a clear Islamic identity, which clearly touched a nerve of increasing importance in Indonesian society.

Javanese Mysticism and Modern Art[17]

Some contemporary artists in Indonesia, specifically in Central Java, consider the making of art not an end in itself but a part of their spiritual practices. Some strive to know the iconography of monuments of the past, not as archaeologists do, but in order to understand the mystical messages embodied in them. At the same time, they are developing a personal, modern visual language of their own. Their spiritual orientation causes them to see mythology and monuments as living texts relevant to the choices contemporary Indonesians make in their daily lives. These spiritual views, in turn, influence the artists' view of the creative process and the self in relation to this process.

Javanese mysticism, referred to as *kebatinan* (mysticism, spiritualism) or *kejawen* (Javanism), variously glossed as 'Javanese science' or 'philosophy', has been studied by Dutch scholars since the colonial era and by other Westerners in the wake of Geertz's *The Religion of Java*

(1960).[18] Javanese mysticism—'all the beliefs that concern potency and the imperceptible world' (Keeler, 1987: 109)—has also been the subject of Javanese and Indonesian language studies, the latter especially in the last two decades. Due to the lack of formal organizations of people studying and practising Javanese mysticism (and therefore its potentially uncontrollable nature), it has also been the subject of scrutiny by the Indonesian government.[19]

It has been argued that Javanese mysticism involves ideas and practices that carry back to pre-Indic influence. Stange writes that both Hindu–Buddhist temples and mosques 'were erected on a landscape already profoundly infused with spiritual tradition' (1980: 33). Today, Javanese mysticism is a syncretic mix of Hindu–Buddhist, Islamic, and indigenous animist beliefs and practices, based on a belief in 'the essential oneness of all existence' (Geertz, 1960: 20). It is practised both by individuals and in

[17]A longer version of the remaining part of the chapter has been published as an essay (Wright, 1991c).

[18]Studies like Douwe Adolf Rinkes, *Abdoerraoef van Singkel: Bijdrage tot de kennis van de mystiek op Sumatra en Java*, Heerenveen: Hepkema, 1909, and Louis A. Bachler, *Gadadara inggih Rama Kresna: kepetik saking serat-serat ingkang kawedalaken dateng*, Djakarta-Betawi: Lodji, 1921, are examples of biographical and literary approaches to indigenous mysticism. See the sociological discussion of mysticism and mystical sects, with interesting passages of informants explaining their history and personal experiences, in Geertz, 1960: 309–52. Other sources on the subject will be found in the notes below.

[19]In 1978, a separate branch of the Ministry of Religious Affairs was established called the Directorate of Local Beliefs, under the Directorate General of Culture, which is under the Department of Education and Culture (Haryati Soebadio, 1985: 21). Mystical practices have often intersected with politics in Indonesian history, as illustrated in the belief in invulnerability rendered by the wearing of spells and amulets, and the total allegiance to certain spiritual leaders which have characterized certain nineteenth- and twentieth-century millenarian movements and rebellions. In the early 1970s, *malam tirakatan* (night of meditation) preceded important rallies or demonstrations during student protest movements; see Rendra, 1979: 51 n. 65.

groups, and may involve meditation, ascetic exercises, fasting, study, and discussion—all directed towards embracing life in all its minute details as a total religious experience.

Like any living thing, Javanese mysticism has changed over the centuries, markedly so since the arrival of Islam, and it is practised in many different ways Certain schools emphasize some aspects over others: today, the term *kebatinan* is used to refer to the more Islamized form of Javanese mysticism, whereas *kejawen* refers to a Hindu-Javanese philosophy which espouses the idea that all aspects of existence, seen and unseen—angels, ghosts, and spirits—can be experienced directly.[20] The more Islamized schools, less comfortable with such a cosmology, which prefer to deny the existence of spirits, tie their formulation of Javanese mysticism to person-centred histories or genealogies—in some cases leading right back to Mohammed (Geertz, 1960: 331). Most, if not all, groups within Javanese mysticism centre around a guru, who commands the loyalty of anywhere from a few individuals to thousands of people, on a regional, national, and even international basis.[21] Although groups vary in practice and use of terminology, the essential content of the teachings remains similar. Far from a strictly codified, dogmatic belief system, Javanese mysticism is one of the cultural creations of Java that illustrates the idea of syncretism—the combining of elements from different religions or cultures, which from the perspective of Western logic appear to contradict each other.

Life is seen as a mystical journey, thought to proceed in four stages from the outer to the inner realms. Rather than a mere passive victim of fate, man is thought to have the power to direct his own spiritual progress (Mulder, 1978: 15). The first stage in the mystical journey consists in correct living, according to social and religious etiquette and laws. At this stage, man is still living in his outer aspects. The second stage constitutes the first step towards a fuller inner life: this stage implies perfecting and reflecting upon behaviour and ethics in the outer world. In the third stage of the mystical journey, man begins to confront truth; at this point the distinctions between various forms of religious ritual and expressions appear meaningless. Finally, at the fourth stage, the goal of complete insight and 'eternal unity between Master and servant' is reached (1978: 22–3).

Meditation is considered an important way to gain insight and strength. It may involve getting in touch with the spirits of ancestors or other powerful beings. In one form of meditation, one's mind-spirit is guided step by step through the stages outlined above, duplicating the mystical journey. The first step, removing oneself from the outer world, is initiated by the act of withdrawing into silence to meditate. A student of meditation described the process like this:

The first part [of the meditation] represents the Micro-level; the next represents the Macro-level; the third is the Cosmic/ Universal. To grasp this, it is easier for me to think in terms of first concentrating on and understanding the Self, then the world and all of nature around the Self, then finally the Universal Principle itself. The specific symbols and colours that appear during meditation all have different meanings depending upon in which of the three stages they occur.[22]

[20]This distinction is made by contemporary practitioners in Yogyakarta, not by Geertz.

[21]For example, the headquarters of Subud, one of the biggest groups, is in London. In the Jakarta *asrama*, numerous foreigners reside on a semi-permanent or permanent basis. Several studies of Sumarah, another large group counting many members internationally, have been done (for example, Stange, 1975).

[22]Here, and in the following, where no other reference is given, quotes are taken from field notes.

A Case of Art and Healing

In 1987, a Hindu-Javanese temple, *wayang* characters, Javanese mysticism, and contemporary painting all connected with each other in a case of medical diagnosis through meditation done by Agus Ismoyo, a Yogyakarta painter who practises *kejawen*. The patient had just been diagnosed by one of the city's most famous Western-trained medical doctors with a 'fist-size, probably malignant tumour, requiring immediate operation'.[23]

Meditating around midnight, after first purifying the room with holy water, incense, and flowers bought at the market the same evening, Ismoyo had a vision which consisted of two images. The first was a *wayang* shadow figure passing across the sky, heading south. The sky in front of the figure was black; behind it, the sky was white. Then the light turned, the sky became green, and the shape of a Hindu-Javanese temple emerged—a temple consisting of three towers, the central one taller than the two flanking ones.

The role of the visionary does not necessarily include elaborating on his visions.[24] This meditation vision was at first described only briefly to the patient, without further explication. Later, through an intermediary, Ismoyo communicated that the patient would have to consider rearranging the priorities of her life, and he proceeded to elaborate according to questions: Was the *wayang* figure a specific one, a recognizable character? It was not: there had been no details with which to identify it. It was a generic *wayang* figure.

After a long time of circling around the issue, it became clear that what were important were the black and white areas in the sky. In Javanese mysticism, Ismoyo said, black symbolizes one's worldly (self-serving material and physical) desires, [*nafsu*], while white symbolizes one's objective context [*kenyataan*]. The two colours together symbolize the direction one's outer and inner life takes, when one's choices are in harmony with one's personality and the outer circumstances of one's life.

The problem with the image in the vision was that the black was in front of the white, leading it, rather than the other way around. This indicated that the patient's desires led her more strongly than did a realistic evaluation of her concrete life situation. This had led to a spiritual imbalance which could lead not only to further spiritual sickness but also to physical disease. The image of a generic *wayang* figure travelling across the sky comes to mean the self on its mystical journey through the world of material illusions and inequalities, in search of unification with the divine.

Next, the image of the *candi*. The painter said that this was a picture of the structure of the patient's personality: she

[23]The patient was a foreign woman familiar with Javanese culture, her companion to the temple (see below) a young Javanese woman. The painter and his artist partner both at first requested anonymity. Later, they reluctantly agreed to the use of their names in this book, as long as it was made clear that their reluctance stems from the association of their individual persons in connection with terms like 'art' and 'artist', indicating a level of certainty and confidence and possible pride in their individual material output. To do this, they feel, would indicate a perception of selfhood and authorship which is incompatible with their spiritual practice and philosophy. They have not, in their own minds, even come close to approaching the essential nature of complete insight that creating art involves.

[24]There are many types of visionaries in Indonesia, from the regular man or woman who claims some psychic abilities, to the village *dukun*, and the guru, traditionally with ties to the courts. They rely more on their own experience with meditation, asceticism, and visions than on any written body of doctrine. Most of the literature (Mangkunegara VII, 1957; Mulder, 1978; Geertz, 1960; Stange, 1975, 1980, 1984) deals with more general aspects of various *kebatinan* groups and not much with instances of specific meditations or visions, complete with symbolic interpretations.

was basically oriented towards God. Furthermore, the temple was clearly a Hindu one, Hinduism being a religion 'based on the knowledge and insight we get from nature—not like Middle Eastern or Western religions which are based on laws'. The patient was told that the temple image was like the Prambanan temple near Yogyakarta, and that indeed she should go there and study it in order to find a functional model for her life. The patient was told to study the reliefs, to find out what they symbolize, and what message there might be in them for her.

'The *wayang* image was heading in the southern direction,' Ismoyo said to the patient. 'Find out what the southern side of Prambanan symbolizes. South is the direction of the worldly life. You should find a way to harmonize your worldly orientation with your personality [*kepribadian*], which is oriented towards god.'

'But you don't have to worry about the tumour itself,' Ismoyo said in conclusion. 'It is not fatal—it is only a signal, a warning. But if you don't take care of the problem and correct the imbalance, after a long time with more signs, there could be more serious effects. For now you need not worry about your immediate health: the green light in the image is the colour of god. If it had been red, that would have been a sign of danger.'[25]

Batik and Painting

The presence of the *wayang* figure in the painter's vision illustrates the close connection between the *wayang* and Javanese mysticism. In his own art, however, Ismoyo did not make use of

[25]In fact, it was later discovered that the patient's 'malignant tumour' was a non-malignant uterine fibroid. For a detailed account of the search for an interpretation of the meditation vision in the meaning of *wayang* figures and at the temple, see Wright, 1991c.

forms as traditional and recognizable as *wayang* figures. Although some Javanese painters draw directly on the iconography of Javanese *candi* and *wayang*, he (then thirty) had worked with more personal images and symbols since, after graduating from high school, he first started painting seriously. Although he received the most rudimentary art education in school, after graduating he did not study with anyone, whether within or outside an art educational institution, and is essentially self-taught.[26] Painting imagery of women

[26]There is a certain aura to the label 'self-taught' (*otodidak*) in Java which I think ties in with wanting to claim or demonstrate self-realized talent and power in an idiom which approximates the Javanese idea of spiritual potency. On the institutional level, *otodidak* is used in opposition to 'graduate' (*lulus*) or 'holding an academic degree' (*sarjana*) and today denotes someone who is an outsider to the increasingly important structure of modern educational institutions and degrees. The deeper implications of *otodidak*, however, tie into older patterns, relationships, and beliefs. According to a pattern of education much older than the modern, institutionalized version—one which was characterized by personal, familial, emotional, and spiritual overtones—artists who are *otodidak* have often studied extensively with individual artists, who play the role of 'father' or 'guru'. When finished with this apprenticeship, the younger artist is thought to have imbued some of the older artist's power and insight which will accrue with time. Even within the educational institutions, the student's relationship to his or her teacher carries resonances of this older system. (For a discussion of how Islamic *pesantren* (boarding-school) education approximates such a model of personalized initiation into the mysteries of life, see Anderson, 1990b: 55.) How *otodidak* may imply being in possession of superior spiritual insight can be seen in the other attributes that are cultivated by many artists who use that label, such as long hair (traditionally a sign of holy men, or of people who have demonstrated the ability to mediate between the living and the ancestors, or have demonstrated their spiritual power in other ways, such as a *dalang*) and an irregular lifestyle without regular wages. The 'self-taught' painters I met had, in most cases, either a higher degree of originality in their work or a higher degree of conforming to traditional spiritual symbolism than academically

and children in harmonious, mysterious unity with nature, his work was filled with details that had significance in Hindu-Javanese thought, such as water, plants, animals, seashells, and so on.[27]

Ismoyo had great difficulty giving titles to or talking about his paintings. When asked about such matters, he usually answered *terserah*—'it depends on/it's up to you'. He was reluctant to sign, date, and exhibit his work; at times he even destroyed it. Yet, he kept on painting, often late at night when the noise of traffic and people had died down and his batik studio was quiet. The process of trying to capture the images in his innermost mind and the frustration of not succeeding was the focus of much of his conversation. At the same time, there was no expression of the idea that he might learn anything of importance from an art teacher or from other painters. The *kejawen* idea that spiritual progress depends on one's own search and experiences finds here its equivalence in the artistic journey.

Ismoyo himself would never have labelled himself an 'artist' or his focus in life 'artistic'. He felt he was just at the very beginning of a total spiritual process and the paintings themselves were less important than the process they signified. From what I gathered, he saw it as a process of searching between form and no-form, between that which *is* but

which cannot be spoken *of*, and that which might be grasped and formulated, given a deep level of spiritual insight. Feeling the urge to paint while experiencing that he could not capture what he 'saw'/felt, was frustrating to him. Lao Tzu's verse, 'The Tao which can be spoken is not the true Tao', expresses the same dilemma.[28]

Since 1987, Ismoyo has been painting more abstract pictures in oils, trying to grasp the form and meaning of the moon, symbol of the feminine principle, both during the day and at night, and trying to capture the immaterial, swirling presence of ether—symbol of the masculine principle and the most elevated of the five elements. His self-portrait (Plate 64), painted in monochromes, shows him prostrate before the rising full moon, against a background of swirling air (ether), punctuated by occasional flame-like shapes. The painter's hand is resting on his chest, in a way that might be interpreted as gripping his heart; his visage is enigmatic, hovering between being overwhelmed by the ferment of inner and outer turmoil and willingly yielding, submitting to it.

The painting is composed with a strong diagonal division, marked by the line of the painter's body going from lower right to upper left. The light of the moon fills the upper right triangle thus created; the darkness of the earth on which the painter lies fills the lower left triangle—a use of triangles and colour which triggers associations to the polarities in the universe, where darkness and the downward-pointing triangle represents female, earth, the material dimension, death, and light and the upward-pointing triangle represents male, heaven, the spiritual dimension, and eternal life. The

trained painters. As most of the first generation of Indonesian painters were *otodidak*, using this term today is a way to identify one's spiritual connection with men like Affandi and Hendra. These artists, it could be argued, hold the same powerful position in later generations' minds that ancestors have held, and still do, in modern Indonesian minds.

[27]Because of the wide scope of my research while in Indonesia, which prohibited my spending the time necessary to bypass this problem of communication, I unfortunately did not get a more detailed explanation of what these symbols signify according to Javanese mysticism—an area for future investigation.

[28]By the same logic, Ismoyo refused to fill out any of my questionnaires or be interviewed formally about his art, although we frequently talked in informal group situations.

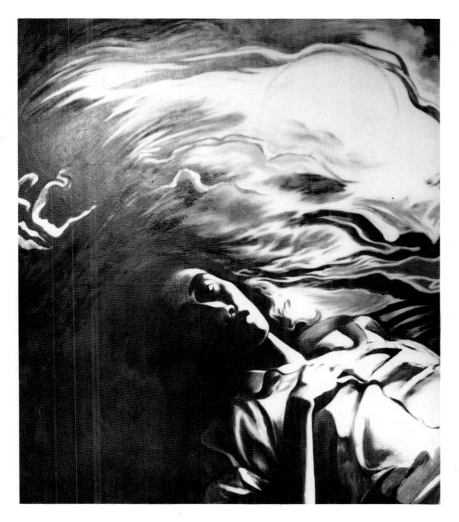

64. Agus Ismoyo, *Self-portrait*, 1988, oil on canvas, when photographed, collection of the artist. (Photograph Astri Wright.)

direction. No doubt his meeting and beginning an artistic collaboration with Nia Fliam, a textile artist from New York who had come to Java to study traditional batik and meditation, furthered his interest in batik.

Convinced that the motifs and designs used in traditional batik had originally been imbued with explicit spiritual meaning, the two artists started studying the ancient patterns. *Kawung*, for example (Plate 65), is a pattern derived from the shape of a fruit stylized into four ovals within a square. The cross design in the centre is thought to represent a 'universal source of energy', the whole representing the structure of the universe. *Semen*, meaning 'sprout' or 'grow' (Plate 66), is a pattern with various motifs that represent the gods, holy places, animals, Heaven, and Earth, the sum of which is thought to refer to fertility worship (Elliot, 1984: 68).

On a formal level, Central Javanese batik cloths are patterned with repeated motifs which cover the entire area more or less densely, either with geometric patterns or motifs derived from nature. In the geometric designs, negative and positive spaces interlock in a balanced design where both have equal value. There is no attempt to break out of two-dimensionality and introduce spatial depth. A similar approach to a pictorial surface echoes throughout Balinese folk painting and much of modern Indonesian painting.[29]

brightest part of the painting is in the centre of the canvas, at the transition point between the dark and the light half: Ismoyo's eye, which gleams in the reflection of the moon.

During the last five or six years, Ismoyo has also increasingly been turning his attention to batik-painting. The art of batik was often passed down from one generation to the next in noble or village families. Given his family's past involvement with batik, the traditional connection between batik and mystical practices, and his father's status as a local guru of *kejawen*, it was perhaps natural that his interest developed in that

[29]Another illustration of what we have referred to as aesthetic affinity (keeping in mind that the term 'aesthetic' here does not preclude a ritual dimension) was given in the summer of 1988, when a group of Aboriginal artists from various northern and western Australian settlements came to study batik with Nia Fliam and Agus Ismoyo. As ideas about pattern, symbol, meaning, composition, and colour were exchanged between the Javanese, American, and the Aboriginal contingents, an immediate rapport was struck up. After ten days they parted with the feeling that their various views

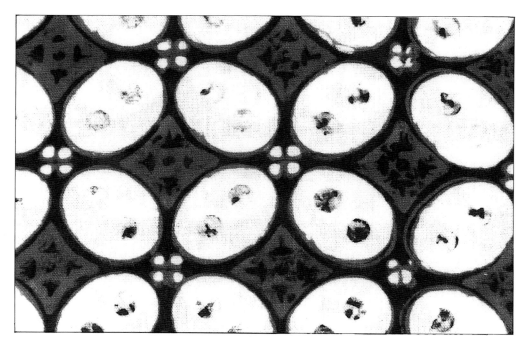

65. *Kawung*, traditional
Yogyanese batik design.
(Photograph Astri Wright.)

66. *Semen*, traditional
Yogyanese batik design.
(Photograph Astri Wright.)

had been greatly enriched in ways that were
immediately accessible and even familiar, and that
the spiritual and aesthetic links between Javanese
batik and Aboriginal sand-painting were deep and
real, and that the medium of batik could easily be
adapted to the contemporary expressive demands of
the latter heritage. This initial meeting has resulted
in annual workshops given to white and Aboriginal
Australians by the Javanese–American artist team at
various locations in Australia, ranging from art
institutes to Aboriginal settlements.

In their research, Nia Fliam and Agus Ismoyo interviewed old artists still living in the Yogyakarta courts. They meditated for insights into the original symbolic meanings of specific motifs, and they sought explanations in the archaeological literature, or directly from motifs found on the ancient monuments scattered throughout the region.

According to *kejawen*, then, the above-mentioned *kawung* pattern symbolizes 'Keblat Papat' or the four directions.

In *kejawen* each direction has a colour and a negative and positive characteristic. The negative is the extreme of the basic characteristic and usually implies greed, excessiveness, and/or madness.... All of the directions have aspects referring to worldly desires. How the energies of a particular direction are used determines one's nature.[30]

North denotes the realm of behaviour and is associated with black. Its basic quality is strength, physical and moral; its negative excess is evil or ruthlessness. East denotes fate (the external, circumstantial reality of our lives) and is associated with white. Its basic quality is the supreme power of the divine as manifest in the cosmos and in nature; its negative excess is laziness. South denotes the worldly dimension and is associated with red. Its basic quality is courage; its negative excess is anger. West denotes the field of love and caring and is associated with yellow. Its basic quality is prosperity, both spiritual and material, generously shared; its negative excess is lovesickness.

Whereas the colours and characteristics unfold in the four directions like four petals on a flower, the centre of the design is perceived as the point of contact to 'the vertical dimension'—the axis which mediates between human and divine. The colour associated with the central point is green.[31]

Ismoyo's interest in how batik constituted a spiritual practice in ancient times, and the symbolism of individual patterns, has resulted in contemporary-looking work that is strikingly different from that of other leading modern batik painters, most of whom claim no connection with *kebatinan* or *kejawen*.[32]

[31]It is interesting to compare this colour symbolism with a passage about *wayang* puppets in Holt: 'Although the use of colors may be becoming more arbitrary, there is still considerable consensus about their meaning. Black is supposed to indicate inner maturity, adulthood, virtue, including calmness. Red, on the other hand, denotes uncontrolled passions, desires. Gold has a double function: it may denote beauty (of the hero), royal or princely status, glory, but may also reflect the desire of the maker or owner of the puppet to make the wayang itself as beautiful as possible. White is said to indicate noble descent, youth and beauty too, but its use is ambiguous. Some say that beings with blue faces are cowardly.... The prevalent facial colors are black, red, and gold. In the course of one play the same character may appear at one time with a golden face and at another with a black face to indicate different aspects of the hero or stages in his life' (1967: 142–3). Between these two systems of colour symbolism, only the colour red seems to hold similar meaning. The fact that the other colours are given differing interpretations may illustrate differences in place, time, and medium (Holt is speaking about dramatic make-up). It may also indicate the fluid nature of a tradition which is oral rather than based on the authority of a written text.

[32]An in-depth study of the modern form called 'batik-painting' has yet to be done, despite the fact that some very interesting work has been done in Malaysia, Singapore, and Indonesia, and even though it is the only true hybrid form between indigenous two-dimensional textile arts and a modern, painterly expression. The relationship to traditional batik, which in Indonesia achieved such a great diversity of beautifully conceived, designed, and executed patterns and styles which rank with any two-dimensional art in quality, should be analysed. For excellent plates that support this statement, see Tirtaamidjaja (n.d.). One of the many aspects of batik-painting that in most cases distinguishes it from oil-painting is that most batik painters employ craftspeople to do the actual waxing and dying, based on their drawn and painted specifications. One difference between Amri Yahya and Nia/Ismoyo would be that the latter

[30]This quotation and the following information is from Nia Fliam, pers. com.

Among those who have come to the fore as innovators of the art in Indonesia in the last twenty-five years is Amri Yahya (b. 1939, Padang, West Sumatra), often referred to as the father of modern batik-painting.

Only a detailed account of the entire batik process—making the design, drawing it on the cloth, applying the first round of wax and colour, then reapplying more wax in some areas and scraping it off others, before dyeing it again, a third and fourth and possibly a fifth time—can make one fully appreciate the process that carries batik artists from creative idea to end result. This process is completely different from painting in oils. To paint on a canvas is to work 'in the positive', adding the forms and colours you want to see in the end result; to work in batik entails working 'in the negative', blocking out the forms you want to appear as positive, keeping in mind at every stage what the final aim is, and allowing for the inevitable departures from this aim the materials themselves cause, in processes involving wax, chemicals, water, and temperatures ranging from hot to cold.

Amri Yahya is known as a pious Muslim who holds a prominent position in Muhammadiyah;[33] he often intones the prayer which opens meetings of artist organizations in Yogya, and often features Arabic calligraphy and terminology in his work. Amri's designs (Colour Plate 19) are abstract plays of colour in which a flat silk screen-like character alternates with areas that signify batik, where one can feel the dripping or painting of hot wax on to the cloth before dye was added. Amri has an enormous output, employs the very best batik workers who translate his painted sketches on to the cloth, runs his personal gallery, and cultivates his international connections successfully. Amri teaches in the Yogyakarta teachers' training college art department and in jest calls himself *raja batik Yogya*—the king of Yogya batik.[34]

Tulus Warsito (b. 1953) has inherited Amri's modern approach to batik-painting and taken it in his own internationalist direction. He started experimenting with batik at the age of twenty and it was through this playful and rule-breaking activity that he discovered the way to create the shadows that have become his hallmark. In his colourful and mostly flat abstract works, a dimension of space is added. In his work *Lightning* (Plate 67), against the square flat red ground, a shimmer of light flashes across the canvas. The light is textured and diffused in different ways with scratchy lines, crackled, striped, and triangular areas, and superimposed across the bottom is Tulus's characteristic, glossy jelly bean shapes, hovering weightlessly, throwing their shadow across the streaks of light as if to prove their two-dimensionality.

Dewa Putu Taman (b. 1954), a Balinese who learned to make batik at the art academy in Yogyakarta, has created unusual, near realist batik-paintings. His portrait of a man (Plate 68) is an unsentimental depiction of an old man seated before the central hall with walls of plaited bamboo and an elaborately carved roof resting on sculpted wooden pillars, all set on a raised stone and brick platform in a traditional Balinese courtyard. The various textures of the background, the

would tend to do more of the actual work on the cloth themselves, so the possibility of the presence of 'signature' in their work would be greater.

[33] An Islamic organization founded in 1912 which was devoted to education and social services (Kahin, 1952: 87).

[34] Pers. com., August 1987. Amri Yahya also paints oil-paintings, with similar compositions and colours to his batik-paintings, but without their strong clarity and sharpness.

67. Tulus Warsito, *Lightning*, 1992, batik-painting, 75 × 75 cm, private collection. (Photograph courtesy of the artist.)

folds of the sarong draped and knotted over the shoulder, and the lines of age in the pensive face are all lovingly treated, combining traditional batik techniques of dots, swirls, and lines with the more modern technique of crackling. The colouring, though traditional in its variations on soga brown and unbleached white, is used in such a way that a sense of depth is created: the background is a medley of mute greyish browns while the man is depicted in golden browns. Finally, many artists working in the modern media of oils and acrylics on canvas are inspired by the tradition of

batik or other textiles (Plates 69 and 70).

None of the above artists, however they mix traditional with innovative approaches to batik-painting, profess to maintain the old mystical dimension of batik-making as it existed within courtly batik cultures. Agus Ismoyo and Nia Fliam (Plate 71), on the other hand, did, though the outcome took non-traditional form. In the process of living, working, and meditating with another artist, they experienced a shift in their approach to art-making as well as to media. Deciding to work collaboratively, creating the design for each piece

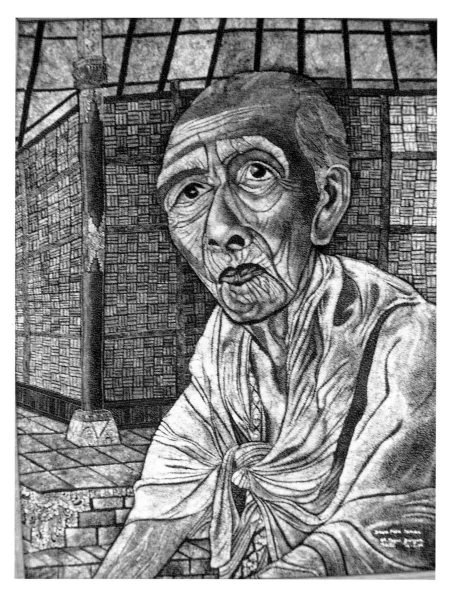

68. Dewa Putu Taman, *Portrait of I Gusti Nyoman Lempad, Famous Balinese Painter and Architect*, 1984, batik-painting, 81 × 60 cm. (Photograph Astri Wright.)

outlines or filled in with dots, or Nia's more watery shapes, often created with folding and dyeing techniques used in African batik (one of Nia's areas of study in New York). Even when the individual shape is identifiable, the other artist may have done the covering, scraping, or dyeing work which constitutes one of the several stages in bringing out the individual patterns. In this way, the Javanese and the American have taken their artistic process yet a step further away from Western notions of the individual self or individualistic creativity.

To support themselves and their costly and time-consuming art work, Nia and Ismoyo had to start up a more commercial line of production, and batik workers were hired on a regular basis to do the waxing, scraping, dyeing, and sunning. These people worked on both the commercial products as well as on parts of the art products, thus introducing yet another factor removing aspects of the actual production away from the control of the individual artist. The art works were not signed; the commercial products—simplified versions of the patterns in their art works, on silk or cotton or rayon, some sewn into clothing—were labelled 'ISNIA'.

One work made in 1987–8 (Colour Plate 20) plays with the theme of Brahma Tirtha Sari (also the name of their batik studio). In the artists' minds, this Hindu-Javanese expression posits creativity as the essence of all knowledge. The work is a symphony of light and deep blue and purple hues. Flat areas with no detailing contrast with the rest of the surface, which is densely treated with a number of different waxing techniques and repeated dyeing. A dark sky, punctuated by starry dots and pairs of jagged lines which evoke lightning or energy, provides a sense of depth. The references to air (ether), water, and blue flames make this a densely conceived and executed work,

together, the two worked on the same piece of cloth with wax brushes and *canting* (wax pens), placing their individual 'signature' styles side by side with pattern areas on which they had both worked.

Thus, in some areas on a single surface, the work of each artist is not readily identified, while in others it can be identified. The latter might be Ismoyo's flame-like shapes built up with repeated

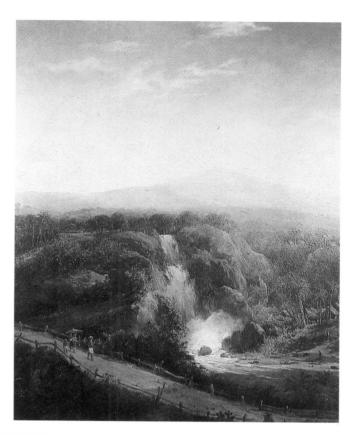

1. Raden Saleh, *Country Road*,
 mid-1800s, oil on canvas,
 59 × 49 cm, collection of
 Balai Seni Rupa. (Photograph
 Astri Wright.)

2. Mochtar Apin, *Intertwined*,
 1987, acrylic on canvas,
 160 × 130 cm, private
 collection. (Photograph
 courtesy of the artist.)

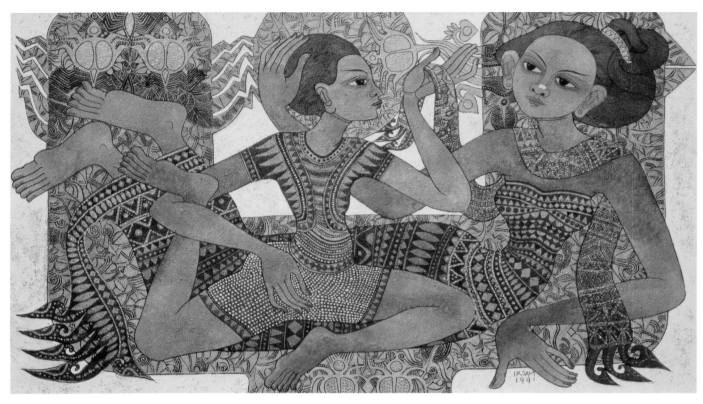

3. Irsam, *Affectionate Love*,
 1991, acrylic on canvas,
 65 × 95 cm. (Photograph
 courtesy of the artist.)

4. Sri Yunnah, *Enjoying the
 Turtle-doves*, 1987, oil on
 canvas, when photographed,
 collection of the artist.
 (Photograph Astri Wright.)

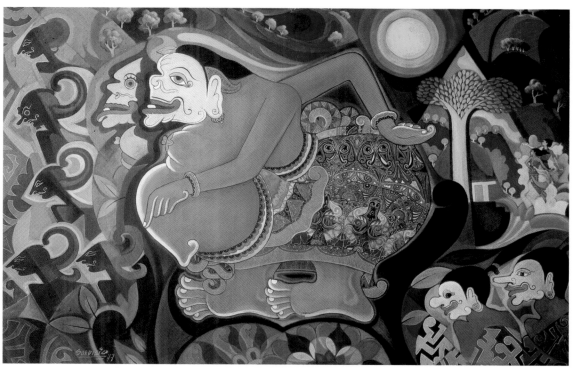

5. Sudibio, *Semar*, 1977, oil on
 canvas, 98 × 148 cm,
 Adam Malik Collection.
 (Photograph Astri Wright.)

6. O. H. Supono, *Balinese
 Priest*, 1980s, oil on canvas,
 118 × 95 cm, when
 photographed, collection of
 the artist. (Photograph Astri
 Wright.)

7. O. H. Supono, *Borobudur— Rupadhatu* (*Sphere of Form*), 1989, oil on canvas, 140 × 140 cm, when photographed, collection of the artist. (Photograph Astri Wright.)

8. Ahmad Sadali, *Mountain Form on Grey Ground*, 1980, acrylic on canvas and hardboard, 80 × 80 cm. (Photograph courtesy of Joseph Fischer.)

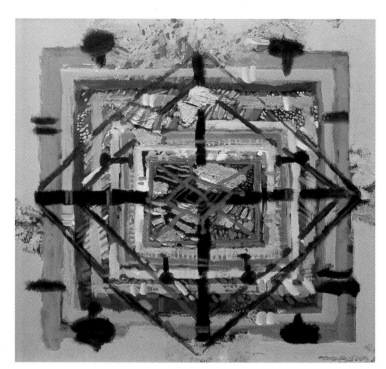

9. Bagong Kussudiardja, *The Court*, 1988, oil on canvas, 96 × 96 cm, when photographed, collection of the artist. (Photograph Astri Wright.)

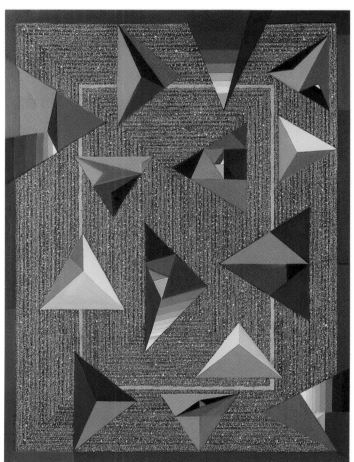

10. Made Wianta, *Flying Triangles*, 1990, oil on canvas, 120 × 90 cm, collection of Ferhan Gorgun, Hong Kong. (Photograph courtesy of the artist.)

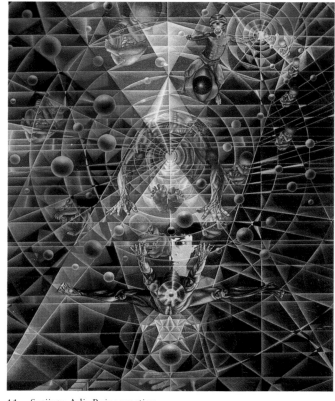

11. Sutjipto Adi, *Reincarnation*,
 1988, oil on canvas,
 140 × 110 cm, collection of
 Mr and Mrs Hamadi
 Widjaja, Jakarta.
 (Photograph courtesy of the
 artist.)

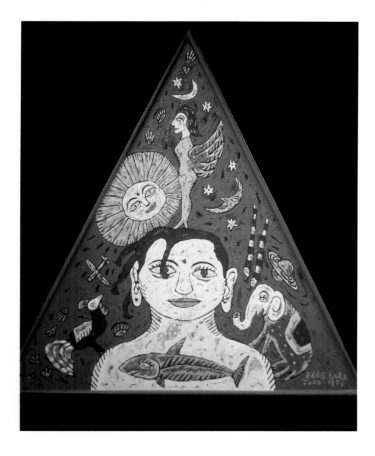

12. Eddie Hara, *Portrait of the
 Artist*, 1986, oil and acrylic
 on hardboard, 100 × 90 cm,
 when photographed,
 collection of the artist.
 (Photograph Astri Wright.)

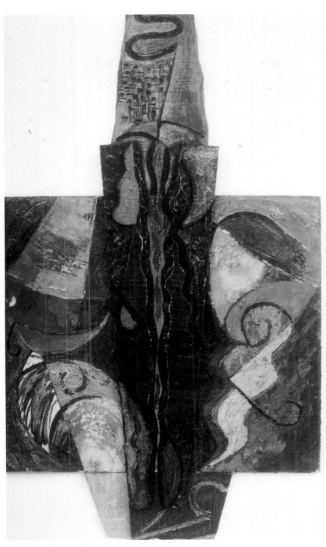

13. Nindityo Adipurnomo,
Gunungan: Mountain Form,
1990, oil on canvas and
wood, 155 × 90 cm, when
photographed, collection of
the artist. (Photograph
courtesy of the artist.)

14. Nyoman Erawan, *Ancient
Time*, 1987, oil and mixed
media on board, 70 × 63 cm,
when photographed,
collection of the artist.
(Photograph courtesy of
Joseph Fischer.)

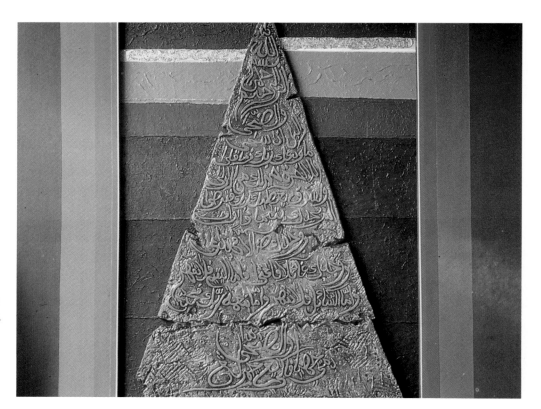

15. A. D. Pirous, *For the Sake of the Sparkling Morning Light*, 1982, gold and acrylic on fibreglass, hardboard, and canvas, 160 × 200 cm, collection of the artist. (Photograph courtesy of the artist.)

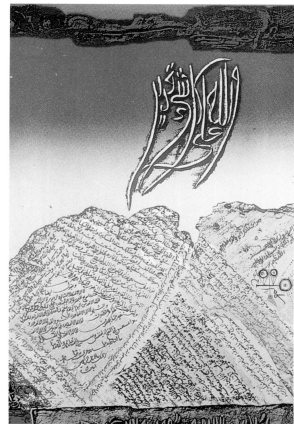

16. A. D. Pirous, *Prayer XII*, 1981, serigraphy, 86 × 56 cm. (Photograph courtesy of the artist.)

17. Srihadi Sudarsono, *Alif Lam Mim—Allah Who Knows All*, 1991, oil on canvas, 130 × 200 cm, private collection. (Photograph courtesy of the artist.)

18. Bambang Priyadi, *There is No God but Allah*, 1987, oil on canvas, 110 × 130 cm, when photographed, collection of the artist. (Photograph Astri Wright.)

19. Amri Yahya, Untitled, 1988,
batik-painting, 36 × 36 cm,
when photographed,
collection of the artist.
(Photograph Astri Wright.)

20. Agus Ismoyo/Nia Fliam,
Untitled, 1988, batik-
painting, 62 × 45 cm, when
photographed, collection of
the artists. (Photograph
Astri Wright.)

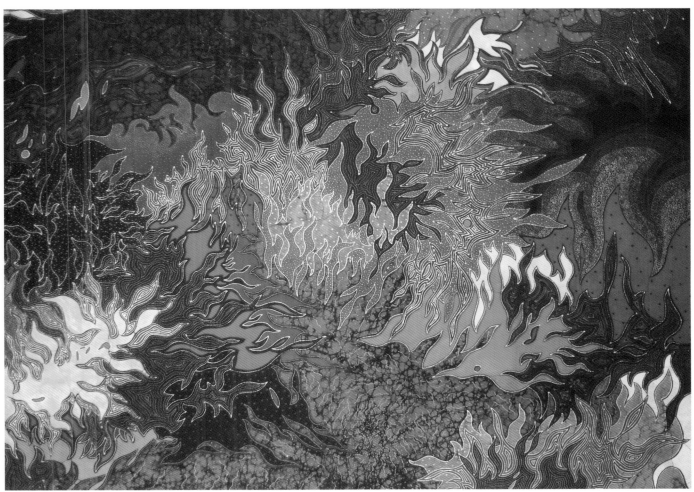

21. Agus Ismoyo/Nia Fliam, *Fire*,
 1988, batik-painting,
 90 × 120 cm, collection of
 Astri Wright. (Photograph
 Astri Wright.)

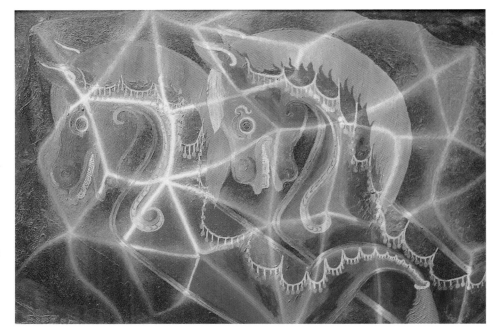

22. Salim Widardjo, *Spirit of the
 Hobby-horse*, 1975, oil on
 canvas, 60 × 90 cm, when
 photographed, collection of
 the artist. (Photograph Astri
 Wright.)

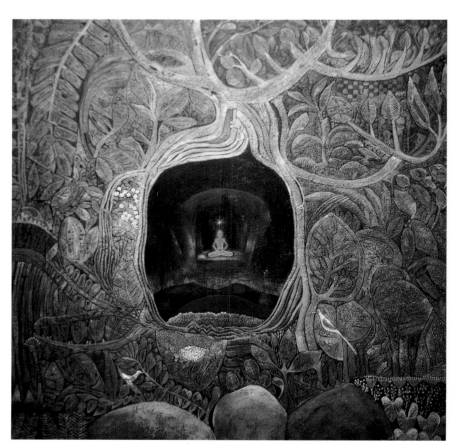

23. Widayat, *Meditating*, 1988,
 oil on canvas, 150 × 150 cm,
 when photographed,
 collection of the artist.
 (Photograph Astri Wright.)

24. Nindityo Adipurnomo, *The
 Cyclical Return of the
 Commemoration of the
 Dead*, 1990, oil on canvases
 and wood, 112 × 102 cm,
 collection of the artist.
 (Photograph courtesy of the
 artist.)

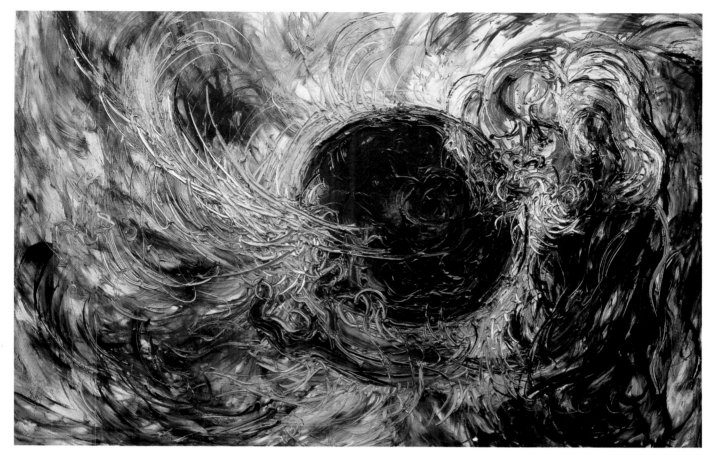

25. Affandi, *Solar Eclipse*, 1983, oil on canvas, 137 × 196 cm, when photographed, collection of the artist. (Photograph Astri Wright.)

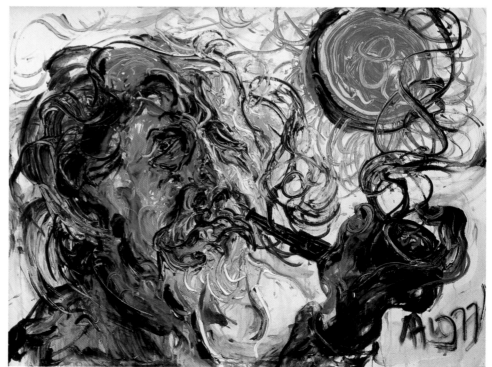

26. Affandi, *Self-portrait with Pipe*, 1977, oil on canvas, 99 × 125 cm, when photographed, collection of the artist. (Photograph Astri Wright.)

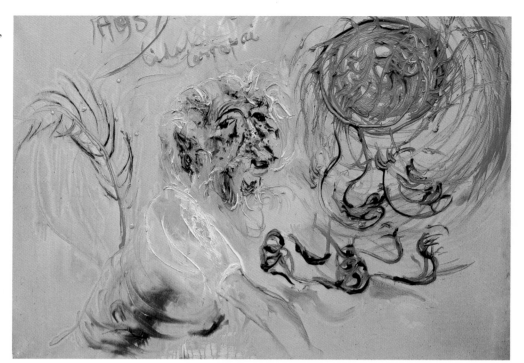

27. Affandi, *Unsuccessful*, 1987,
 oil on canvas, 100 × 130 cm,
 when photographed,
 collection of the artist.
 (Photograph Astri Wright.)

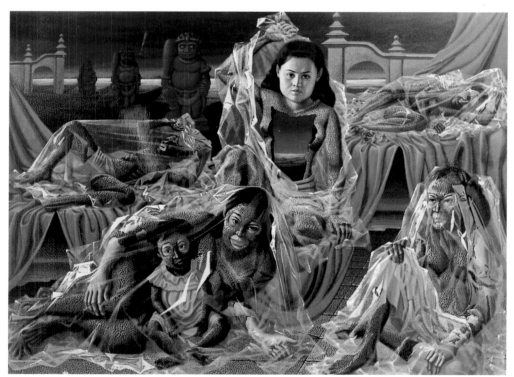

28. Effendi, *Plasticization*, 1991,
 oil on canvas, 110 × 150 cm,
 private collection.
 (Photograph courtesy of the
 artist.)

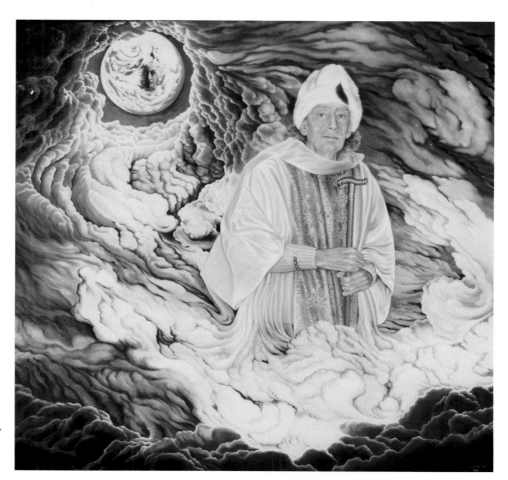

29. Lucia Hartini, *Inside Salvador Dali's Imagination*, 1990, oil on canvas, 145 × 145 cm. (Photograph courtesy of the artist.)

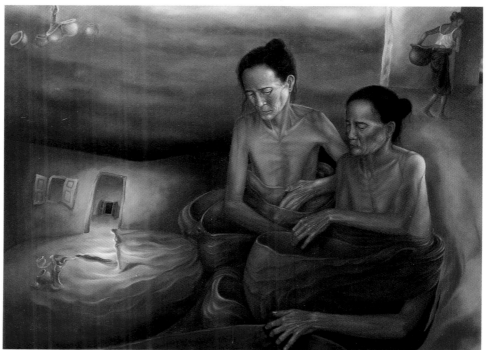

30. Ivan Sagito, *Figures Searching and Digging within Themselves*, 1987, oil on canvas, 100 × 127 cm. (Photograph courtesy of the artist.)

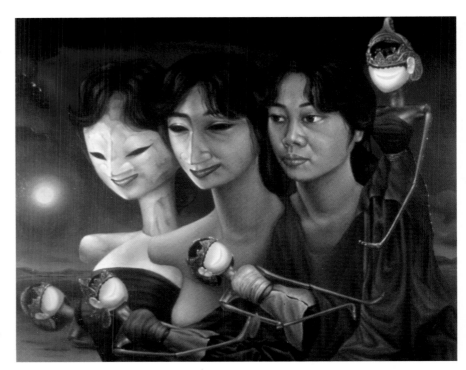

31. Ivan Sagito, *Metamorphosis in the Image of Transience*, 1987, oil on canvas, 50 × 60 cm, collection of the artist. (Photograph Astri Wright.)

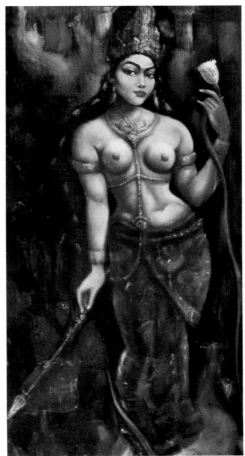

32. Agus Djaya, *Nyai Roro Kidul*, *c*.mid-1950s, oil on canvas, 183 × 93 cm. (Sukarno Collection, Vol. IV, No. 5.)

69. Mochtar Apin, *Batik Variant*, 1987, acrylic on canvas, 130 × 130 cm, private collection. (Photograph courtesy of the artist.)

filled with surging movement. In general, according to the artists, the theme of the interplay between fire and water, and the delicate balance that allows them to work together, is central to their work.

Fire (Colour Plate 21) is dense in a different way: rather than attempt to depict burning flames, it is more conceptual and speaks to the nature of fire as symbol. Flickering, sparking, licking, darting flame-like shapes fill the work with hues of red, mauve, ochre, and yellow against darker areas of brown and indigo, all interlocking as negative–positive forms so that no 'empty' background space exists; each part of the two-dimensional design is a complete and

equal statement in itself. The surface treatment of each body of flame is different: some are delineated with repeated, concentric, or dotted lines, other areas are dotted with large, medium, or small points; some are in contrasting colours, others in shades of the same colour, yet others are crackled. The work is a display of the variety of ways a surface can be treated, and many of the techniques used are traditional ones.

The choice of water as the subject of some of their work (fecundity; unifying the polarities, coming as it does from the heavens to penetrate the earth, producing life) and of fire as the subject of this

is the colour of balance, equilibrium; violet is the colour of compatibility (as between partners or lovers); yellow is the colour of love, and when it merges with green—the colour of the divine; the greenish-yellow that results represents divine love.

In ISNIA's art can be seen applied a notion of self similar to the idea in Javanese mysticism of a soul or spirit, separated from but journeying towards reintegration with the absolute, universal soul. In this perspective, the making of a work of art becomes equivalent to the mystical journey. The artist attempts to overcome the limitations of the individual self through meditating on and manipulating the materials, uniting mind with action, tools, and materials. Transforming matter becomes a metaphor for transforming the soul. Working with another artist on every step of a long and complex process, mind is united with mind, a metaphor for overcoming the illusion of separation between individuals.

Ismoyo's father, a local guru in Yogyakarta, whose mantle Ismoyo has been taught since boyhood he will inherit some day, says that in *kejawen* human beings are ranked into five levels of spiritual attainment. The second highest level is held by artists.[35] Artists are

70. Fadjar Sidik, *Like Lurik Cloth: Like a Mountain*, 1990, oil on canvas, 90 × 70 cm, collection of the artist. (Photograph courtesy of the artist.)

predominantly red work, illustrate the artists' preoccupation with *kejawen* symbolism. On the most basic level, according to Ismoyo, fire and the colour red represent youth, the passions, desire for wealth, and madness. It represents the earthly, material dimension. But fire also consumes earthly matter, transforming and conveying it into the ethereal.

In addition to this interpretation of red and the scheme of colour symbolism referred to above, other colours were interpreted, as following, by Ismoyo: blue

[35]From a hand-out prepared for the Prakarti Foundation, Yogyakarta, October 1987. Benedict Anderson has pointed out to me that there is no mention of artists as a separate or special group in traditional Javanese mystical literature; this is probably, therefore, a recent rewriting of older ideas. Rather than invalidating the point, this only makes the inclusion of artists into Javanese cosmology all the more interesting, illustrating that it is not based on a static formula. The call on 'tradition' is a commonly performed claim to legitimacy. In this instance, the high status given to artists may reflect Ismoyo's father's preparing his son as his legitimate heir to his spiritual following, or it may reflect aspects of *kejawen* that have not been elaborated upon in the sketchy literature that does exist.

71. Nia Fliam and Agus Ismoyo, 1988. (Photograph Astri Wright.)

perceived as people whose gift of seeing goes beyond the world of appearances; artists are people whose faculty of sight signifies insight.

Although many cited mysticism as a source of inspiration, only a few painters I encountered in Java were as active in practising *kejawen* techniques as Ismoyo (Colour Plate 22).[36] Whether Muslims, Protestants, or Catholics, many older as well as younger artists none the less draw on ideas and symbols rooted in the cultural matrix in which Javanese mysticism plays a central role.

With the varying depths of personal involvement and degrees to which mystical ideas are accepted or rejected by the younger generations of artists, it is commonly known that even the form rejection takes is shaped by what is being rejected. Moreover, since Javanese mysticism still flourishes as a part of Javanese culture, some knowledge of it is clearly essential to any scholar of Javanese art, also the modern.

[36]The most extreme version I heard of a painter-mystic was of a man living in or near Jakarta, who could only paint when naked on an island off the coast. When inspired, it was told, he would throw off his clothes, jump in a row-boat, and go to the island to paint. Naturally, I could not find out the name or whereabouts of this painter and it is impossible to say how many feathers originated this particular chicken [cf. Norwegian proverb: 'The story about the five feathers that became two chickens']. The point is, again, the way the Indonesian imagination works in regard to the image of artists.

4　The Syncretic Artist

72. Mulyadi W., *Mother and Child*, 1985, oil on canvas, 85 × 85 cm, collection of Balai Seni Rupa. (Photograph courtesy of the artist.)

ONE of the characteristics of twentieth-century Balinese painting is its crowded quality: every inch is filled with vegetable, mineral, animal, and human forms, usually with no governing overall perspective that gives prominence to one part of the painting at the expense of others. This tendency to fill a surface completely with decorative, geometric, or representational elements has, by some Western scholars, been negatively described as a *horror vacui* (fear of emptiness) characteristic of folk and indigenous cultures (the latter generally referred to by the same authors as 'primitive'). It would, it seems, be more accurate to state this formal and aesthetic principle more positively, as a love for denseness or lushness, or more neutrally, as an urge to visualize a richness of vibrating, pulsating life and growth, a feeling that has been associated with animism but which can be discussed in more complex terms that allow greater sophistication to the art work, the culture concerned, as well as the analysis (for example, Focillon, 1989). This quality can be seen in many, if not most, of the arts throughout Indonesia, tribal and traditional, rural and courtly. It also characterizes much modern Indonesian painting. The taste for the elaborately decorated two-dimensional surface has led to an abundance of art works in which the decorative quality dominates and the subject-matter becomes secondary or is uncomplicated and sweet (Plate 72). Women, children, and goddesses are frequent subjects. Another popular school of decorative painting depicts village life as abundantly harmonious and fertile: Suhadi's work (Plate 73) is representative of the best in

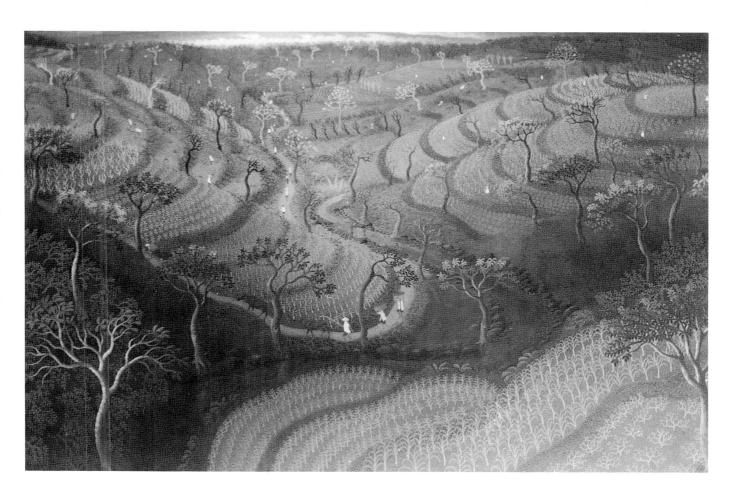

73. Suhadi, *Fertile Land*, 1980,
oil on canvas, 95 × 145 cm,
collection of Neka Museum.
(Photograph Astri Wright.)

this style: every detail in a generous
natural world that has been agriculturally
shaped to perfection stands out in
ordered clarity, mirroring the peaceful
ordering of the universe.

Another quality which has been cited
as characteristic of Javanese and the
larger sphere of Indonesian cultures is
syncretism. Claire Holt cites visual forms
used in Indonesian megalithic cultures
which re-emerge in Candi Sukuh and
Candi Tjeta (fifteenth century,
Central Java) as historical evidence of the
process of syncretism, the way Indic and
other religious systems were
'Indonesianized'. Examples are the
pyramid, the pylon, and the obelisk as
well as ancient symbols such as lizard
and toad which relate to fertility, magic,

and the pursuit of immortality (Holt,
1967: 30–3, 35). Another example cited
is the overlapping and fusion of Shaivaite
and Buddhist cults in East Java from the
tenth century on (Holt, 1967: 68, 80).
Geertz defines Javanese village culture
and religion as 'a balanced integration of
animistic, Hinduistic, and Islamic
elements, a basic Javanese syncretism
which is the island's true folk tradition,
the basic substratum of its civilization ...'
(1960: 5).[1] Such processes of adaptation

[1]There is evidence of attempts at controlling this
tendency towards tolerance and inclusiveness in the
New Order. In *History of the National Struggle*, a
textbook used in national primary school
education, a series of questions with the correct
answers according to the *Pancasila* are given. To the

74. Widayat, 1988. (Photograph Astri Wright.)

After Affandi, Widayat is among the best documented of modern Indonesian painters (Sudarmadji, 1985; Kusnadi, 1987; Subroto and Surisman, 1988). Widayat is one of the most productive Indonesian painters. No longer seeking new themes or modes of expression, he—like Affandi and Hendra and many other senior artists—repeats old themes in slightly altered compositions, and is a favourite among collectors.[2]

No modern Indonesian painter has given so much canvas space to the image of the tree, the forest, and the garden as Widayat; few have persisted so consistently in modern media in depicting the crowded and organically alive universe of the ancestors, with references to Islam, the Old Testament, and Buddhism, giving equal respect and presence in turn to each. Widayat has taken the traditional Indonesian principle of repetition further than most, applying it to motifs like fish, birds, vegetation, masks, and human beings, without losing the underlying feeling of an intense personalized processing of meaning and form which so much Indonesian decorative painting lacks.

Widayat is inspired by nature in its myriad forms. These he treats like magical signs, to be repeated like a mantra, creating decorative rhythms that pulsate across the canvas. As in Chinese landscape paintings, humans never dominate Widayat's work. When they do appear, they are integrated into their environment, existing in the half-light of archaic time, myth, and legend; they are the conveyers of a story, timeless lesson, or act. Even in those canvases where people are the main focus, they emerge from a background which is painted in similar hues. When the title points to a

and assimilation of foreign elements, forging them into a personally and culturally unique idiom, are evident also in the work of contemporary Indonesian painters.

Widayat and the Magic Universe

The art of Widayat (b. 1923) (Plate 74), who lists Islam as his religion, exemplifies both the formal 'crowding' and the syncretic approach to religious imagery.

question 'Can we embrace two religions?', the correct answer cited is 'No' (Leigh, 1992: 263).

[2]When I visited him in March 1991, Widayat had just opened an exhibition of thirty works in Jakarta, and a second exhibition of fifty new works which he was working on was scheduled to open in Jakarta the following November.

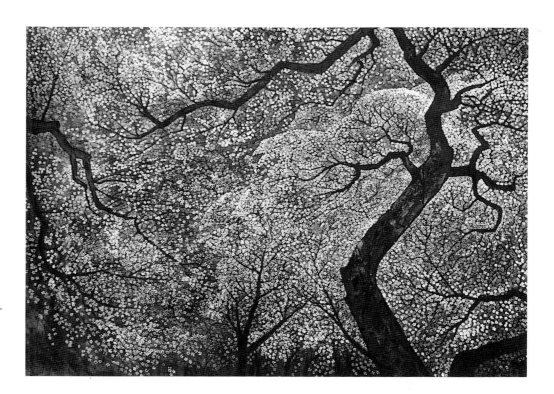

75. Widayat, *Sakura*, 1981, oil on canvas, 143 × 145 cm, when photographed, collection of the artist. (Photograph Astri Wright.)

vernacular theme, such as *Going to Market* or *Watching Sekaten*,[3] there is an existential dimension to the work: the people's progress represents the life journey, their faces marked with questions, insecurity, or pain. This quality is acutely present in a work like *Vietnamese Refugees Fleeing* (reproduced in Sudarmadji, 1985: 33, 36, 37).

'Mass' is a key concept in Widayat's work. In the painting of a Japanese plum tree in bloom (Plate 75), the sheer number of individually painted flowers is overwhelming, yet this mass, which all too easily might have become too sweet, is firmly held in place by the dark, jagged calligraphic lines of the trunk and branches. In the case of *Herd of Ducks* (1981), the exuberance of white ducks heading across the canvas from right to left against a brown ground has no such mediating or organizing element: the mass is undifferentiated, all parts of the canvas are equal: from a distance this gives the effect of a rough tweed weave. This also characterizes his portrait of Affandi, in which a small mask-like icon of the aged painter's face is repeated across the canvas a hundred times. One of the most unified mass images in Widayat's *oeuvre* is the drawing that marks the beginning and end of the text in Sudarmadji's book entitled *Widayat— Pelukis Dekora Magis Indonesia* [Widayat—Indonesia's Magic-Decorative Painter]. Repeating the first image in the book at the very end, in the same way as in a *wayang* performance, demonstrates the Indonesian penchant for marking places of transition, with special emphasis on beginning and end (1985: 8, 54). Here, a crowd of people milling about are drawn in narrow outline, each form filled in with close parallel hatching. The image of the crowd is so dense that no space is left between the overlapping

[3]Sekaten is an annual night market festival and ceremony on Mohammed's birthday held outside and within the Solo and Yogyakarta courts.

people; they are like a single multi-faced, many-eyed entity.

Born in Central Java, as a young man Widayat worked in Bandung as a commercial painter. He sold 'pretty landscapes' from door to door or on the pavements with his teacher, a postal worker who painted in his spare time. Between 1945 and 1949, Widayat did intelligence work in Sumatra. Here, he also made propaganda posters for the Republican Army and designed scenography for photographic studios and weddings. Widayat was still in Sumatra when he read about the establishment of ASRI in Yogyakarta in 1950 and immediately returned to enrol. At ASRI he studied with the first batch of art students under Hendra Gunawan and Trubus, painting in a realistic manner (Spanjaard, 1988: 115). In 1954, Widayat, along with G. Sidharta and a few other students, founded Pelukis Indonesia Muda (Young Indonesian Painters), the first student *sanggar* in Yogya (Sudarmadji, 1985: 14). In late 1954, Widayat was hired as a teacher at ASRI, where he taught until 1988, well liked by his students for his active involvement with their work and his forthright style in giving critiques (unusual in exceedingly polite Java). In 1972, the government awarded him the 'Anugerah Seni', the highest award of artistic merit, and in 1974, his painting entitled *Family* was selected as one of the best works at the first National Painting Biennial (Sudarmadji, 1985: 15).

Widayat's exposure to both folk and primitive art, combined with his memories of living in the Sumatran jungles, resulted in his work becoming more decorative in 1959 (Spanjaard, 1988: 116). In these early works we find forms that have direct forebears in the motifs on a wide range of indigenous arts, from prehistoric times up to the present, from the kettledrums to the textiles found around the archipelago.

Motifs such as zigzags, lines of repeated triangles, dots, circles, stylized birds, and plants, are all drawn in a strong and simple linear manner.

That decorative in Indonesia need not be perceived as superficial or 'designish' is illustrated in Widayat's comments:

A painting of quality does not merely show off its surface beauty; what is important is that it reveals the depth of its content ... it must be filled with meaning. A painting must speak of the mental and spiritual dimension, the restlessness and experience of life, the realm of aesthetic and intellectual ideals, and so on. According to Fadjar Sidik this is what in Chinese is called *chi* and, according to Suteja Neka, what in Javanese is called *taksu*. Just like a kris made by a famous priest who has invisible powers.... This is the kind of painting I am talking about—painting which rather than lightweight is heavy with content, which causes addiction and makes us drunk.... I am a great admirer of primitive art, which is always loaded with magical and meaningful elements. In my paintings I want to incorporate such elements ... and if an art critic from the Philippines calls my work 'magic-decorative', I fully agree with such a description (Sudarmadji, 1985: 47; author's translation).

Widayat's most decorative work is that with fish/underwater themes or with garden/forest themes, such as in *Flora and Fauna* (1980) or *Adam–Eve and the Animals* (Plate 76). In this painting, a large tree dominates the scene. The roots extend into the bottom half of the canvas and the branches' wide embrace dominates the upper half. Each of the tree's leaves is drawn individually, the smaller ones stylized like the dots you see on batik, with a decorative row of larger leaves painted in red emerging from the tip of each branch, set against the mass of foliage. A feeling of depth behind the tree is created by a gradual 'hazing over', created by bluer tones and a lessening in the sharpness of outlines.

The small details in the foreground capture our eye after we have finished

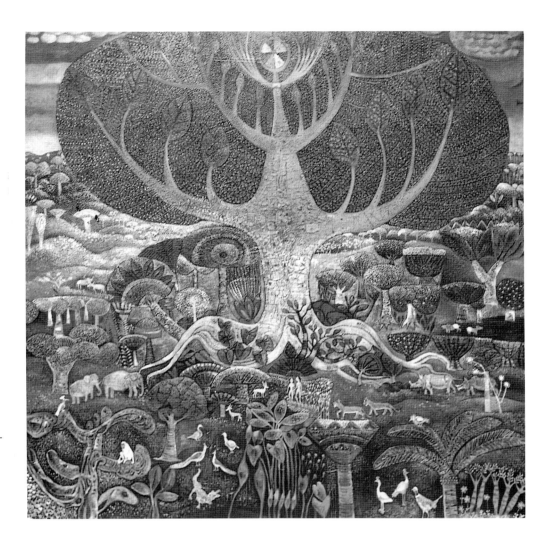

76. Widayat, *Adam–Eve and the Animals*, 1988, oil on canvas, 138 × 138 cm, when photographed, collection of the artist. (Photograph Astri Wright.)

with the tree: here, Adam and Eve stroll along, twin-like, their delicate bodies naked, seemingly crowned by a fan-shaped plant just behind them. Around them is an array of animals, mostly in pairs—deer, elephants, tigers, rhinoceroses, herons, peacocks, crocodiles, and monkeys. All coexist peacefully in a landscape of the most fantastical trees, giant flowers, or vegetables. Besides earth tones, there are muted reds, greens, and blues; this painting is less monochromatic than many of Widayat's works.

The tree-trunk constitutes the most stylized and 'empty' part of the canvas,

giving a sense of vertical thrust which brings to mind the axial image of pillar/*lingga*/mountain. Further inspiring such a reading, which refers to Hindu–Buddhist iconography, is the form in the top of the tree which resembles a multicoloured diamond, embraced by candelabra-like branches. The jewel is a symbol which variously occurs in Buddhist and Hindu art and literature, which may refer to sharpness and brilliance of mind, the principle of divine or complete knowledge, and so on. The presence of this jewel in the main tree in the Garden of Eden inspires a reading quite different than that embedded in the

numerous renditions of the same scene by European artists. Apples and snakes are completely absent, as is any sense of the sinister or forbidden quality of knowledge so prominent in the biblical story and its visualizations. In Widayat's painting, knowledge is depicted as something of the highest beauty and of a lasting rather than destructive nature. The fact that the artist has chosen to depict the couple and the garden in perfect harmony before the fall, rather than the intrigue and gender war in the presence of evil that infuse European master works of the Adam and Eve parable, is significant and points to different perceptions about nature, sin, and knowledge.

Asceticism and meditation are motifs which have preoccupied Widayat for decades, as witnessed by a small woodblock print in Chinese-inspired style called *Hermit* (Plate 77). The sight of Widayat seated cross-legged on a table, facing the canvas propped against the wall, conjures up the idea that he might indeed see painting itself as a form of meditation. Like Bodhidharma facing the wall in meditation, Widayat works on his painting from a stationary position, slowly and methodically adding detail after detail. For long periods his concentration is unbroken by the physical movement to and fro and the constant change in perspective that painting in a standing position allows. Mella Jaarsma, a Dutch artist living in Yogyakarta, commented on this difference: 'When I came here I saw Nashar painting while squatting, and I decided to try it. I actually think you concentrate better in that position—it gives the chance for better self-reflection' (Wright, 1990c: 4).

In *Meditating* (Colour Plate 23), painted thirty years after *Hermit*, the imagery has achieved an idiosyncratically Javanese synthesis. The tree of life motif merges with the motif of the mountain, in an unusually clearly conceived depiction of the natural fertility cum spiritual transcendence symbolism. The roots of the tree form a dark hollow, deep within which an emaciated naked figure can be seen in meditation posture, illumined by a brilliant star shining above his head. Surrounding this womb-like cave is a typical Widayat forest, thriving down to the last of its myriad details, including a male and female bird. Every form bears witness to the fertility of Widayat's imaginative world. The cluster of red and white flowers directly below the cave— the only instance of bright, pure colour

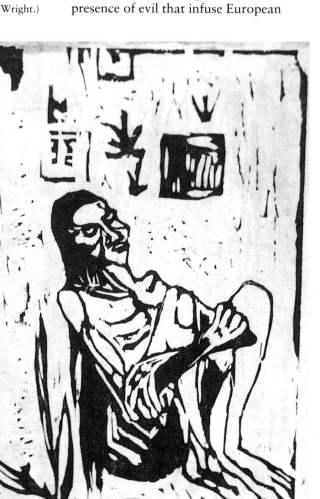

77. Widayat, *Hermit*, 1957, woodblock print on paper, when photographed, collection of the artist. (Photograph Astri Wright.)

on the canvas apart from the star and birds—can be read as his tribute to the homeland which supports his art, both materially and spiritually.[4]

[4]The Indonesian flag is red and white and the colours are frequently flown. In the hands of someone who personally fought to bring about the birth of his nation, as Widayat did, this must be read differently from the nationalist or propagandist use of flag colours by governments.

78. Ninditjo Adipurnomo, 1988. (Photograph Astri Wright.)

Ninditjo Adipurnomo: Death, Dance, and Art

Ninditjo Adipurnomo (b. 1961) (Plate 78), from Semarang, north Central Java, is a younger generation artist who exhibits a syncretic approach in his life and work. Raised a Catholic, Ninditjo was close to one of his parish priests, who taught him about Western thought and supported his pursuit of an artistic career, strengthening his desire for cross-cultural exploration.

Ninditjo's interest in psychology, spirituality, and the origin and function of symbols has caused him to continuously examine his own experience in light of his readings (see Colour Plate 13). In the paper which every student at ISI has to write about their theory of creativity, Ninditjo compares Western and Javanese ideas about creativity, citing among others C. G. Jung and Mircea Eliade.

Ninditjo's understanding of himself and his culture was deepened in 1986–7 when he studied at the National Academy of Fine Arts in Amsterdam. Here, Ninditjo's longing for his homeland caused him to formulate ways in which he felt Indonesian culture was different from Dutch or European. One quality he reminisced about was the physical closeness of Indonesian life: 'Life in Indonesia consists in intimate relations, for example, how a mother lovingly carries her baby everywhere, tied to her body with a piece of cloth. In the Netherlands, a mother walks behind the baby-carriage. [In my art, I want to] create a world within the world, by way of a symbolic language, in which the unity and connection between all things becomes clear …' (Spanjaard, 1987).

The coldness of the climate and, as they see it, in interpersonal relations, are recurrent themes among Indonesian artists who have studied abroad—the inverse of what Europeans often

experience as a frustrating lack of privacy when living in Indonesia. M. Sulebar Soekarman, a Jakarta-based abstract painter and teacher at the Jakarta Art Institute, describes this experience as well. On the one hand, his two years in the Netherlands were liberating for him and his art. On the other hand, through a particular experience that parallels that of A. D. Pirous in New York, Sulebar came to see fully how different he was from Europeans, in fact, how 'Indonesian' he was:

It was so cold during the winter and the scholarship was so small, I didn't have money to buy warm clothes, so I started spending my days in museums with my drawing-pad. Then one day I had a big shock: in the ethnographic museum in Rotterdam, I stood before an exhibition that seemed so familiar, yet I didn't recognize it at first—then I realized it was classical sculpture from Java! And in the next room I saw carvings from Bali, and in the next, sculptures and artefacts from Kalimantan, Sulawesi, and Irian Jaya! It was as if these things were part of me, speaking to me from within, saying: 'We are you and you are us; neither of us belong here; we belong under a different sky, where the sun is strong and the people are warm and never speak without considering the other person's feelings first....[5]

Nindityo, who had met Dutch art student Mella Jaarsma the previous year in Yogyakarta, found in the Netherlands an adoptive family in hers. Thus, his outer experience was not as lonely or hard as the stay abroad is for many Indonesians. On a psychological level, however, it was none the less intense and

Nindityo's art changed dramatically during his time in the Netherlands.

Before I went to Holland, I painted the way we were taught at school, learning about colour, composition, and technique. I painted with my head only. In Holland everything was so different—the weather, the food, the people, the light—everything!—that I started seeing myself and where I came from with new eyes. And this influenced my painting. Now I feel like I am painting from me, from my heart, and from my subconscious.

Having been brought up a Catholic, Nindityo had not thought about the problem of imported religious cultures until he came to Holland:

I realized that a Javanese Catholic is different from Catholics elsewhere, because we have internalized Javanese culture since childhood. We've gone through all the Javanese ceremonies—from the seventh-month ceremony when the woman is pregnant, to the seventh-day ceremony after birth; the feet-touching-the-ground ceremony, the circumcision ceremony, and the forty day mourning period after someone dies. So, in addition to our faith in God and Jesus and Mary, the Javanese ceremonies become a deep part of us. This goes for Javanese mythology too....

On the other hand, Nindityo felt the need to search towards a Western-style individualism to create his own synthesis with his native culture. Protesting the process by which Javanese individuals' emotions are suppressed, Nindityo writes: 'The clods of emotions that get buried in this way are the basic force that pushes me to dig deeply into myself and vomit up individual, personal values in my art.'

Up to 1985, Nindityo's student work in Yogyakarta had been composed of small-scale decorative images of people and houses, line-drawings filled in with colour inspired by his teacher Widayat. In the Netherlands, Nindityo, for the first time, had the chance to see the masters of

[5]Unless otherwise specified, my quotes come from interviews, conversations, or letters exchanged with the artists in the period 1988–91.

Not only artists experienced, for the first time, their 'Indonesianness' during prolonged stays abroad; noted nationalist and revolutionary statesman Sutan Sjahrir reports a similar experience in his *Out of Exile*, quoted in Legge, 1972: 43.

European and American art. He developed an affinity for the work of Karl Appel, Lucebert, Constant, and Jorn (members of the Cobra group) and deepened his old liking for artists like Kandinsky, Klee, Miro, and Chagall.[6] What Nindityo liked about their work was their spontaneity and honesty. His own work became increasingly large-scale, focusing on only a few figures. Colour began to play a more important role than line in his work. Subject-wise, Nindityo was no longer as involved with the outer world. It seems that his serious involvement with themes and figures from Javanese mythology, such as Ganesha or Bima, began during this time (Spanjaard, 1987).

Since then, Nindityo's paintings have developed into dynamic abstract works, with forms that, upon closer investigation, yield interpretations of a personal-symbolic nature. The large canvases are generously covered with colours like blue-grey, dark ochre, sea green, orange-red, blue-red, and black, occasionally cut through with a primary red or yellow, all laid on in thick impasto with the palette knife. An original development has been the addition of carved and painted wooden beams, either as asymmetrical frames or, more often, as separate sculptural pieces that in different ways complement and enlarge on the presence and meaning of the painted canvas.

When Nindityo Adipurnomo returned to Indonesia in 1987, Mella Jaarsma returned with him as his wife. Since the founding of their gallery in February 1988, they have played a central role among the young artists in Yogyakarta. CEMETI Gallery is dedicated to showing the work of talented younger Indonesian artists. The owners also exhibit young Western artists who have some connection with Indonesia. With monthly solo exhibitions eleven months out of the year, CEMETI plays an important role in Yogyakarta's art world, where only a handful of places occasionally exhibit works of modern art and where it is difficult for younger artists with no previous exhibition experience to be shown. To exhibit locally in CEMETI, a gallery run on a very low budget with a good public relations network and a mailing list that reaches across the nation, can be a stepping-stone to securing gallery space and sponsors in Jakarta, where national recognition and the larger art market beckon. Certain interrelations in art and thought exist among the young artists active around CEMETI, which, besides Mella and Nindityo, include Eddie Hara, Heri Dono, Iwan Koeswanna, and others. In their works, themes of mythology and folklore mix with more universal ideas about the pure art of children and commercial arts, such as cartoons (Plate 79).

Throughout 1988, many of Nindityo's semi-abstract paintings bore titles that referred to mythological characters and philosophical ideas from the Hindu-Javanese epics. Ganesha appeared frequently both in his drawings and in his paintings. Nindityo said that he identified with Ganesha in his role as protector, a role which underscores the solidarity and connectedness which he cherishes as part of interpersonal and neighbourhood relations in Indonesia. The figure of Bima—the second and the strongest of the five Pandawa princes from the *Mahabharata* epic, to whom ancient pre-Hindu cults are believed to have transferred their worship after the arrival of Hinduism (Stutterheim, 1956: 105–43)—also figures in Nindityo's work from this time. The story of Bima's dangerous descent into the world ocean

[6]The Indonesian artists cited in my 1988 questionnaire as his favourites are Nashar, an eccentric abstract painter in Jakarta, and Iwan Koeswanna, one of the young artists of the CEMETI group.

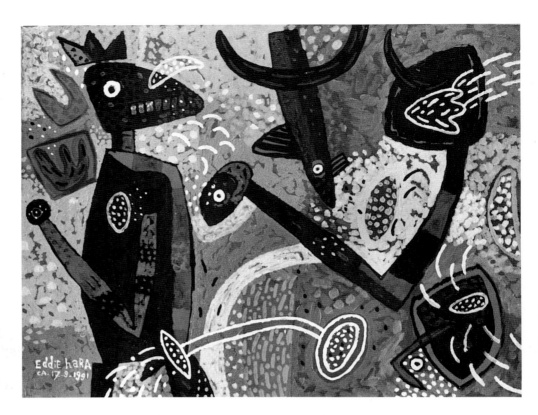

79. Eddie Hara, *His Fish, His Snake, and Himself*, 1991, acrylic on canvas, 46.0 × 60.5 cm. (Photograph courtesy of the artist.)

in search of self-knowledge inspired *Bima = Dewaruci* (Plate 80).[7] In the thick swirls of colour which sweep around the canvas like a hurricane or wave, we glimpse here a form reminiscent of Bima's upward-curving head-dress and there a form like his pointed finger-claw extended in front of his body, as if to balance himself during his turbulent descent into the oceans. Half a foot under the painting hangs a carved beam, painted grey and white. A single line in the painting is picked up again by a carved line on the beam, causing our eyes to connect the two across the void of the wall. In an attempt to fuse the three-dimensional beam into a single whole with the painting, Ninditho uses the space of the wall as an integral part of the composition.

Though interested in Hindu–Buddhist thought and Javanese mythology, Ninditho does not intend that his works be the sum of separate, conventionally rooted symbols. Thus, Ganesha and Bima stand, in part, for what they mean in the traditional mythology, in part for personal and abstract qualities he cannot name and which could not become manifest without form.

Ninditho is always observing himself and the ways in which his activities, interests, and ideas intersect in his art: 'My work consists in playing with forms that arise from an idea or activity which is obsessing me at the moment. Right now I am fanatic about Javanese dance, which I study under a teacher three times a week. So the forms of the kris and the *ukel*[8] appear in my work, almost of their

[7]For an outline of the story and an interpretation of it as a symbol for *semadi* (meditation), see Mangkunegara, 1957: 17–18.

[8]The kris is the ceremonial-magical serpentine-blade dagger, owned by men of achievement, royalty, and nobility, and wielded by the classical

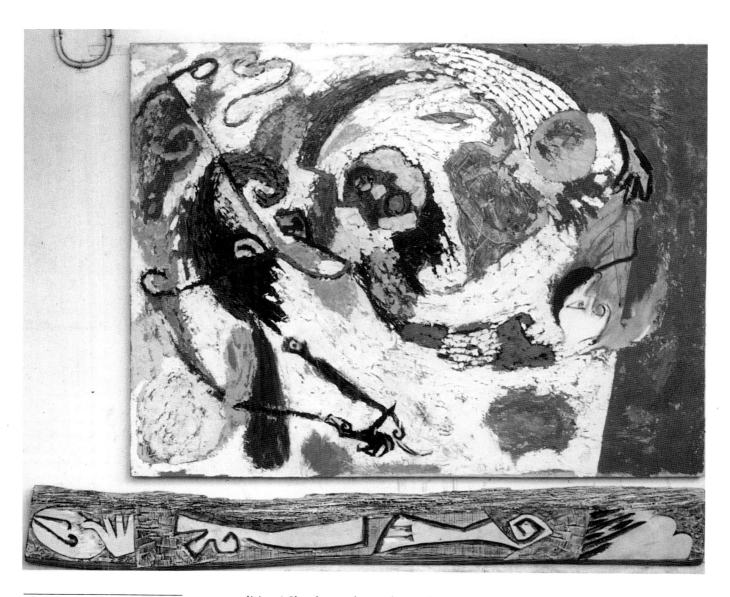

80. Nindityo Adipurnomo, *Bima = Dewaruci*, 1988, oil on canvas and wood, 155 × 120 cm, when photographed, collection of the artist. (Photograph courtesy of the artist.)

own volition.' Slowly, studying classical Javanese dance replaced meditation exercises and a shift in his work became apparent in 1989. Conventional mythological themes became less important; dance and movement became more important, always linked—formally and symbolically—to spiritual themes.

Javanese dancer (male or female) in certain roles. The *ukel* is a small, circular movement of the hands in classical Javanese dance; it is also the name of a spiral motif in batik or on wood-carving.

Nindityo's titles increasingly reflected a preoccupation with essential insights into aspects of life, local and universal, which he felt were better represented by abstract form than by the use of mythological figures. Finally, an interest in death entered into his work, as in Mella's (Plate 81). A major turning-point in this direction came after a month-long visit with the Toradja people of Sulawesi. Fascinated with reports of local burial customs and ceremonial art, the artist couple had long wanted to travel here.

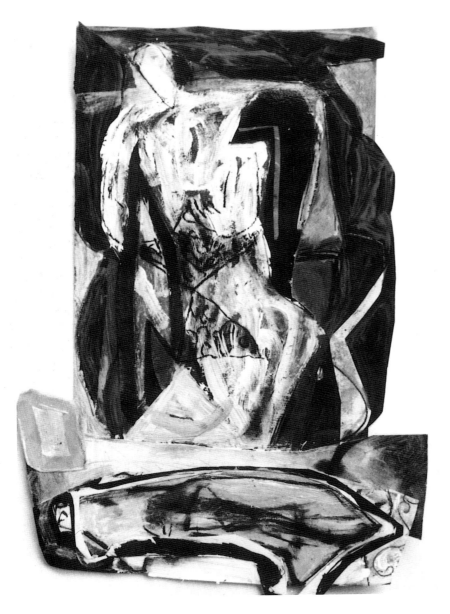

81. Mella Jaarsma, *Culture of Death*, 1989, acrylic and photograph on canvas, 150 × 100 cm. (Photograph courtesy of the artist.)

put the pieces together like they originally were constructed, in a natural way, only carving a few forms—at that moment I know exactly how the wood must be treated.... Then I let it hang for days and days, sometimes weeks, until I get a new reaction, and add something to the canvas.'

A work entitled *Worship* (Plate 82) is spurred by the experience of visiting the Toradja and confirms anew old preoccupations of Nindityo's. The work takes the old canvas and beam composition in a new direction, placing a wood construction between two canvases. Nindityo explored this more symmetrical approach in various works throughout 1989. The colours of the left canvas are darker, while the right canvas is lighter, formal qualities which can be illuminated according to Hindu symbolism in which left is considered the realm of the feminine, darkness, earth, and death and right the realm of the masculine, of light, heaven, and eternal life.[9] The curved lines associated with the feminine and the straight lines associated with the male are here present in both the canvases, which are of equal size. The space between the canvases is mediated by the crossed beams. This could be read as an integration, on the visual plane, of two essential complementary qualities. Through the mediating role of the wooden beams, crossed like an 'X', echoes the idea of separate entities interlinking, coming together, an act which symbolizes the idea of transcendence and unity. Superimposed on this train of thought is the association to a Christian frame of reference, in the shape of the St Andrew's cross.[10] In

Staying with the Toradja, Nindityo was inspired by their wood architecture and the carved wooden coffins. In their use of carved mahogany beams he discovered a point of direct affinity. Nindityo usually carves old beams of teak that he finds at a sawmill in Yogyakarta. About the aftermath of the Toradja visit he writes: 'I am now really falling in love with wood and its material character. Sometimes I am moved just to

[9]Although Nindityo does not consciously paint according to Hindu cosmological symbolism, he is familiar with such ideas through his study of meditation, mythology, and classical Javanese dance.

[10]Nindityo has also created art with Christian themes: in 1983, he carried out a commission for a

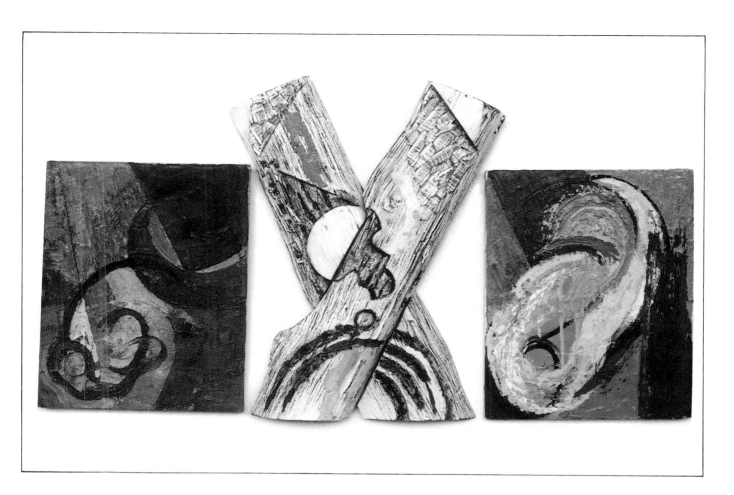

82. Nindityo Adipurnomo,
Worship, 1989, oil on
canvases and wood,
70 × 120 cm, work in
progress. (Photograph
courtesy of the artist.)

Hindu-Javanese thought, the centre is a
spatial designation which reverberates
with potential and power (Anderson,
1990b: 35–8); here, all division ceases to
exist and enters into the true state of
undifferentiated existence behind all
illusory appearances.

Another central theme in both Hindu
and Javanese thought is that of the dance.
In Indian art the cosmic dance is enacted
by Shiva, who brings all creation into
being and then threatens to destroy it if
not restrained and balanced by his female
consort—an anthropomorphic
visualization of the need to balance the

male and female principles. In the South-
East Asian archipelago, dance has been
one of the most important art forms,
probably for millennia. In Java and Bali,
it became an expression of the synthesis
of Hindu philosophy with original
animist and ancestral practices. That the
dance in Indonesia is a relevant tradition
also among modern, urban, and
internationally oriented groups is
illustrated by the fact that many well-
known painters in Indonesia are also
acclaimed as dancers: examples are
Basuki Abdullah, Nyoman Gunarsa, and
Bagong Kussudiardja. This is also evident
in some of the painters of the younger
generation, where the importance
attached to movement causes many to
break out of the frame and incorporate

mosaic in the church of St Theresia, and in 1985–8,
fourteen stained glass windows for the Krapyak
Church, both in his hometown Semarang.

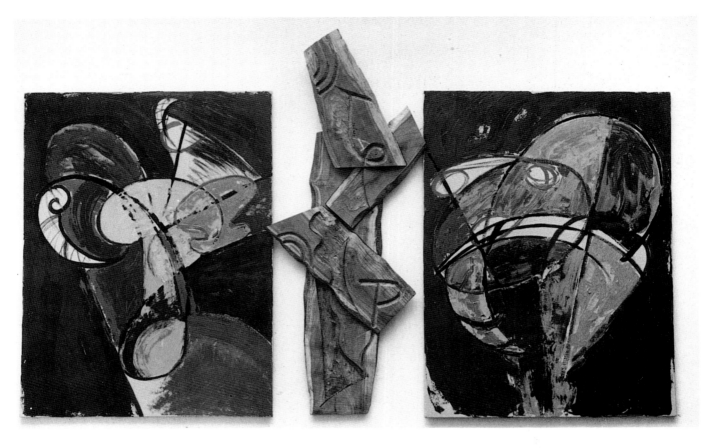

83. Nindityo Adipurnomo,
Dance, 1989–90, oil on
canvases and wood,
100 × 228 cm, work in
progress. (Photograph
courtesy of the artist.)

movement into their works in different
ways. The work of both Mella Jaarsma
and Nindityo Adipurnomo are examples
of how classical Javanese dance continues
to exert itself upon the minds of modern
artists.[11]

Although he studies classical dance,
Nindityo writes, 'I don't feel like a real
dancer, but more like a spectator who is
pretty fanatic in the sense that my eyes,
my mind and my feelings all join in

[11]The fact that it is not only acceptable but
considered admirable that artistically inclined
people 'do' sculpture, painting, dance, shadow
puppetry, etc., with no slurs of 'amateur' being
hurled at them, shows that the boundaries between
conceptual and professional categories are not as
tight in Indonesia as in the West. The 'doer' will be
judged by the result of his work, but there is no
a priori assumption that one person cannot do more
than one thing well.

watching. The Javanese female dance, so
delicate and so slow, makes me drift
away, and the magnetism of the dancer
directs my concentration towards the
centre of the earth.'

The composite painting *Dance*
(Plate 83) consists of two canvases which,
like other works, flank a central wooden
sculpture: here, parts of beams are
assembled into a dynamic form abstractly
reminiscent of the *tribhanga* ('S'-like)
posture of Indian dancers. The work
vibrates with a sense of movement not
found in Nindityo's earlier work. Though
finely balanced, these compositions of
swirling, continuous lines create a
balance quite different from earlier
paintings, which in comparison seem
quiet, centred in meditative, timeless
space, working around themes of
historically relevant religious symbols. A

84. Nindityo Adipurnomo and Mella Jaarsma, still-photograph from *Intro–Extro Variform*, 1990, performance piece with Javanese dancer. (Photograph courtesy of the artists.)

spiral is embodied the idea of return, which, as the title indicates, is one of the core ideas of the work.[12]

In these works, time, the promise of constant metamorphosis, has entered into Nindityo's *oeuvre*. Although the colours are those we have come to recognize as his own, the feeling of the work is lighter and more fluid than previously. The presence of curved, spiralling forms harks back to his earlier work, but here the associations to the trunk of Ganesha, the *ukel* of batik, or the dancer's hand movements, have been abstracted into pure form. These are set in a space of extended time, frozen in vibrating colour and line on the canvas, and echo in the carved lines of the sculpture. Memories of futurist works and of choreographic drawings of dancers' progression across the stage are evoked; Nindityo has here created an instance of art which relates both to the larger world of modern art and to his own experience.

Partaking in controlled, harmonious movement, then, is a central aspect in Nindityo's life, causing him, on the one hand, both to visually absorb and to practise dance, and on the other hand, to create visual art. All of these aspects are occasionally brought together in collaborative multimedia performances.

Intro–Extro Variform, performed in 1990 by Nindityo, Mella, and a Javanese dancer is an exploration of the relationships between moving form, light, shadow, and colour. Dressed in black and concealed behind a shield-like vertical canvas, the dancer's hands in classical Javanese poses emerge from the dark into layers of speckled and coloured light—the projection of slides of Mella's and Nindityo's paintings (Plate 84). The

related work, characteristically with a philosophical title (Colour Plate 24), has similar qualities, though Nindityo here uses the compositional device of combining three smaller canvases with a fourth sculptural piece. Not only the painted surfaces but the work as a whole is based on the form of the spiral. In the

[12]This title, in Javanese, is difficult to translate succinctly. *Putaran* means 'turning, revolving'; *apeman* means 'the ceremony when one eats *apem*', a small ritual pancake, and *ruwah* is the day when one commemorates the dead.

moving, shifting tableau is like a stained glass window come alive in four dimensions (Wright, 1990c: 22). In past performances, the two artists have danced behind a bolt of cloth, held up on either side like a screen and slowly rolled from left to right, the artists painting on it as they dance. Drawing on ideas from both *wayang* and classical dance, the Javanese sources of inspiration are clear in such performances. So are the modern, Western sources: Nindityo acknowledges an interest in Oskar Schlemmer's theatrical works, for which the artist created both choreography and scenography and himself danced and acted. However, the synthesis and feeling in Nindityo/Mella's work are quite different.

In Nindityo we meet an artist who is creating a synthesis which can only be appreciated when both local and Western traditions and meanings of art are known. Coming from an Indonesian context where many artists continue to repeat the icons of the past more or less mechanically, and others use them in their art as decorative forms devoid of original philosophical significance, Nindityo's visual language is his own. He is an artist who is preoccupied with interpreting the past only in so far as it constitutes a personally resonant living present, which is transformed into an idiom that does not ignore the potential both for tension and syntheses inherent in modern life.

5 Transition from 'Soul' to 'Psyche'

THE following two chapters begin to move away from a view of the mountain as a metaphor for a spiritual world-view, towards a view in which psychological dimensions are emphasized. Here, the mountain is seen more as a graph of society, with its patterns of social interaction and ways of perceiving power and selfhood. In the artists' lives and the works discussed here, ideas about soul and spirit are still present but with psychological overtones; ideas about the influence of social realities on individual fate and personality also play a role in these art works. In part, this is due to the impact of increased Westernization and a more advanced stage of modernization; in part to a more secularized education and a new emphasis on personal experience. Apart from Affandi, the artists discussed here belong either to the younger generation or to a small group of active and committed female artists, until recent years viewed as a marginal group among modern Indonesian artists.

Affandi: The Existentialist Self-portrait[1]

Affandi (1907?–90) is among the first Indonesian painters to become preoccupied with the human condition and to probe the depths of human emotional experience in all its diversity, from birth to death (see Chapter 7).

Variously referred to as the father of modern Indonesian painting, Indonesia's first modernist and *sang empu*, Venerable Master, Affandi (Plate 85) painted without stop, with the frenzy of a man possessed, for nearly sixty years, winning national as well as international fame, awards, and patrons.[2] Besides being firmly rooted in the local worlds of Java—West, Central, and East Java—as well as Bali, he travelled extensively, living and painting in India, the Netherlands, Italy, and the USA. Affandi always cultivated the image of a simple, unsophisticated man, driven above all by the need to paint what moved him, likening this need to the hunger the body feels when going without food for a period of time. Affandi's unusual personality and choice of vocation combined with his enigmatic but undeniable charisma to create a life which took on the stature of legend even in his own time. The widespread attention he received in the media caused people of all walks of life, urban and rural, Indonesian and foreign, to recognize his name and face and to make

[1] This chapter in part draws on essays published as Supangkat and Wright, 1990, and Wright, 1990a.

[2] Affandi is the only modern artist in South-East Asia to merit mention in the standard textbook of South-East Asian art—four sentences in the very last paragraph of the book (Rawson, 1990: 275).

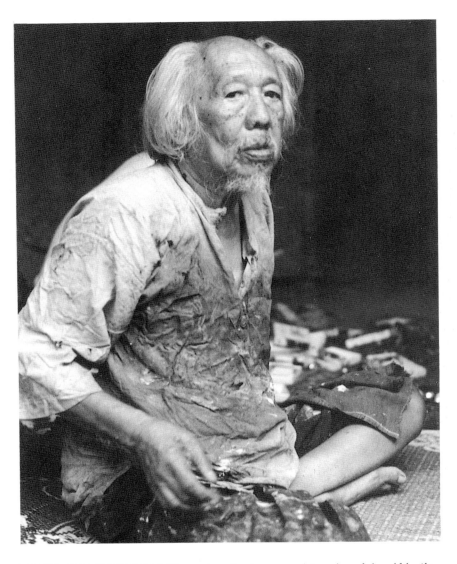

85. Affandi, late 1980s.
(Photograph courtesy of
Kartika Affandi-Köberl.)

could no longer paint much, and through
his long illness before he finally passed
away in 1990 (Plate 86).[3] Furthermore,
Affandi's emphasis on the self-portrait
and his interest in probing his own
psychological and emotional depths, set
him apart from both his contemporaries
and most Indonesian artists since—an
aspect of his work that has not
commanded much attention.

In November 1987, reclining on a
bamboo bench in the middle of the
Affandi gallery, the frail painter gave one
of his last interviews. He spoke in heavily
accented but fluent English, stroking a
few white hairs on his chin, his voice very
weak and occasionally disappearing
altogether as he chuckled soundlessly.

My first memory of painting...? Well, I was a
very small boy and it was a very, very hot day
in Cirebon.... I went to the kitchen and asked
my mother for one cent to buy ice-cream. Can
you imagine—only *one cent*!—but my mother
didn't even have one cent to give me. I could
not accept that—I got so angry, I screamed
and cried and screamed and cried, until my
mother took a bucket of cold water and threw
the water over my head!

So there I was sitting on the kitchen floor,
dripping wet ... and *then* I started to draw
with my fingers in the mud that had formed
on the dirt floor. THAT is my first memory of
painting![4]

Several of Affandi's brothers and
sisters died young. Affandi remembers
that the children used to sleep in a row;
one day he woke up to find that the
siblings on either side of him were dead
from typhoid. Feeling that he owed his

the pilgrimage to his colourful, self-built
museum in Yogyakarta.

So much has been written about
Affandi and his enormous *oeuvre* that he
will not be discussed at length here
(Sumaatmadja, 1975; Popo Iskandar,
1977; Sudarmadji, 1978; Umar and
Raka, 1987; Supangkat, 1990a).
However, no account of the 1980s can be
representative without some mention of
him as he, along with his artistic family,
continued to occupy the imagination of
the Indonesian and wider Asian art
community, even after 1987 when he

[3]To a lesser degree, the same is true of
S. Sudjojono, who died in 1986. However, I did not
have the opportunity to interview him personally or
see and photograph a representative selection of his
work from all periods of his life. Furthermore, he is
the subject of the late Sanento Yuliman's
Ph.D. dissertation (1981) which hopefully will be
published as a monograph.

[4]Where no other reference is given, quotations
are taken from an interview with Affandi in
November 1987.

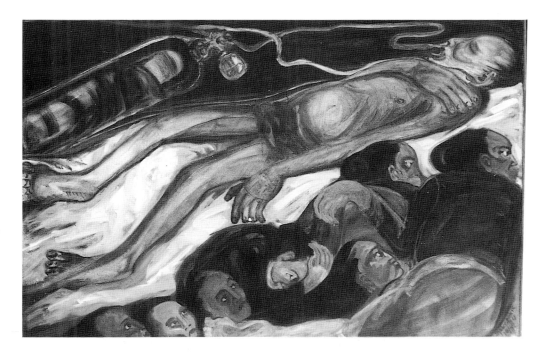

86. Djoko Pekik, *Painter at Death's Door*, 1984, oil on canvas, 98 × 140 cm, when photographed, collection of the artist. In 1990, Djoko also painted Affandi on his death-bed. (Photograph courtesy of the artist.)

own life to tenuous chance or fate, he would commission *wayang kulit* to be performed at his home on his birthday every year, as an offering and for continued protection. 'No one knows when my real birthday is, so we celebrate it whenever I feel like it!' he said. This feeling generally arose three or four times a year.

In the interview, Affandi talked about how hard it was to make a living during the Japanese Occupation and the war and, later, during the struggle for independence. Sukarno's interest in, and support of, artists had been crucial, mainly psychologically but also at times materially. Affandi also talked of how difficult it was, even after better days had arrived, to keep everyone in such a large extended family as his happy. About his work, he said:

I have never been satisfied with a painting. I have not yet painted a good one. There is always something wrong. If I can see what is wrong with a painting, sometimes I can repair it, but often nothing can be done. That is why I still have to work very hard, trying to learn how to paint well.

I am old now. Who knows? Tomorrow I may be dead. So I must work very hard while I still can. And when I die, I want to die here in the gallery, surrounded by my wife and children and grandchildren and all my paintings.

During the interview, Affandi exuded a peaceful detachment from the ticking of the clock and the business of life.

'I am the luckiest man in the world,' Affandi suddenly said in his wavering voice. 'Because when I paint, I am completely happy. When I paint, the only things that exist are God, the subject, and myself.'

His eyes crinkled as he glanced over: 'And these paintings are my money! I don't have to keep my money in the bank! I just hang it on the walls! Who else do you know who can hang all their money on the walls like this? Heh-heh-heh....'

Against the wall near us, up on a ledge, the canvas he had painted that very morning sat drying. It depicted a man selling balloons, a playful cloud of

coloured spheres above his head. Affandi had seen him at the Sekaten night fair and had become so enamoured with the sight that he had asked this man to come to the gallery the next day. After spending a couple of hours painting him, he had bought all his balloons as recompense for the trouble.

Affandi would spend a long time looking for painting subjects, and then a long time studying the subject, probing into its being, until he felt he had become part of it. Only then would he start squeezing and smearing paint from the tubes on to the canvas, working it with his fingers, palms, wrists, and the back of his hands. Painting for Affandi was a process of fixing into colour and form the storm of energy from his emotions which had arisen through concentrating on something which had initially inspired him.

Throughout his long painting career, self-portraits remained an important theme in his work. These offer an unrivalled chronicle of images of self in Indonesian art, produced over a period of fifty years. They show the life progress of a highly original man, who wanted to see nothing but what was there, before his eyes, in its most essential form. Affandi's style has been called expressionistic but to him his works were more true to the subject than any degree of photo-realism could have been—an honesty which had more to do with emotional experience than with intellectual analysis. As he said in the 1982 film by Yasir Marzuki, *Hungry to Paint*, Affandi did not see himself as a clever man, 'not like Picasso'. He was more like Van Gogh—a man of strong emotion, which in turn gave rise to works of art; the stylistic similarity between himself and Van Gogh that people always point to was a matter of emotional affinity. In all of Affandi's work, including his self-portraits, his aim was to capture the very essence of the life-force which suffuses the universe.

This caused him to identify with and repeatedly attempt to capture the sun in paint, thick and dynamic swirls in blue, or orange, or red, or—as in *Solar Eclipse*—black (Colour Plate 25). Here, we see him sorrowfully embracing the black ball of the eclipsed sun, the disappearance of which to Affandi meant the death of everything in the universe, hence of all meaningfulness. One of Affandi's favourite signatures was a kind of cartoon figure pictogram with paw-like hands and feet and the sun (or sunflower) for a head.

In other self-portraits we see Affandi as the intensely concentrating young painter in the 1940s, seated naked before his easel, brows knit as he studies the play of light and shadow on his own body. We see him rising with elation up into the star-filled night sky, holding his first grandchild, both of them naked. We see images of Affandi approaching middle age, a strong, somewhat heavy face depicted in authoritative thick strokes of dark green, red, or black (Colour Plate 26); we see him age and soften, the colours becoming brighter and warmer in tone. As his strength ebbed and he no longer could fill the entire canvas, his paintings acquired a lighter feeling; here emerged a late style different from the stronger style of the 1960s and early 1970s, with the ageing painter not afraid to rise to new challenges. 'It is much more difficult to paint with bright colours than with dark,' Affandi said. 'I must try very hard if I am going to succeed.'

Affandi was convinced that 1987 was the year he would die. By 1987, his two friends and fellow pioneers of socially rooted modern Indonesian painting— S. Sudjojono and Hendra Gunawan—had gone. That year Affandi painted the canvas entitled *Unsuccessful*. Apart from a whisk of bamboo and a red sun crowning his portrait signature pictogram, he painted a sketchy image of himself against the background of the

primed canvas, in light oil-colours, almost disappearing into the background (Colour Plate 27). The effect lies more in the relief of thick impasto than in any outline or colour, and in the contrast between the more realistic image of himself, fading away, and the still vital pictogram.

The same year Affandi painted another self-portrait entitled *Dead* (Plate 87). In darker greys mixed with whites and yellow, the form of a dead fighting cock hangs upside down in the centre of the canvas; below it to the right, the face of Affandi emerges from the shadows, a ghost-like apparition, seemingly severed from any bodily context. This dislocation is emphasized by the presence of a foot in the upper left of the canvas. Placing his face on the ground, below where the feet of the living tread, makes Affandi's identification with the dead cock and with death complete.

However, 1987 slipped quietly by and Affandi was still alive, but the life was indeed ebbing out of his paintings and, to all purposes, Affandi the painter was gone, in his physical manifestation, even before his spirit had quite given up.

Looking at Affandi's self-portraits as a group, it is hard to agree with the prevailing view, held by most Indonesian artists and collectors, that Affandi's art was in decline during the last decade of his life. Preferring the work which spans the mid-1960s and 1970s, which is predominantly in darker, greenish hues, they see no merit in the later, more sketchy and light-coloured work. However, this judgement may be a failure to let go of the old image of 'Affandi' and follow him into a new phase: the later works, which speak of different things, can only be dismissed from a perspective that desires a successful formula to remain the same over time, and a point of view that disregards the peculiar insights that change, ageing, physical weakening, and the awareness of approaching death may bring.

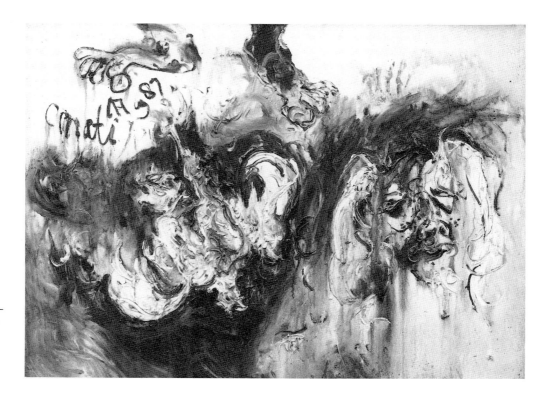

87. Affandi, *Dead*, 1987, oil on canvas, 100 × 130 cm, when photographed, collection of the artist. (Photograph Astri Wright.)

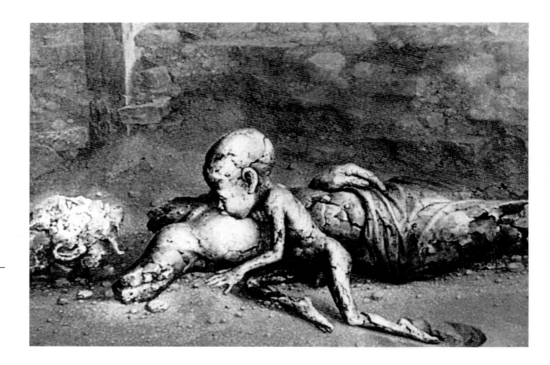

88. Agus Kamal, *For Some Reason*, 1986, oil on canvas, 100 × 140 cm, collection of the Fukuoka Museum. (Photograph courtesy of the artist.)

The canvases produced in the last two years of his life bear eloquent testimony to a man beginning to disappear, step by step becoming a shadow of his former self; the attempts at self-portraits are shadows of a physical presence which more and more becomes a disembodied psychological one. The head that we can barely discern in the last pictures Affandi painted with the help of his daughter Kartika, is like that of an unborn child. With the last remnants of physical power, combined by the force of his will with the strength of his closest child, Affandi was until the end trying to record, with characteristic honesty, and in a way unprecedented in the history of Indonesian art, the closing of a life cycle that began in Cirebon some eighty odd years earlier.

Javanese Surrealism and Ivan Sagito

A notable group of young painters based in Yogyakarta work in a range of surrealist styles. Agus Kamal's

preoccupation with the ravaging paradox of time results in works that blend ideas about life and death through hyper-realistic depictions of sculptures in various degrees of decay (Plate 88). In other works Kamal plays with the visual connection between the shrouds of corpses and Muslim women covered for prayer. Effendi's work has developed from depicting women who are part shadow puppet, part human, in strange dry, coral-like landscapes, to including men and women in more complex compositions with references to modern technology (Colour Plate 28). Lucia Hartini is the only female surrealist painter to have claimed attention to date and to have acknowledged her debt to Salvador Dali (Colour Plate 29). In her work, she often depicts planets travelling through swirling space, covered by oceans (see Colour Plate 36). Besides these painters in Yogya, there is a group of highly talented young surrealist artists, both self-taught and academically trained, in Surabaya and Malang in

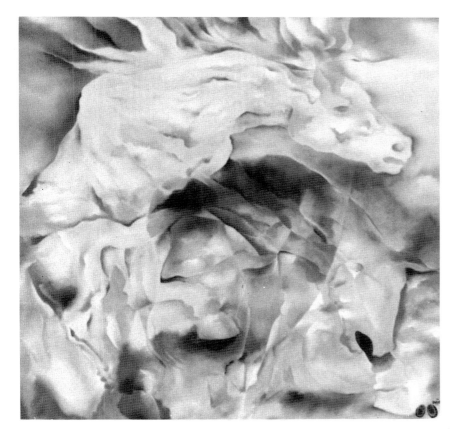

East Java (Plate 89).[5]

Ivan Sagito (Plate 90), who claimed national attention and critical praise with his first solo exhibition in Jakarta in 1988, paints his preoccupation with the transience of human life, and the tension felt by the individual caught between life's existential experience and the demands of communal life. Sagito's canvases, painted in fine glazes with an astounding technical virtuosity, most often depict women: old women caught in baskets or performing Sisyphus-like tasks; young women searching for something in barren landscapes while dissolving into billowing cloth or wooden *wayang golek* puppets (Colour Plate 30).[6]

[5]It is peculiar that the interest in surrealism appears to be stronger in East Java than elsewhere in Java or Indonesia. This begs questions about the nature of the local imagination, which already between the tenth and fifteenth centuries caused a classical style to develop which was quite unlike, and more fantastic than, the model style from Central Java (Holt, 1967: 66–93).

[6]*Wayang golek* is a *wayang* form known in Java

89. Dwijo Sukatmo, *Dynamism of the Horse*, 1982, oil on canvas, collection of the Directorate-General of Culture. (Photograph courtesy of the artist.)

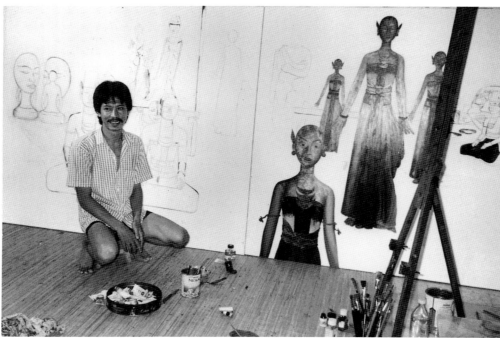

90. Ivan Sagito, 1990. (Photograph Astri Wright.)

Sagito seems to use the female form to comment on a culture that represses personal emotional expression, questioning, and individuality. Since women are socialized into a narrower range of roles than men, in Java as in so many parts of the world, Sagito may feel that using the female form is more visually and conceptually effective to convey a message about socialization in general.

When asked, in 1988, to write a short biography, Sagito wrote:

I am one of four children. My parents work as traders. Started painting at sixteen. My parents did not give their permission when I expressed my desire to become a painter. In my family environment, my paintings are not liked, but they are liked by my friends.

Born in Malang, East Java, in 1957, Ivan Sagito moved to Yogyakarta when he entered ASRI at eighteen. After graduating, he stayed on in Yogya because of the lively artists' milieu and because Central Java, with its traditional mystical world-view and culture, fascinates him. Sagito feels like a foreigner in Central Java, attracted to it and at times at odds with it.

When asked what he experiences as special about Yogyakarta, Sagito mentions local preoccupations with the spiritual and the magical:

I don't know if it can be described—but when you are around the *kraton*, in Taman Sari, places like that—even if it is really quiet and no people around—it seems there is always a presence there ... something looking down on it all, a party of some kind. I don't know if it's something supernatural. But I don't feel this elsewhere—in Malang, for example.[7]

In his work, Sagito is talking about mental rather than material culture, about psychology as much as about spirit, about the transience of all things ('I am obsessed with transience!' he writes), and about a tradition that is as confining as it is liberating. Although he paints in the style of classical Western surrealism, especially as formulated by Salvador Dali, Sagito has developed his own idiosyncratic surrealist iconography. The claim, made by some, that Sagito's work is plagiarism of Dali and Magritte is short-sighted in that it fails to take into account the numerous fundamental differences in Sagito's approach to the subconscious. He is more interested in what might be called communal rather than individual subconscious experience. His human figures exhibit less interest in anatomy or nudity, and in his landscapes there is less interest in a merging or metamorphosis between human beings and nature. The overall intent of the works appears to differ markedly.[8] The interpretation of individual paintings is more meaningful when seen in the context of Sagito's whole *oeuvre*, which exhibits a remarkable degree of symbolic consistency. He returns to the same themes, over and over again, examining them from different angles, and so the individual canvases mutually elucidate each other's meaning.

Motifs that reappear in his work are flowing clothing, especially the *selendang* (long scarf used to carry children and

which uses three-dimensional wood puppets on rods, whose heads and arms can be manipulated. The stories traditionally performed in Central Java are based on the Amir Hamzah epic. In some areas, the *Mahabharata* and *Ramayana* epics are performed, while many puppeteers perform local legends and stories. These puppets are more realistic than their *wayang kulit* counterparts: 'Their expressive faces, like very good masks, have fluid smiles, fierce scowls, are sweetly dignified or riotously grotesque' (Holt, 1967: 125–6; see also Foley, 1979; Buurman, 1988).

[7]Interview with the artist, 7 January 1989.
[8]In his reply to my artist questionnaire, Sagito lists Picasso, Vermeer, and Piet Mondrian as his favourite Western painters, and Hendra Gunawan and Nyoman Lempad as his favourite Indonesian painters.

goods or draped decoratively over the shoulder), loose hair, empty faces, tall, elongated figures, puppets, bamboo poles, torn and ragged banana palm leaves, and high walls that block one's view. In most of his canvases, a certain uniformity and lack of individuality is stressed by repeating the same gesture, form, or figure across the canvas. Using softly graded earth tones enlivened by an occasional luminous blue or red, he creates a tonal delicacy and beauty which takes the sharp edge off a frequently depressing portrait of existence, conveyed through an orchestration of Javanese symbols and startling juxtapositions.

Sagito does not like imposing labels on art. If anything, he says, his work is rooted in a kind of 'image associationism'.[9] He believes that painting as an act can help the individual—the artist as well as the viewer—to better see the 'real'. This is not a reality where the factual outer world is seen as separate from the subjective inner world, but one where the two merge and become one. The symbolic elements Sagito uses are Javanese; what is new is his emphasis on the subconscious and on ambiguous moods rather than on a harmonious spiritual life:

Things that inspire me to paint are an atmosphere of sadness, loneliness, and ruminations on the existence of mankind which cannot be comprehended.... My wish is to create an impression which stirs the imagination towards associations. The imagination is not in opposition to the real; maybe it creates a form of reality of its own, one that runs parallel to and which further enriches our understanding.... The imagination cannot but be based on reality.

[9]Typescript by Sagito in response to questions from Suwarno Wisetrotomo, Yogyakarta, 1 September 1988. Where nothing else is noted, subsequent quotations are taken from here; author's translation.

In our imagination, Sagito feels, lies our creative potential for liberation from suffering:

Apparently an illusion can touch the soul more deeply than reality. For example, a bamboo rack for drying clothes suddenly appears to be a cross. In this illusion ... is felt a deep religiosity, deeper than when facing an actual cross. And this becomes a matter of obsession: why is it that illusions give rise to the sense of transcendence?

Working through his intellectual and emotional preoccupations in a concrete visual medium, the artist allows the public a private view of his inner self and the process of creativity:

To create is like dredging up an offering, little by little ... dredging forth bits and pieces of the soul, which are first submerged and then can flow into life. Besides painting to make myself happy, I paint as an attempt to find—as far as possible—my essential self. Thus, painting for me is simultaneously a mirror of both the soul and the mind (Alliance Française, 1986; author's translation).

Sagito's paintings, however, do not stop at being self-expression. He feels that art has more wide-ranging and active roles to play, among which is 'to uncover ideals of beauty within the art lover, while at the same time awakening subtle and gentle feelings which can be touched by humanistic values and develop people's awareness about what is the meaning of life'.

The world we enter in Sagito's paintings is at once familiar and strange. Objects and spaces take on new and strange roles, as do the people who inhabit them. Everyday Indonesian objects—wells, baskets, poles supporting clothes-lines, laundry hanging out to dry—at times exchange places with people, in a world where the life of objects is intensified and the life of people appears numbed.

The women Sagito paints range in age from girlhood through maturity to old

age. Although most often depicted in groups, they are nearly always isolated from each other, neither interacting nor connecting. Some are faceless; the faces of others are concealed behind wooden masks, scarves, or the drapery-like clothing of another woman. Themes of isolation and concealment occur again and again. Even mothers holding children do not seem to be sources of love and security. The young women in Sagito's canvases all seem apprehensive—standing, sitting, lying around, or leaning against poles. Some lean over the edge of

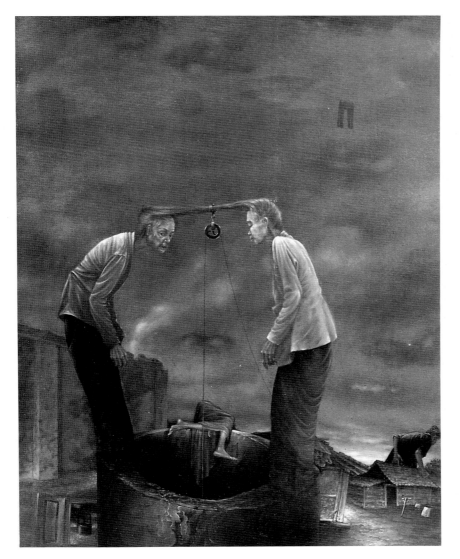

91. Ivan Sagito, *Eternal Transience*, 1982, oil on canvas, 125 × 100 cm, when photographed, collection of the artist. (Photograph Astri Wright.)

wells or large baskets, as if searching for something.

Even in the few instances where women are doing something together, such as in *Eternal Transience* (Plate 91), they appear to be co-operating as victims or slaves to a greater authority, which they have no power to challenge or refuse. Two old, crooked women stand at the top of a well, one throwing a frightened glance to the side, the other with her eyes closed. Their long grey hair tied together above the cavity supports the pulley and rope which pulls the bucket up from the well. Across the rim of the well lies the inert body of a young woman dressed in red.[10] In the distance can be seen a tall green concrete wall and impoverished bamboo houses, dwarfed by the figure of a giant woman in blue, her back bent with age, heading away from the scene. Against murky brown clouds, a single pair of trousers is hung up to dry on a clothes-line which begins and ends nowhere.

What is the well these women are guarding and slaving over? With its cracking walls, situated in that desertscape, can it possibly hold any water? Does the fact that the old women's hair or necks do not break indicate that the bucket is indeed empty? Is it an image of drawn-out suicide rather than challenging oppression, or is this a poignant image of the strength and persistence of the human being, who manages to go on, against impossible odds and acute suffering, at whatever the price?

Wells can be interpreted as symbols of life-giving waters, of deep hidden secrets, of things contained from the world at large with only guarded access. Wells may symbolize female sexuality and the cycles of procreation. The young woman lying on the rim here is wearing a red

[10]This motif occurs in another painting from the same period, where a red doll lies across the rim of a well.

dress; red, in Javanese thought, represents passion, and the worldly and material dimension. Maybe Sagito intends the figure of this woman to symbolize an impatient attempt to immerse oneself in the waters of life, leaping into the well (cum passion/sexuality) instead of waiting for the few drops young women are allowed to imbibe, at the socially prescribed times. According to such a reading, the old women would represent the social conventions that regulate human passions, even when they themselves have been victimized by the same norms. Conversely, the lifeless figure of the young woman indicates that to challenge these norms is equivalent to self-destruction.

Depicting metamorphosis from one form and one level of being to another is one of the hallmarks of surrealism. In many of his works, Sagito has chosen to use the form of the *wayang golek* puppet as a central motif in the process of metamorphosis. Works such as *Metamorphosis in the Image of Transience* (Colour Plate 31), depict an individual woman gradually transforming until she has become a perfect *wayang golek* puppet. This brings the notion of time into the painting—an aspect of existence which preoccupies Sagito, as many of his titles suggest (see Plate 26). 'Time is what makes us aware of the reality of how transience, repeated endlessly, becomes eternity,' Sagito writes.

In the relationship between women and puppets in Sagito's paintings, there is a progression of forms through time. The youngest girls may play with dolls; they have, as yet, no relationship to the puppets. It is as the women mature that they start merging, first with each other (one woman's body blending into another's), then with *wayang golek* figures. Slowly each young woman's body becomes the support for the puppet, her head concealed in the puppet's dress.

Finally, the naked, searching female face is exchanged for the stiff and stylized wooden smile and empty eye sockets of the puppet. This is a powerful comment on the erosion of individual identity and the adoption of social masks and public expressions. From the perspective of women, too, the loose hair and flowing informal clothing of the young girl is tied up tightly and formalized into the proper image of womanhood.

Clearly many fascinating interpretations can be applied to Sagito's work, from art historical, psychological, sociological, and feminist perspectives. To employ a single approach would be to deny the many rich layers of meaning inherent in the works. He may choose to paint women because he finds the female figure an eloquent symbol for humankind. Women may appear more fragile and powerless in society, even in Java where ideas about gender, economic relations, and status are orchestrated according to a different and more complex pattern than our own (Atkinson and Errington, 1990). In the popular imagination, women are frequently thought to either see themselves as victims or be more accepting of their fates. Women are also closer to the act of birth and thus, by association, to death. Philosophically, on the other hand, the fate of women is the fate of every human being—and in Sagito's world, it appears that nobody is in control of their life. All are puppets, and free will, happiness, and physical and spiritual closeness do not appear to enter into the equation of existence.

In light of the earlier discussion about the symbolism of the mountain/tree of life motif and its prevalence in Indonesian art, the absence of mountains and vegetation in Sagito's paintings is striking. This is not a Javanese landscape; only in the dead mother crater of Mount Bromo in East Java do you find a comparable barrenness. This is not the

fertile, teeming image of nature used to indicate the world of *wayang* in the image of the *gunungan*, the tree of life cum cosmos. Even after the first *gunungan* has disappeared from the *wayang* screen, the audience retains the memory of the image of a fertile and harmonious world during the performance, a memory which is reconfirmed at the end of the performance with the return of the *gunungan* to the middle of the screen. Sagito's 'screen', on the other hand, is empty. The only leaves that may appear in his work are the torn leaves of the banana tree. The banana palm could not possibly function as symbol of a fertile world. Unlike other trees, it provides no permanent shelter to birds and animals, and the leaves, the wrapping paper of the poor, are later thrown away as garbage. The banana tree is cut down immediately after the fruit is harvested: thus it would symbolize a life cycle cut short.

Why does Sagito use this landscape as a background for his figures? Does he use it as a generalizing device, to make his visual statements more universal in their appeal? This may be so on the most basic level, but if his paintings are about states of mind, the landscape indicates a larger mind state than that of the actors moving within it. One feels that Sagito is talking about a psychological context which in itself has no nourishment, no fertility. There are no valleys or lush gardens in which people can lose themselves, where they can attain moments of beauty or intimacy, either with each other or with nature.

In another group of Sagito's paintings of *wayang golek* figures, the feeling is different than in those just discussed. Here, the *wayang* figures do not seem to be the final stage of the metamorphosis; rather, they appear to be only one stage along the way. Beyond the puppet stage may lie another. In *Soul/Spirit* (Plate 92), Sagito creates completely empty faces,

mere outlines of hair framing empty cloudscapes, a flame, or a luminous moon sickle.

The word 'empty' recurs in Sagito's discourse about how he paints people, and especially their faces. It soon becomes clear that by 'empty' he does not mean an unqualified negative. It is not necessarily, or always, the emptiness of a vessel after its desired contents have been poured out, but that of a vessel which has been emptied of the undesirable (the ego) and is ready to receive, to be filled—with illumination, the nectar of immortal life, or with god. Emptiness, Sagito says, better represents people's essential being. This may be his way of expressing what the poet Rendra refers to as *kamar sentong*—'a room in a Javanese house which is always left empty, and symbolizes that place in the human soul which no alien entity may enter' (Lane, 1979: xxxix). Sagito says he uses the convention of emptiness in part 'so that the viewers can make anything they want out of it'. This is one of the ways the painter elicits the energies of the viewer as co-creator.

The empty faces filled with a small flame, which to Sagito symbolizes the soul, become not only an expression of the terror of loss of individuality (though this seems to be the emphasis in many of the works), but illustrate the idea that as embodied souls we all participate in the same reality and partake of the same substance that infuses the universe. With this, another dimension is added to the processes of metamorphosis in Sagito's paintings, which brings them beyond the level of commentary on social norms and restrictions on personal expression. On a more metaphysical level he seems to be addressing the idea that to locate one's spiritual essence, the source of one's essential belonging, one has to go through the painful process of giving up the self.

Here may lie the clue to why Ivan

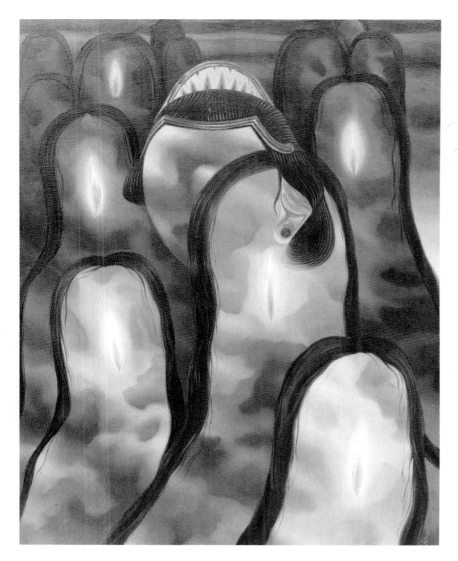

92. Ivan Sagito, *Soul/Spirit*, 1988, oil on canvas, 40 × 30 cm, when photographed, collection of the artist. (Photograph Astri Wright.)

The cow/bull is another central symbol in Sagito's work, evoking the spiritual dimensions of the bovine prevalent in Hindu-Javanese mysticism. The Indonesian word *sapi* has no gender and thus represents, among other things, the Hindu–Buddhist idea of undivided unity. Sagito has spoken of how the *sapi*, to him, is the ultimate symbol of patience and endurance—the ability to receive whatever life doles out, and to grow through this practice of *nrimo*.

In the self-portrait entitled *Mask* (1986), the artist presents one solution to dealing with existential pain. Masks function as shields—false identities which may be imposed on one—but they also enable one to successfully conceal oneself in order to play different but necessary roles. In *I Want to Become a Sapi* (Plate 93), he depicts himself as a man metamorphosing into a cow/bull. He is squatting in a desert, before a strange ridge of rock. In the rock-face the shapes of faces and a man emerge eerily. Partly covered by a cloth of the type used to drape corpses, Sagito looks out at the viewer with a pained expression. The left side of his face is dissolving into the spectral image of a *sapi*, duplicating the form of the bovine head growing out of his knee. The process seems to be sucking all life from the painter: his abnormally long and thin arm ends in a hand that is completely skeletal. The draped cloth partly hides the transformation which is taking place, but from under the cloth a severed, emaciated leg emerges. Were it not for the title, one might not realize that this painful process was one both desired and sought by the artist.

Accepting one's fate as something predetermined is a quality which occupies a central place in *kebatinan* thought. Thus, this self-portrait may be intended as the superior answer to human suffering: the *sapi* symbolizes the ultimate ability to bear any burden, patiently—a symbol of spiritual invincibility.

Sagito can live with what at first looks like a desultory and bleak vision of reality, without becoming depressive or nihilistic:

Reality has to just be accepted—*nrimo*. Not in the completely passive sense, and yet not striving as excessively as the 'Übermensch', who with a forceful mobilization of all his powers, repeatedly fails. It has to be an attitude of surrender, a willingness to answer and understand, with among other things, a willingness for constant self-examination (searching and digging).

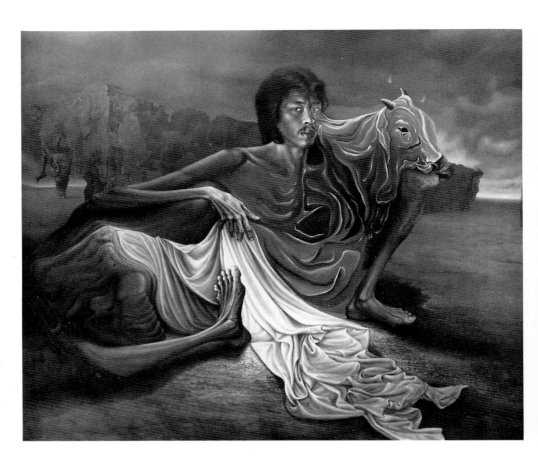

93. Ivan Sagito, *I Want to Become a Sapi*, 1984, oil on canvas, 110 × 140 cm, when photographed, collection of the artist. (Photograph Astri Wright.)

Becoming like a *sapi* is a higher path than hiding behind masks or becoming wooden puppets, performing only the movements prescribed by the puppeteer's manipulations, and wearing always the same fixed, wooden smiles.

Ivan Sagito is extremely prolific and driven by his work. The question is whether he can withstand the pressures of the staggering financial and critical success of his first solo exhibition in 1988, and the ensuing demands of the art market which require him to paint the kinds of images that sell the best (the woman becoming *wayang golek* theme). It is possible that his success will shatter the lifestyle of simplicity, freedom, and quietude within which Sagito originally worked and professed he wanted to continue.[11] Meanwhile, his work depicts the transience of life in a hauntingly modern idiom, at once Javanese and universal, which in an unprecedented way focuses our attention on themes of human, woman, and self.

[11]Pers. com., February 1989. In March 1991, Sagito mourned the fact that he had few of the paintings he had created over the last years left. Having exchanged his earlier cramped, rented dwelling for a beautiful new home which he himself designed and built, he feels the pressure to keep painting, both to support his higher lifestyle and to meet the demands of an expanding number of collectors.

6 Women and Contemporary Painting

IN the transition from a more purely spiritual world-view to a more sociological one, an important perspective is that of Indonesian women artists. If they operate within a different set of norms and expectations than those of male artists, we need to take a brief look at the situation of women in Indonesian society in general.

The problem areas Indonesian women have identified since the beginning of the indigenous women's movement in the 1920s and 1930s, are the same ones women face world-wide: equal opportunity in education and in the workplace, equal pay for equal wages; equality before the law and, specific to Indonesia, reform of marriage laws and practices as traditionally defined by *adat* (tradition, customary law, proper behaviour) and Islamic law.[1] The abolition of polygyny has been at the top of the list since the beginning of the women's movement (Wieringa, 1985: 10). The figure usually cited as the pioneer of the women's movement is Kartini, a Javanese princess who, in letters to her Dutch friends around the turn of the century, advocated equal rights and opportunities for women.[2]

Images of Women in Modern Indonesian Painting

Throughout the history of art in South-East Asia, the female form occurs in many styles, media, and contexts. Generally, it represents that half of the universe which is not male, at times as an equal partner to the male form, such as

[1]Millions of rural village women in Java work on the land, as traders, in informal food establishments, or small craft industries, control household finances and have thus a greater degree of independence and freedom of movement than many women throughout the world, especially the Islamic world. This facilitates a degree of social mobility based on their own achievement. However, their access to education and greater degrees of social mobility, let alone positions of formal power on a regional or national level, are limited by the same complex of values that limit educated, upper-class women—values which, since the beginning of Western influence, particularly with the coming of Islam and under Dutch colonial rule, have become more entrenched and conservative (see Vreede-de Stuers, 1960).

[2]Kartini continues to engage writers of official histories, those who challenge such official histories, and foreign scholars. The first group has made her one of the 'national heroes', using her as a role model for the present conservative definition of women's roles in Indonesia. Among the revisionists, both men and women, Kartini is treated in different ways, some interpreting hers as a limited and privileged perspective which she all too easily abandoned in consenting to a traditional marriage. The third group, Western scholars, is also divided in interpreting Kartini's significance; some ascribe to her a genuine feminist view (Thomson, 1980).

seen in many indigenous textiles and carvings of ancestor figures. After the arrival of Hindu influences, the female form comes to represent the realm of biological cum spiritual fertility and the earth-bound (including the demonic) in opposition to the male spheres of mind as spiritual fecundity and the divine.[3] These two realms have been represented in the Hindu image of the *lingga* and the *yoni* (see Plate 40). The essential unity of male and female has, in Indonesian sculpture, as in India, been celebrated in a form of Shiva, the *ardhanarisvari*, where the left half, vertically, is female and the right half is male.[4]

In the *wayang*, which has been so influential in teaching ethics and social norms and in providing models for male and female behaviour, virtuous, strong, active, and respected male figures are numerous (though all have their own peculiar weaknesses). Searching for a female character with similar attributes, however, turns up only one: Srikandhi. The ideal woman in the *Mahabharata* is Sumbadra, in the *Ramayana*, Sita— women who are passive, quiet, beautiful, pure, their heads bowed down, gaze averted. Srikandhi, on the other hand, with her head raised and her eyes scanning the world before her, is active, confident, and as skilled in archery as her consort, Ardjuna (who, fortunately for him, also has a proper wife in Sumbadra). However, the gender of even this single example of a female model that might provide present-day

Indonesian women with a mythological model more appropriate to the challenges of modern life, is contested by some.[5] It is probable that the decline in importance given to the feminine in Javanese art, from the prehistoric era, through the Hindu–Buddhist era to the form of Srikandhi known today, is a result of the patriarchalizing influences of Islam, first, and later, Dutch colonization.

Paintings of women from the first decade of Indonesian Independence introduce yet a new note in the depiction of the female form. The prominent role given to women in pre-modern cosmologies in the modern era assumed new content, context, and visual forms, while still to an extent resonating with the power of past iconographies. Modern

[3]Needless to say, there is considerable richness in the various Hindu and Buddhist traditions which accord different status and roles to the feminine. In opposition to Western notions of body as female, mind as masculine, Tibetan Buddhism, for example, posits that compassion be represented as masculine and wisdom as feminine.

[4]See the posthumous statue of Kertanagara in the two aspects of *hari-hara*, a combination of the two deities Vishnu and Shiva in one image, and *ardhanari*, a combination of male and female in one image (Holt, 1967: 81).

[5]Not having come across any literature on the specifics of changes from the original text in the course of Javanization, I was surprised, while travelling to Ajanta with a Brahmin from Pune in 1988, to discover that Srikandhi—a female figure in Javanese *wayang*—was a male in the Indian version of the *Mahabharata*: prince Sikhandi [*sic*] was the reincarnation of Amba, daughter of the king of Kási, whose revenge for his failure to return her love could only be wreaked on Bhisma in a later lifetime if she were reborn a man (Narasimhan, 1965: xvi). With my self-appointed Brahmin teacher, I tried to pursue a discussion of the fascinating process of cultural assimilation and native psychology that must lie behind this kind of rewriting, but he was so disgusted at this bastardization of the text that he would not discuss it further.

To further convolute the question of Srikandhi, Benedict Anderson related the following: 'When asked about this difference between the Indian and the Indonesian versions in the mid-1960s, Mas Purnadi, professor at the Law Faculty at University of Indonesia and son of Purbatjaraka, laughed and said that "of course people in the kraton knew quite well that Srikandhi was a man who liked to dress up as a woman, and with whom Arjuna had a homosexual relationship—that's why Srikandhi is the only woman in *wayang* who doesn't have any children!" But this, he said, would be difficult for the people to understand or deal with so the popular *wayang* treats "him" as an ordinary woman.' (Pers. com., August 1990. See Chapter 8, fn. 30.)

paintings illustrate the ease with which traditional forms of the goddess or of female power or personification could be swayed into Westernized, contemporary looking images of the woman as an upper-class, sexual object.

According to legend, the ocean which washes the barren coastline called Parangtritis near Yogyakarta is the home of Nyai Roro Kidul, Queen of the Southern Ocean, a demonic spirit who was pacified by spiritual marriage to and precious gifts from the Sultan of

Yogyakarta from the seventeenth century on (Holt, 1967: 116–17). In popular thought, the Queen of the Southern Ocean is known to dress in green; she is constantly on the look-out for young men to drag down into her underwater empire. The presence of extremely strong undercurrents, even at shallow water levels, resulting in drownings every year, feeds this local belief. Thus, the seductive nature of Roro Kidul, as depicted in the two next paintings, echoes with the Christian-derived view of woman as evil temptress. Agus Djaya's *Nyai Roro Kidul* (Colour Plate 32), shows an Indianized goddess with bulging breasts, its exaggeration and flesh colour rendering it more tactile than its prototypes on Indian temples. Basuki Abdullah's *Nyai Roro Kidul* (Plate 94) shows a woman who, with her tight-fitting, low-cut green silk evening gown, fashionable strand of pearls, and 'wet-'n-wild' loose hair, is a high-fashion sex goddess of the type that became the model for élite women who, for half a century, have flocked to Basuki's studio to be painted. Basuki's approach to portraiture is, in his own words, 'To paint my subjects, not as they *really* look but the way they feel inside.'[6]

In Basuki Abdullah's *The Battle between Rahwana and Djataju in the Abduction of Sita* (Colour Plate 33), a muscular Rahwana lifts up a pale, passive, half-naked Sita while fending off the bird Djataju (Rahayu). As much as a rendering of a mythological scene, it is a modern Indonesian depiction of the male fantasy of sexual conquest.

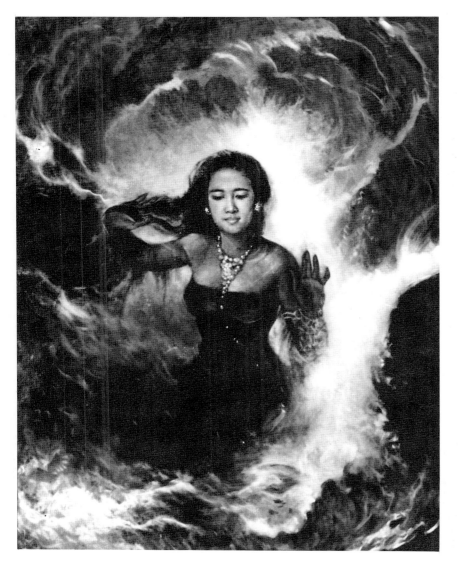

94. Basuki Abdullah, *Nyai Roro Kidul*, *c*.mid-1950s, oil on canvas, 159 × 120 cm. (Sukarno Collection, Vol. II, No. 105.)

[6]Quoted by a Jakarta artist. Basuki Abdullah has for sixty years specialized in painting the élite, both at home (as palace painter to Sukarno, portrait-painter of the economic and political élite, and the only painter who has received visible support by President Suharto) and abroad (as palace painter to the Thai Royal House, 1962–72). For a complete biography and a collection of critical statements from Indonesian artists, critics, and patrons, see Agus Dermawan T., 1985.

The process of secularizing and sexualizing the goddess is evident in the many paintings of women found in the Sukarno collection. Indeed, the four volumes of the Sukarno collection were published at a time when Sukarno's alleged support for the women's movement had been demonstrated as mainly rhetorical: violating the top item on the agenda of the central women's organizations, Sukarno, in 1955, took a second wife.

A perusal of these reproductions illustrates that women are one of the largest single theme groups represented. Basuki Abdullah figures prominently with his many contributions to the genre. His depictions of women range from idealized and pretty portraits, such as those of Sukarno's wife, to unabashed pin-ups, like *Reclining Nude* (Plate 95). Other paintings of women are rationalized as contributions toward visualizing 'national' culture and 'Indonesian' identity. Starting with the

painting entitled *Daughter of Indonesia* (Dullah, 1956: Vol. II, Pl. 94) where a pretty woman in traditional Javanese dress and a *selendang* over her head stands on the shore gazing out to sea, we proceed to encounter paintings entitled *Sunda Girl*, *Solo Girl*, *Arab Girl*, and—of course—numerous versions of 'girls' from that most mysterious, sensual, and exotic of all the Indonesian islands—Bali (Plate 96). These works are early examples of an attitude propagated by the government (the majority of which are Javanese men) both against Indonesia's ethnic groups (the more exotic the further from 'Java') and against women.

Paintings by the late Belgian painter, Le Mayeur, and the Italian, Antonio Blanco (still living in Bali and selling well to the Indonesian élite), spring from the same attitude. Le Mayeur's numerous canvases entitled *The Enjoyment of Life*, depict beach scenes with nude and semi-nude Rubenesques lying and sitting under

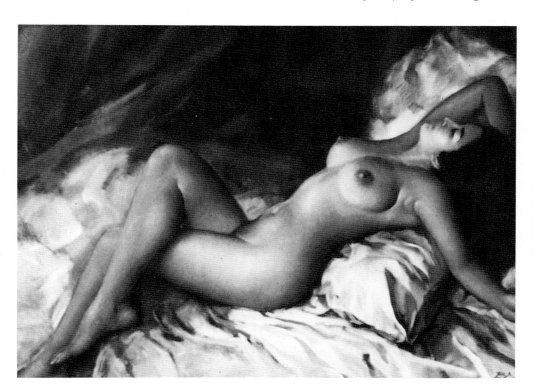

95. Basuki Abdullah, *Reclining Nude*, *c.*mid-1950s, oil on canvas, 79.5 × 120.0 cm. (Sukarno Collection, Vol. IV, No. 87.)

the trees. The true enjoyment, however, is on the part of the viewer, who is placed in the position of a sultan viewing his harem through the lace-carved marble screen. Coming out of a long-standing tradition of objectifying woman and the female body in the West, and as Westerners living in Indonesia, these painters also nourish this attitude in Indonesia, facilitated by the admiration for pale skin and things Western still evident in personal discourse.

Not all visual images have equal ideological intent or power. There are examples of how the worship of the female form and associated powers of inspiration, procreation, and nourishment is genuine in the minds of the first generation of Indonesian painters. Agus Djaya's painting, *Girl under Full Moon* (Plate 97), depicting a young woman standing in half shade, eyes half-closed, surrounded by dark, deep, mysterious colours, is a sincere and mystical work, and Sudibio's symbolist rendition of the Goddess of Rice (Plate 98), is a theme he returns to in many versions throughout his career. Other works by Sudibio are dominated by a more generic or modern form of the goddess figure. Some paintings show the artist humbly prostrate on the fertile land before her, others show his face turning into a skull as he serves his muse (see his *Inspiration* (1954) in Holt, 1967: 245).

S. Sudjojono was the most polemical of the first generation of Indonesian artists. Regaling the dishonestly idyllic landscapes and portraits of the 'Beautiful Indies' school, he appealed to Indonesian painters to paint the truth and not a romantic ideal. Even Sudjojono, however, appealed in the late 1930s to a goddess figure as the giver of the highest possible reward to which the artist could aspire:

Probably you will suffer, be burned by the heat of the sun, as your aching chest gasps for breath or hunger gnaws at your insides ... but when you die, you will not journey in vain to the palace of the Goddess in Art in the land of eternity; you will dare to knock at her gate, saying: 'Goddess, I have come.' And the Goddess will open the door and joyfully invite you herself to enter.... And you will further be able to say: 'Have I sacrificed enough to prove my love for you, Goddess?' [And she will answer:] 'Enough, enough, enough' (Holt, 1967: 196).

However romantic such passages, the efforts of Sudjojono and like-minded contemporaries, bolstered by the harsh realities of the breakdown of the

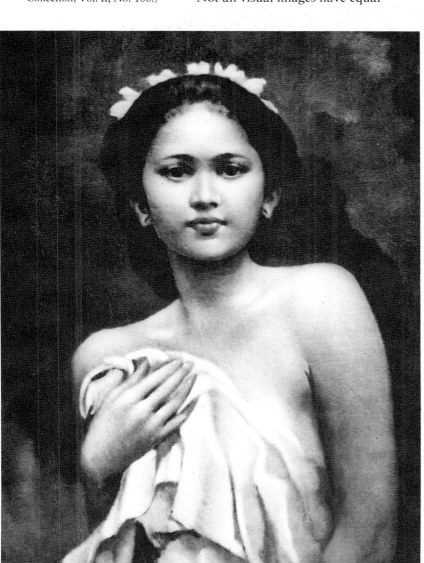

96. Basuki Abdullah, *Girl from Bali*, 1942, oil on triplex, 68.0 × 50.5 cm. (Sukarno Collection, Vol. II, No. 106.)

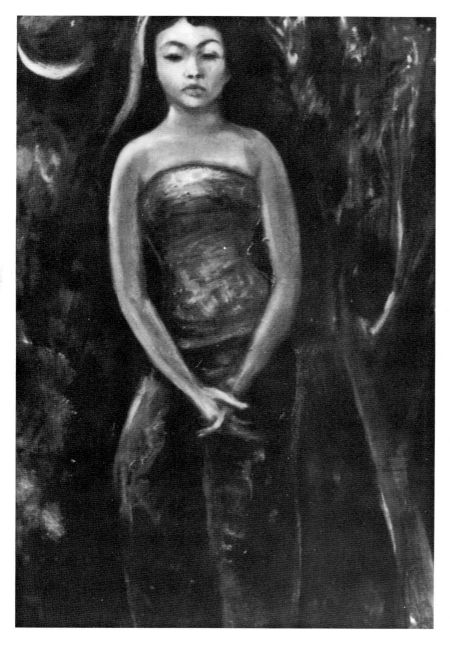

97. Agus Djaya, *Girl under Full Moon*, c.mid-1950s, oil on canvas, 99 × 74 cm. (Sukarno Collection, Vol. IV, No. 3.)

represented in works which depict women of different types and in different manners than those discussed above. In Surono's *Girl Student* (Plate 99), the sweetness of earlier depictions is largely gone and qualities other than beauty and sensuality are stressed. Surono's serious young student is focused on things beyond her own appearance or effect on the viewer, and the reference to the education of women is itself new. The woman in Sudjojono's *Before the Open Mosquito Net* (Plate 100) is unprecedented with her direct, unsmiling stare. Her deathly pale face—probably whitened by powder in accord with the beauty associated with white skin—shows no hint of coyness. Instead, her anger, irritation, or sadness leaves room for interpreting her as a complex human being.

Today, severely damaged, Affandi's *Mother in the Room* (Plate 101) depicts a solitary woman, bent with old age, standing aimlessly in a room made of plaited bamboo (sign of poverty), facing a clock on the wall. With echoes of Van Gogh and Edvard Munch, we encounter here a degree of expressive realism unseen before in Indonesian art. Similarly, *My Wife and Child*, rather than a sweet icon of motherhood, is an image of a mother and child relating naturally, hanging on to each other in a playful and comradely way, as if caught at the moment they just happened by to see what Affandi was painting.

Both romantic and realistic levels of discourse can be found in the work of certain artists dating to the same era. Nowhere is this more evident than in Hendra Gunawan's depictions of women (see Chapter 8). At times they are symbols of the fertility, beauty, and life-force, inherent both in the female and in the land. At such times Hendra's work is as symbolic as it is sensual. At other times, women seem to represent the Indonesian people and their indomitable

economy, the Japanese Occupation, and the ensuing war for independence, represented a turning-point in the concerns of modern Indonesian artists. A new degree of realism entered their work, often depicted with expressive psychological intensity (see Chapter 7). This also affected the way women were

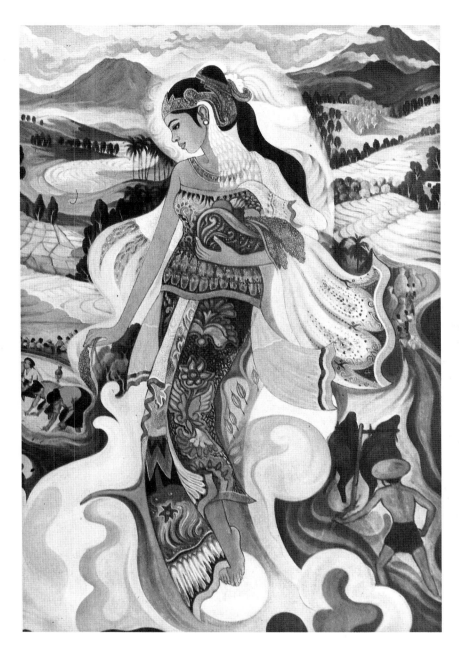

98. Sudibio, *Dewi Sri, Goddess of Rice*, n.d., oil on canvas, 140 × 100 cm. (Adam Malik Collection.)

Women and the Art World

Few early paintings or modern art works in other media by Indonesian women exist. Many talented women were cut off from devoting their lives to art. In 1901, Kartini wrote to Stella Zeehandelaar that her younger sister, Rukmini, was clearly talented in drawing and that her highest desire was to become a painter, but her wish to study art in Holland or in Batavia was never fulfilled (Sanento Yuliman, 1988: 10). Tridjoto Abdullah (b. 1916), daughter of the famous Abdullah Soerio Soebroto and sister of the two famous painters, Soedjono Abdullah and Basuki Abdullah, started sculpting after her three children were grown. Moerdowo compares her favourably to Basuki Abdullah. Mrs Tjokrosuharto, he writes, 'has a much more sincere approach to Indonesian culture ... and she is now one of the most able artists in Indonesia' (1958: 83). However, her works were never accorded attention and have been lost (Sanento Yuliman, 1988: 10). The list of aborted artist careers is undoubtedly longer. It is only in the last few years that social changes and personal persistence allow Indonesian women the possibility to pursue a serious career as an artist and not only as a 'Sunday painter'. The pressures against this happening, both from official and social holds, are none the less still formidable.

It is not surprising, then, that not many exhibitions of women's art are held.[7] The three main groups of women artists range from the Ikatan Pelukis Wanita Indonesia (Association for Indonesian Women Painters), which approximates an

will to survive against difficult social odds. Since the late 1960s, with the disappearance of the emphasis on popular life and work, woman as decorative subject-matter has returned to modern Indonesian painting, either in the guise of Balinese or Javanese dancers or more urban models of leisure (Plates 102 and 103).

[7]During 1987–9, I only saw two solo and three group exhibitions of work by women artists, compared to the forty odd solo and group exhibitions I saw of work by male artists. Similarly, I seldom saw paintings by women represented in the private collections I visited.

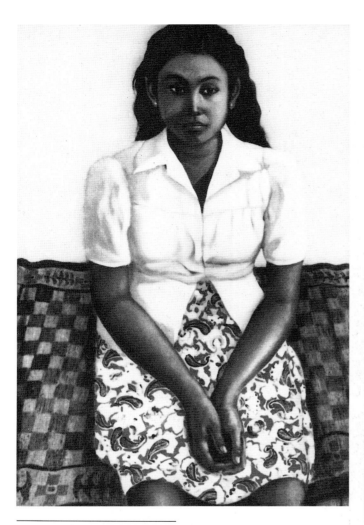

99. Surono, *Girl Student*, c.mid-1950s, oil on canvas, 88 × 60 cm. (Sukarno Collection, Vol. IV, No. 20.)

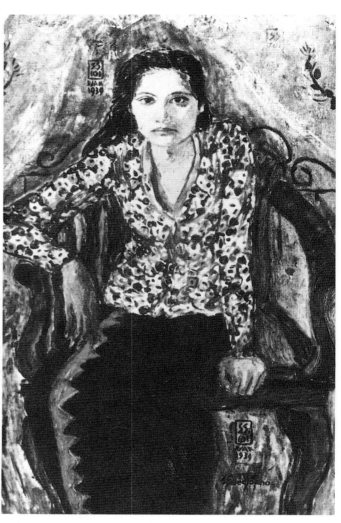

100. S. Sudjojono, *Before the Open Mosquito Net*, 1939, oil on canvas, 86 × 66 cm. (Sukarno Collection, Vol. II, No. 86.)

'auxiliary women's art club', to a semi-professional group called Grup Sembilan (Group Nine), to the most serious group of female artists, Nuansa Indonesia. Significantly, those artists in Grup Sembilan who raise it above an amateur woman's group are also central members of Nuansa.[8] However, some professional female artists in Indonesia, like Kartika, no longer want to exhibit even with Nuansa, since they feel it classifies them as 'women artists', causing the public to see them as just another 'ibu-ibu' group.[9]

[8]It is these same women who produce some of the most outstanding works exhibited in larger mixed-gender exhibitions, such as the Jakarta Art Institute's faculty exhibition in October 1988.

[9]*Ibu* means 'mother', 'Mrs', or 'Lady'; *ibu-ibu*

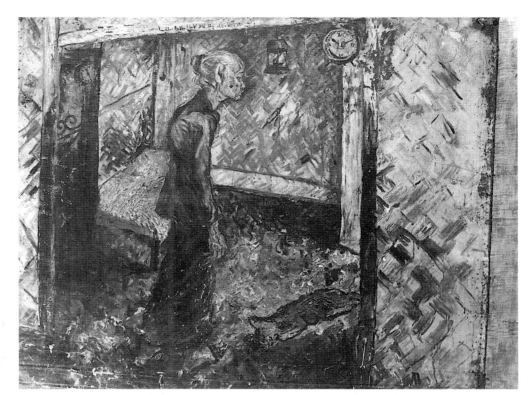

101. Affandi, *Mother in the Room*, 1949, oil on canvas, 139 × 157 cm, when photographed, collection of the artist. (Photograph Astri Wright.)

102. Kusnadi, *Reclining Girl*, 1964, gouache on paper, 55 × 75 cm, collection of Wisma Seni Nasional. (Photograph courtesy of the artist.)

In an essay in the Nuansa Indonesia exhibition catalogue for 1988, Sanento Yuliman, after a brief discussion of the roles attributed to women artisans throughout history, describes the situation for Indonesian female artists today.

After naming three well-known mythical female Indonesian heroes, Sanento asks, 'Should not societies, which in their mythologies give to women a heroic role, also allow women to play an important role in the fine arts?' (1988: 8). He then surveys traditional roles of women in various processes of artistic production among different ethnic groups in Indonesia, and highlights the tradition of patterned hand-drawn textiles as particularly important to the development of modern fine arts. Whether *ikat*, where the threads are dyed into specific patterns before they are woven; *songket*, where gold-leaf is wrapped around certain threads before they are woven; batik, where the patterns appear in a process alternating between wax drawing and dyeing, or painting, with dyes directly on to the cloth, these art forms were all done by women. He describes the social and symbolic importance of these textiles, from their use as symbols of power and signs of descent, as gifts and exchange objects, to inheritance treasures and vehicles of healing. If these precious objects had suddenly ceased to exist, Sanento writes, the effect on society could have been fatal, causing chaos, enmity, and destruction.

In the twentieth century, new fields of artistic endeavour opened up to, and became dominated by, men. Furthermore, men have been allowed to enter into, and even take over, roles and professions previously held by women. At the same time, the opposite has not been permitted, Sanento writes.[10]

Women Artists in the 1980s

In the last decade, a few women have emerged who insist on defining themselves as artists, professionally, and women, privately, choosing to operate with, and managing to juggle, multiple definitions of self and roles (Wright, 1988h). 'Professional' in this regard does not mean that they, as artists, can live from sales of their art alone; rather, it denotes the degree of seriousness which the artist shows towards her work and the amount of time spent on the various phases of the creative process (Wright, 1988g).

Many of Indonesia's female artists are married to artists, a fact which can both facilitate and hamper their own careers. It can facilitate a woman's career in that she will, through her husband, have access to contacts within the art establishment; in most cases, however, it seems to hamper a woman's career in art. 'The feeling is, when you get married, you don't compete with your husband. You work as a team. Two painters in the same house would not look good, plus it might not be economically feasible,' one female artist told me. The idea is frequently implied that it would not be good if the wife's work was better or sold better than the husband's.

Farida Srihadi, Nunung W. S., Lucia Hartini, and Kartika Affandi-Köberl, all women with serious commitments to

refers to 'the ladies', as in 'Ibu-ibu dan Bapak-bapak' ('Ladies and Gentlemen').

[10]For example, in the ceramic-producing village of Kasongan, men create the decorative sculptural pottery that has become popular among the élite in recent years, while women are relegated to making the cheap ware used in household activities. In the field of textiles, men are the ones who do the hand printing and machine printing of batik cloth, whereas women are relegated to the slow task of hand drawing batik, poorly paid by urban-based dealers and star designers who, in turn, resell them at sky-high prices.

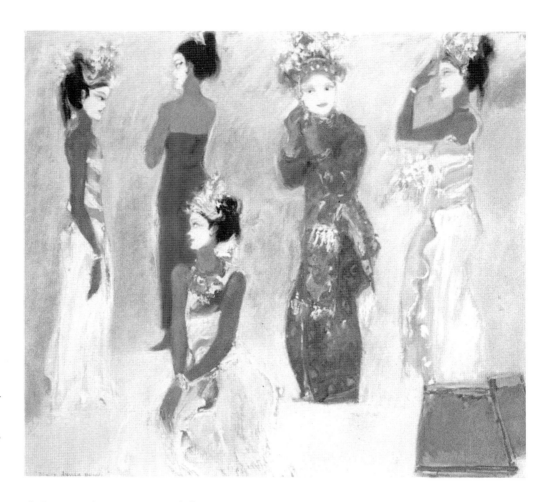

103. Srihadi Sudarsono, *Balinese Dancers*, 1987, oil on canvas, when photographed, collection of the artist. (Photograph courtesy of the artist.)

their art and as active in exhibitions as any women artists in Indonesia, all married fellow artists. Farida married her teacher, the well-known painter Srihadi Sudarsono, whose work in the 1960s and early 1970s represents some of the best abstract work of the Bandung school. Srihadi now paints semi-abstract landscapes and pretty but vacuous images of Balinese female dancers (Plate 103).[11] Farida's earlier work was also of Balinese women, mostly depicting them at work. She admired them for being 'strong' because they were always working

[11]A recent painting by Srihadi of a Balinese Baris dancer, exhibited at the Jakarta Art and Design Expo 1992, shows a degree of intensity and depth which has been absent in his works for years.

independently. In recent years, Farida has turned to painting near abstract landscapes, such as *The Voice of Nature* (Colour Plate 34), colouristically sensitive and strong compositions that vibrate with spiritual overtones. She paints no self-portraits and no overtly autobiographical work. Now teaching at the Jakarta Art Institute, Farida has begun to receive national attention in the last few years and increasingly, the proud pose of supportive and artistically inclined wife to one of Indonesia's most famous artists is being replaced with a presentation of herself as an artist, independently, and in her own right. At the same time, she is becoming more commercially successful (Plate 104).

Nunung W. S. studied briefly with

104. Farida Srihadi, *Starry Night*, 1991, acrylic on canvas, 140 × 140 cm. (Photograph courtesy of the artist.)

Like Farida's, Nunung's abstract works are not directly autobiographical but, with the occasional title like *Women and Problems* (Colour Plate 35), they come conceptually a step closer to addressing issues concerning women. In bright primary colours, Nunung has in this painting created a strong and simple composition dominated by a large calligraphic swirl in red; though broken, the movement is continued by white lines that in jagged, repetitive form play in and out around it. The red is imposed on a background of yellow, bleeding into black and blue, and the red oval almost encloses a shimmering mass of white. Whether the juxtaposition of light and dark and of curved and straight lines can be read according to traditional iconographies remains up to the perception of the individual critic: Nunung has made no statements indicating such preoccupations. An admirer of Helen Frankenthaler, her comments reflect a desire to express her emotions and her experiences with colour rather than with line. In the last three years, Nunung has been experimenting with paints on paper which she crumples into a textured surface, resulting in abstract works of great flow and delicacy (see Plate 19).

Lucia Hartini, who graduated from the Yogyakarta Secondary School of Fine Arts (SSRI), was until recently married to an artist who left all the housework and child care to her. Too poor to afford help in the house, Lucia painted in her kitchen in between cooking and other duties. It does not take much imagination to read an autobiographical comment in *Imagination XII* (Colour Plate 36), in which the image of a gigantic cooking wok floats above the curving outline of a planet with turbulent oceans and land-formations. The wok is on fire.

Another of Lucia's powerful works is *Spying Eyes* (Colour Plate 37), an example of a more conscious use of the

Nashar, a Surabaya artist, and later married a fellow student, M. Sulebar Soekarman (see Plate 54). After completing his art studies in the Netherlands and France, he was promptly hired by the Jakarta Art Institute. 'Everybody knows that Nunung is a better artist than her husband,' a prominent female artist said. The fact that he, rather than she, gets the appointment and the consequent prestige reflects two things: the status a degree confers on a person in Indonesia, and the priority given to men in the hiring process. It must be noted, however, that Nunung has always been supported strongly in her work by her husband, who shares the domestic responsibilities, and more and more has come to identify himself as an art historian and researcher, without giving up his own artistic pursuits.

female form in her works. Here, a young woman in foetal position hovers in mid-air between zigzagging, parallel walls of brick. Rather than crossing mountain ranges, like the Great Wall of China which it indirectly resembles, the wall crosses banks of clouds. The wall is cracking but still appears solid enough. Floating over it are two lengths of blue cloth, one of which supports the prostrate woman. Surrounding her, perched on the wall, are eyeballs, omitting rays of purple, blue, and red light towards the woman. It is a work filled with questions, one of Lucia's strongest to date. It marks the beginning of her inclusion of human figures, especially women and children, into her vast and previously impersonal cosmoscapes. In recent years, Lucia Hartini's work has been receiving increasing attention, as far as Japan and the United States.

Hildawati Soemantri, ceramicist and faculty member at the Jakarta Art Institute, is representative of the strong contribution of Indonesian women artists in the area of sculpture. It is perhaps because modern Indonesian sculpture is peculiarly underdeveloped for a culture with such a rich sculptural history that women have been able to carve a significant niche for themselves within the field. Besides Hildawati's, of note are works by Edith Ratna, Dolorosa Sinaga, and Rita Widagdo. Hildawati creates modern ceramic works unlike anything else seen in Indonesia. Some of her works, such as groups of broken bowls arranged sculpturally, echo of a functional past. Conceptual and abstract, her work communicates a restrained anguish. *Broken Dream I and II* and *Accident in Space, or Form I* (Colour Plate 38) speak of failure and breakage. The cylindrical form of the latter, which externally could be viewed as a *lingga*, can, since its hollowness is revealed by the cracks and holes, also be viewed as

the vagina, passageway to fertility. This cylinder is dry, cracked, and cold; it could hold or nourish nothing within itself.[12]

Despite the fact that her works are more expressive of pain than those created by most Indonesian artists, Hildawati in no way sees herself as a feminist; rather, she dislikes discussion about inherent social restraints on women in Indonesia. 'Indonesia is a very accommodating society,' she says. 'Women have not been the underdogs, they have always been able to work. If a woman makes an issue out of feminism, it is because she feels subservient to her husband. This is based more on personality than on culture.'[13]

Compared to other women in Indonesia, these upper middle-class female artists have opportunity and freedom. Many have travelled and some have studied abroad. Not all of them need to be economically productive, though some do. For those who do not, the challenge is to resist the social pressure to fill their leisure time with meetings and social gatherings of official and informal women's organizations, to create the time for a career in art. If they have the right connections, they have in the 1990s increasing access to funding and exhibition spaces as well as gallery representation.

Rebirthing a Modern Woman: Kartika Affandi-Köberl

Kartika (b. 1934) (Plate 105) is the daughter of the celebrated painter Affandi and his first wife, Maryati, who was also artistically inclined. Now in her late fifties, Kartika is a rare example of a

[12]This way of viewing space both externally and internally is familiar from Hindu architectural iconography, also as practised in classical Javanese art.

[13]Pers. com., November 1990.

105. Kartika Affandi-Köberl, 1988. (Photograph Astri Wright.)

second-generation painter in Indonesia, one of the few painters, male or female, who grew up in an atmosphere where paint, canvas, and art talk were central parts of life, not merely considered a new, Western, 'modern' thing to do. Up until 1989, she was one of only three women painters, to my knowledge, to have had solo exhibitions in Jakarta.[14]

Kartika's background is unusual even for Indonesian middle-class, educated women. Born in Jakarta, she lived there and in Bandung during the years leading up to the Japanese Occupation. The family was so poor that they often did not know where the next meal would come from. Affandi painted houses and movie posters, and collected tickets at a local movie house (Umar Kayam, 1987: 215). When Kartika was fifteen, Affandi received a grant to study art at

Rabindranath Tagore's school, Santiniketan, in India. Upon arrival, Affandi was perceived as so accomplished that Tagore said: 'You're already a painter! You don't need to learn from us! Why don't you just travel and paint, and put Kartika in the art academy instead?' However, Kartika, who had already painted with her father for many years, did not study painting; instead she took dance and music lessons.[15]

From the age of seven or eight, Kartika had been instructed by her father in how to paint with her fingers directly on the canvas.[16] Like Affandi, she has no permanent studio, preferring to paint outside in the village environment, interacting directly with her subjects while painting them. This is unusual in Indonesia, where most painters paint in their studios and often from photographs or from sketches.

Kartika's work might be divided into two groups. The first is her 'breadline' work that she knows will sell, that combines the quality of the pre-Independence 'Beautiful Indonesia' school and 'ibu-ibu' art with her own vision. In her 'beautiful scenes', Kartika plays with lyrical images of sweetness and nostalgia, a style which, despite the reservations of Western art critics, is highly regarded in Indonesia.

Here are bright, harmonious landscapes both from Indonesia and abroad, images emphasizing the harmony and intimacy of Mediterranean orchards and the exoticism of Venice. Here are snow scenes, often from Austria, which are among her strongest landscapes. Painting with her bare hands in the cold

[14]Maria Tjui exhibited her work at Balai Budaya in Jakarta in November 1987; Kartika exhibited at Duta Fine Arts Gallery in Jakarta in April/May 1988; Kartini Basuki exhibited her work at the French Cultural Centre in 1988 or 1989.

[15]Where nothing else is noted, quotes and information are from interviews between November 1987 and March 1991.

[16]Affandi wanted to experiment with her to see if it was possible to bypass the stage of realistic studies and still produce a good artist. Clearly, this made it all the more difficult later for Kartika to liberate herself from her father's strong influence.

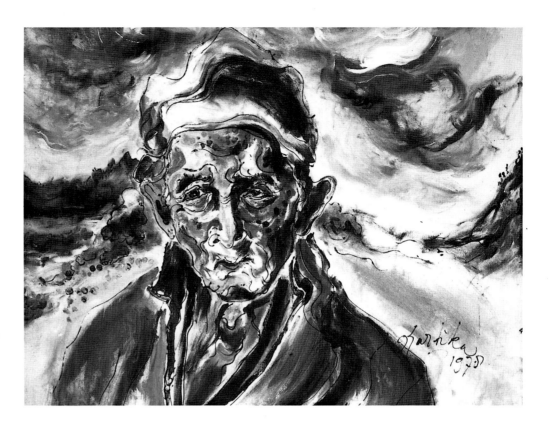

106. Kartika Affandi-Köberl, *Hindu Priest*, 1978, oil on canvas, 78 × 98 cm, when photographed, collection of the artist. (Photograph Astri Wright.)

and snow, she is less likely to be tempted to overwork the canvas. Here are nostalgic depictions of Indonesian village life: bird markets, ox carts, rustic houses, bamboo groves, rice-fields, farmers plowing, and family scenes. They depict the exotic splendour of the touristic, such as temples, terraced rice-fields, and dancers in Bali or colourfully carved East Javanese fishing boats, as well as vistas and landscapes from Europe (Colour Plate 39). It is in the energetic handling of the paint, combined with delicate, well-balanced compositions that make many of these works superior to those of all but the best Indonesian painters working on similar themes.

The second and more significant work historically, as well as that which most clearly distinguishes Kartika from other Indonesian painters, is her portraiture. Many of her portraits achieve a psychological depth rarely seen in an art world in which the individual is still largely depicted as a character type or as part of a community. Kartika paints people in a way that gives them a tangible psychological dimension, never flattering her subjects by painting them more superficial or beautiful than she sees them.

Hindu Priest (Plate 106) shows an old man, close up, as he walks on a beach. It is a preoccupied, intense image, which could be taken right out of an Ingmar Bergman movie. There is nothing here of the glamour and romance or mystique and aura that so often characterizes images from Bali (compare Supono's *Balinese Priest*, Colour Plate 6). Similarly, Kartika's *Husband and Wife* (1986) shows an old Austrian couple seated at their table, bathed in the light coming in from the windows in the thick stone wall, two old people at peace with themselves in their waning years.

Following in the populist footsteps of Affandi, Kartika also paints rural workers, beggars, and handicapped women. The old man in *Seated Fisherman*, resting on the beach by his boat, looks up at the sky with a weary expression. The handling of the paint and colour creates the impression of skin in folds over an emaciated frame. Close up (Colour Plate 40), his torso is a strong, abstract statement. Both Affandi's and Kartika's work, when viewed at a short distance, communicates the aesthetic experience of creative energy deposited in thickly flowing, curving lines of paint. However, one of the things which distinguishes Kartika's work from her father's is the range of colours in the thin background washes under the thick impasto relief of oil-paints. Furthermore, compared to her father's, Kartika's compositions are more controlled and planned, her lines less wild and emotional. A final difference between the two is the way they interact with their models: Kartika becomes acquainted with the people she paints. An old beggar

woman had posed for Affandi for years without ever being encouraged to talk about herself. Kartika, on the other hand, knew her life story intimately (Plate 107).

In style, Kartika's work ranges from the sweet and idyllic to an expressive realism that can be harsh. The latter is evident in her paintings of beggars, handicapped people, and suffering animals. She also depicts the uncompromising progress of old age. Kartika's black-and-white work has an energy about it that stops the rendition from becoming sweet.

Most involving of all are Kartika's self-portraits. A case can be made for how her personal history has shaped her self-image, which in the case of self-portraits directly informs her art. The artist's unusual degree of openness about her past and how her emotions became encoded in paint makes her art and her life seem like two inseparable strands in a single narrative.

Kartika was engaged to a young Javanese artist at fourteen; at seventeen, they were married. Saptohudoyo, after

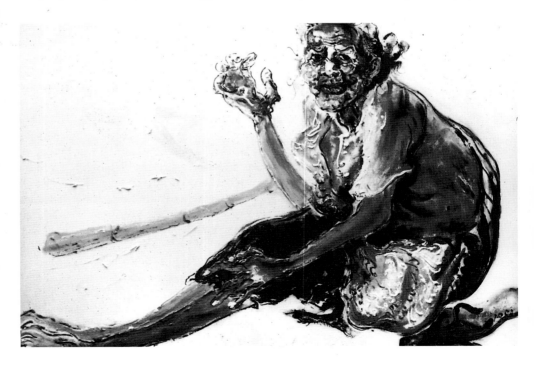

107. Kartika Affandi-Köberl, *Beggar Woman*, 1988, oil on canvas, 99 × 130 cm, when photographed, collection of the artist. (Photograph Astri Wright.)

studying fine art and design in Amsterdam, London, and Boston, taught at the Yogya art academy. Coming from a petty nobility family in Central Java, and having married into the most important artist family in Indonesia, Sapto quickly developed his talent for public relations and entrepreneurship. Kartika, a strikingly beautiful young woman, was allowed to occasionally dabble in painting (with materials given her by Affandi), and was frequently asked to model, fully dressed, for groups of painters in Yogya.

As everyone who reads the women's magazines and newspapers in Indonesia know, their marriage was a stormy one.[17] From the beginning, Sapto was alternately unfaithful and repentant. Kartika tells how her anger, hurt, and depression were thus continuously provoked—yet the children kept coming, and with social pressures which quietly sanction polygamy (both formal and informal) and censor divorce, she did not feel ready to initiate a divorce till several years after the birth of their eighth and last child. A self-portrait from 1966 reveals Kartika as a tired and drawn woman, a bitter line of disillusionment around her mouth. The vigour with which she treats the paint underlines her state of mind.

After four years of bi-weekly appearances in Islamic courts, the divorce was granted in 1974. Throughout this time Kartika had to challenge Islamic laws pertaining to women's rights both within and after the termination of marriage. In the process, she was criticized as immoral, and effectively ostracized by friends and social contacts. She withdrew to the fold of her family— her parents, children, and grandchildren.

The second beginning in Kartika's artist career occurred around 1980. In 1980–1 Kartika studied painting restoration in Austria to enable her to repair Affandi's paintings, many of which are in a terrible state.[18] While in Austria, loneliness and ample time for reflection planted the seeds which resulted in her most feminist or liberated visual statements, and paved the way for her unique and symbolic self-portraits. This was also where she met her present husband, Gerhard Köberl.

The two paintings painted in 1981, *The Moment of Beginning* (Colour Plate 41) and *Rebirth* (Colour Plate 42), are two of the strongest autobiographical statements in modern Indonesian art concerning the pain of a woman's search for her identity. Such works are especially shocking in a culture which emphasizes emotional restraint and the suppression of individual pain. They are unique in that they are disturbing, and by some standards, ugly—qualities that are not sanctioned within what might loosely be described as an Indonesian aesthetic (see Chapter 13). Here are depictions of that part of a woman's body which is most taboo. *The Moment of Beginning* is based on a composition that throws traditional iconographies into chaos, with the head depicted lower than the body, and bleeding female genitalia dominating the right, upper part of the canvas. The sense of falling violates a cultural urge towards balanced and upright reserve.

Not seeking to idealize her own features, Kartika has given us an image which is instantly recognizable as *her* as well as of every woman who has to fight to gain freedom from imposed definitions

[17]What details in the following do not appear in the mass media, Kartika told quite openly in a lengthy interview recorded by TVRI in November 1988, from which selections were used in the one-hour-long 'Profil Budaya' (Cultural Profile).

[18]This is due, in part, to their being made with cheap materials and stored under terrible conditions, in dust and humidity, sometimes rolled up and crushed under other objects. Affandi's habit of drenching the canvas surface with oil before painting also promotes more rapid deterioration.

of self and self-respect. Tearing off mask after mask till she reaches the bare bones of her skeleton is a powerful way of suggesting that those were roles she was socialized to play, not really her.[19] Depicting herself as an old woman with a shaven head being reborn from her own body is a potent illustration of the idea that liberation and psychic rebirth can only come from within the husk of the old self.

Kartika's lack of reticence about her body is unusual in Java. In this respect, also, she is at odds with a culture in which the body, sexuality, nakedness, left-handedness, and such like, are areas of life that are considered necessary to suppress. Kartika describes an innocuous enough incident that brought great embarrassment to her mother:

I remember I woke up one night—I must have been around five, and said to my mother, 'I want to peepee!' And she said, 'fine, go and do it quickly and then go back to sleep; your father is going to sketch Mami now and you must not tell anyone.' So, the next morning I woke up early and ran out to greet the milkman. My mother was at my heels as I told him eagerly:
'My father painted my mother in the nude last night!'
'Oh really—can I see the painting?' said the milkman.
'No, of course not,' said Kartika, 'I am not allowed to tell anyone about it!' And Mami, coming right behind me, heard it all—her face was bright red.[20]

Kartika's depiction of the female body provides a sharp contrast to Basuki Abdullah's plastic Barbie-doll pin-ups (such as *Reclining Nude*, Plate 95), whose nudity is so unreal as to hardly bother anyone. Kartika, on the other hand, paints the heaving and tearing of birthing labour in a manner that does not eschew reference to the natural functions of the body. In this way, she is also following in the footsteps of Affandi, whose paintings of nudes have been the subject of much scandalized attention (*KOMPAS*, 26 May 1990). Possibly the first, and definitely the most persistent, among Indonesian painters to understand human anatomy by studying his own, his wife's, and various models' bodies, Affandi's nudes are exceptional in a culture where finding models who would pose nude was almost unthinkable at first, and has remained difficult.[21] The sensitivity surrounding the issue of an artist working directly with a nude woman may be one reason why Widayat, who has executed masterly drawings of nudes, has subtitled them 'nudes drawn from the imagination' (Kusnadi, 1987: 50–2).

The sensational treatment in the media of the question of nudity in Affandi's art illustrates how it is actively suppressed in Javanese culture. The fact that people in overpopulated Java occasionally bathe naked or relieve themselves in rivers and ditches and can be seen from the road, illustrates only that nakedness in the context of personal hygiene is not considered shameful or considered a

[19] As suggested by Kamalpreet Sidhu, a student of mine, an alternate reading might be to see the woman trying to pull her face back on, to cover her naked, revealed self or emotion. In either case, the terror and pain are at the centre of the work.

[20] The milkman, Sudarso, went on to become a well-known painter.

[21] A self-portrait in pen and ink from 1948 shows Affandi seated naked on a stool (Umar and Raka, 1987: 26). Reproductions of a beautiful water-colour of a reclining nude from 1943, an oil of a nude from 1947, a hilarious *Nude with Two Cats* from 1952, and the two delicate nudes from 1965, illustrate Affandi's return to the subject over a period of more than twenty years (Umar and Raka, 1987: 74, 72, 80, 122, 123). The Bandung painter Mochtar Apin, who studied in Holland and France, is another well-known Indonesian painter who has continued to paint nudes regularly throughout his career, ranging from fairly realistic to cubist and near abstract. Black-and-white photographs of three of his nudes can be seen in the Claire Holt Collection at the New York Public Library's Dance Collection at the Lincoln Center.

display, and is not 'seen'. All other instances of nakedness are socially taboo; references to body functions related to sexuality are accompanied by embarrassment, and are subject to extensive 'off-colour' joking and rewriting.

Kartika, however, speaks freely of the body. Her own generous body emanates motherly sensuality—one not constrained by narrow moral precepts, the fear of how people will interpret or judge her, or any embarrassment about the body's natural functions.

An only child until her half-siblings were born when she was in her twenties, Kartika was in different ways extremely attached to both her parents. She inherited her free spirit, perseverance, and stubborn will to be herself, including the notion that she has the right to act upon a strong libido, from her father. She inherited her ability to nourish, feel compassion, and suppress her own feelings before men from her mother.

The 1980s saw Kartika finally confident about being in control of her life. Her hard-gained independence and her determination to make her own decisions and hold her own ground is evident in a painting entitled *Self-portrait with Goat* (Colour Plate 43).

In mid-September 1988, Kartika started working on a new type of self-portrait. It was a triple portrait, showing Affandi to the left, Maryati to the right, and herself in the middle (Plate 108). In her numerous preparatory sketches, made sitting on the floor before her parents, relaxing on a bamboo bench in the shade under Affandi's house on stilts, Kartika was searching for a way to depict the different elements she has inherited from each of them:

First I wanted to paint Papi's face really large and overlapping with mine, so that we had one eye in common—I guess I feel like I am more like my father. But then, after working on this idea for a while, I realized how much I am like my mother too. So I thought of

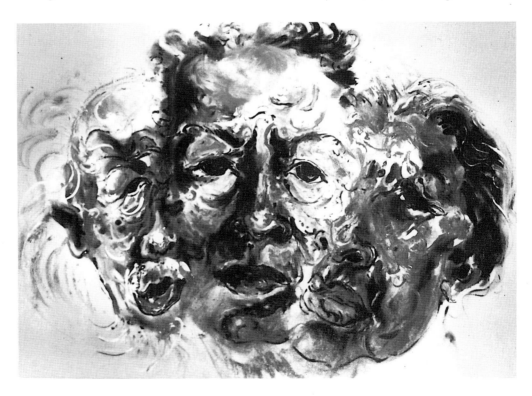

108. Kartika Affandi-Köberl, *Self-portrait with Mami and Papi*, 1989, oil on canvas, when photographed, collection of the artist. (Photograph Astri Wright.)

painting them, one on each side of me, slightly behind me, peering out above my shoulders. But then I thought that was not strong enough. I would really like to show us all the same size, our faces growing out of one neck. But I am not sure if I can do this without it looking really ridiculous.

Kartika knows herself, and her worth as a person and an artist. She is confident and free of many of her society's norms and judgements. She is comfortable with her multiple roles as artist, painting restorer, president of the Affandi Foundation, employer, wife, mother, grandmother, and economic matriarch of a large family and patron of a village. She also approximates Western notions of a 'feminist'. When National Television wanted to do a 'Cultural Profile' interview with her in connection with National Kartini Day, celebrated in honour of the first champion for women's education, Kartika's answer was: 'I am not interested in being interviewed because I am a *woman painter*. I will gladly do an interview as a painter, but why should that be on the one day a year which is set aside for women? When do we have a special day set aside for men?' At this last question she burst into laughter (Wright, 1988a).

Despite being the daughter of Indonesia's most famous painter, Kartika has only recently been recognized by the art establishment. Her parentage, which has brought her a certain amount of fame since her youth, would no doubt have greatly facilitated her career had she been a male who decided to follow in his father's footsteps.[22] In 1989, Kartika was

represented in only one of Bali's three major galleries (Rudana's) and in one of Jakarta's (Duta) although she sells as well as famous male painters. Like other Indonesian artists up until the recent development of gallery networks, Kartika has sold out of her home and the Affandi Museum, which houses both her and Maryati's work besides that of Affandi.

Kartika is the only female painter who has thought or dared to openly express the pain and struggle of a woman in search of her true identity no matter how this might clash with culturally imposed roles of womanhood. In this way, she is one of the few painters in Indonesia, male or female, who touches on Western-like notions of identity and self in an art environment which nourishes a very different approach to self-expression.

Summary of Part I: Roles of the Artist

Having discussed several individual artists and their work in the preceding chapters, it is useful to summarize a few observations about the roles the painters appear to have more or less consciously cast for themselves. The roles of modern Indonesian artists and the meaning of their work, besides being representative of Western-inspired innovations of the modern era, also resonate within a realm of ideas that trace their genealogy directly back to pre-modern artists and art works. Contemporary individual artists use differing terminologies to describe their philosophies of art, spirit, and the artistic process, but these can often be interpreted as variations on a set of interrelated ideas. When artist roles centre around traditional ideas about spirituality and creativity or syntheses of these, they will, despite individual variations, be recognizable to a wider,

[22]The art world's slow and grudging acceptance of Kartika as an artist has been rationalized on the basis of her work being 'too much like her father's'. This accusation reveals a lack of sensitivity to the many subtle ways in which her work differs from that of her father's. Furthermore, the accusation could be made about many other painters to whom are paid enormous amounts of attention. Basuki Abdullah, for one, is the son of the well-known

painter Abdullah the elder (1878–1941) and his style is as close to his father's as Kartika's is to Affandi's.

non-specialist audience.

In one case, the artist is seen as an interpreter of spiritual insights and concrete messages. The artist is seen (and possibly sees himself or herself) as a person imbued with the perceptive abilities and creative powers to give tangible form to aspects of reality which remain intangible to most people. This would apply to artists like Agus Ismoyo, whose interpretive efforts are made both on behalf of themselves and a public to whom they are willing to lend guidance, when approached.

Another role is the artist as seeker of individual blessings. The artist is seen as a person imbued with god-given talent, whose duty it is to serve God's will by pursuing this gift to the full, the pursuit basically synonymous with the pursuit of God. This effort is essentially a closed circuit, continuously running back and forth between God and the individual, the art being the material evidence of this process. Ahmad Sadali could exemplify this model.

Some artists play the role of synthesizer of seemingly contradictory religious ideas, as presented in the Hindu–Buddhist, Islamic, and Christian traditions. Widayat's and Nindityo Adipurnomo's work are examples of this. Widayat creates ahistorical, non-temporal visions about the 'teaming life of the universe', while Nindityo creates paintings in a cross-cultural version of spiritually and ethnically informed abstraction.

At least on the rhetorical level, the art work as a marketable end-product is not the primary focus of these artists. In some cases, the work is perceived as too personal to part with,[23] in some cases it is destroyed.[24] In some cases, when a work is marketed at a high price,[25] this is rationalized as God's providing a livelihood, a tangible form of blessing (*rezeki*).

The artists that stand somewhat outside of the above interpretations are those whose art approaches the inner life in more secular formulations. These artists seek to depict psychological realities without particular reference to an external deity or spiritual dimension. Artists like Ivan Sagito and many of the women artists are addressing the shaping of the person rather than, or in addition to, the transcendental dimension of the soul; they address the spirit as it is influenced in concrete and tangible ways by cultural traditions embedded in, and propagated through, social relationships. While not necessarily focusing on, or challenging, those relationships directly, they depict psychological states created in their wake. These artists are working outside of, but tangential to, the perimeters of spiritual tradition. Hovering as they do somewhere between the perception of the mountain as a spiritual entity and a material one, their art works exhibit qualities that resonate with some of the meanings that 'modern' holds elsewhere in the world, also in Euro-America. Preoccupied with the emotional or existential pain that arises in the course of living in a post-colonial, late twentieth-century society, these artists constitute a bridge to the next part of this study.

[23]A. D. Pirous mentioned this feeling as one reason why he does not sell every painting he makes, and why he has not pursued galleries to carry his work.

[24]Agus Ismoyo has, on occasion, covered a painting with black paint.

[25]One of Pirous's works was, in 1989, priced at Rp 10.5 million (*c*.US$5,830); many other similar examples of works by different artists could be cited.

PART II
The Mountain as Metaphor for Society

7 The Mountain as Society

IN the modern era, the image of Indonesian society is increasingly dressed in new terms and categories, which differ in emphasis from the world-views discussed in earlier chapters. The inclusion of divine, mystical, and magical forces as aspects of reality (and therefore of society) still persists, but these are no longer always or automatically placed at the centre of explanations of causality; something of a separation between the 'sacred' and the 'secular' takes place.[1] The art and artists discussed here show the influence of the development of ideas first introduced, one might argue, after the arrival of Islam, and more significantly, after the arrival of the Dutch, to be further shaped during the nationalist movement and ensuing independence.

Although Islam claims no separation between the realms of religious and political authority and provides a model for the state, Javanese interpretations have differed. Whereas 'rural religious teachers held to more purely Islamic formulations, the Javanese élite mixed them within an Indic-Javanese framework. Dutch alliance with the traditional bureaucracy deepened this tension and strengthened the subordination of mosque officials (*penghulu*) to the governing élite (*priyayi*)' (Stange, 1980: 43–4). A germ for the idea of a separation between sacred and secular, between religious and earthly power, between a spiritual and a social community can be located in Islam's view of God as radically separated from man. 'Between God and man there is an immeasurable distance. God is all powerful, all knowing, and all merciful; man is nothing more than his creature' (Anderson, 1990b: 70). In contrast to Javanese cosmology, where divinity is perceived as 'something formless and intangible suffusing the whole universe', most visible in human beings of extraordinary spiritual and/or political powers, under Islamic influence the idea of power becomes 'removed from the world, since it lies with God, Who is not of this world but above and antecedent to it' (1990b: 70).

With the arrival of the Dutch East India Company (Vereenigde Oostindische Compagnie) in the South-East Asian archipelago in the first years of the seventeenth century, the foundation was laid in place for what was to become a large and efficient state machinery, with the gradual development of a highly specialized bureaucracy which reached deep into native society. 'Education, religion, irrigation, agricultural improvements, hygiene, mineral

[1]As has been documented at length, there is no absence of mystical vocabularies and personal idiosyncrasies in the wielding of socio-political power in modern Indonesian history. See Mochtar Lubis, 1969; Legge, 1972; Anderson, 1990b.

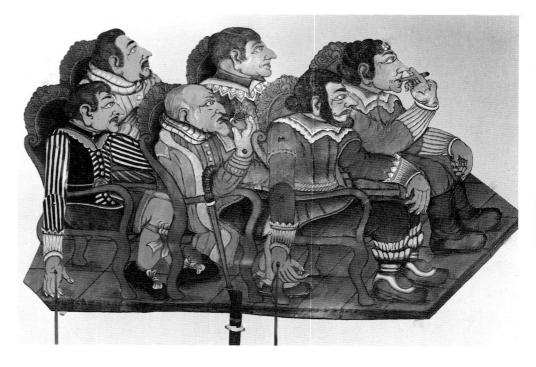

109. Lebar, *wayang* puppet depicting Dutch delegation, exhibited at 'Wayang Creation Exhibition', Yogyakarta, October 1988. (Photograph Astri Wright.)

exploitation, political surveillance—all increasingly became the business of a rapidly expanding officialdom' (Anderson, 1990d: 97–8). This system was based on rationalist notions about efficient methods of maintaining peace and stability, fuelled by secular loyalties within a clearly arranged and hierarchically organized institution where each rung was marked by clear rewards.

The gradual desacralization of power, and the accompanying disillusionment with old ways of thinking about power, was facilitated by seeing it in the hands of foreigners—tall, large-boned and (from the Javanese perspective) ill-mannered Dutch who in the *wayang* vocabulary fit the description of the *raksasa* (giant-demon) (Plate 109). These outsiders were seen wielding authority over the native aristocracy. Even within the Indies' bureaucracy, 90 per cent of which was native, and the Royal Netherlands Army, the highest positions were reserved for whites (Anderson, 1990d: 98, 100).

A central factor contributing to a waning in the old belief that the earthly realm mirrored the divine was the impoverishment of unprecedented large sections of the population during the latter half of the nineteenth and the first decades of the twentieth century, which reached massive proportions when the East Indies state and trade apparatus fell apart during the Japanese invasion.[2] At the same time, the slow but sure increase in Dutch-style education led to a greater degree of literacy, and much of what was previously perceived as mysterious now became recoded in Western scientific terms. The fact that an active experience of the mysterious none the less remains a part of Indonesian culture today may illustrate the ongoing tendency towards dualism, as expressed in traditional Javanese cosmology. The more the 'rational' mode of operation gained

[2]See Kahin, 1952: Ch. 1; Geertz, 1963; Anderson, 1990d: 99.

eminence in the Indonesian nation, the more new mutations and adaptations of older modes of thinking occurred.

At the beginning of the twentieth century, Indonesians began to look more self-consciously to their past as well as out into the world, in search of a definition of self which contrasted with perceptions of 'the native' cultivated by the Dutch for 300 years. Study clubs, where young Javanese, Sundanese, and Sumatrans (predominantly of noble or privileged backgrounds and educated in Dutch schools) discussed foreign literary and political documents, were important vehicles for the introduction of new ideas. Among other things, various European Marxist writings were introduced, mostly in Dutch. Here were theories that addressed social inequities and proposed agendas for their improvement, to be carried out with new types of institutions and attitudes, such as the forceful notion of solidarity along horizontal lines or classes. However, at the same time as new ideas, vocabularies, and modes of action were developing in some sectors, an entrenchment into older, highly stratified world-views and ways of operating was taking place in others, specifically among people employed and (relative to the rest of the population) empowered by the Dutch. This process was facilitated by the affinities between Dutch officials' modes of analysis and behaviour and traditional Javanese ones (Anderson, 1990c: 123–51). However, leading figures in Indonesian politics would also make use of traditional language and imagery pertaining to power, as illustrated in different ways by both Sukarno and Suharto.

Thus we see that, in twentieth-century Indonesia, to speak of a secular world-view can only have a measure of validity when seen in conjunction with traditional world-views discussed in preceding chapters. Present-day Indonesia—

whether in the areas of politics, education, or interpersonal interaction—exhibits a mix of localized rational/modern and revitalized mystical/traditional values.

During the last hundred years of Dutch colonization, large parts of the village economy had been turned from individual family subsistence agriculture to a foreign-owned, cash crop system, with increasing numbers of labourers indentured into the web of usury which developed around the wage system. Java was particularly hard hit by the Great Depression, suffered under increasingly harsh Dutch taxation and measures of control leading up to the outbreak of the Second World War, and further deprivation and hardship during the Japanese Occupation (Furnivall, 1944: 25–7).

Educated Indonesians, seriously underemployed, if not unemployed, under the Dutch (Kahin, 1952: 33–49), knew there was no other choice but to participate in modernizing their world, whether by continued collaboration with the Dutch, guided by colonial educational and institutional examples, or by full-scale revolution, overturning political as well as material, social, and conceptual structures that kept them in different forms of servitude.

The early decades of the twentieth century saw the emergence of real political mass organizations in the popular movement (*pergerakan*), which gave rise to Islamic, nationalist, and communist organizations (see Shiraishi Takahashi, 1990). During the course of the revolution, people increasingly gained a sense of how it might be possible to influence socio-political realities from below. The 'mountain' as a diagram of Indonesian society during the revolutionary era and the first years of Sukarno's rule would read like a squat triangle with a wide baseline, with

spotlights illuminating the lively activity along its foot and up the sides.[3] This triangle would be characterized by a certain blurring of boundaries between one part and another.[4]

In contrast to this triangle is the 'mountain' diagram of the New Order:[5] an image which shows many reversions to the Dutch colonial state model, with the weakening or abolition of political and mass organizations and a Pancasila Democracy instituted in its place. With little political power in the hands of the lower-class Javanese and all other ethnic groups, and obligatory support of the government party GOLKAR demanded of all civil servants, a statewide system reinforces the ideology of 'mono-loyalty' and a relatively small army maintains internal security (Anderson, 1990d: 117). The New Order triangle would appear tall, with a narrow baseline.[6]

[3]Seeing the mountain as a diagram for society is not purely the author's poetic invention. Geertz reports that one of his informants in the 1950s drew a diagram of Indonesian society as a triangle with horizontal divisions representing a hierarchy of occupational ranks. The bottom segment consisted of 'landless agricultural workers, handmen, unemployed, beggars, etc.'. The next segment up from the base consisted of 'small craftsmen, petty traders, plantation workers'. The middle was occupied by 'traders, store-owners, land-owning peasants' below 'petty clerk and lower teachers'. The lower part of the top was occupied by 'high clerks and administrators, high teachers', and at the pinnacle the informant wrote 'government officials' (1960: 361).

[4]Anderson describes this as a situation in which the nation's interests are given scope and priority at the expense of the state's efficiency, in which 'power shifts decisively into the hands of extrastate organizations typically recruited on a voluntary and mass basis' (1990d: 96).

[5]'Orde Baru', the name given to Suharto's reign, in contrast to 'Orde Lama' (the Old Order), the term used in retrospect for the Sukarno period.

[6]Drake (1989) describes a country with 'severe regional disequilibrium', where the majority of valuable regional exports go to Java, and more than half of this to Jakarta. In particular, she writes, Java's widespread poverty and deprivation is reflected by the fact that 'the incomes of well over

Artists and the Struggle

With Java increasingly drawn into the upheavals of world events in the first four decades of this century, and the developing nationalist movement calling for an end to colonialism, it was inevitable that many artists in the 1930s and 1940s should be as concerned about politics as about art and see the two as inextricably intertwined in their lives.

The Indonesian Revolution, fought in the fields and the villages against a superior military presence, stimulated artists to look at peasants and workers through new eyes. During the Revolution, many artists worked for underground organizations, sketching on the battlefield, painting posters for popular mobilization, and painting portraits of revolutionary heroes (Plates 110 and 111). The artist functioned as a witness who could pass on, in tangible form, what he had seen. Even children were in some cases organized to pose as cigarette or snack sellers and roam the streets in search of information about Dutch activities, which they would then record in quick sketches. Some of these child fighters remained artists after independence.[7] Another new form of

one-half of the inhabitants of Central Java, Yogyakarta, East Java and the small islands towards the east fall below the poverty level'. She argues that the fact that, in reality, not as large a percentage as this are deprived of sufficient food illustrates that people are not tied into the money economy at the lower levels of society and practise a certain amount of barter and sharing (quotes from the review of Drake's book by P. W. van der Veur, *Journal of Asian Studies*, 1990: 42(2)).

[7]Dullah (b. 1919), palace painter and curator of the presidential collections under Sukarno, organized children's resistance groups. When the children, who could be more mobile than grown men, came upon an incident between Dutch and Indonesians, they would pull out their hidden crayons and paper and sketch it quickly before running off. Dullah has devoted a whole room to children's art of the revolution in his museum in Solo. Some of the children he worked with were

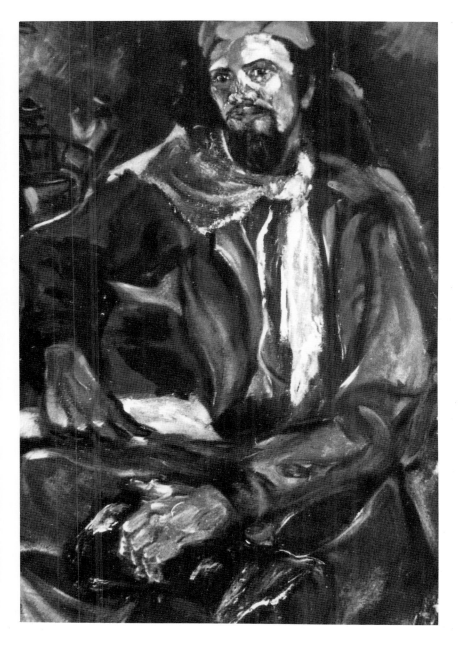

110. Sudjana Kerton,
Napitupulu, 1946, oil on
triplex, 100 × 70 cm.
(Sukarno Collection,
Vol. IV, No. 31.)

subject-matter in painting, introduced during the Revolution and developed with Sukarno's support in the 1950s, was that of history painting. One of the most frequently painted historical figures was Prince Diponegoro (Plate 112).[8] Many artists devoted time and energy to painting scenes from the history of the struggle of the peoples of the archipelago against foreign oppression: Hendra Gunawan, for example, painted historical scenes to give to the museums in the provinces where the incidents had originally taken place (see Chapter 8). Numerous exhibitions have been held of paintings of the Revolution, and amateur portraits of national heroes are paraded through the towns and cities every 17 August (Plate 113).

It is against the background of New Order society—which combines in its image of a highly stratified mountain both Javanese neo-traditional vocabulary and a Western capitalist language of development—that one must examine the work of Indonesian painters who insist that society be their source of inspiration, whether this be from a political or humanistic, communal or personal perspective.[9]

captured and sent to Dutch children's prison, never to be seen again (Dullah, 1982b; Interview, August 1988).

[8]Prince Diponegoro led a rebellion called 'The Java War' against the Dutch in Central Java between 1825 and 1830. As the nationalist movement developed in Indonesia, historical forerunners for the independence movement were sought and Diponegoro was hailed as a major historical hero of the Indonesian people (see Carey and Wild, 1986b: 6–11). In the mid-1950s, a series of paintings of historical events termed 'nationalist' was commissioned by the Jakarta publishing house FASCO, to be used in schools. In 1956 and 1957, Claire Holt photographed twenty-six of these paintings, mostly by Zaini and Oesman Effendi, with a few works by Trisno Soemardjo and Basuki Resubowo. A catalogue, *Petundjuk Lukisan-Lukisan Peristiwa Bersedjarah Indonesia*, Jakarta: FASCO (*c*.1950s) was subsequently published of this work.

[9]Based on information like that sketched in fn. 6, it is clear that an artist growing up in Central Java would not necessarily need a radical political commitment to be inspired by themes of poverty and hardship in his art. By the same token, it is not hard to understand how someone growing up in such a social setting might feel driven to attempt to change social conditions according to ideologies which actively address the lives of the bottom two-

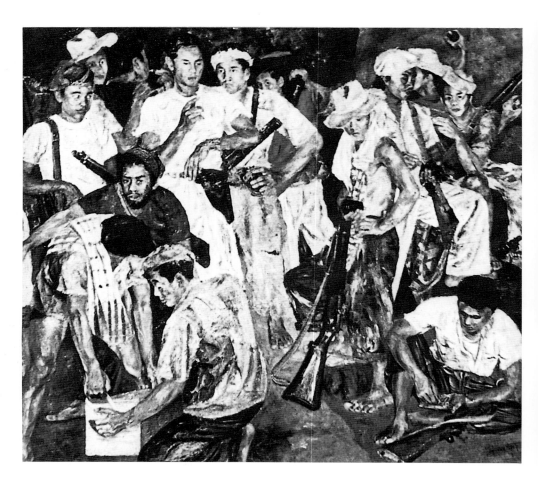

111. Duliah, *Guerrillas Preparing*, 1949, oil on canvas, 179 × 198 cm. (Sukarno Collection, Vol. II, No. 60.)

Geertz, taking his examples from contemporary Pare in West Java, describes the contemporary 'art world' in Indonesia as made up of

the interplay of expressive forms from the mass media, folk arts, rituals, court traditions, public ideologies—some quite new, some very old; some direct and improvisatory, crude even, some allusive and highly worked, effete even; some technically undemanding (a guitar strumming, a song parody), some technically extraordinarily demanding (a *wayang*, a Quranic chant); some with hardly any pretentions beyond emotional appeal and personal sincerity, some suffused with the aura of ancient myths and great revelations (1990: 93).

Many of the same qualities apply to the wide spectrum of contemporary Indonesian painting. The lack of reference in Geertz's description to 'high' art forms imported from abroad, such as classical music and painting, may indicate that these are not practised much in Pare, a small town of around 60,000 in the Kediri Regency. It is in the larger cities on Java that these cultural forms have a more visible presence.

The process of searching for alternative formulations to the traditional interpretation of society as microcosmos, and a more sociological formulation of society and man's place within it, can be traced in the works of both visual artists and writers. As they search for a new set of concepts with which to interpret life, they give tangible form to these

thirds of the nation's population. See also Kahin, 1952: 24–8; Hart, 1986: xiv.

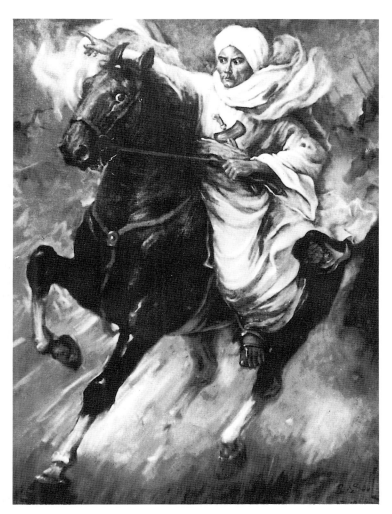

112. Basuki Abdullah,
*Diponegoro Leads the
Battle*, 1949, oil on triplex,
150 × 120 cm. (Sukarno
Collection, Vol. II, No. 95.)

113. Schoolchildren parading
portraits of national heroes
in Ambarawa, Central Java,
17 August 1984.
(Photograph Astri Wright.)

intellectual and emotional experiments through their artistic products. Since mysticism—whether animist, inspired by Indic religions or by Islam—increasingly was perceived by many intellectuals since the 1930s and 1940s as a main source for their nation's servile attitude and backwardness, many artists made conscious efforts to replace it with a more secular world-view.

The Mountain as Metaphor for Modern Creativity

Pramoedya Ananta Toer's use of imagery is illuminating in this respect. The image of the mountain figures prominently in an essay from the early 1980s in which he recalls a transformational moment in his life. Suffering in Dutch imprisonment between 1947 and 1949 for his nationalist activities, he had begun to contemplate suicide when he remembered his mother's teachings in Javanese mystical practices. Having rejected his Javanese mystical heritage a decade earlier, Pramoedya now decided to practise *patiraga*, the annihilation of the body through intense mental concentration (1983: 25 n. 2). Since the guards had taken care not to leave anything around with which the inmates might kill themselves, the power of the mind/spirit was the only solution left to him.[10] However, as the story goes, Pramoedya's attempt failed, and instead he had a vision:

What He [the Lord] gave me was a mountain, on top of which stood a four-pillared Greek temple crowned with a triangular pediment, and a full-blazing sun still higher up. You can see that it was no longer a question of reason, or of the flesh (1983: 26).

[10]This is in contrast to the rational mind, which Pramoedya had come to give prominence in his view of man; the rational mind in control of the body, as described by the Platonic oppositional pair, *rasio/daging* (Pramoedya, 1983: 25 n. 3).

During this experience, Pramoedya found himself on 'an island of happiness', which

contained within it liberation, a total freedom to survive as a self, intense, immune to all political, military, social and economic power in no matter what system—a sanctuary of meditation, a *conditio sine qua non*, which provided me the possibility for creative endeavor. This island is a *mysticum*, where creative work is faith. It's true; creative work is a form of faith (1983: 26).

Later in the essay Pramoedya returns to this vision, interpreting it as a 'diagram of the creative mechanism':

The mountain is simply the *pesangon*,[11] with its intenseness symbolized by the peaks; the temple is the knowledge, learning, intelligence and wisdom that could be abstracted from, formulated out of, the mountain, while the sun was the 'I', in its integrity. It is this sun that makes everything beneath visible or invisible, bright or dark. When all three are present in the *mysticum*, then the creative process has begun. The mountain and the temple are the tangible raw materials which only come to life when struck by the sun's rays. . . . And with the aid of this diagram literary criticism, and art criticism in general, can trace the mountain which makes possible the erection of the temple, and then the sun that illuminates it (1983: 36).

Apart from the mountain, which one at first glance might relate to the traditional image of the mountain as the totality of the world, its top signifying proximity and access to the divine, there are several points that relate to the present discussion of artists and society: the use of the mountain to represent processes of socialization, casting human life in social science terms rather than in spiritual; the presence of a Greek rather than a Javanese temple; the use of Latin in addition to Javanese mystical vocabulary, and the image of the sun. In these images

[11]*Pesangon* refers to the totality of cultural and personal baggage one is given during one's formative years.

Pramoedya is drawing on a culture outside of his own—or rather, he has made elements alien to Javanese culture part of his own intellectual and emotional experience. Having such elements in a vision suggests a deep level of psychological integration.

To Pramoedya, the sun shining down on the mountain in the vision represents the ego. This signifies the emergence in an Indonesian's world-view of the individual as a psychological entity, and in an unprecedented position of prominence, essentially taking the place previously occupied by the divine. Indeed, although Pramoedya invokes the Lord at the beginning of his vision, and writes throughout about the creative process as a fundamentally religious experience, it is Life which he sees as the higher principle which he must serve. In addition to the Western-derived imagery, Pramoedya also uses Javanese terminology, such as *patiraga* and *pesangon*, but these elements of tradition are arranged in a new way, side by side with non-traditional ones.

In Pramoedya's world-view, which I offer as an example of one individual's modern definition of the 'mountain', representative in the broadest terms of the painters in this section, the world is no longer seen as a reflection of a harmonious universe, governed by immutable cosmic laws. The function of art is no longer to celebrate this patterned order, whether represented in the figure of the ruler, in the life of the community, or in the individual's mystical experience. New forms of art have to be assigned a new function. Writing about literature, Pramoedya states that the function of art is to stimulate 'rational and emotional awareness and responsibility towards the infinite variety of life. Essentially the greatness of a literary creation depends on the degree to which it can stimulate such awareness and responsibility' (1983: 28). As we shall see, this thought resonates with the work and ideas of many of the painters in the following chapters.[12]

Painting the People[13]

In the first decades of the twentieth century, as the doors were opened, not only on Western but world history and thought, a small group of future Indonesians also became aware of Western art history. 'Painter' in the modern Western sense was introduced as a new category and career option—one with a modern, international aura. Likewise, foreign definitions of art and creativity were introduced, new concepts which Indonesian artists could fill with meaning, according to their own ideas and needs.

Imagine the entire world of art opening up through books and foreign teachers, and the occasional Javanese or Sumatran returned from study abroad. Imagine the cultural products representing human endeavours over thousands of years, presented on a single platter, like the famous 'rijsttafel' the Dutch had created out of various regional 'Indies' cuisines. This new world of art was filled with some familiar mythological themes in new garb—themes of creation and destruction, of good and evil, of the comings and goings between divine and human. Contact with Western art, however, also presented new visions of a type never seen before in the South-East Asian archipelago: images of fruits, flowers, and food *not* presented as offerings; lifelike portraits of prominent

[12]Given the political sensitivity surrounding someone like Pramoedya, whose recent work is banned, and with several of his underground disseminators and readers presently in jail, some painters would not agree with his stance on these issues or with my use of him as an example; others would.

[13]An earlier and longer version of this section is previously published as Wright, 1990d.

individuals *without* divine attributes; images of the naked body, male and female, of history in the making, and of regular people at work. In the 1930s and 1940s, pictures depicting peasants and workers as heroic figures overthrowing old structures to give room for new, found their way from the Soviet Union, Mexico, and China to pre-Independence Indonesia.[14]

From the time they first began painting non-traditional themes, many Indonesian painters incorporated themes and motifs into their work that had previously held no indigenous aesthetic value. This process of incorporating the new, the everyday, the lowly, and raising them to positions of respect, insisting on their participation in a system of aesthetics, continues to this day, as the following chapters will demonstrate.

The process of 'opening up' new areas of life to artistic legitimacy is familiar from Western art history. Gombrich wrote: 'We call "picturesque" such motifs as we have seen in pictures before. If painters were to keep to those they would have to repeat each other endlessly. It was Claude Lorrain who made Roman ruins "picturesque", and Jan van Goyen who turned Dutch windmills into "motifs"' (1984: 411).

Much modern Indonesian art could be called picturesque in the sense that safe and time-sanctioned themes and motifs are repeated. Most of these works would fall into the category of neo-traditionalist, decorative, mythological, or spiritual in an institutionalized sense. In contrast are those painters who wanted to try new and unfamiliar subject-matter. This was often identical with the most familiar themes, events, and sights in the painters' own lives, and

so a uniquely Indonesian range of categories of genre painting was created.

In Europe, it was Millet and Courbet who, in the nineteenth century, laid the foundations for the modern developments of genre painting by adding to the notion of genre a new mode of representation: realism. Millet shocked the public with his absence of artistic conceits and aesthetic clichés: his pictures of non-idealized peasants dressed in drab clothes, performing their tasks on the land, were at first seen as crude. Here, for the first time, we start approximating a depiction of the life of the lower classes in realistic dimensions. It is this attitude towards the subject, along with the stylistic novelty of a pre-impressionist approach, which causes Millet to be counted as one of the fathers of modern art.

Courbet was no less shocking: depicting himself, the Painter (a figure of elevated status since the Renaissance) as a wandering, manual labourer, he decried all vanity and pretence in a call for artistic integrity. In words relevant to the Indonesian situation, he wrote in a letter of 1854: 'I hope always to earn my living by my art without having ever deviated by even a hair's breadth from my principles, without having lied to my conscience for a single moment, without painting even as much as can be covered by a hand only to please anyone or to sell more easily' (Gombrich, 1984: 404).

The distinction between harmonious images of content villagers and depictions of the people's real-life conditions, frequently cause for suffering, is an important one. It is the latter which is the subject of this part of the discussion, and which has at times been the subject of intense political controversy.

In Asian societies, hierarchical cosmologies, operative as powerful ideals for the structuring of life on earth, even as conditions change, have affected the way people of different backgrounds

[14]For articles in Indonesian on socialism and communism, see *Bintang Merah*, the Indonesian Communist Party's newspaper and later journal of the late 1940s.

have been depicted in art through different eras.[15]

The manner in which human beings have been depicted in Indonesia throughout the ages eloquently reflects a changing world feeling. In prehistoric times there were generalized, schematic representations of human beings differentiated mainly by sex characteristics. In Hinduistic Indonesia a distinction appears which on the one hand stresses status, high and low, and on the other the polarities, divine and demonic. In this era of deified kings, beauty is the attribute of gods and princes. Ordinary mortals have cruder features, naturalistic at first but gradually assuming ugly or amusing grotesque forms. In Islamic Java such typology persists in highly stylized puppets and masks. It is no coincidence that shortly before the Revolution the individualized person, unique as a character, emerges with force upon the Indonesian art scene (Holt, 1967: 6).

Throughout the history of Indonesian art, glimpses of the lower classes at work and play, with a smattering of erotica, are relegated to peripheral scenes in temple reliefs and in *wayang beber* scrolls. Traditional art in Indonesia was mainly concerned with mythology and the ritual and spiritual aspects of life. This appears to be so, at least, in those works that have been preserved, such as the architecture and reliefs of Buddhist and Hindu temples, in the shadow plays and the *wayang* puppets, and in the rich body of textiles from around the archipelago.

It was in the late 1930s that S. Sudjojono, a young painter filled with the sense of mission of the nationalist movement, a general socialist outlook, and a growing awareness of himself as an artist and an Indonesian, took up arms against what he saw as an insincere idealization of reality. Attacking the practice of painting only 'pretty landscapes' and other 'acceptable' themes, Sudjojono called for artists to be truthful both to themselves and to art:

Every artist must take as his starting-point his own nature. An artist must be courageous in all things, especially when it comes to offering his ideas to the world, even if he does not receive any public recognition at all.... Each and every artist must embody these two qualities, *truth* and *beauty*. Not beauty in the sense recognized by the public at large, but from the point of view of aesthetics as understood by the artist himself (1946: 7; author's translation).

According to Sudjojono, the Indonesian artists needed to find themselves, as individuals, and develop the courage to express what they believed in openly:

To love truth is difficult for the artist, because this love will cause frequent conflicts between him and his neighbour, between him and his society, and between him and the world at large, because the world at large fears the truth (1946: 23; author's translation).[16]

The truth, to Sudjojono, lay in recognizing that the life of the artist was inextricably bound to the life of the Indonesian people. Thus, individualism, though important, was not enough; it had to be transcended with a sense of solidarity or comradeship:

Who will show the world: 'Look, this is how we are' ... A generation who will dare to say: 'This is how we are', which means this is our condition of life now, and these our desires.... The new artist would then no longer paint only the peaceful hut, blue

[15]Differing ideas of 'the people' and depictions thereof in relation to changing social structures and cultures in twentieth-century Asia, is a research topic which awaits in-depth investigation. The tradition of mainly depicting rulers and deities in non-perishable materials, in accordance with the hierarchy of values, has left large gaps in the pictorial record of society at large.

[16]Much of the painting of 'the people' has been undertaken in opposition to the approach to the view of art represented by Basuki Abdullah, seen by artists like Sudjojono to be producing what might be called the 'Beautiful Heritage for the Beautiful Élite'.

mountains, romantic or picturesque and sweetish subjects, but also sugar factories and the emaciated peasant, the motor cars of the rich and the pants of the poor youth; the sandals, trousers and jacket of the man on the street.... This is our reality. And the living artist ... who does not seek beauty in antiquity ... or in the mental world of the tourist, will himself live as long as the world exists. Because high art is work based on our daily life transmuted by the artist himself who is immersed in it, and then creates.[17]

According to Sudjojono, the artist would then understand that the single word 'Indonesia' implies ideas of 'being together, waking up, working, falling, sacrificing oneself, and struggling without end' (1946: 18). Many of Sudjojono's works focus on the wartime experience of common people (Colour Plate 44) and his ideas inspired many of the younger artists who matured in the context of the struggle for independence (Colour Plate 45).

The other early painter of the common people was Affandi, described as 'one of the most important interpreters of the people's life and emotion' (Moerdowo, 1958: 83). During the Japanese Occupation, Affandi lived in Bali for a while and here he spent most of his time sketching soldiers and peasants. During a two-year stay in India, he was 'totally fascinated with the life he found all around him. The homeless, refugee camps, market-places, simple village homes, and the slums were all favourite themes in his paintings' (Umar and Raka, 1987: 216).

Affandi's stay in Bali and India set the tone for an artistic agenda that characterized the rest of his sixty-year-long painting career, painting scenes of peasants and fishermen, all over Java and Bali, an agenda which has had great impact on how painters in Indonesia see

and work today. Most of Affandi's paintings could not be called genre paintings, however; their style and feeling are too existential for that. Nevertheless, they spring out of an attitude which signifies profound respect and admiration for the hard physical labour and the life experience of those who maintain society in the most fundamental of ways. One fascinating painting (Plate 114) shows Affandi squatting (a popular informal position in which to rest, eat, talk, and generally hang out) amidst the bustle of people going to and fro, of whom feet, legs, and hands are seen.

Concurrent with Sudjojono and Affandi in Java, another painter made his own unique contribution to the painting of genre scenes in what was soon to be officially named Indonesia. In the small kingdom of Ubud in Bali, Gusti Nyoman Lempad (1865–1978)[18] started painting men and women at work in the kitchen, the market-place, the yard, and the field (Plate 115) (Holt, 1967: 168–88; Puri Lukisan, 1984: 9–10). In simple lines drawn in India ink on paper, often reinforced with a line in a lighter shade, Lempad depicted the people carrying out everyday activities, with a minimum of background setting to distract our attention from the main focus.[19] In Bali, where every surface, whether cloth,

[17]Holt, 1967: 196; quoting from the same text by Sudjojono; her translation.

[18]As different dates are given in different publications for this artist, I use the dates quoted in the Neka Museum catalogue.

[19]Such scenes from everyday life were traditionally depicted in temple carvings and in *wayang beber* scrolls, but always as part of and accompaniment to the greater whole. It is the isolation of such themes as worthy of depiction in themselves which separates Lempad from tradition. He never took the step, however, to the kind of realism found in the work of Affandi and Sudjojono. An explanation may be found in the very different conditions of life in Ubud. Bali did not suffer the effects of Dutch administration and the large-scale exploitation of resources until the first decade of the twentieth century, and therefore retained more of its culture intact.

114. Affandi, *Myself in the Midst of the People*, 1954, in 1955, in the collection of KPPK, Bagian Kesenian Yogyakarta. (Photograph Claire Holt. Courtesy of the Dance Collection, New York Public Library for the Performing Arts, Astor, Lenox, and Tilden Foundations.)

115. Gusti Nyoman Lempad, *Selling and Drinking Palm Liquor*, 1930s?, ink and Balinese paint on paper, 23 × 32 cm, collection of Puri Lukisan. (Photograph Astri Wright.)

stone, or wood, is filled with highly ornate and detailed patterns, and where the ceremonial part of life is most often highlighted as typically Balinese, the scenes painted by Lempad from the 1930s on are stunning in their simplicity, showing people dressed for everyday work rather than in formal temple dress.[20]

Cultural Policy and the New Order

The Indonesian state, through its large civil servant corps and its military, plays an active role in the life of the community. This is evident in local and national decision-making, and reflected in various ways in intellectual and artistic production. Faced with the overwhelming challenge of bringing some kind of unity to a nation with little a priori ethnic, linguistic, economic, cultural, political, or religious homogeneity, the state makes great efforts to see that these differences are not formulated politically. Instead, the government attempts to 'culturalize' those differences, enforcing a distinction between 'the realm of "custom"' (folklore, faith, costume, art) where variation is tolerated, even celebrated as a kind of spiritual richness, and the realm of power, where any intrusion of such matters in any form at all is feared as a possible prelude to general upheaval' (Geertz, 1990: 79). This point is vividly illustrated by the policing of cultural events: the police permit a poet or a theatre group needs to stage a performance is the same kind of permit needed to stage a public rally or demonstration (Chudori, 1990). In this sense, officialdom makes a clear connection between crowds gathered to view artistic performances and those gathered to make a political statement.

Official Indonesian state doctrine is called the Pancasila. This expression, meaning 'five moral principles' (originally a set of Buddhist precepts), mentioned in the fourteenth-century Javanese epic poem, the *Nagarakertagama*, was reformulated by President Sukarno in June 1945 (Anderson, 1990c: 123–51). The Pancasila was posited as the foundation of the Republic of Indonesia—(1) belief in one God, (2) humanitarianism, (3) national unity, (4) democracy, and (5) social justice— and has been adopted also by Suharto's New Order. Since 1985, it has been proclaimed the only political ideology acceptable for all mass organizations— political, religious, and otherwise. It is applied to all subjects of study, in all educational institutions, at all levels, and passing Pancasila examinations is obligatory for all civil servants.

Within the Indonesian political system, called Guided Democracy under Sukarno in the late 1950s and renamed 'Pancasila Democracy' under Suharto, the notion of state guidance not only continues to be central but has been increasingly systematized in recent decades. Describing the difference between life in Pare in the 1950s and upon his return in 1986, and especially the period following the 1965–6 massacres, Geertz writes:

Competitive electoral politics was first muted, subsequently virtually eliminated, to the point where today it can scarcely be said to exist at all. Difference (religious, class, cultural, ethnic) remains, only somewhat altered and at least as sharp. But, driven, or frightened, away from partisan expression, it has entrenched itself in institutions (schools, churches, cults, welfare organizations, professional groups, cultural associations) that can be represented as non-political; moral, aesthetic, or recreational enterprises, merely functional and indifferent to power. The world has been turned less upside down than inside out.

[20]The largest display of Lempad's work is in the Neka Museum in Ubud, where a whole room has been devoted to him. Some other works can be seen in the Denpasar Art Gallery and in the Puri Lukisan in Ubud. For reproductions, see Holt, 1967: 61, 88, 175.

The leading elements in this inside out world, where the contest of interests cannot be directly expressed and ideology must be made to look like art without art being made to look like ideology, are: (1) a state-orchestrated civil religion of vast proportions and uncertain content; (2) a neo-Javanism often mistakenly confused with it by outside observers; (3) an increasingly indigenized Islam dispersed into local expressions; (4) and what I can only weakly call—the thing defeats me—a quasi post-modernism of a quasi proto-middle class. What in the 1950s was a rehearsal for civil war, is in the 1980s an exhibition of divergent thought lines, separated performances, and unjoined arguments. Parallel totalisms that battle without meeting (1990: 79).

Unlike the United States, the Indonesian state today defines culture as one of the areas in need of guidance, both directly and indirectly, right down to the level of the form and meaning of individual cultural products. Unlike the People's Republic of China, which since 1949 has held to the Maoist tenet that 'culture is politics' (and vice versa), the Indonesian government does not call its involvement with the art 'political', and takes extensive measures and steps to ensure that cultural production does not appear to be 'political', at least not in the 'wrong' way. Reference to politics in any sense other than the laudatory rhetoric used by the Indonesian government is avoided. In both the People's Republic of China and in Indonesia, instances of censorship (of published literature, poetry readings, films, and art exhibitions) occur in the name of the well-being and the development of the nation. This degree and form of 'guidance' is usually explained as necessary at this stage in the development of the nation, when people are not yet mature enough to handle freedom of thought and expression.[21]

In *Cultural Policy in Indonesia*,

published by UNESCO in 1985, then Director-General of Culture, Haryati Soebadio, wrote:

An interrelation has to be acknowledged between culture and development, and likewise between the development of culture, cultural identity and the country's material development; because, in the formulation of its cultural policy, Indonesia, as a still developing country, has to remain aware of the cultural dangers and consequences as well as the side-effects of development for its people. On the one hand, development needs a culturally congruent environment to be successful, while on the other, it also tends to bring negative side-effects in its wake, which may only be solved through cultural measures (1985: 12).

The practical reality of such statements can be tested by investigating the nature and degree of control exercised on the press. Since the Indonesian Press Council was established by presidential decree in 1967, its role has been to provide, on behalf of the government, 'intellectual guidance' to the journalists and press organizations (Dhakidae, 1991: 451–2 n. 42). This guidance includes delineating the function of the press: 'A newspaper has the duty and responsibility to disseminate information of progress and the success of [national] development to its audience.' This is done by 'reflecting the facts that should be known by society, especially the *positive facts*'.[22]

Such pronouncements must be read from the perspective that public communication in Java is traditionally couched in cautious, inoffensive terms, reflecting cultural and personal, self-imposed levels of censorship. Thus, the cultural policy of the New Order has roots in traditional as well as modern political institutions. The Javanese belief

[21]This official view is frequently echoed in personal conversations.

[22]From the Indonesian Press Council, *Manual for the Ideal Guidance of the Press*, section on 'the positive interaction between the State, the Press and Society' (Dhakidae, 1991: 455; original emphasis).

116. Gateway poster proclaiming the happiness family planning brings, Peliatan, Ubud, Bali. (Photograph Astri Wright.)

that undesirable phenomena, crises, and negative events of any kind reflect the diminishing power of the ruler must be kept in mind here (Anderson, 1990b: 33); furthermore, the very pronouncement of negative statements might cause them to come true. It is therefore paramount for the ruler to prevent natural or socio-political disasters from happening, and if they do occur, it becomes imperative to limit recognition of them. The suppression of open debate, questioning, and criticism follows as a matter of logic.

The emphasis of the Indonesian state on 'harmony and social solidarity' is reflected in the development of national culture and carried out through a network of government branches responsible for education, youth organizations, and local and national cultural activities. Close co-operation between three Directors-General—of Culture, of Radio, TV and Film, and of Information—in Jakarta as well as

through the regional government offices, facilitates such control (Haryati Soebadio, 1985: 34). The need for controlling measures is justified by referring both to real and perceived crises; the language of apology for such controls is typically vague and rhetorical:

Social pressures and restlessness are increasingly expressed in the mass media. Various forms of violence, crime and juvenile delinquency occur more frequently every day, clearly indicating the existence of inconsistencies in the institutions which regulate social behavior and intercourse. This situation may be overcome by adequate cultural development ... by means of increasing opportunities and socialization, in which knowledge of the values and principle ideals that make up the national customs are promoted (1985: 34).

Part of the government effort at controlled cultural development is the use of various art forms as tools of propaganda and education (Plate 116). Another effort in this direction was the establishment of state museums in every provincial capital; by 1985, ten of the prospected twenty-seven museums were 'functioning'. To develop the arts at the levels both of artistic creativity and art appreciation, the government had, by 1985, established thirteen cultural centres called Taman Budaya (Garden of Culture) in provincial capitals, where performances of traditional and contemporary music, dance, and drama alternate with exhibitions of an artistic and informational nature. Furthermore, assistance is given to state art schools and academies; to the organization of national festivals of art; to art competitions and for certain international tours that display the proper image of national culture (Haryati Soebadio, 1985: 38–41).[23]

[23]The provincial museums and cultural centres range unevenly from North Sumatra to Sulawesi. In the case of museums, the Moluccas have received

New Order Silence

One of the distinguising features of the New Order has been the suppression of dissident voices in national media, public performances, and literary and visual arts. A contemporary poem bemoans this silence:

Brothers and sisters who have hidden away
your secrets for years on end
Sisters and brothers who have stored up pain
and articulated the stinging of your souls in a
long muteness
Brothers and sisters who are still oppressed
and still do not weep, who respond to
suffering with jokes and laughter
Sisters and brothers who have fallen out of the
pages of the history books
Brothers and sisters who are very learned
about the ways of confronting all the
robberies and oppressions
Sisters and brothers who are mute in the
morning, mute at midday,
mute in the afternoon and at night
Brothers and sisters whose patience and
restraint remind me of the mysterious smiles
of the prophets
Tell us with the silence of your lips that
muteness is the clearest statement, that silence
is the greatest word
That stillness contains the loudest voice
conceals a terrifying power.[24]

The lack of cathartic treatment of the events surrounding the demolition of the Communist Party and the overthrow of Sukarno in 1965 has had a remarkable effect on Indonesian art. Unlike the People's Republic of China, where after the end of the Cultural Revolution 'speaking bitterness' was practised in public events as well as in the new literature, no such process has taken place in Indonesia, despite the traumatic memory of the widespread bloodshed.[25]

A rare exception to this silence might be found in a painting by A. D. Pirous entitled *The Sun after September 1965* (Plate 117). This work consists of abstracted, cubistic figures, seemingly both men and women in draped clothing, their faces turned down towards the earth, away from the large, looming disk of the sun immediately behind them.

It is important for someone from the northern hemisphere to bear in mind the different perception of the sun that prevails in the tropics. This is not that source of light towards which we eagerly turn winter-pale faces to soak up warmth and vitamins; it is a potentially destructive force from which one seeks shelter. It is this sense one gets from Pirous's painting; here, the sun is treated very differently than, say, in the work of Affandi, where it is the ultimate symbol of the life-force.

Another work which could be interpreted as a reference to the events of 1965–6 is a black-and-white ink drawing by Priyanto of water buffalo, their heads, perched on thin, scraggly necks, bent down towards the earth with suffering expressions. One of the three heads has the features of a human being, crushed by pain (Plate 118). The symbolism of the water buffalo (*kerbau*) should be kept in mind, both as a tribal symbol of victory, such as in Minangkabau legend (Holt,

one; further east, no museums or cultural centres had been built by the date of publication, which leaves Irian Jaya and Nusa Tenggara Timor 'underdeveloped' in this respect—a situation which reflects general development policies.

[24]The first of five stanzas in a poem entitled 'Gaping Wound' by Emha Ainun Najib, written in 1981; translated by Micheal Bodden (forthcoming).

[25]A great deal of the work by LEKRA artists and others was destroyed in the aftermath of 1965 and artists resist talking, even among themselves, about the period. Some of the work, however, can be gleaned through research in magazines and journals published in the 1950s and early 1960s. Attention to this part of Indonesian art history is necessary for the record to be complete. See *Bintang Merah*, the Indonesian Communist Party publication and its English language equivalent, *Review of Indonesia*, for poetry and occasional drawings. *Zaman Baru*, the LEKRA publication, has more reproductions of paintings and drawings, in addition to poetry, short stories, and drama.

1967: 22–3); as the highest ranking of sacrificial animals; and of the greatest importance in agricultural labour and its symbolism (Barnett, 1979). The buffalo was also the nationalist emblem of the Indonesian Nationalist Party (PNI), co-founded by Sukarno in 1927 (Legge, 1972: 89–136, 211–12, 244–68).

With the transition from Old Order to New Order, official favour shifted from the art academy in Yogyakarta to the art academy in Bandung. With the censorship of anything that might be seen as leftist, the modern art which met with New Order approval was characterized by individual expression, and internationalist and decorative styles ranging from abstract to realistic. Curricula in both Bandung and Yogyakarta were standardized according to Western methods of teaching art, with reliance on slides and reproductions in books—a method which 'tends to distance students from actual contact with art as a physical reality' (Miklouho-

117. A. D. Pirous, *The Sun after September 1965*, pre-1967, 135 × 150 cm. (Photograph Claire Holt. Courtesy of the Dance Collection, New York Public Library of the Performing Arts, Astor, Lenox, and Tilden Foundations.)

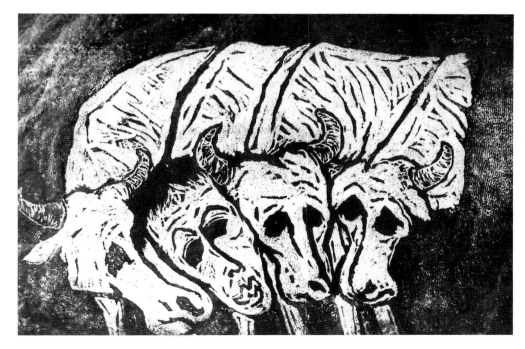

118. Priyanto, *Four Kerbau Heads*, pre-1967. (Photograph Claire Holt. Courtesy of the Dance Collection, New York Public Library of the Performing Arts, Astor, Lenox, and Tilden Foundations.)

Maklai, 1991: 17). The students of the early 1970s were encouraged to distance themselves from the social context of their own art. Many students have expressed the opinion that, for the first time since Sudjojono's challenge in the late 1930s to Indonesian artists to stop painting Western-style romantizations of Indonesia for wealthy tourists and a Westernized upper class, an élitist and Westernized concept of Fine Arts became dominant.

About five years after Suharto officially came to power, a younger generation of artists began to insist on their right to create art which was both inspired by, and relevant to, their social contexts. These young artists, and other like-minded contemporaries were vocal and active enough that, by the end of the 1980s, Indonesian painters were once again divided into two major groups: those who believe art serves personal, spiritual, decorative, or leadership interests, and those who believe art should address people's socio-economic and psychological experiences, whether from the perspective of empathy or with the aim of social change. The artists in the latter group come from different backgrounds and have drawn on their own life experience, interests, and aesthetic sensibilities in developing their art. But all of them, in their work and variously in their lives, have rebelled against the attitude that 'the people are still ignorant' (*rakyat masih bodoh*)—a phrase commonly heard in élite circles (Rendra, 1979: 32 n. 47). In the search for attitudes about the 'little man' in Indonesian society, it becomes clear that it was during the revolutionary period and in Sukarno's political rhetoric and multi-ideological juggling that the villager was elevated for the first time to a prime position in history, and posited as central to the prospects for a national future. The villager—whether in the context of the rural environment or in the urban metropolis—is still in various ways the focus of a large number of contemporary Indonesian artists.

8 Documents of Infatuation: Hendra Gunawan

'HENDRA GUNAWAN is considered one of the best and most versatile painters of Indonesia, and, together with Affandi and S. Sudjojono, is one of the "fathers" of the modern movement,' according to Claire Holt (1967: 324).[1] This feeling was voiced again at the time of Hendra's death in 1983, when many of Indonesia's most prominent artists, paying their last respects, described him as an 'exceptionally dedicated artist', an 'infectious teacher', an artist whose 'Indonesian-ness' was indisputable, and a man whose 'infatuation with the people', as well as with the republic, was lifelong (*KOMPAS*, 1983a, b, and c).

Hendra would have to be counted, not only as one of the fathers of Indonesian painting, but of genre painting in particular. Even among his contemporaries, his interest in the life of the Indonesian people was considered remarkable. By the late 1940s, when Hendra and others had been painting the daily life of the people for a decade, it had become a standard part of modern Indonesian art. In fact, during the latter part of the Sukarno era, it was the main theme artists were encouraged to pursue. Consequently, after the fall of Sukarno, the theme in itself became suspect because of its associations with the Old Order and with communism.

Although the majority of the painters discussed in this study were alive in the late 1980s, it was felt necessary to include Hendra, even though he had already passed away. This is because much of the public discussion which occurred in various forums in 1989, including the daily press, about the acceptability of showing art by 'communist artists' or 'national traitors', inevitably evolved around the figure of Hendra, the most well-known of this group of artists. In addition, and perhaps ironically, the other main reason to include Hendra here is that he, throughout the research for this book, was repeatedly acclaimed Indonesia's greatest painter by the majority of artists, art students, and collectors interviewed, whether people with a radical world-view or people comfortable with the *status quo*. Thus, because of the political sensitivity that surrounds him, hardly anything has been published about Hendra. Furthermore, it is difficult to view more than a handful of late examples of his work in any public place.

'The Oasis', one of Jakarta's élite restaurants, boasts a dozen Hendras on the walls of its most exclusive dining-rooms. One of Jakarta's fanciest advertising agencies chose the work of

[1]An earlier and longer version of this chapter is in Wright, 1990d.

119. Hendra Gunawan and family, 1978. (Photograph courtesy of Lukas Mangindaan.)

Hendra as the theme for one of its most successful art calendars. Thus, ironically, the work of this painter, who in the annals of national security ranks as a traitor, accompanies the political and corporate élite in Jakarta in their day-to-day business and oversees their festive gatherings when out on the town. In the late 1980s, Hendra's paintings were among the most highly priced on the Indonesian art market as well as those most frequently faked.

The general public, however, finds it hard to see Hendra's work. One or two canvases hang in the poorly lit halls of Jakarta's Municipal Art collection (BSR). A few more are in the Adam Malik Collection, though usually only one or two are on public display at any one time. At the Duta Fine Arts Gallery and at Oet's Gallery, another three or four might be seen, and half a dozen more hang in the Neka, Agung Rai, and Denpasar Art Centre collections in Bali. These works, however, are not fully representative of his *oeuvre*. Most of Hendra's work is dispersed in private collections, some collectors owning a

dozen or more of his paintings; Ciputra tops the list with between fifty and sixty works.

The near absence of the work of an artist that commands so much admiration and is accorded such an important place in the history of modern Indonesian art surrounds the artist with an aura of mystery which begs investigation.

Hendra Gunawan (1918–83) (Plate 119) was born in Bandung, West Java. His father was a railroad official who gambled and his parents were divorced when he was young.[2] According to one collector, Hendra's father drove him away from home at an early age because all he wanted to do was paint and perform.[3] After high school he started wandering from village to village, eventually becoming known as a healer. Joining a theatrical troupe when he was nineteen, he painted scenery as well as

[2]Except when otherwise noted, the following biographical information and quote is from Holt, 1967: 324.
[3]Interview with Lukas Mangindaan, May 1988.

acted and danced. It was presumably during this time that he studied landscape painting with Wahdi and modern art with Giorgi Giseken [sic], a porcelain industrialist in Bandung (Liem Tjoe Ing, 1978: 223).

After meeting Affandi in 1939, Hendra decided to take up painting as a serious vocation. With a few friends, he founded his first art club and a few years later, when Sudjana Kerton established the group Frontline Painters (Pelukis Front) to paint battle scenes in Bandung in 1945–6, Hendra also joined this group. At the same time, he organized a *reyog* troupe, a group of 'costumed entertainers who offered popular comic shows'. This period marks the beginning of a lifetime's involvement with artist organizations and with popular culture, both as an active participant and as an observer.

During the Japanese Occupation, Hendra lived in Bandung, but like Sudjojono, Affandi, and a handful of other painters, he often visited and exhibited his works at the Japanese-sponsored Cultural Centre (Keimin Bunka Shidoso) in Jakarta. The Keimin Bunka also had subsidiaries in Bandung and other larger cities.[4] The other important centre for nationally oriented cultural activities was Poetera (Poesat Tenaga Rakjat, Centre of the People's Strength) in Jakarta. This was led by Sukarno, Hatta, and Ki Hadjar Dewantara, leaders of the nationalist struggle; Affandi and Sudjojono were in charge of the artistic division (Sudarmadji, 1975: 30). It is probable that Hendra also exhibited there.

After the outbreak of the Revolution in 1945, Hendra fought with the Indonesian armed forces and served for a time as a military judge, all the while painting anti-Dutch posters. When terrorist activities by Dutch troops forced the republican government to leave Jakarta in 1946, after the allied victory and the Indonesian proclamation of Independence, Hendra went to Yogyakarta.[5] At first a member of Sudjojono's newly formed group, Young Painters of Indonesia (Seniman Indonesia Muda), Hendra joined with Affandi, Kerton, and others to found the People's Painters (Pelukis Rakyat) in 1947.[6] This became 'the most active and numerous' of the several art organizations in Yogya (Holt, 1967: 218).

Members painted, among other things, 'documentary scenes of the Revolution' and, under Hendra's ten-year-long leadership, undertook numerous public projects, both sculptural and architectural. Hendra's statue of Jendral Sudirman is an example of his psychological approach to form: its style contrasts sharply with the public sculpture commissioned by Sukarno for Jakarta in the early 1960s, which gets as close to international social realism as anything ever produced in Indonesia.[7] In

[4]On the history and motivations of nationalist artists who collaborated with the Japanese during this period, see 'Sumbangan gambar para seniman' (Arsip Nasional, 1989: 71–83), especially the statements by Sudjojono (pp. 81–3).

[5]For descriptions of these political events, see Kahin, 1952; Anderson, 1972.

[6]In the short biography given in Liem Tjoe Ing (1978), nothing is mentioned about Hendra's life after the late 1940s, even though the book was published thirty years later when Hendra was still alive. Similarly, in a volume published a year after he was released from prison, the two pages devoted to Hendra only take him up to 1957, citing *Bride and Groom of the Revolution* (1957) as his masterwork, with no mention of more recent work (Departemen Pendidikan, 1979: 185–6).

[7]Edhi Sunarso's sculpture *Welcome* (1962), shows a man and a woman side by side, their right arms raised to the sky, in a wave of welcome. Their postures are reminiscent of revolutionary fighters or athletes depicted on Soviet or Chinese posters. Sunarso's sculpture *The Liberation of West Irian*, based on a sketch by Sukarno and Henk Ngantung (governor of Jakarta and influential artist), shows a muscular giant at the moment of having torn apart the chains which bound his hands and feet, lifting his hands victoriously above his head.

contrast to the exaggerated, Atlas-like proportions of these giant statues, with bulging muscles and victorious postures, Hendra's life-size sculpture shows a small man, with a thin body, ravaged by the deprivations of war, illness, and self-sacrifice. Hendra's statue takes its point of departure in General Sudirman's actual features: rather than the extravagant and melodramatic quality of the Jakarta sculptures, it is the power of the spirit that emanates from within the oversized military coat which communicates the heroic stature of the man.

The People's Painters arranged numerous exhibitions and provided an alternative to the art academy for gifted young artists who could not afford, or did not want, to enrol there. The group also provided home and studio space:

The asrama consisted of a large main house and several smaller structures nearby. In the main house, Hendra, his wife and little son occupied one of the bedrooms which also served as his private studio. A spacious, high-ceilinged front room served as the community's gathering place, lounge and art gallery. At a large round table in the hall consultations were held and projects were discussed. Whenever possible, the People's Painters acted as a body; commissions ... were usually executed cooperatively by several members of the group. It was in their paintings that they asserted their individuality (Holt, 1967: 218).

Although they split off from Sudjojono's group in 1947, the aims of the People's Painters were similar: 'art must be dedicated to the people; be inspired by them and also be understandable to them' (1967: 218). On the other hand, the People's Painters never strongly advocated the use of social realism, which was more and more influencing Sudjojono's own style. In his informal way of teaching, Hendra stressed folk art, such as *kuda kepang* and *ketoprak*, then a new theatrical

form.[8] At times, Hendra told Holt, he thought himself too Westernized and he deplored imitations. Thus, he urged his students not to depend too much on Western art and to 'crystallize their own characters [and] have confidence in their own peculiarities' (Holt, 20 December 1955).

From 1950 to 1957 Hendra taught at ASRI in Yogyakarta. During these years he participated in international art activities, in 1951 attending the Youth Festival in East Berlin and later visiting Italy, Rumania, the Soviet Union, and the People's Republic of China. His long-standing dream, never realized, was to study mural painting in Mexico.

In the early 1950s, Hendra became a member of the central committee of LEKRA, the Institute for People's Culture, an organization affiliated with the Indonesian Communist Party.[9] In 1955, he was nominated by the party and then elected as a non-party member to the Constituent Assembly.[10] Due to the consequent need to be closer to Jakarta, Hendra moved to Bandung in 1957,

[8] *Kuda kepang* is a trance-dance where the male performer dances with a hobby-horse made of plaited grasses. Variations of this are performed throughout Java, such as *kuda lumping*, which uses a hobby-horse made of leather; see discussion and photographs in Holt, 1967: 104–5. *Ketoprak* is a type of popular theatre, usually performed in open air. See Holt, 1967: 128, 222, 276, and the reproduction of the painting *Ketoprak* by Suromo on p. 224.

[9] LEKRA was established in 1950. By 1951 it claimed to have established twenty-one branches throughout the Indonesian archipelago (Foulcher, 1986: 12, 20).

[10] In a situation where art materials were too expensive for most artists and LEKRA supplied studio space, instruction, materials, and opportunities to be exhibited, there were strong material incentives for artists to join LEKRA (Holt, 1967: 218, 247). Foulcher suggests that the history and thought of LEKRA must be seen as separate from that of the Communist Party, because its allegiance to Marxist principles was vague and general (1986: 19).

where he built a house in the village of his birth, and ran a chicken farm to supplement the meagre earnings from his painting.[11]

In 1963, Hendra, who had been married more than a decade, fell in love with a sixteen-year-old student who used to practise singing and dancing in the local LEKRA cultural centre where he taught a group of young painters. Five years later, she became his second wife. In the aftermath of the coup of 1 October 1965, Hendra was sent to prison for his political involvement. While there, he was allowed to paint as well as give lessons; his young second wife was among his students (*TEMPO*, 1983; field notes).

Hendra remained in Bandung's Kebon Waru prison for thirteen years. After his release in 1978, he spent most of his time in Bali, inspired by its visual opulence and lively art and ritual. He died there in July 1983, survived by his first wife and their three sons, and by his second wife and their ten-year-old son (*KOMPAS*, 1983b: 12).

Hendra's pre-prison work is better known than that of the later period, which is the focus of this discussion. During the 1940s, Hendra painted propaganda posters. His paintings from this period are dark canvases: a train rushing through the countryside, the roofed stalls of a market, guerrilla fighters resting or waiting in bluish landscapes, gatherings of people on the river-bank, women delicing each other, nursing babies, or gossiping. In a 1946 exhibition of West Javanese painters in Yogyakarta, arranged by Sudjana Kerton at the request of Sukarno, the titles of Hendra's works are *Attack*, *Hunger*, *Bomb Crater*, *Ruined Home*, and *The Road after the Flood*.[12]

[11]This is as far as the biographical information from Holt goes.
[12]From a photocopy of the original exhibition brochure kindly supplied by Sudjana Kerton.

The paintings from this period are today politically 'safe' in the sense that they have not yet been tainted by the 'communist propaganda' which supposedly infused Hendra's work once he became a member of LEKRA. Nor do they yet exhibit his peculiar genius for colour, and the fully developed stylistic aspects which became evident during the 1960s.

One early painting is *Wawayangan* (Plate 120). Here, we see the back of a long-necked, emaciated woman, a straw hat hanging over her shoulders. Her head is turned in profile as she looks at a small twirly-box (one of the simple children's toys for sale at markets in Java) in her raised hand. A thin, raggedly dressed child in the left corner is gazing longingly up at two *wayang* puppets on a stand. We can feel this moment's distraction in a life of hardship, provided by the worn woman's distant memory of playfulness and childhood dreams. This memory is marred by her realization that the twirly-box is all she can afford to give her child; even the cardboard *wayang* figures are beyond her reach. The painting evokes a similar feeling as Kurosawa's movie *Dodeskaden*, in which the harshness of madness, poverty, and death are momentarily alleviated by dream, fantasy, and play, which in the end lose out to reality. The emaciated woman in Hendra's work is quite different from the women he later paints, who brim over with life and sensuality.

From the scattered glimpses one can get of his early period, one sees a remarkable consistency. Although his style and colours developed, Hendra's choice of themes did not change dramatically throughout his painting life. From the very beginning, it seems, Hendra was painting people in contexts of work and play, in celebration, struggle, and death. Such themes were well established long before he joined LEKRA. Seeds of Hendra's mature style were already in place in the 1950s, such

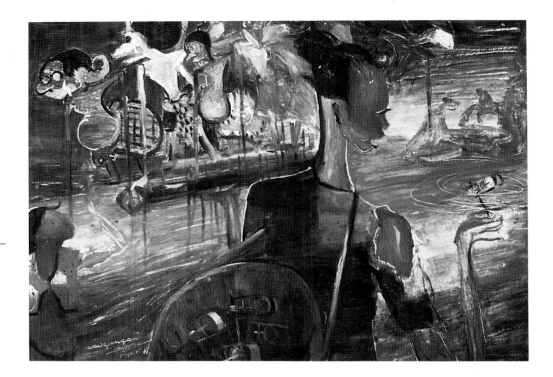

120. Hendra Gunawan, *Wawayangan*, 1949, oil on canvas, 60.2 × 80.3 cm. (Photograph Claire Holt. Courtesy of the Southeast Asia Program and the Carl A. Kroch Library Rare and Manuscript Collections, Cornell University.)

as the tendency to depict people in profile or in silhouette, with a certain stylized exaggeration of facial features, expressive body movements, and long thin arms. This vocabulary is related to that of the *wayang*, which has influenced so much in Indonesia's visual and performing arts, and is one of the features that make Hendra's paintings look 'Indonesian'.[13] Using a modified version of such conventions, his human figures are more types than individuals.

The interesting thing that has

[13] The 'Indonesian' quality of Hendra's work has been remarked upon by other eminent Indonesian painters (*KOMPAS*, 1983: 12). Because of his sensuous depiction of tropical landscapes and people, Hendra has occasionally been likened by foreign observers to Gauguin. Apart from their styles being quite different, this comparison misses an essential point: unlike Gauguin, an outsider and tourist in Tahiti, Hendra is painting a world with which he is intimately familiar, a world with which he was deeply involved from childhood until death, even during the decade in prison, when his depictions of it took on a certain dreamlike intensity.

happened in Indonesia, in retrospect, is that paintings of peasants, workers, or poor people, whether depicted in hardship or in enjoyment, partaking in the banter of the market or watching the performance of a trance-dancer, have become tainted as 'communist'. What has happened, in other words, is that from the official point of view, large areas of genre painting have become suspect, after the briefest of blossomings amounting to a couple of decades surrounding the Revolution. Until then, painters had mostly restricted themselves to certain stock themes with no relation to social conditions; after the fall of Sukarno, painters were encouraged to return to safe, traditional themes, rooted in a world-view with no place for politics or visualizations of the dream for structural change which would benefit the people at large.

Under Sukarno, the working people as a heroic subject worthy of artistic attention was introduced for the first time in Indonesian art. The way this happened

in Indonesia was completely different than in the Soviet Union or China. Indonesia never had a one-party communist government and party control of artistic production could therefore never be as severe as in the communist world; hence, the freedom of Indonesian artists was never as severely limited.

In fact, LEKRA's stylistic requirements in the visual arts, compared to the situation in Soviet Union or China, were never very clearly defined. According to Foulcher, it was

the overriding force of 'state of mind' ... which marked LEKRA's aesthetic philosophy. Its evaluative criteria were never stylistic or methodological, and it never in practice questioned the material basis of cultural production in Indonesia. This meant that LEKRA engaged with, rather than negated the bourgeois nationalist tradition, adopting some of its products and some of the tendencies within it, even as it condemned others.... In some cases LEKRA espoused aspects of the modernist aesthetic, transforming the content and intention of art forms, while perpetuating their stylistic criteria.... As ideas and their function wedded to a non-specific notion of 'artistic beauty' remained the overriding consideration, so the nature of cultural production was in one sense remarkably diverse, allowing for experimentation in a number of different directions (1986: 25–6).

The 'state of mind' demanded of a writer or a painter was one of solidarity with the people and a will to work for the improvement of their lives, both on a material and cultural level. Thus, the focus was more on democratic populism than on a strictly Marxist ideology.[14]

On the other hand, even though party control of the arts was not as severe in Indonesia as elsewhere, the early 1960s did see an increasing polarization of factions in a cultural field where LEKRA was a dominant force. This was signalled by an increasing degree of censorship and pressure to produce 'correct' art, now for the first time phrased with Maoist-inspired terminology (Foulcher, 1986: 107–8). Some artists reacted by enrolling in cultural organizations affiliated with the military which, in turn, waged a battle of denouncement and harassment of LEKRA artists. These old divisions between artists are still felt today and surface occasionally in the press, such as in 1989 when several prominent artists denounced the plans to include LEKRA-affiliated artists like Hendra in the Exhibition of Modern Indonesian Art during the Festival of Indonesia in the United States.

The pressure to produce correct art in the late 1950s and 1960s was especially felt by writers, who appear to have been under more pressure than the painters. In October 1963, a cultural manifesto (Manifest Kebudayaan) calling for an end to the cultural domination of any single group, was published in a journal named *Literature* (*Sastra*). The manifesto clearly referred to LEKRA, which by then had Sukarno's strongest support. Signed by sixteen writers, four painters, and one composer, and joined by fifty more signatories after publication, the manifesto was banned by Sukarno six months later, the magazine was closed, and some of the signatories were dismissed or demoted from their positions.[15]

A. D. Pirous described the feeling of artists who were not working in a LEKRA idiom:

[In late 1965], before the *coup d'etat*, the situation was very heavy; clouds, darker and darker, were hanging over our heads, all the paintings should be social realist, even in Bandung. In all of Indonesia, not only in Bandung, the door was getting tighter and tighter, closing our possibilities of exploring

[14]This description could characterize the communist movement in general.

[15]Talk given by Goenawan Mohamad at Cornell University, 1 March 1990. See also the contemporary press and Foulcher (1986) for further discussion.

modern art, and of making abstract painting. It's not that it was not *allowed*, but there was no place for it.... I felt afraid to show my own work! I felt afraid to show in exhibitions, because the critics would point out that this is 'imperialistic painting' and this is done by a painter from the Bandung school, so the Bandung school should be closed!... It was a very, very touchy and very frightening situation. And then came the *coup d'etat*, and after it failed, in 1966—it was the first time the group of Bandung could again come to Jakarta and hold an exhibition. That exhibition consisted of eleven artists from Bandung.[16]

The extent to which Hendra, as a member of LEKRA, was committed to the full range of policies advocated by the Indonesian Communist Party, is not clear. It is useful to remember that to be a member of LEKRA was not synonymous with being a communist (May, 1978: 32). In a 1958 essay in one of LEKRA's publications, Hendra wrote: '*From the people, by the people and for the people. If I am spellbound by this beautiful and truthful sentence, it is because I am in complete agreement with its meaning.*' He goes on to bemoan the fact that this principle is not implemented as a political and philosophical guideline, whether in Indonesia or throughout the world, although the socialist countries come closest to it. This lack of implementation of basic human rights, as he sees it, is due to the 'cultural terrorism of the imperialists' and the imbalance between technological and moral/political development, using technology as a means to repress rather than liberate the peoples of the world.[17] Indonesia, Hendra writes, needs to rethink its treatment of its cultural workers who

fought in the revolution; their continued patriotic, political, and humanistic work, he says, is threatened by the absence of strong government support. He also addresses the problems facing Indonesian society as a whole, especially the need for better universal education and more jobs that match people's qualifications (1958).

After Hendra's release from prison, clear allegorical parallels to the political turmoil and violence committed by a regime he saw opposing the interests of the people can be seen in his work. One example is the work entitled *Pangeran Kornel*, which depicts Prince Kornel from Sumedang meeting with Daendels, the Dutch Governor-General who built the highway across Java using forced labour. Corpses of corvée workers who were punished or died at work hang from the trees like heavy fruit. Three of the lines of a poem by Hendra, painted on the canvas, read: 'Beneath the raging whip/ the planks of bridges are people/ the leaves of trees, human beings'[18] (*TEMPO*, 1979; author's translation). Apart from the insight Hendra's poetry gives in regard to his intent with a particular work (he frequently wrote poetry in the corners of his paintings), the picture of an artist who is at ease in several media emerges: besides being a painter, sculptor, and performer, Hendra was also a poet.

'In the early sixties Hendra ... devoted time to painting nationalistic subjects, in a more conventional style than in the past' (Holt, 1967: 324). Hendra's interest in history painting, like many of the painters of his generation, started with his revolutionary experience, from which he generalized to similar experiences of other people and other eras. His interest in nineteenth- and early twentieth-century uprisings against the Dutch,

[16]Interview with the artist, June 1988.

[17]The leftist press in Indonesia of the 1950s is full of references to the atom bomb and its victims, with much poetry and painting created around this theme. In 1958, an exhibition of Indonesian painters' work on this theme was enthusiastically received in Peking (see *Zaman Baru*, 1958).

[18]I have not seen this work which was described in the *TEMPO* article. Also quoted is Hendra himself: 'Indeed this painting arises from a feeling of sadness. I cry when I look at it.'

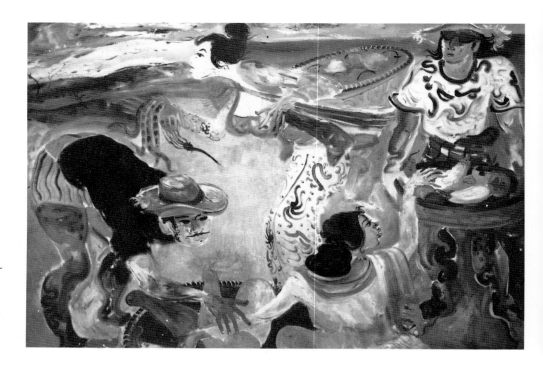

121. Hendra Gunawan, *Vegetable Sellers on the Beach*, 1975, oil on canvas, 139 × 199 cm, collection of Lukas Mangindaan. (Photograph Astri Wright.)

evident in several large-scale canvases painted in the five years between his release from prison and his death, was the last form his preoccupation with the struggle for self-definition took. Not long before his death, Hendra wrote to Ciputra in Jakarta that he had completed paintings depicting *The Struggle of Prince Sumedang against Daendels* and *The Buleleng War in Bali* which he had offered as gifts to both regions' local museums. At the time of his death, he was working on a monumental painting of Prince Diponegoro, which he intended to give to the Museum of Central Java. He was also planning paintings for the museums in Sumatra, Kalimantan, Sulawesi, Lombok, and Ambon.[19]

Hendra also did portraits on commission, painting the faces of the patron(s) more realistically than the typically riotous, colourful expressionist style of his free work. But genre painting remained the most common theme of his work, from beginning to end.

One of Hendra's late depictions of a market scene, painted while in prison, is *Vegetable Sellers on the Beach* (Plate 121). Composed as a circle and evocative of a dance, four people (two men and two women) are shown, each trying in vain to catch the next person's attention, each in turn ignoring the one who is reaching out for them. This painting could be read as a satire of unrequited interest. It can also be read as an allegory of a communal relationship—a mating dance where the energy of flirtation is passed on in cycles of return, the way gifts traditionally travel (see Hyde, 1979). The painter has placed himself outside the circle, passive, an observer wearing sun-glasses and a touristic T-shirt depicting a monster head.[20]

[19]Ciputra kindly shared this information from a personal letter to him from Hendra.

[20]Hendra's use of the monster imagery in connection with himself is significant and invites a number of interpretations. See the discussion below of his self-portraits in jail.

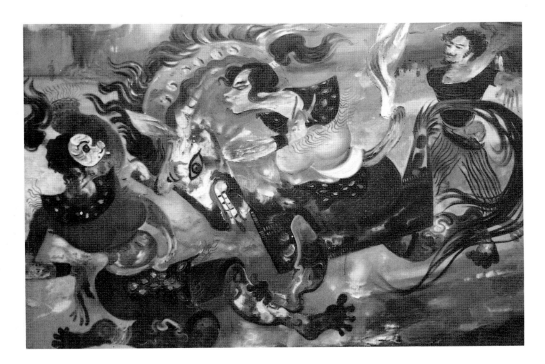

122. Hendra Gunawan, *Hobby-horse Trance-dance* (detail), 1976, oil on canvas, 148 × 203 cm, collection of Lukas Mangindaan. (Photograph Astri Wright.)

As demonstrated by the numerous versions he painted of the *kuda lumping* trance-dance (Plate 122), Hendra was fascinated by intense emotion in high-pitched and extraordinary situations, which he reformulated into dramatic vignettes which highlight the presence of human courage and perseverance *vis-à-vis* desperation. The dancer on the hobby-horse is said to take on the spirit of the horse; in Hendra's work, the dancer is usually a woman accompanied by clowns, whipped on by the team boss. In the painting of a snake-dancer (Colour Plate 46), a poor village woman dances in a frenzy with a poisonous snake around her neck, her ragged, emaciated child plying the horrified onlookers for coins. Once again, Hendra is present on the edge of the scene. Unlike the rest of the onlookers, reeling away from the snake-dancer, Hendra's face is thrust forward, eyebrows raised in shocked fascination. Once again, he is wearing sun-glasses—a device he frequently uses. On the one hand, the sun-glasses enable the observer

to see without revealing or committing himself, and so they may function as a mark of objectivity on the part of the painter who is the witness or narrator of the event. On the other hand, the sun-glasses mark the observer as an outsider, someone who is different. An exploration of the meaning of this device of Hendra's would have to take into account the associations that wearing sun-glasses had for someone who came of age in the Sukarno era, with its allusions to cosmopolitan, virile charisma, and power.

Lukas Mangindaan, a Jakarta-based child psychologist and collector of traditional as well as modern Indonesian art, tells a story which enables us to glimpse Hendra at work, from experience to memory to finished work (personal interview, May 1988). During the 1940s or 1950s, Hendra had seen a female street performer by the roadside, dead from the bite of the snake she had performed with. He never forgot this sight and in ensuing years is said to have

painted several versions of it. As his work matured, even the most everyday themes that came under his brush increasingly became infused with this same intensity of emotion rooted in experience, rendered through the manipulation of contrast and exaggeration.

Having started his painting career making the large banners that announce new movies, Hendra liked to work on large canvases. Some of his canvases are filled with crowds of people, others focus on a few figures that take up the foreground, with distant vistas in the corners of the canvas. The focus is rarely on a single figure; usually some kind of relationship is depicted, either of an intimate or a communal nature. In a single work, we may be presented with the contrast between close-up and distant views, between large-scale and small-scale figures, and between thick, dense areas of paint and airy, open ones. This contrast often correlates with parts of the canvas which are highly worked and well-defined, and others that are sketchy and roughly indicated, often with a single, confident brush stroke.

Some areas are outlined, others are shaped by colour only. We encounter forms that are flat and others that are more modulated, rounded. Certain textural areas and shapes are coarse and others are refined. Nearly all of Hendra's paintings are composed of curves and 'S'-shapes that repeat, interlock with, or play anti-phonally against each other. Some works appear to be more symbolic, others more descriptive; some are dense with psychological intensity, others are lyrical and light. Some incorporate references to passing time, others concentrate on depicting a single moment.

From the early 1970s on, women become even more important than earlier as the main subjects in Hendra's paintings.[21] Favourite themes are women

in groups of three, on the beach or at the market, grooming each other's hair, bathing, getting dressed, or walking through the countryside with baskets on their backs, a goat on a leash. Nearly always, the women are nursing or carrying infants, at times slung on their backs among fruits and vegetables, held tight to their mothers' bodies by colourful *selendang*; at times, the child nurses as the mother walks.

Hendra's women are types, not clearly distinguishable individuals, and many interpretations of their roles and meanings are possible. At the most basic level, they are nourishing, nursing, mothering beauties, voluptuous and undulating bodies wrapped in brightly coloured cloth. Their forms are echoed by the forms of papayas, eggplants, and cucumbers. They are young and their long graceful arms, exaggerating the elegant hand movements that are so typically Javanese, contrast with their thick feet with widely spaced toes—the feet of villagers and farmers. This way of depicting feet, as well as the use of exaggerated profiles, with long necks, protruding noses, and large eyes, echoes the stylization of the human form found in *wayang*.

Hendra celebrates female beauty, suppleness, and strength, placing his women always in the midst of nature, often close to the ground and near the ocean, with babies and fruits as signs of ongoing procreation—a process in which men seem to play an entirely secondary role. Men were often the focal points of Hendra's earlier work with revolutionary and historical themes, but apart from his own self-portraits, they disappear almost entirely in his work painted in prison. After his release, women continue to

[21]Clare B. Fischer has suggested that Hendra offers a refiguring of women's bodies that 'supports

a feminist understanding of the active subject' (unpublished paper, November 1991). This perspective illuminates a central quality that distinguishes Hendra's depiction of women from those by many other male artists, such as discussed in Chapter 8.

dominate his canvases, with men depicted only in crowd scenes. One might say that, for various biographical and political reasons, he chooses to use the female form to signify the greater truth and beauty of the land and the people which he simultaneously celebrates and longs for in his work.[22]

Life in prison robbed Hendra both of life's sense of purpose and its variety. This, coupled with his longing for his family, charged his paintings with an emotional and expressive intensity beyond that of the earlier works. Hendra's prison paintings, filled with themes of longing, intimacy, and togetherness remembered, radiate with colour—clashing, surprising, sweet—but somehow almost always brilliantly resolved in the composition as a whole. Nurhaeni, Hendra's second wife, proudly tells that he learned about colour from her, an amateur painter, when she studied painting with him in prison. Later this story was confirmed:

Nuraeni [sic] had worked in a clothing and fabric store in Bandung as a salesgirl. That was how she became used to seeing a variety of brightly colored material. When she started her painting lessons, her use of bright colors attracted Hendra's attention, who in turn asked her how she was influenced. Of course her use of bright colors was just an inspiration for Hendra, and it was his genius that later developed his unique colorful style during his prison period. If you study Hendra's pre-prison period, [however], you will also notice his use of some expressive colors. His statement that he was influenced by Nuraeni was also a sign of his humility.[23]

The direct autobiographical reference to its author's incarceration in *Dry Lizard* (Colour Plate 47) is unusual in Hendra's works.[24] Throughout his life, Hendra painted a limited number of self-portraits, most of which have clear symbolic overtones.[25] More often he is the onlooker, the artist (his gaze veiled), immersed in but separate from the crowd—a Hitchcock-like cameo appearance that nearly goes unnoticed. In this painting, an old man, recognizably Hendra, with long hair and wispy beard, sits before a prison window. He is feeding a dead lizard to a cat, who stretches up on its hind legs in anticipation. The painting is dense and dark, with nuances of red, pink, grey, and black. There is no view out the barred window and very little light comes in through it. The old man's skin is blotchy. His bare legs and feet become highly patterned areas of colour play, with the snaky lines that are so typical of Hendra's treatment of legs and that, according to Mangindaan, represent varicose veins. It may be that the dark red and black colours of the legs and feet represent the cold: the old man is wearing a sweater and a jacket over his batik shorts, which are patterned with dragons of Chinese influence.

The immediate focus in the painting is not isolation and gloom—it is companionship. The old man's face is softened in a half-smile, emitting a glow of patience and acceptance which gives him the look of a Chinese sage, someone having transcended his physical surroundings. The cat paws his leg impatiently, its swaying back a generous curve of lithe energy. The old man has just finished the small fish of his own meal, fried right there in the wok at his

[22]It has been suggested that Hendra's attachment to painting mothering women stems from his unhappy severance from his own mother at an early age. The resurgence of passion when he fell in love with his second, much younger wife provided him with a new female model around which to centre this long-standing predilection (Lukas Mangindaan, pers. com., May 1988 and March 1990).

[23]Lukas Mangindaan, pers. com., March 1990.

[24]This work is also referred to as *Cicak Kering* (*Dry Lizard*).

[25]One self-portrait from the late 1940s or early 1950s in the Claire Holt Collection shows Hendra's face, his mouth open in a wide laugh. It is a moment's movement caught in rapid brush strokes, like an impressionistic snapshot. This is to my knowledge the most realistic self-portrait Hendra ever painted.

feet, and is about to lower the lizard into the mouth of the waiting cat—a moment of anticipation and shared nourishment.[26] The norm of prison life, otherwise devoid of adequate nourishment and companionship, is alluded to in the depiction of this fleeting moment of contrast.

It is on reflection that we realize this is no sage who has acquired wisdom through solitary seeking: prison is not a hermitage of choice. We realize that this companionship is not as innocent as it seems. Even the lizard—in Indonesia seen as a friendly household presence and signal of good luck—has succumbed to the harsh surroundings. The story does not end with that: according to Mangindaan, who visited Hendra in prison regularly, the cat itself was later eaten by inmates.

The treatment of the paint in this canvas illustrates many of Hendra's most typical features: the thin washes of the red walls and grey floor contrast with the impasto of the legs, feet, arms, and face. Colours are chosen both for their power to express the theme as well as for the joy in putting them against each other. Some areas are delineated with outlines, some forms are shapes of pure colour. In some places, like the cat's whiskers and the fish bones on the plate, Hendra has incised lines into the wet paint with the point of the brush handle.

In the lower right-hand corner, we find a poem. The poem's few but eloquent images add an important dimension to this semi-allegorical self-portrait by alluding to the harsh context of prison life, only indirectly raised in the picture itself:

> Dry lizard
> little Dauk[27]
> for twelve years I have not bathed
> in this fossil's space
> the sky reduced to a square
> communication to iron
> and hungry for everything
>
> the only news that slithers past the bars
> is the scream of motor bikes day and night
> and the incessant exhaust
> from the swollen hungry birds
>
> the smiles of the sky
>
> nothing but a painting
>
> caught between a dry lizard
> and a spoiled cat.
> (author's translation)

A completely different painting is the self-portrait with child (Colour Plate 48). Here, a young man, with Hendra's characteristic long hair and beard, sits on a carved stone on the beach. His face is lifted dreamily towards the sky, his young son on his knee. Although the compositional device is the same as in the self-portrait in prison—the canvas divided diagonally from the top left down to the bottom right corner, the figure filling the left triangle, facing right—here the man is seated against a wide open vista, a beach-line stretching back and up to meet the mottled purple sky. The two self-portraits could be read as a pair, one communicating 'closed'/'stuck', the other 'open'/'free'.

The sharp crimson of the sand and other warm colours dominate, contrasted against the man's pale face and bright green hand set against the pink of the boy's shirt. Is the scene a haunting memory, one Hendra relived a thousand times during the long days and nights of a decade in jail? A memory merged with the visualization of how it will be to once

[26]The Chinese-inspired dragon pattern, the reference to a Chinese sage, and the Chinese cooking wok at his feet, may be allusions to the reason he is in prison: the communist party in Indonesia (PKI) had close diplomatic relations with Mao; furthermore, the ethnic Chinese minority in Indonesia were thought to be associated closely with the PKI, hence the Chinese community suffered especially badly during the massacres and in the legislation that followed.

[27]The name of the cat.

again be free, that intensely longed-for moment? In this work, Hendra pictures himself, in the way we all apparently do in our dreams, at the peak of youth. As in the prison painting, however, there are forebodings of another, less innocent reality lurking within the beautiful scenario. The stone under the young man is carved into a monster's face, and in the darkest part of the painting, the lower left corner, is a formless whale-like beast whose large mouth hovers disconcertingly close to the oblivious young man's naked toes.[28]

The interpretation of the painting as a memory is here plausible. Hendra can be seen in a situation where he is savouring the freedom which allows him to be in the middle of the blazing symphony of nature with his son. He is as yet unaware of, but already senses, the dark force that is moving in on him, which is the very foundation upon which he sits. At this level, the painting becomes an allegory of the artist who, although immersed in beauty, cannot deny the shadow side of reality. Hendra was of the same generation as Sudjojono; however different his style from Sudjojono's, he was no less concerned that the artist's main role be the pursuit of truth. The monster head can also be given a political interpretation—the embodiment of clashing ideologies momentarily subdued in Hendra's dream, but not crushed.

Among Hendra's paintings of women, the following two of his late works provide an interesting contrast (Colour Plates 49 and 50). One shows three prostitutes getting ready for work, the other depicts three women on the beach huddling over an infant. One is of urban working women, putting on make-up as they sit before their shacks on the banks of a city river. The other is of village women, those most often seen in Hendra's paintings, caught in the midst of sickness, waiting and nursing. Both groups have been painted with almost caricature-like distortion, but the one of the three prostitutes is light, absurd, and a trifle grotesque, with a jazzy quality unusual even for Hendra. The distortions of the other painting, on the other hand, do not invite laughter: they invoke our empathy, for there is a sense of urgency about the three women, united not by their shared profession and common goals, like the three prostitutes, but by the immediate need of the child.

In *Nursing the Neighbour's Baby* (Colour Plate 49), the white-faced woman on the right is sick, possibly dying (a concoction of traditional Javanese medicine is plastered on her forehead). She tries in vain to squeeze out some milk for her baby. The young woman in the middle, her face green (a device Hendra often used when painting his most beautiful women), is feeding the baby, while the woman holding the green one's lush long hair, her face rough and red (possibly indicating her servant status), looks off into the distance, beyond the edge of the canvas, as if to see if help is coming.[29]

This tightly composed, cohesive group fills almost the entire canvas, leaving only enough space around the edges for the suggestion of a poetic landscape. The

[28]There is a reproduction of another self-portrait in the Adam Malik Museum (Liem Tjoe Ing, 1978: 42). It is more realistic, of a middle-aged Hendra wearing sun-glasses, sitting on a similar stone-carved monster face. Although no date is given, the style indicates that it was painted during the prison period. However, I have yet to uncover another example of the aquatic creature in Hendra's work.

[29]Hendra is also said to have used colours to denote different ethnic groups, such as green skin for the Sundanese of West Java (his own ethnic group), and black/dark for the Central Javanese (Lukas Mangindaan, pers. com., March 1990). If one can argue that a connection to traditional Javanese colour symbolism is present, in which green is the colour of the divine, this colour reference in Hendra's work clearly merges with his personal vocabulary of fertility and the life principle which women like the one in this painting represent.

patterns of the women's clothing and their different psychological states are set off against each other in ways that keep guiding our eyes around the canvas in circles. In contrast to the exposed legs, thighs, and midriffs of the prostitutes, the bodies of these women are covered except for the pale breast of the sick woman, exposed because it is not covered by the baby's head, because it has no milk. Moreover, rather than the prostitutes, with all their flesh showing (though significantly, not their breasts; traditionally in Java, thighs are considered more sexually arousing), it is the green woman on the beach who embodies sensuality in idealized form.

The three prostitutes (Colour Plate 50) are depicted with a kind of comradely eye, caught as they are putting make-up on their white-painted faces, bringing to mind the make-up used by popular theatre groups. Indeed, performing is their job. Here, they are caught behind the scenes, as it were, a theme Hendra enjoyed painting.[30] The prostitutes are hard-working (note Hendra's colour play with 'varicose veins') and poor (note the hovels), and their occupation at times prohibits them from being the nourishing mothers Hendra usually paints (note the little girl reaching for her doll between one of the women's legs, ignored and left to her own devices). The dreamy, poetic vista in the background with outlines of minute figures, the snaking, pink line of the arm and shoulder of the woman on the right, painted with a single brush

stroke, the foot and the waist of the woman on the left merely indicated in outline or suggested by coloured dots against the grey of the background, and the form of the scarf over the shoulder of the woman in the foreground echoing the shape of her large feet—these are all familiar features of Hendra's style.

Hendra was a man of strong feeling who tended to act out his emotions. No doubt his long-standing involvement with drama and performance facilitated this.[31] One of his paintings shows a man intensely embracing a woman, the colours hot and the strokes of his flying hair and their intertwined clothing dizzy with emotion. The title, I was told, was *Me and My Wife*. When asked what the number 572 in a corner of the canvas meant, Mangindaan, who had commissioned the painting on one of his visits to the painter in prison, said: 'That marks his wife's five hundred and seventy-second visit in prison.'

Hendra was not afraid of admitting to tears. He wrote to Ciputra about his reaction to seeing the Ancol Art Market in Jakarta soon after he had been released from prison:[32]

The first time I went into the Art Market I had to go out again, and go under some trees so that no one would see me. Under those trees I cried, because I remembered the time when I was still studying painting and I had to try to sell my work myself—from neighbourhood to neighbourhood. Once the gate was closed in my face by a lady whom I approached, who

[30]One of his works, entitled *Ardjuna Nursing*, is a backstage scene, where Hendra plays with the gender switching referred to in Chapter 6, fn. 5. However, here it is not Srikandhi but Ardjuna who bears the brunt of the joke. Hendra shows the ultimate playboy image of masculine spiritual cum physical virility, played by a woman (not unusual in classical Javanese dance or popular theatre), who between scenes nurses her baby. Srikandhi may be a man in drag; then again, Ardjuna may be a woman in drag.

[31]In Claire Holt's photographs from her 1955 visit to Pelukis Rakyat, Hendra is the only painter of a group of four or five who is in a different position in every photograph; never looking directly at the camera, he is busy clowning with the other painters, hiding behind them, and hanging on them, creating action in the otherwise stiff situation that photographing people in Asia so easily becomes.

[32]Ciputra built the Art Market (Pasar Seni) as part of the Ancol amusement park north of Jakarta on the coast, with numerous booths where all kinds of artists and craftspeople, modern and traditional, could sell their work.

probably did not want to be bothered with having to refuse to buy my painting and probably knew what it was like to be hungry because she had no money.

But now young painters do not have to do such things. Hopefully those who are at the Art Market will become good artists without having to suffer hunger like I did.

Even when I first read about the existence of the Art Market, I cried, because it was exactly this kind of place I had dreamed for years that our artists would one day have.[33]

The works from 1978 till his death five years later lack the intensity of the prison paintings. Many of these are bright and superficial, the people in them too effortlessly going about their everyday lives. The underlying emotions are less intense, less poignant, and the conventions of how Hendra painted women and landscapes seem to have become somewhat automatic. Suddenly, Hendra was free and in demand—a difficult situation for any serious artist, let alone someone who had been deprived for so long and then regained his life.

There is no doubt that Hendra was one of the greatest pioneers of modern Indonesian art—a man whose work contains certain stylistic elements borrowed from Europe, but whose synthesis is so complete that he is experienced as *the* 'Indonesian' painter *par excellence*. He was a man infatuated with his country and his people; a Gauguin who did not need to leave his country to find his paradise. Hendra was a man who needed to participate—in performances, in teacher–student relationships, in the psychological undercurrents between the people whom he painted. He was also deeply involved in the process of building a new, moral Indonesian society after having fought, with body and art, to overthrow oppressive old structures.

Art works have a suprabiographical level of meaning and existence. Though shaped within, and in turn illuminated by, the life history, social circumstances, culture, and personality of the artist, the work of art must in the final analysis be allowed separation from these, to be tested on its own merits. Looking at Hendra's paintings today, removed from the era in which they were produced, it is evident that he never painted mere political propaganda. This must also be the perception of the Indonesian public or he would not openly be the favourite of so many with close ties to the government.[34] Hendra's paintings exude a love for the spirit, shapes, and colours of the land, which he sees as beauteous and generous, and of the women, whom he sees as fertile and nourishing, symbols of, among other things, the vitality of the Indonesian people: Hendra's women represent a people in charge of themselves, no longer victim to oppression by others.[35]

[33]From an unpublished essay about Hendra which Ciputra wrote after the artist's death (author's translation).

[34]Comparing Semsar's work (Chapter 11) to that of Hendra, the contrast between art with a clear political message and Hendra's becomes clear. Hendra's work was, after a long internal debate, allowed to participate in the Modern Indonesian Art Exhibition in the United States.

[35]Professor Onghokham of the University of Indonesia disagrees with my perception of beauty in Hendra's work. At one point in our discussion, he exclaimed: 'But Hendra's paintings are so *bitter*, they are not sweet or beautiful at all!' Some of the twenty-one works exhibited at Taman Ismail Marzuki, 3–14 July 1979 (*TEMPO*, 1979), clearly support Onghokham's view. However, I did not have access to any of these works. In some of the works in three private collections to which I had access, there is a level of bitterness present, but it is rarely the predominant quality. *The Snake-dancer* (1977) and *Wawayangan* (1949) are exceptions. Even in these, nowhere is there an accusing finger pointed at anyone in particular, only on the level of implication, where a political interpretation becomes the responsibility of the viewer. Onghokham's comment raises the important question about what conclusions a complete retrospective of Hendra's *oeuvre* would yield. It is

To Western eyes, accustomed to the whole range of visual political–economic propaganda practised in our part of the world,[36] the political or ideological messages that may be present in such works are expressed in veiled or allegorical form, and presented in combination with aesthetic and emotional qualities that go beyond any history-specific message. An intrinsic Indonesian reading of these works would probably uncover meanings which are more specifically subversive than what is common in the traditional arts (excepting the age-old use of parts of the *wayang* narrative as a medium for local political satire and commentary).[37] However, it would appear that the hypersensitivity to political expression of any remotely populist kind in Indonesia today has exaggerated Hendra's reputation. Analysing Hendra's paintings on the level of political allegory might yield rich results, as in the case of many celebrated masterpieces in the history of art. Indeed, one can argue that a good work of art always has a political dimension; however, a good work of art never works on the level of political message alone.

possible that many of Hendra's more overtly 'political' paintings and sculptures were destroyed during 1965–7. Onghokham's reaction also suggests that the pursuit of Indonesian perceptions and readings of individual art works, such as those by Hendra, yields valuable comparative insights, also to art works which may no longer exist.

[36] By 'political', I refer to the whole range of government- and business-directed, consumer-oriented propaganda by which the general public is constantly assaulted.

[37] In the *wayang*, the *punakawan* (clowns) indulge in political commentary (see Anderson, 1990a). Lane, paraphrasing Rendra, cites the tradition of criticism in the *goro-goro* incidents in *wayang*, where figures such as Semar and the more rarely appearing Wisanggeni, derive their power from their 'complete honesty in confronting those in authority, even the gods' (1979: xxxv–xxxvi).

9 A Nationalist Come Home: Sudjana Kerton

SUDJANA KERTON (b. 1922) lives on a mountain on the outskirts of Bandung, where, during the Revolution, he worked as an artist-journalist, sketching events on the battlefields for nationalist publications.[1] From the Bandung of his childhood and youth to his present home and gallery overlooking the city, it has been a long journey, covering thousands of miles and nearly thirty years abroad.

'When we first came back here, it was very quiet. There was no road, only a footpath!' Kerton reminisces. 'So everybody said, Who is that *crazy* man, building a house *there*—there's no *water*, no *road*, no *people*! What would *anyone* want to live *alone* for!' Kerton bursts into laughter. 'You know, here in Indonesia, if you live alone, far away from everybody, it looks funny!—And everyone said this place was *angker*—what's the word—*haunted*!'[2]

Sudjana Kerton's home is a circular building which, from afar, looks like a bundle of rice, the stems tied together at the top. The structure is held up by four fifty-year-old coconut palm trunks, placed in the centre of the circular floor-plan. Kerton chose the circular design because it symbolizes eternity and his idea of perfection: 'No beginning, no end; wholeness and unity' (Santoso, 1988). One-third of the circle is devoted to a gallery, where the walls are covered with murals, paintings, and prints; the rest of the circle originally consisted of living-room and bedroom. Today, the kitchen, dining-room, and additional bedrooms are located in another wing, added later without disturbing the outline of the main structure. Kerton has named his home 'Sanggar Luhur', Lofty Studio, referring to its elevation and to the heights of artistic achievement to which he felt the place inspired.

Kerton has a loyal partner and career manager in his American wife, Louise, who is an excellent writer, correspondent, and secretary.[3] Speaking little Indonesian, Louise joined her husband in Indonesia

[1] An earlier version of this chapter was published as Wright, 1990d. Where nothing else is noted in the following, information and quotes are taken from interviews and letters between June 1988 and March 1991.

[2] The reality of ghosts seems to be universally accepted in Indonesia, even in urban settings and among educated people. During my eighteen months in Indonesia, I collected many stories of personal encounters with ghosts and demons of various sorts. In some cases, the old animist idea of place spirits may have merged with the idea of human spirits that find no rest beyond the grave.

Many documented ghosts stay in a certain location and are harmless as long as they are addressed respectfully and receive regular offerings.

[3] One sad aspect of collecting information about artists in Indonesia is that many of them have not kept any kind of record of their work.

after the studio-home was built, leaving two of their three grown children half a world away. Appropriately, the gallery is dedicated to her.

Because he was away from Indonesia for so long, there are no biographical entries about Kerton in Holt (1967) or Liem Tjoe Ing (1978), presently the two main sources for Indonesian artists' biographies. Kerton spent his childhood in downtown Bandung. His father, an accountant and clerk in Bank Ekspor-Impor, owned some rice-fields, so Kerton became familiar with the cycles of the work on the land.[4] This laid the foundation for his lifelong interest in the experience of village people, who remained his main subjects even during the three decades abroad. During this time, he painted scenes from his childhood and youth, tinged with the nostalgia of memory and distance.

In Bandung, Kerton studied art with Dutch teachers like Joos Pluimenz, Ries Mulder, and Henk de Vos. He received his first training and sense of vocation, however, from his first cousin, Kendar Kerton, seven years his senior, who was raised in the same household. Kendar, considered one of the most talented artists in Bandung before he was twenty, was sought for advice and critiques by both elders and peers in the artist community. When he was dying from tuberculosis in 1939, Kendar's last words to the young Sudjana were to the effect that since he himself could not fulfil his life's calling to be an artist, his cousin should continue it. Since then, Sudjana has signed his works S. Kerton in memory of his cousin.[5]

Kerton set himself up as a portrait painter in 1940. At first making a living by painting portraits of Dutch and Japanese residents, he later showed little interest in painting the rich. His preoccupation lies with real, tangible, struggling people, whom he depicts with something between satire and a kind of intimate monumentality, be it the black street musician in New York, the group of 'punks' in SoHo, the Javanese woman harvesting potatoes, or the Balinese duck-herder heading home at sunset (Colour Plate 51).

When the Japanese occupied Indonesia in 1942, Kerton was twenty years old. Campaigning to realize their plans for the East Asian Co-Prosperity Sphere, the Japanese allowed a greater degree of Indonesian participation in government and cultural organizations than had the Dutch, and the Japanese Cultural Centre and Poetera in Jakarta became an active centre for art classes and exhibitions (Holt, 1967: 199–200; Sudarmadji, 1975: 29–30; Sanento Yuliman, 1976: 11–12). Bandung was close enough to Jakarta that there was much coming and going of artists between the two cities, and also Kerton participated in group exhibitions at the Keimin Bunka. In 1945, he founded Frontline Painters (Pelukis Front) to paint battlefield scenes at a time when fighting was heavy in and around Bandung.[6]

I first knew Hendra and Affandi in 1938–9 in Bandung. We often painted together, still learning but having no formal training, getting our ideas from books and

[4]According to his father's wishes, Kerton worked in a bank for three or four years until he could bear it no longer. His father almost collapsed at the news that his son wanted to be a painter.

[5]Kendar painted nationalist themes like portraits of Diponegoro and Sukarno. When the family fled to Tasikmalaya during the evacuation of Bandung on 24 March 1946, all their belongings were left

behind, including Kendar's and Sudjana's paintings. None of these were retrieved upon their return three years later.

[6]According to Kerton, the information printed in *KOMPAS*, 1983: 12, that Hendra Gunawan founded Pelukis Front in 1945, is incorrect and is attributed to the general lack of accuracy about events of these years and the fact that Kerton's role was forgotten during his long stay abroad (see below).

magazines.... Affandi often came to my house to have his paintings judged by my [half-] brother who had been to art school. At the time of the Japanese Occupation, all artists were together, pursued good art work, not art for tourists. This period saw the beginning of a new era in art. Artists were encouraged, exhibits were organized in every big city. Every year there was a grand exhibition in Jakarta, juried by Japanese art experts. Perhaps it was all for propaganda purposes, but it did help the artists.

During the Revolution (1945–9), Kerton went to work as an artist-journalist, sketching directly on the battlefield in an era when Indonesians did not have easy access to phototechnology (Plate 123). The Indonesian resistance movement, which began as guerrilla units

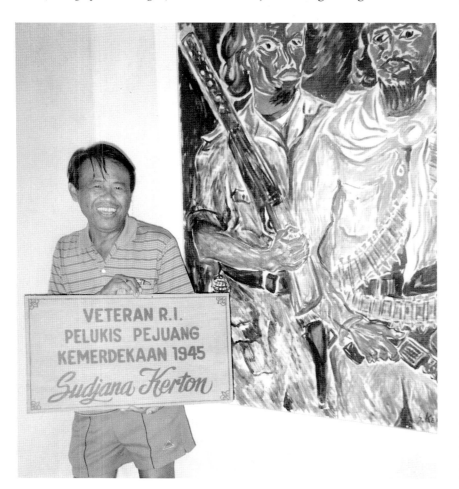

123. Sudjana Kerton, 1990, with plaque that reads 'Veteran of the Republic of Indonesia, painter of the struggle for independence 1945', near the painting *Two Guerrillas*, 1985, oil on canvas, 139 × 94 cm. (Photograph Astri Wright.)

VETERAN R.I.
PELUKIS PEJUANG
KEMERDEKAAN 1945
Sudjana Kerton

and was renamed the republican army after the Japanese had left, was made up of amateurs and volunteers, many without guns.[7]

Kerton remembers how hard it was for everyone, let alone a painter, to find food and basic necessities during that time. Such memories are vivid in the minds of the older artists. Some, such as Dullah, bemoan the fact that the younger generations today do not know what it means to struggle; they do not know what it means to have something greater than themselves to fight for (interview with Dullah, August 1988). Like Kerton, Dullah still occasionally paints scenes based on memories and sketches from the Revolution, composed as monumental historical tableaux (Plate 124).

Sudjana Kerton's memory is sharp for those significant details that best communicate the essence of an event. This facilitates his method of working from remembered images rather than directly from the subject-matter itself. It was on the battlefield that his habit of collecting mental 'snapshots' and doing quick sketches, to finish the actual art work later, was formed.

The first time the art of the Indonesian Revolution was exhibited was in an exhibition of Frontline Painters' work in Tasikmalaya, West Java, in 1946. 'After the Japanese left and Bandung was bombed [in March 1946], the artists here painted scenes of the destruction to raise money for the Red Cross.' Kerton submitted about fourteen works, mostly battlefield scenes. President Sukarno enthusiastically ordered all the paintings sent to Yogyakarta immediately, and he charged Kerton with organizing an exhibition there. Sukarno wanted to

[7] See the interview with General Nasution, 'A Soldier's Story', and painter Mara Karma's stories of resistance in 'Meanwhile in Bukit Tinggi' and 'Running the Blockade' (Carey and Wild, 1986a). For a discussion of events in Bandung during the Revolution, see Smail, 1964.

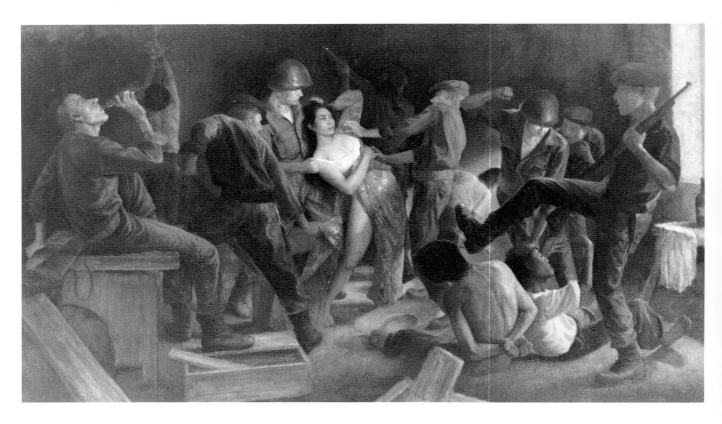

124. Dullah, *Guerrilla Courier
Girl*, 1978, oil on canvas,
350 × 200 cm, collection of
the artist. (Photograph
courtesy of the artist.)

show the world that independent
Indonesia had art, not only war; he
wanted the art to bear witness to the
bombing and killings, the martyrs and
heroes, and he wanted the Bandung
artists to set an example for those of
Central and East Java. The exhibition
opened for five days in May the same
year, with the President giving an
opening speech and the First Lady cutting
the ribbon. Of the sixty paintings by
seven artists, eighteen were by Kerton,
with titles like *Victim of Shelling*, *Don't
Know Where To*, *Bamboo Spears*, and
the painting Sukarno personally bought,
Courageous, Tenacious and Disciplined.[8]

Based in Yogyakarta for the remainder
of the Revolution, Kerton joined Hendra,
Affandi, Sudarso, and others in the

[8]From a photocopy of the original exhibition
brochure, lent by the artist. The other participating
artists were Hendra, Suparto, Abedy, Barli,
Turkandi, and Kustiwa plus two unnamed
caricaturists.

founding of Pelukis Rakyat.

Each member had the duty to teach painting
and sculpture to young people in the *sanggar*.
This organization was often ordered by
President Sukarno to organize exhibits for
foreign guests to show that Indonesia had
good modern art. It received money from the
government. We would meet once a month at
the homes of different members to discuss art.
I was also ordered, separately, to arrange
exhibits for the President in other cities
throughout Java.

Kerton lived in a military complex,
working for the military magazine *Patriot*
as well as for *Orientasi*, both as a portrait
artist and war artist, sketching political
and frontline events, and often travelling
with Sukarno to document the President's
activities. His sketches of places and of
parliamentary meetings are
straightforward, rapid pen-and-ink
sketches. With all of his paintings from
this period lost, Kerton's contemporary
oil-paintings, based on old sketches from

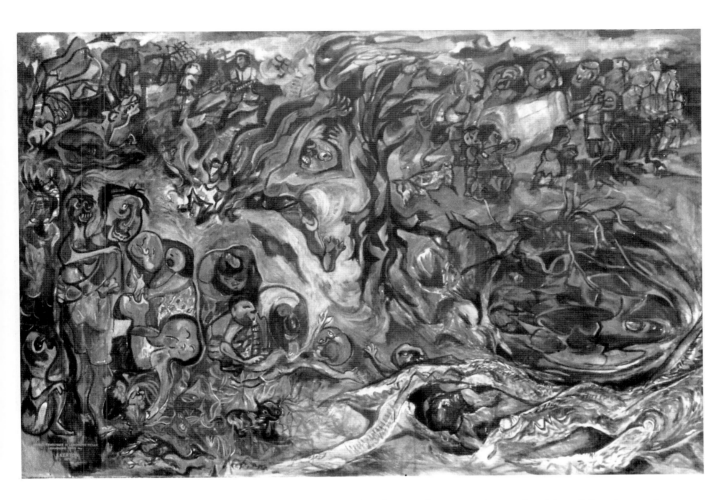

125. Sudjana Kerton, *The Bombardment of Lengkong*, 1985, oil on canvas, 200 × 290 cm, collection of the artist. (Photograph Astri Wright.)

the battlefield, are done in the distorted expressionistic style he developed later, which conveys the feeling of the horrors he saw (Plate 125): 'I saw—three or four or five day old corpses—they had expanded of course, the bodies. Seeing all these things in chaos, I had to then make [legible] pictures. I didn't need to work from models; it was all there, in my mind.'

Kerton's work was lost, burned, or destroyed for the second time when the Dutch occupied Yogyakarta in December 1948. Kerton himself escaped by sheer chance because he had been ordered on a mission to sketch events on Timor and his flight was the last one to leave Yogya. By the time he landed, Yogyakarta had been occupied by the Dutch and his editor, Oesmar Ismail, was under arrest.

From a booklet of sketches and photographs assembled by the artist and his wife in 1981, the nature of some of his early work can be gleaned. Apart from their skilful execution, what characterizes these works is the intensity of feeling or mood they convey. When more than one figure is depicted, a complex psychological relationship is often portrayed. It is always the feelings of the subjects rather than of the artist which emerge as significant. A pen drawing of Affandi at the Taman Siswa school in Jakarta in 1949 shows the artist serious and thoughtful. A clay sculpture shows the evacuation of a mother and her children—an expressive work about the chaos, clinging, and fear in such sudden, unplanned movement. An oil-painting of the artist's daughter from

1955 shows the child heading out of the canvas, looking back at the painter with big round eyes, as if caught by surprise.

A realistic self-portrait from 1946 radiates with stubborn commitment and a will to fight for a cause greater than his own self-preservation; a portrait of a guerrilla fighter from 1947 shows an emaciated, hollow-cheeked figure with burning eyes, grimly going on with his mission. The painting of Napitupulu (see Plate 110) shows a man with a red scarf tied around his head lost in temporary reflection, strong large hands momentarily at rest, and a feverish glaze in his eyes. No weapons are shown here, yet the dress and the look of the man give him the unmistakable identity of a fighter.

Sudjana Kerton left Indonesia in 1950. Ironically, only a year after the Dutch had stopped killing Indonesians, he was the first Indonesian artist invited by STICUSA (Foundation for Cultural Co-operation between Indonesia and Holland) to study art in Holland.[9] He was selected as the best young artist at an exhibition arranged by STICUSA in Jakarta. This was his ticket, both to wider artistic horizons and to the first flicker of respect from his father when the latter heard that the fellowship consisted of 10,000 guilders, 'a lot of money at that time!'

Arriving in Holland and Paris, Kerton heard about the wartime exodus of European artists to the United States.

Realizing that New York was now the Mecca of modern art, he decided to study there before returning to Indonesia. He was offered scholarships to the Institute of Contemporary Art in Washington, DC and the Art Students' League in New York. Choosing the latter, he began a fruitful course of study among students from all over the world and with teachers who challenged him in new ways. His Japanese instructor, Yasuo Kunoyoshi, told him: 'Sudjana, you work well, your perspective is perfect—your colour is perfect—but something is missing in your work.' When Kerton asked what that was, the answer was: 'You!' Kerton protested that he had been working for almost twenty-five years, but Kunoyoshi patted him on the back and told him to concentrate on working in black and white. Kunoyoshi asked him:

'Have you ever tasted a green apple?'
'Yes!'
'What did it taste like?'
'A little sour....'
'And how about a red apple?'
'A little sweet....'

Kunoyoshi gave Kerton the assignment to do a green and a red apple in black and white, in such a way that one could feel clearly which was sweet and which was sour.

If Kerton's self was not clearly expressed in his work, this 'absence' may in part be explained culturally. Coming from a culture where the individual is subordinate to the group, whether the immediate or extended family, the neighbourhood, or the larger society, Kerton also came of age in an era when individuals were involved in an intense struggle to bring about the birth of a nation, with all the demands for personal self-sacrifice that revolution entails. Before coming to the United States, Kerton neither had the cultural predisposition nor any inner, personal pressure to make either himself or an

[9]STICUSA, a Netherlands government foundation established in 1948, with headquarters in Amsterdam and an office in Jakarta, gave scholarships from 1950 on to Indonesian artists to study and exhibit in the Netherlands. The foundation also published a monthly magazine with news of Indonesia-related cultural events both in Holland and in Indonesia. Other painters who received similar grants during these years were Baharuddin M. S., Mochtar Apin, and Rusli (Holt, 1967: 208, 322, 327). Literary figures, such as Pramoedya Ananta Toer, also received STICUSA grants.

individual aesthetic mode of expression a major goal in his work.

The formal technical and aesthetic dimensions of what Kerton learned from Kunoyoshi still occupy him today:

With sound you can make colour—and also with taste you can make colour. So of course I tried to study what is a green apple? How does it taste—and what is its form. . . . Black and white have many colours, remember that. . . . You can have nuances in black and white, that's how you can make a red apple and a green apple. . . . The red one is more shiny. The green one has more nuances, shadows, and there, between the greenness and the light, there are colours. . . . If you don't understand black and white, you will always be confused by colour. That's why I always say to my students: 'I'd like to see your black and white first.' Because I think it's more spontaneous. There's no such thing as 'I will try the colour of red or blue and then erase again' . . . there is no such thing, because in black and white, that's *it*. That's you. You do it or you cannot do it—you have to start again. . . . So that's why I make many drawings—quick sketches—before I paint something.

In the United States, Kerton did all kinds of things to support his family and realize his dream of returning to Bandung to build a studio and home: he opened a shop selling crafts from Indonesia and framing pictures; he demonstrated, taught, and sold batik paintings; he even taught Indonesian cooking on television, all the while painting and exhibiting. He exhibited in Holland in 1951 and 1967; in 1951–2, he participated in a travelling exhibition of Indonesian artists in the United States, showing in major cities, including New York and San Francisco. From 1955 to 1965, apart from participating in group exhibitions, he had two solo shows in the US.[10] In 1964,

competing with Picasso, Henry Moore, and Raoul Dufy, his design was chosen by UNICEF for their international Christmas greeting card. Meanwhile, he maintained his Indonesian contacts, playing host to Affandi on his several visits in the late 1950s and 1960s. Kerton also maintained his contact with Sukarno and was occasionally called back to Indonesia, such as in 1965, when he helped design the Indonesian contribution to the World's Fair. He was also commissioned to paint a mural in the Indonesian Embassy in the Netherlands.

The most striking difference between Kerton's early paintings and his later work is the total absence of humour in the early works, which are characterized by a deep seriousness. This is not surprising, given the era and the subject-matter. Our knowledge of this period and of the way he worked, only deepens our understanding of his art. The change in preoccupations reflects the change that has taken place in Indonesia as a whole, as well as in his own life circumstances and his artistic development, aided by the influence of his Dutch, American, and Japanese teachers during his long stay abroad. Kerton, however, is still fundamentally the same: now as before, his role is in part to open people's eyes. Although no longer a fighter of revolutions, he is still a painter with a mission.[11]

[10]The 1951–2 exhibition was the first major showing of modern Indonesian art in the USA. The Modern Indonesian Art Exhibition sponsored by the Festival of Indonesia, in 1990–1, was the second

and larger exhibition. In the mid-1950s, Kerton exhibited, among other places, at the US Library of Congress, New York's National Arts Club, and San Francisco's Palace of the Legion of Honor. His two solo shows in New York were at the Monede Gallery on Madison Avenue (1961) and at the Hicks Street Gallery in Brooklyn Heights (1964).

[11]There are other artists who, from the point of view of style, humour, and commentary, are related spirits to Kerton, such as the first-generation painter Otto Djaya and the much younger Heri Dono. There are also similarities between Philip Sherrod's and Kerton's art, but this must be based more on

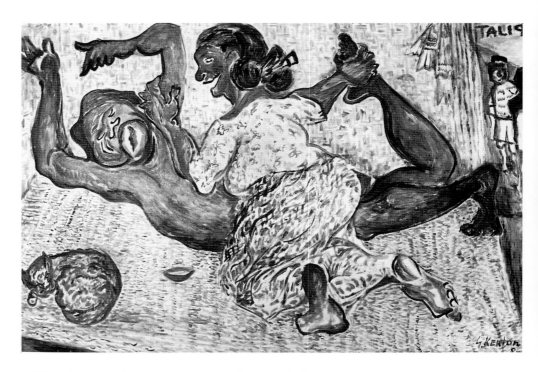

126. Sudjana Kerton, *Massage*, 1984, oil on canvas, 66 × 96 cm, when photographed, collection of the artist. (Photograph Astri Wright.)

Togetherness, closeness, and mutual help are important themes for many Indonesian painters, especially those of the older generation. The canvas of *Relievers* (1979) is divided diagonally into a dark, highly patterned part and a light, sketchy, 'empty' part.[12] In the

darker part, a woman massages another woman, seen from behind; in the light part, an old woman delices the hair of a younger woman, who is nursing a baby. It is a bold combination of contrasts and a condensation of activities which fill the entire canvas. The theme of delicing is a familiar one throughout South-East Asia and many Indonesian painters have used it.[13]

Another painting with the same theme, *Massage* (Plate 126), has a completely different tone. It shows a feisty middle-aged woman, grinning widely or shouting something as, with a mighty pull, she flexes a man's body into an arch. His agitation, as his body is bent into the shape of a 'C', counterbalances the cosily rounded form of a cat, sleeping on the mat, oblivious to anything else.

what Kandinsky calls a similarity of 'inner mood', ideals, sympathies, and affinities rather than direct influence. When I asked him, Kerton had not heard of Sherrod. Similarly, when he came to the Netherlands and everyone said his work reminded them of Raoul Dufy's, he did not know what they were talking about. Such examples support the importance of emphasizing stylistic affinities rather than copying; see Introduction.

[12]The paintings discussed below are reproduced with a series of other works in Kerton and Kerton, 1990. This book has eighteen colour reproductions of work spanning the years 1978–89. The volume is structured like the cycle of a day, from morning till sunset, showing people at work in the fields, picking tea, harvesting rice, digging for potatoes, and, after working hours are over, at play. We see animals, children, men, and women engaged in gambling, dance, and flirtation. A second book with a more extensive text about the artist's childhood, wartime experiences, and thoughts on art, is in the planning stages.

[13]A beautiful painting by Hendra from 1954 shows three women grooming each other, one seated behind the other (the little girl's doll constituting the fourth in the row). It captures the meditative mood this labour of patience induces (reproduced in Holt, 1967: 222).

Despite the distortions, the woman's body is completely believable from the point of view of movement. The man's even more radically distorted body is believable from the point of view of his state of mind—the healing techniques employed by village women are not always painless! One wonders whether she, with a hint of gleeful revenge, is not getting back at someone who, by extension, represents all men, for the hardship village women in Indonesia often endure in the name of male authority, lawful polygamy, and the broad licence given to men's need to satisfy their 'natural needs'. This, however, would be a clearly subordinate theme to the comic and graphic qualities of the moment depicted.

The earth tones and the spotty look of *Massage* are typical of many of Kerton's canvases. He is not afraid to leave parts of the canvas unpainted and to place different shades of colour next to each other without necessarily mixing them. In parallel lines or brush strokes, his paintings range from nearly monochrome to a low-key palette of light and warm hues, with only rare use of bright or primary colours.

Sudden Rain (Colour Plate 52) is painted with such fluidity and thinned-out oils that, appropriate to the subject-matter, it gives the impression of a water-colour. The driving rain of a sudden monsoon squall hammers against the young boys who make their way down the darkened slope with their buffalo and ducks. The mountain crags and terraced rice-fields are drenched, conveying the feeling of wetness every bit as vividly as Hiroshige's famous print of farmers caught on a hill in a rainstorm.[14]

Playing Dominoes (1986) shows five men playing cards at the roadside, while a sixth one sleeps next to them (J. Fischer,

1990: 108, Pl. 89). It is a study in the variety of facial expressions, body postures, conversations, characters, and comradely relationships typical of Indonesian village men at leisure. It is a scene that can be seen every day, and for that very reason most contemporary Indonesian artists would pass it by. Whether these men are unemployed (gambling away sorely needed funds from the family pot) or not, Kerton's sense of humour is at its most freewheeling and easygoing. This is also the case in the painting of a couple bargaining with a *becak* driver for a ride, while another driver sleeps nearby, his mouth wide open (J. Fischer, 1990: 76, Pl. 57). It is this kind of work which, according to Kerton, elicits responses like 'Ya! That's exactly how it is!' from amused neighbouring farmers who call in at Kerton's studio.

Other works, such as *Sunday Outing* (Plate 127), are intended, in part, as satire. Apart from the fun of trying to compose six people on a single motor cycle (which in Indonesia happens often enough in real life), Kerton wanted to paint the scene as a warning about how dangerous this all too frequent practice is.[15] According to Kerton, it is more effective in Indonesia to do such things with humour, since outright criticism is considered insulting and more or less taboo.

This painting is depicted in the more flat and decorative style that characterizes Kerton's murals (Colour Plate 53), the facial features distorted beyond caricature to flat areas delineated by

[14]The print *Shono*, from the Fifty-three Stages of Tokaido series.

[15]This painting evokes a work by Otto Djaya. In a black-and-white drawing in a different style, equally effective as Kerton's work, Djaya has depicted six people on a single motor cycle (Holt, 1967: 253). Though both works are caricaturistic, Djaya's does not show the Western modernist influence evident in the cubist distortions of the faces in Kerton's work. Unlike Djaya's, which has no setting, Kerton's work is placed in an urban context.

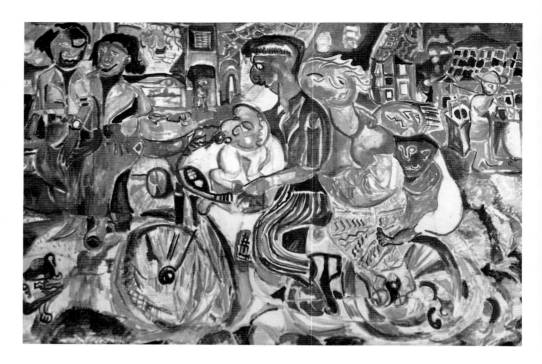

127. Sudjana Kerton, *Sunday Outing*, 1978, oil on canvas, 93 × 145 cm, when photographed, collection of the artist. (Photograph Astri Wright.)

circles, scrolls, and zigzags. In such details, the Western modernist influence is clearly shown. At times, he uses such conceits side by side with more standard techniques of caricature-like distortion, as in *Five Legs* [colloquial term for movable food-stand] (1970). This work shows a lively scene inside one of the innumerable temporary eating places that appear along the main roads of villages and towns at night. Two men dressed as women (transvestites are common roadside entertainers in Java) are playing ukuleles and singing, and the male customers are eating, singing, laughing, and shouting, all having a raucous good time.[16]

The wit and humour in such works contrast dramatically with the formalist play of Kerton's silk screens, composed of bright flat colour areas and undulating line-drawings, and a group of water-

colour and ink paintings. The serious tone in the latter is different from the works of the war era: these images, of a kind rarely found in Indonesian art, depict an internal state of deep psychological or emotional intensity.

Loneliness (Plate 128) is a work of agonizing expressivity, showing a figure hunched together, face hidden, a single eye uncovered as it searches for the sign of a caring presence. With a simplicity reminiscent of Zen painting, it is a picture of existential *angst*. At first, the cartoonish figure almost makes us laugh, but the laughter gets stuck in our throats. The white body is outlined swiftly and simply against the dark background by a few brush strokes reminiscent of Chinese calligraphy. It also bears echoes of a tradition in West Java of paintings in which the outlines of figures or animals are composed of calligraphically transformed Arabic script.

More than by their colouristic qualities, Kerton's paintings are characterized by their creative solutions to the problems of composition, and his

[16]In Kerton's more recent work, however, the faces are less abstract, with features that look more Indonesian. This can be seen in works like *Wedding (Nyawer)* (1988) (J. Fischer, 1990: 37, Pl. 32).

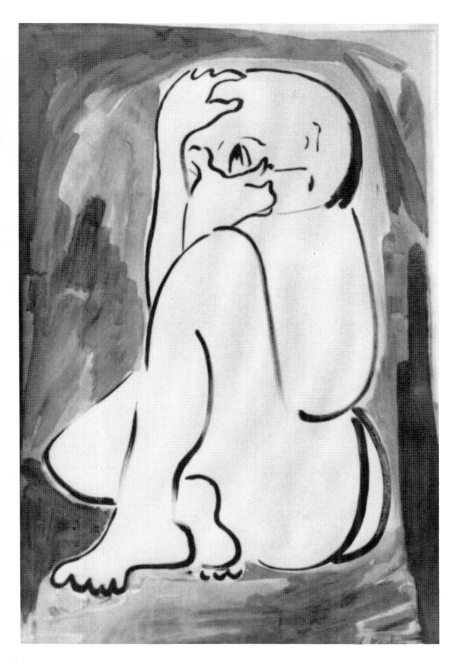

128. Sudjana Kerton, *Loneliness*, 1982, water-colour on paper, 91 × 60 cm. (Photograph courtesy of the artist.)

About his way of painting, Kerton says:

In my work, I am not looking for anatomy—I am looking for expression. Of course, you must study! Psychology ... people's everyday life.... And you must *think*. Just like making bread—you work it over before you bake it. Then the result will be more beautiful than external reality, you see. Say a painter wants to paint a beautiful flower which he saw outside. But someone says: 'It doesn't look like the real flower.' But of course! *He* made that flower, not from nature, but from his *mind*!

Kerton's style may seem spontaneous, but the idea for a painting and the planning of the composition and technique may take as long as a month to be worked out in his mind before he even puts brush to canvas. In a statement which resembles Affandi's attitude, Kerton says he needs to know not only the outer but the inner qualities of his subject before he starts painting. 'What we learn from school is book knowledge: anyone can master it. But what you cannot learn is feeling—your feeling and your experiences. The experience of touching a stone and of touching a human being....'

Living abroad, it was the sensory experience of life in Indonesia which Kerton painted without stop. Now that he lives surrounded by his own culture, interacting with the subjects of his paintings, the local villagers, there is an ambivalence about his attitude to life in Indonesia. It is the oft-repeated story of the immigrant's return. After the tension and sacrifice and hopefulness of participating in the bloody birth of his nation, the uneven development, inefficiency, and bureaucratic corruption that today are encountered on a daily basis are a shock to a returned patriot. Though he admires and respects the ability of people to be happy, he cannot live their lives as he sees them doing, always huddling close in groups, bowing

unique style of drawing. Heir to Western traditions of naïve art, expressionism, and the cartoon and caricature tradition, there is both a childlike innocence and a devilish wit at work in Kerton's style, which refers, not in the final analysis to West Java villagers, but to the people of his imagination.

Kerton's Place in Indonesian Art History

During the Revolution, Kerton's work received a fair amount of attention in publications affiliated with the Indonesian government and the military, and at exhibitions. In 1979, after the artist returned to Bandung, he received an award from the Governor of West Java in recognition of his social and humanitarian activities with the United Nations, and his efforts to introduce the art and culture of Indonesia while abroad. Nevertheless, Kerton feels that Indonesian artists and art writers, even those he knew personally, forgot him during his years abroad and do not give him the attention he deserves as one of the noted revolutionary artists.[17]

Kerton feels that discussion and argument about art and ideas are important sources of general cultural energy and creativity. He mourns the lack of dynamic dialogue and good, sharp criticism in Indonesia, where the harmonious, positive, and polite rhetoric tends to characterize interpersonal communication.

Without a traditional Javanese respect for convention but with a deep respect for people who work hard, endure, and enjoy despite hardship, and with the ability to step back and comment on human folly and ignorance, wherever he encounters it, it seems unlikely that Kerton would be included in the hierarchical civil servant structures that the art academies in Indonesia generally are. This is unfortunate since Kerton, with his experience of studying as well as teaching at the Art Students' League, could be a valuable resource to Indonesian art students.

Since the Revolution, Sudjana Kerton has not been politically involved. When I mentioned 'caricature' as one characteristic of his work, he responded:

No, not caricature—that is politics! And ... not that I don't like politics ... when I worked for the United Nations I was always listening to the speeches and I am very concerned too. But since 1968, I always warned the artists not to get involved in politics; just think of Hendra and everybody. I warned them when I was in Yogya, but—people at that time, they were very forceful and very angry.... People call me a bourgeois artist, because I am always neat—no long hair, no beard!

Now that Kerton has been living in Indonesia and exhibiting new work for more than a decade, a bridge can be built to his role in the pre-liberation art scene, and an assessment of his importance in modern Indonesian art attempted.[18] With his involvement with Indonesian culture and the question of whether to attempt to incorporate an Indonesian sensibility into the modern arts, his preoccupations are similar to those of other prominent Indonesian artists. In this sense, Kerton is part of the movement and culture, both of his own and of following generations. Kerton writes:

I believe that the rich cultural heritage of Indonesian art should form a foundation for the work of the younger generation, who should have a new style and form. While still respecting the traditions of the past the artist should be able to express himself in any way he chooses. Each artist should feel a spirit of

[17]His name is rarely mentioned in recent art historical writings pertaining to the revolutionary period. Hendra Gunawan, on the other hand, in 1958, wrote, 'Painters Affandi, Sudarso, Surono, Suromo, Barli, Kerton, Abedy, Dullah, Harjadi and many others' exhibited works that "documented the suffering of the people ..." (1958: 3).

[18]In 1991, the artist and his wife returned to the USA to collect a large number of works made in the three decades abroad. In the years to come, access to his work from the American period will allow for a full analysis of Kerton's oeuvre.

responsibility for his country, a sense of pride in the great traditions, and a desire to create new works for [a] new society. Each artist ... should be respected as an important force in the lives of all people. Automatically they will learn to appreciate and enjoy the value and quality of good art work and to realize that this is only the beginning of a new era in Indonesian culture.... It is my hope to see all artists in Indonesia free to work toward some great new pattern, and the high standards of the past will be a driving force in this accomplishment.[19]

Kerton does not offer any general theories on how the 'rich cultural heritage' can constitute the basis for modern Indonesian art. One solution is found in his own way of working. With his emphasis on the freedom of the artist to choose, he is against any kind of official guidelines in this respect; thus, he adheres to the idea that the way in which each individual artist will accomplish his or her goal will be different.

According to Hardi, ex-member of the New Art Movement and one of the most outspoken artists of the younger generation, Kerton must be ranked, along with S. Sudjojono, Hendra Gunawan, and Affandi, as one of the four pioneers of modern Indonesian painting (Naniel K., 1988).

''Just look!' says Hardi, as he points to the canvases exhibited at the Erasmushuis in Jakarta in 1988. 'All of Kerton's paintings truly mirror the face of Indonesia. The anatomy of his people all show protruding jaws!' Hardi insists that at this point in time, Kerton may be the only painter from Bandung who chooses 'the life of the masses as an object to be put on to canvas' (Naniel K., 1988).

Kerton's paintings are multifaceted: they are exaggerated, hilarious, and poignant. They are about water and grain, people and animals, work and play; about times shared and times alone. They are suffused both with a quality of intimate, nostalgic involvement and the more distant perspective of the outsider. With their sharpness, humour, and local as well as universal levels of meaning, they are simultaneously about life in Indonesia and about human beings everywhere.

[19]Statement in 1984 exhibition brochure.

10 Expressing Empathy: Djoko Pekik

WHAT moves Djoko Pekik (Plate 129) to paint, he says, is the plight of people who are living in regions infertile from century-old deforestation, erosion, and overpopulation, where work is scarce and farming is meagre at best.[1] It is his deep empathy for people who somehow go on surviving, even with the odds of modern life against them, which emerges in Djoko Pekik's paintings (Plate 130).

Djoko submitted the following as his contribution to the 1989 National Painting Biennial catalogue:

My experience of history, of Indonesia, of mankind and its dreams and achievements, along with people's individual lives and daily strategies, is deeply meaningful to me. It is this experience which I pour on to the canvas. But here a technical and artistic struggle occurs. Not only must the meaning of symbols, both traditional and modern, be considered in the course of this artistic struggle, but also people's appreciation of things, our time-period, and our surroundings. People's goals and reality—harsh, bitter, and sweet—must be considered.

I am often made aware of the fact that one thing can mean many things; meanings are always tempted, teased, and tried by time and space.

This not only happens with meanings, but also with emotions—once ignited they can lead in many different directions. While seeing and admiring the development of my country, I meet village people in the city. They are looking for work and for development. They form long lines, both to the city and within it. They mesmerize me. They make me sad—and here I invite them to speak directly to you. They carry many burdens on their backs and they are part of the history of this land made from our spilled blood, Indonesia (Dewan Kesenian Jakarta, 1989; author's translation).

As the youngest of six children, none of whom his parents could afford to educate properly, Djoko easily identifies with the hardship he sees in other people's lives. 'What I paint is nothing but a portrait of my own life,' Djoko said during an interview in 1990. 'Two of my older siblings only had three years of elementary school. Even to this day, many of my relatives have a hard life.... It is complicated life circumstances like that which I put on the canvas; that is the only thing I can do' (Sinaga, 1990).

Djoko Pekik (b. 1938) grew up in Grobogan, Purwodadi, Central Java. At the age of twenty, he entered ASRI in Yogyakarta. After graduating in 1963, he decided to stay on in Yogyakarta, which had remained the most important centre for painting and artist organizations in Indonesia throughout the 1950s. Here, young art students could meet important painters like Affandi and Sudjojono, who

[1]An earlier and longer version of this chapter is in Wright, 1990d.

only taught occasionally at the academy, at the city's various *sanggar* (art studios).[2]

This was the setting Djoko Pekik came to from his remote childhood village. It was an inspiring time filled with artistic debate and argument. No one, least of all a man in his early twenties, could have foreseen the outcome of the painters' political-artistic romanticism, clad in a language which resembled the traditional Javanese village ethic of *gotong-royong* (mutual help, interdependence) in the modern form promulgated by Sukarno.

[2]Based on information from the regional Department of Education and Culture, Claire Holt wrote that Yogyakarta in 1955 (with a population of 270,000), had seventy-four officially listed art organizations. Seven of these were associations especially for the plastic arts. It was estimated that between two-thirds and three-quarters of all of Java's painters lived in Yogya. A centre for higher education, the city also supported a student population of 8,000 (Holt, 1967: 215).

129. Djoko Pekik, 1990.
(Photograph Astri Wright.)

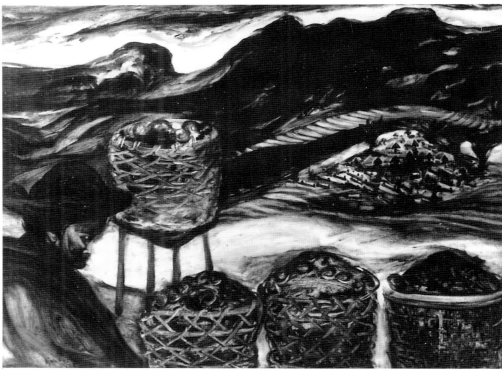

130. Djoko Pekik, *Potato Vendors*, 1980s, 100 × 150 cm, when photographed, collection of the artist. (Photograph Astri Wright.)

Then the sky fell down. Painters were seized and killed or sent to prison, art organizations were banned. Some of those who had been involved on the fringes, who had just gone along with friends, to be near respected teachers, spending time now in the studio of one famous painter, now in the home of another, were also imprisoned; all shrank back into the woodwork. Some of the artists continued painting quietly, others entered other professions. The subject that had so dominated modern art in Yogya—the life and struggle of the common people—disappeared. It was only in the work of isolated individuals like Hendra, in prison, and Kerton, in the United States, that daily life remained a source of inspiration. In early 1989, a quarter of a century after the 1965 *coup* and its violent aftermath, an obscure fifty-two year old painter was planning his first solo exhibition in Jakarta in which he was going to exhibit paintings which in choice of subject-matter constituted a bridge back in time, crossing that gulf of silence.[3]

Djoko has been living in Yogya for more than thirty years now. His home and textile shop, where his wife takes in sewing, is located in the south of Yogya, around the corner from the art academy and not far from the Sultan's palace. Handwoven cloths are creatively displayed on racks, draped on walls, and folded in neat stacks. Here are found both whole bolts of cloth and ready-made items of clothing—all *lurik*, a tightly woven cloth characterized by stripes in quiet hues, which is woven on handlooms by older women in the remote villages of Central Java—the places where Djoko finds many motifs for his paintings. For two decades it was *lurik* that supported Djoko, his wife, and their eight children.

This is a kind of cloth that the tourists hear and see little of during their sojourn amidst the far more glamorous and widely displayed textiles like batik and *ikat* in all the regional colours and styles. *Lurik* is a low-key form of expression which has only minimally engaged the attention of scholars of Indonesian textiles.[4]

Did you know that the various combinations of stripes and colours all have specific meanings? Like this one with a stripe down the middle, named 'pass me by', is used to carry a baby whose older and younger siblings have all died and who therefore needs special protection. This cloth is considered powerful and protective enough to make misfortune pass this child by....

And did you know that the *lurik setagen* they used to wrap around the waist of the women in the Paku Alaman[5] was 21 metres long? Once you had wrapped a woman tightly in that, she looked as straight-backed and slender as a coconut palm, even if she was fat to start out with![6]

The connections one may find between Djoko's paintings and *lurik* are indirect, but certain parallels between these two forms of aesthetic expression can be sensed. This provides a strikingly different example than the relationship between batik and modern painting, which is more frequently singled out.

Like *lurik* itself, Djoko's paintings are strong, dark, and simple. Naïvely drawn figures in heavy outlines are set in simple, clear compositions. Like the colours of *lurik*, his are low-tone and earthy, and like the textile's repeated stripes, his figures generally occur in groups, in a choreographed repetition of rhythmic

[3]This was made possible by the emergence of privately owned and managed galleries. For various reasons relating to past political events and resulting cultural policies still in operation, the exhibition did not take place as planned. See below.

[4]The only mention of it I have come across is a three-page essay (Yogi, 1980).

[5]One of the royal courts in Yogyakarta.

[6]Interview with the artist, January 1989.

movement. The individual is not often the focus of Djoko's work. Single figures, when they appear, are representatives of a whole disenfranchised group (see Colour Plate 56).

Djoko treads a fine balance between straightforward and oblique statements, at times stopping just short of explicit political criticism.

I am not a political person and clearly do not understand politics at all. In my paintings, I want to tell as widely as possible what I have experienced, using my own feelings and thoughts, such as they are, with my limited strength so lacking in knowledge and in science. Because I come from a poor family in a back country village, and then got some higher education and lived in the city, my feelings and thoughts are definitely concerned with the different circumstances that shape people's lives.

I have been asked whether, given the themes I paint, I want to change the fate of people who are still leading a backward existence. I answer that of course I would like to change the fate of people who do not yet have a decent standard of living but remember how small my role is in painting; I could not influence anything, even though I would like to give something, no matter how small, to the art of painting in Indonesia today.[7]

Contrary to mainstream Indonesian painting, so much of which is harmonious, pretty, and idealist, in part because such a large part of everyday Indonesian reality is rarely depicted, in Djoko's canvases we see and feel the hardship of the people who live in the depressed mountain region along the southern coast of Java, and of unemployed villagers seeking work in the city. We sense the emptiness behind the masks or make-up on the faces of performers, the loneliness and fatigue of *becak* drivers[8] and night-watchmen, and female coolies carrying meagre supplies to and from distant markets (Plate 131).

With little regard for technical skill, Djoko treats the oil paints almost as water-colours, diluting them with oils and sweeping them across the canvas in broad, wet strokes. Here, he emulates Affandi's technique of creating a thin wash as the ground for the high impasto of oil colours squeezed straight from the tube. Unlike Affandi, however, Djoko paints with wide brushes, not with his hands, and does not bother with impasto accents on top of the colour washes.

This 'wet' technique demands that Djoko work quickly, and he finishes most of his paintings in a single standing. Once the canvas is dry, he feels he cannot continue, because he will not get the desired effect. Thus, he spends much time thinking about his subject-matter and planning his paintings, often while travelling far into the countryside along the mountainous coast on a bicycle, sometimes carrying as many as six canvases in a rack he has designed especially for this. 'Sometimes these canvases get caught by the wind and suddenly my bike is like a boat with sails!' he laughs wryly, rolling the ever-present clove cigarette between his fingers.

Sometimes, Djoko cycles the 17 kilometres to the area named Parangtritis on the southern coast. Parangtritis was always a favourite place for Affandi to paint, and for lovers to gaze at the full moon over the ocean. It is a place with mystical overtones.[9] Djoko, however, is not in search of mystical motifs. He paints the ocean and the

[7]Letter from the artist, March 1990; author's translation.

[8]A *becak* is a three-wheeled bicycle taxi, where the driver sits on a bicycle seat behind a two-seater (often filled with three or more people, goats, furniture, produce bound for market, or food for twenty-five), pedalling it forward. It is an important symbol of the *orang/rakyat kecil*, the small person in society, and of the strength and tenacity and patient endurance of the undernourished poor.

[9]See Chapter 6.

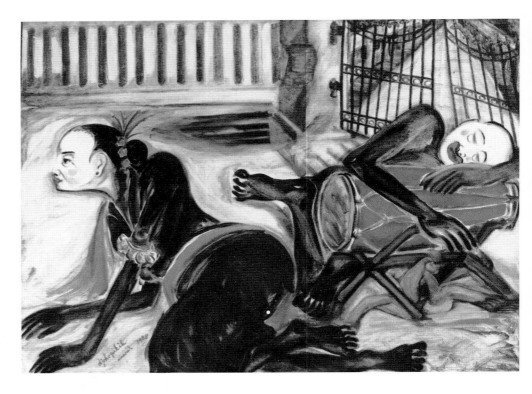

131. Djoko Pekik, *Wandering Singers Resting*, 1988, oil on canvas, 98 × 138 cm, when photographed, collection of the artist. (Photograph Astri Wright.)

beach-line in an expressive, monumental way. The meeting of strong natural forces at Parangtritis, and how this nature frames scenes of human activity, are both important to Djoko: he paints poor villagers walking winding paths through desolate landscapes to distant markets (Colour Plate 54).[10]

Djoko Pekik works in bleak tones dominated by moss green, black, ochre, and cream, enlivened here and there by a deep red or blue. The main themes of his paintings are people working; performers or average people entertaining themselves; life, procreation, and death; and landscapes.

The paintings of people at work are the ones that seem the most bitter and hopeless. Djoko's people are driven, haunted, at times desperate. They seem to

have been this way for so long that their emotions have become dulled. They are like empty shells that continue to pull their heavy loads, day in and day out, automatically, without hope.

The seller of young coconuts, a refreshing drink in the hot weather, searches the empty beach at Parangtritis for a customer. Three weary men carrying axes and sacks walk close by the viewer along a high ridge; way below them throngs of people are visible on the beach, tiny as ants. Four gaunt women with pale, drawn faces approach a stack piled high with sacks, coolies at the Beringhardjo market in Yogyakarta. Behind them fancy red cars are parked— cars used to transport people, not goods. Four male coolies looking for work in the city stare out from the canvas with empty eyes, looking as though they might drop from hunger any minute. They are standing above a busy intersection where dozens of cars are caught in a traffic jam. The life and death struggle of the poor is,

[10]Some of these works are *Pantai Parangtritis* (1988), *Coming Home from the Market* (1989), or a royal ceremonial procession, bringing offerings to Ratu Roro Kidul, *Sadar Wisata Pelabuhan* (1989).

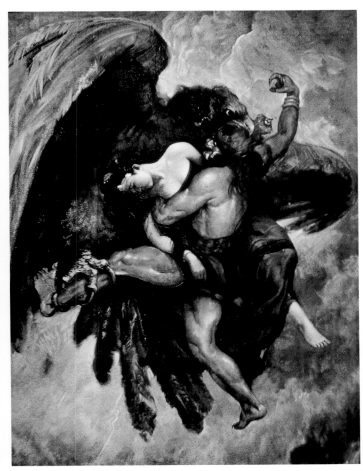

33. Basuki Abdullah, *The Battle between Rahwana and Djataju in the Abduction of Sita*, mid-1950s, oil on canvas, 160 × 120 cm. (Sukarno Collection, Vol. II, No. 96.)

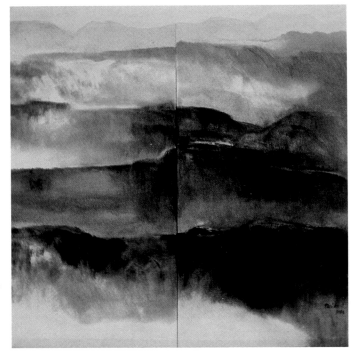

34. Farida Srihadi, *The Voice of Nature*, 1988, oil on canvas, approx. 150 × 150 cm, collection of the artist. (Photograph Astri Wright.)

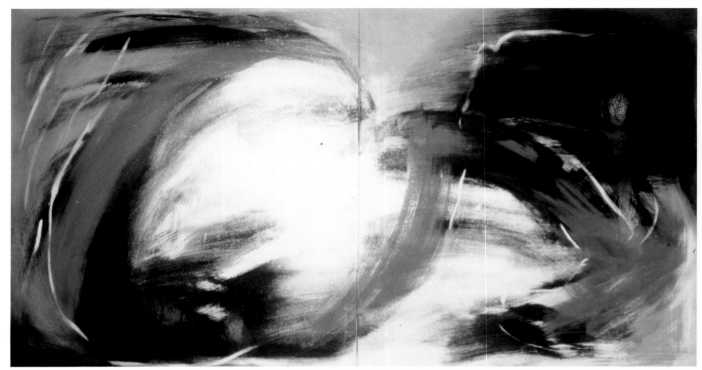

35. Nunung W. S., *Women and Problems*, 1987, oil on canvas, approx. 100 × 200 cm, collection of Pia Alisyahbana. (Photograph Astri Wright.)

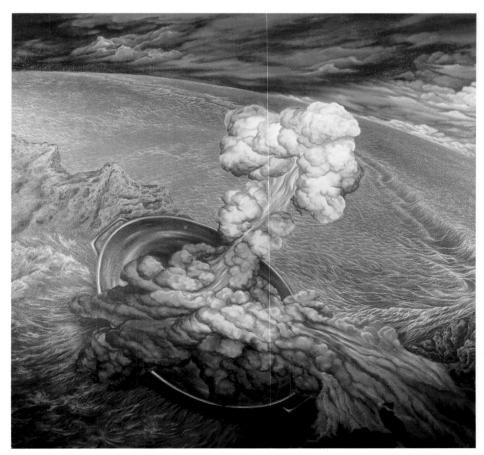

36. Lucia Hartini, *Imagination XII*, 1987, oil on canvas, collection of the artist. (Photograph Astri Wright.)

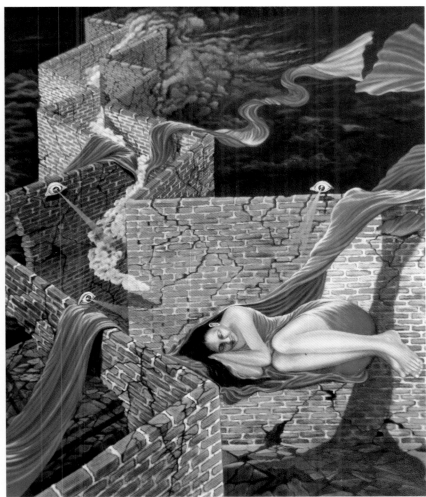

37. Lucia Hartini, *Spying Eyes*,
1989, oil on canvas,
150 × 140 cm. (Photograph
courtesy of the artist.)

38. Hildawati Soemantri,
Accident in Space, or Form I,
1988, ceramic, when
photographed, collection of
the artist. (Photograph Astri
Wright.)

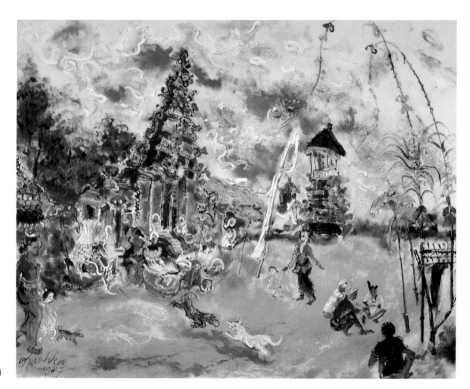

39. Kartika Affandi-Köberl, *Balinese Temple*, 1987, oil on canvas, 100 × 120 cm, when photographed, collection of the artist. (Photograph Astri Wright.)

40. Kartika Affandi-Köberl, *Seated Fisherman* (detail), 1979, oil on canvas, 110 × 140 cm, when photographed, collection of the artist. (Photograph Astri Wright.)

41. Kartika Affandi-Köberl, *The
Moment of Beginning*, 1981,
oil on canvas, 116 × 198 cm,
when photographed,
collection of the artist.
(Photograph Astri Wright.)

42. Kartika Affandi-Köberl,
Rebirth, 1981, oil on canvas,
133 × 132 cm, when
photographed, collection of
the artist. (Photograph
Astri Wright.)

43. Kartika Affandi-Köberl, *Self-portrait with Goat*, 1988, oil on canvas, 100 × 120 cm, when photographed, collection of the artist. (Photograph Astri Wright.)

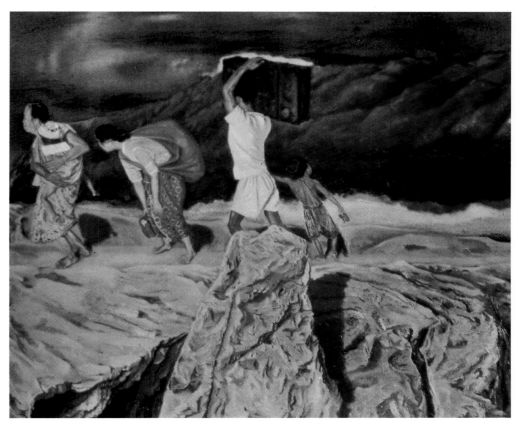

44. S. Sudjojono, *Fleeing*, 1947, oil on canvas, 104 × 144 cm. (Sukarno Collection, Vol. II, No. 90.)

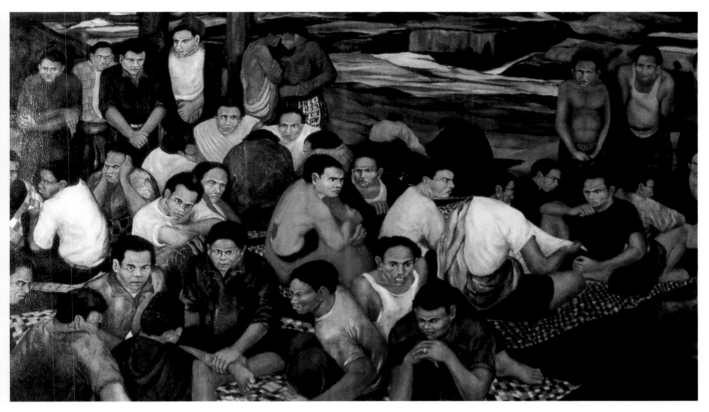

45. Amrus Natalsya, *My Friends*
(detail), 1957, oil on canvas,
247 × 251 cm. (Sukarno
Collection, Vol. IV, No. 25.)

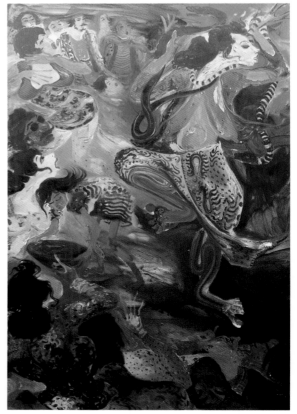

46. Hendra Gunawan, *The
Snake-dancer*, 1977, oil on
canvas, 196 × 136 cm,
collection of Lukas
Mangindaan. (Photograph
Astri Wright.)

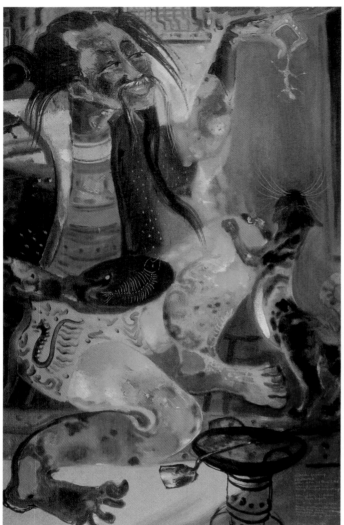

47. Hendra Gunawan, *Dry Lizard*, 1977, oil on canvas, 147 × 89 cm, collection of Lukas Mangindaan. (Photograph Astri Wright.)

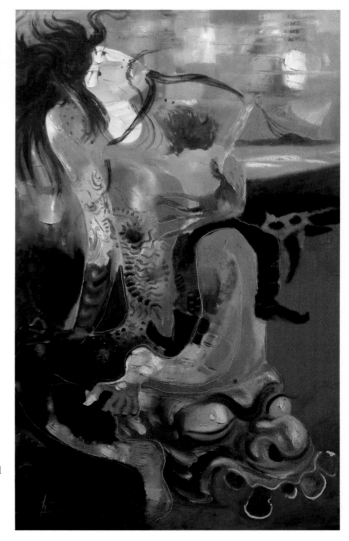

48. Hendra Gunawan, *Self-portrait with Child*, 1978, oil on canvas, 152 × 97 cm, collection of Lukas Mangindaan. (Photograph Astri Wright.)

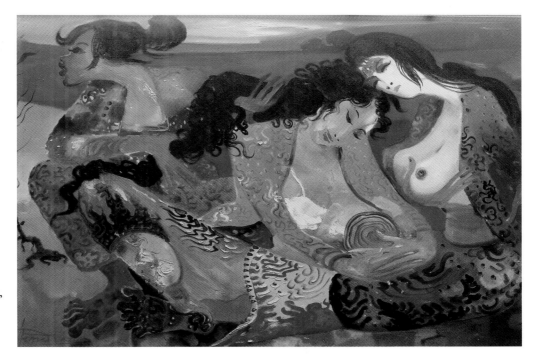

49. Hendra Gunawan, *Nursing the Neighbour's Baby*, 1975, oil on canvas, 94 × 149 cm, collection of Lukas Mangindaan. (Photograph Astri Wright.)

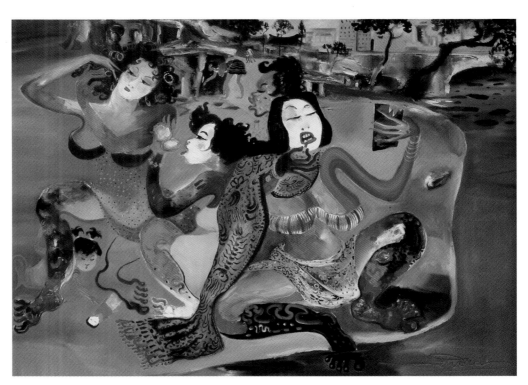

50. Hendra Gunawan, *Three Prostitutes*, 1978, oil on canvas, 146 × 200 cm, Adam Malik Collection. (Photograph Astri Wright.)

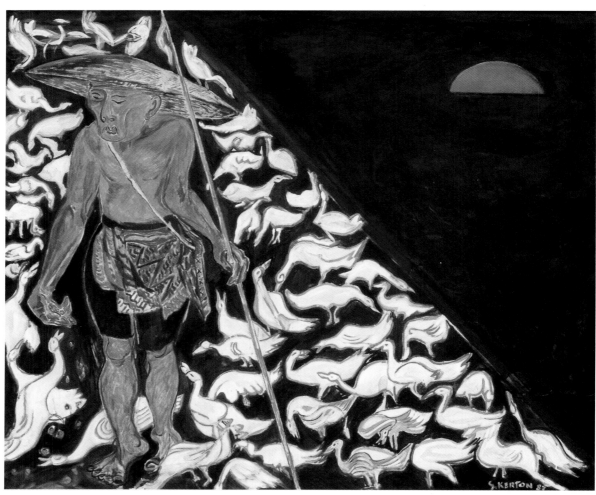

51. Sudjana Kerton, *Sunset*,
 1987, oil on canvas,
 125 × 148 cm, collection of
 the artist. (Photograph
 courtesy of the artist.)

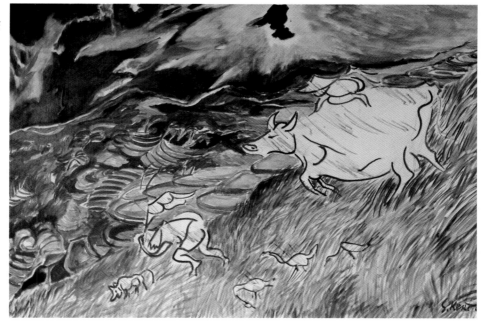

52. Sudjana Kerton, *Sudden
 Rain*, 1985, oil on canvas,
 78 × 120 cm, when
 photographed, collection of
 the artist. (Photograph
 Astri Wright.)

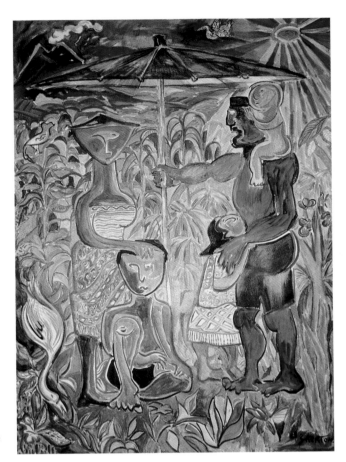

53. Sudjana Kerton, *The Protector*, 1982, oil on canvas, 140 × 100 cm, collection of the artist. (Photograph courtesy of the artist.)

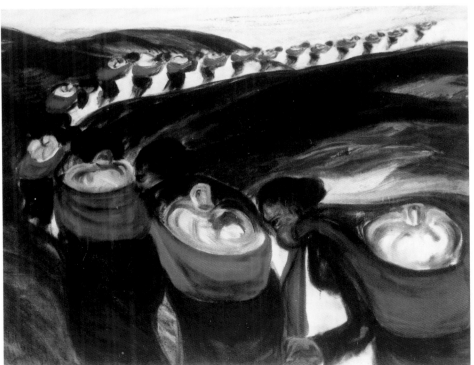

54. Djoko Pekik, *Home from Market*, 1987, oil on canvas, 98 × 138 cm, collection of the artist. (Photograph courtesy of the artist.)

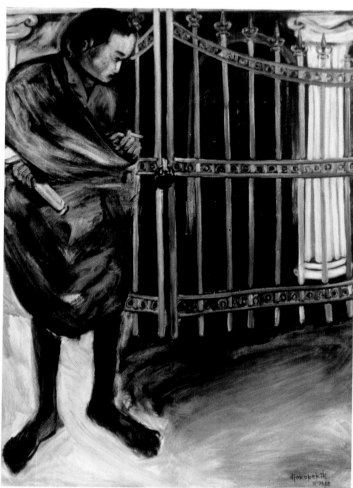

55. Djoko Pekik, *Night-watchman*, 1988, oil on canvas, 138 × 98 cm, collection of the artist. (Photograph Astri Wright.)

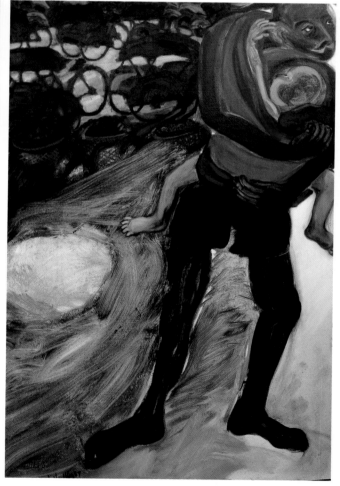

56. Djoko Pekik, *Becak Driver Taking Care of Child*, 1987, oil on canvas, 138 × 98 cm, collection of the artist. (Photograph Astri Wright.)

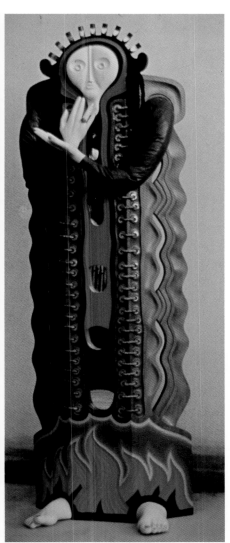

57. G. Sidharta, *Weeping Goddess*, 1977, leather, wood, and paint, height 193 cm. (Photograph courtesy of Joseph Fischer.)

58. New Art Movement, *Malioboro Man*, 1987, installation, Fantasy World Shopping Mall Exhibition. (Photograph courtesy of the artists.)

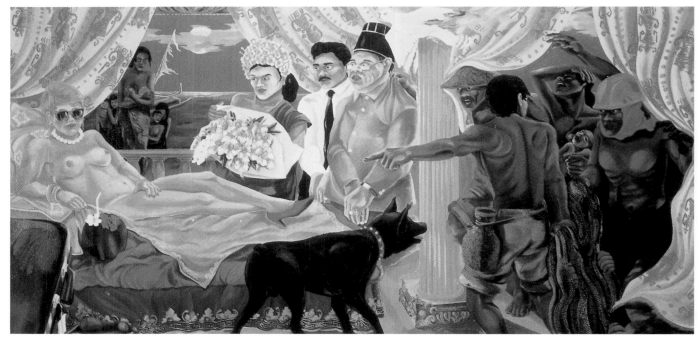

59. Semsar Siahaan, *Olympia,
Identity with Mother and
Child*, 1987, oil on canvas,
145 × 295 cm, collection of
Robert Sumendap.
(Photograph courtesy of the
artist.)

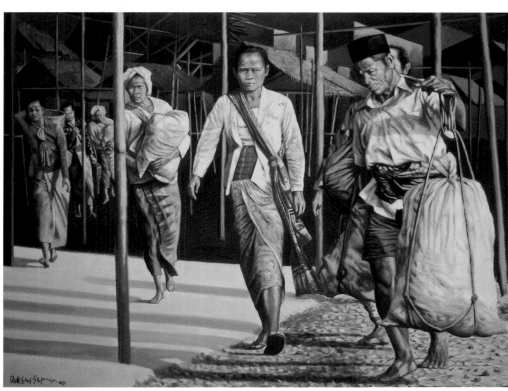

60. Dede Eri Supria, *Going to
Market*, 1985, oil on canvas.
(Photograph Astri Wright.)

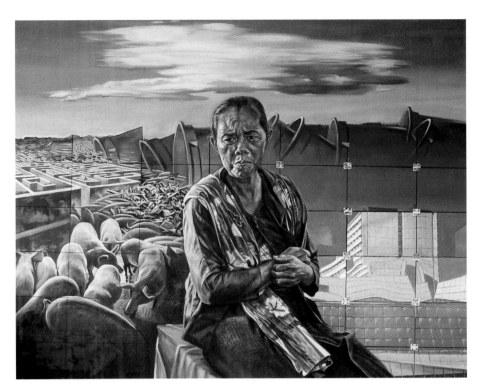

61. Dede Eri Supria, *Mother and Portrait of a City*, 1983, oil on canvas, collection of Fukuoka Art Museum. (Photograph Astri Wright.)

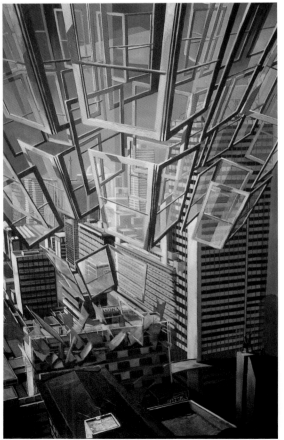

62. Dede Eri Supria, *View of Jakarta I*, 1985, oil on canvas. (Photograph Astri Wright.)

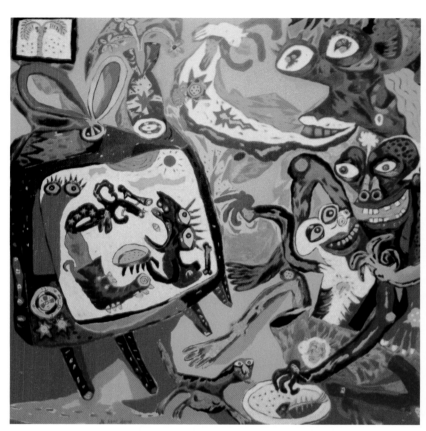

63. Heri Dono, *Watching TV*,
 1988, acrylic on canvas,
 146 × 146 cm, when
 photographed, collection of
 the artist. (Photograph
 Astri Wright.)

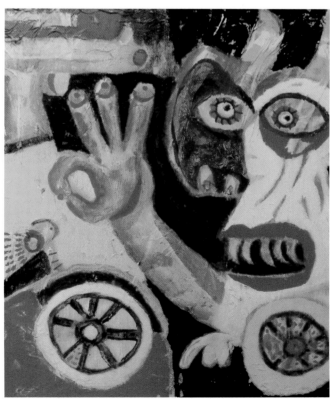

64. Heri Dono, *Campaign*, 1987,
 gouache on paper,
 32 × 28 cm, when
 photographed, collection of
 the artist. (Photograph
 Astri Wright.)

also in this work, juxtaposed against the lifestyle of the wealthy, not without its own frustrations.

Djoko's paintings are built on a series of very simple, indeed naïve, contrast effects. One typical compositional device is the placing of three or four large figures in the foreground, the backdrop seen from a bird's-eye perspective (see Plate 133). There is nearly always the convention of repeated forms which calls to mind the stripes in *lurik*: four coolies in a line, in identical postures, set against a dotting of jelly bean-like automobiles, scattered like marbles across the wide highway—symbol of national development in the discourse of social critics; a symbol with sarcastic overtones.

In many of the paintings, the foreground figures are placed on the baseline of the canvas, which puts them almost in the same space as the viewer, but their gaze is unfocused, going off in all directions, which makes it impossible for the viewer to make eye contact with them. This puts the viewer in the same position as the labourers; powerless and invisible, the viewer becomes a voyeur to suffering of such long standing that it has become an unselfconscious posture.

In a striking painting in the category of working people, a night-watchman stands before a fancy wrought-iron gate (Colour Plate 55). The padlock hangs prominently in the middle of the gate, through which two white Grecian columns and an ornate doorway are visible—a typical élite house in Java. Ironically, iron and lock are not felt to be sufficient safeguards for the rich as they sleep through the night: the night-watchman is an inevitable member of any urban servant staff. Usually unarmed, he is himself only protected by the sarong he wraps around his shoulders and his clove cigarette. As so often in Djoko's work, the man is seen in profile, not unlike Djoko's own, gazing absent-mindedly at the gate. His bare legs and feet, dark

against the contrasting white ground, are important expressive elements in Djoko's work in a way that contrasts with Hendra's use of the same elements. This is another example of how, in modern Indonesia, bare feet have come to symbolize the lower and backward classes; historically, before Dutch influence, both king and peasant walked barefoot.

The paintings that deal with life, procreation, and death depict these themes variously both from an individual and from a mass perspective. The most personal of these paintings is a beautiful long canvas entitled *My Family* (Plate 132), where the profile of the central figure of the woman has a serenity and monumentality that recalls a classical Greek frieze. Djoko here depicts the moment before the birth of his seventh child: we see Djoko himself, surrounded by six children, all looking towards the highly pregnant woman. Larger than life, she sits facing them, head bowed down with weariness and her long body like a branch heavy with fruit. Featured thus, wearing a red robe, she recalls personifications of Mother Earth. A young daughter holds her feet, perhaps massaging them, and the youngest of the six children embraces and kisses her ballooning belly, where number seven, yet unseen, is preparing his moment of entry into the world. The sky or ground behind the attentive children is burning red against the dark green and black of the figures and the pale faces.

Other paintings in this category are tenuous images of nourishment threatened. There is the water buffalo calf nursing an emaciated buffalo cow, which stares up towards the sky with an expression of suffering. There is the young boy stretching, reaching, trying in vain to get to a water jug in the middle of the table, which remains just beyond his reach. There is the dying man in *Painter at Death's Door* (see Plate 86), tubes

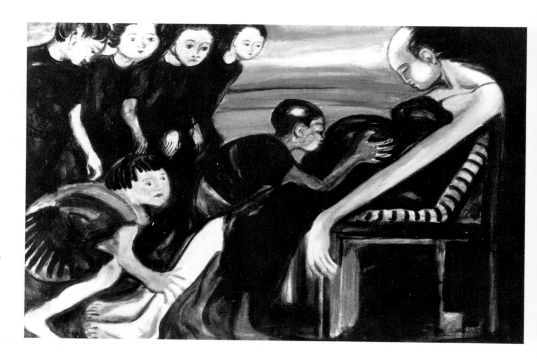

132. Djoko Pekik, *My Family*, early 1980s, oil on canvas, 98 × 145 cm, when photographed, collection of the artist. (Photograph Astri Wright.)

sticking out of his arm and nose, his body no longer able to take nourishment.

On closer observation, it appears that the paintings in the category of working people also speak of a tenuous existence. This is illustrated in *Becak Driver Taking Care of Child* (Colour Plate 56). Here, as the *becak* driver steps to the right, looking off the canvas in desperate search for a customer, the single figure composition divides the canvas diagonally. Djoko's use of dark brown for his skin sets off the white of the eyes, enhancing their expression, a technique Djoko often employs. The rough traces of the brush through the wet paint echo the turmoil of the man who is apparently failing to support himself and his child. The desperation of the situation is enhanced by the darkness of night, when few people would be out in need of transport, and the great number of empty *becak* parked in the background, all competitors for the occasional customer that might come by.

Some of Djoko's paintings show mass-scale hunger, longing, and mourning (J. Fischer, 1990: 36, Pl. 30). One of the most powerful of these mass images is *Solidarity with the Driver of the Train* (Plate 133). In the foreground of the painting are four men carrying sledgehammers and sickles; behind them stretches a platform full of people, their faces represented as spheres with minimal detailing. The other side of the tracks is also filled with people waiting, and the train which is just pulling in to the station is covered with humankind, hanging from the windows and covering the top. Above the tracks runs a highway, and in the background the skyscrapers of a large metropolis can be seen. Djoko writes:

I painted this after I saw at Bintaro/ Kebayoran Lama in Jakarta a freight train carrying goods—but it was full of human passengers, among them labourers, coming home from work. Of course they only paid little or nothing, while in Jakarta there are already flying highways with fine cars and hardly any passengers inside.[11]

[11]Letter from the artist, April 1990; author's

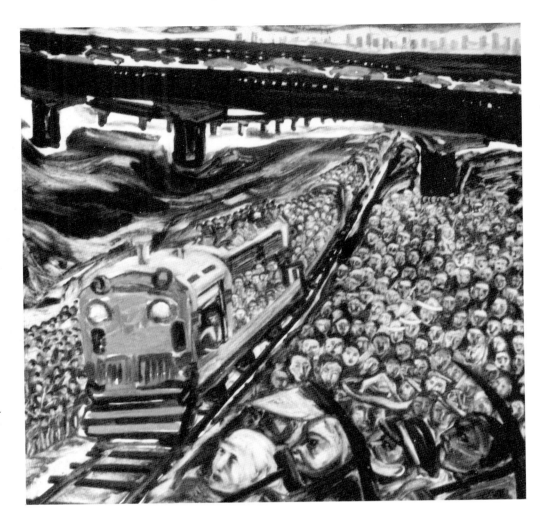

133. Djoko Pekik, *Solidarity with the Driver of the Train*, 1989, oil on canvas, 150 × 150 cm, when photographed, collection of the artist. (Photograph Astri Wright.)

What he does not mention here is the sarcastic dimension the painting acquires when one knows that he painted it with the refrain of a particular children's song in mind. The lines, made famous by Bing Slamet's lively delivery, go: 'Ride the train, tut-tut-tut; whoever wants to come along to Bandung, Surabaya, can get on for free; my train does not stop long, hey my friend, hurry up! Get on right away!'

Djoko Pekik's landscapes are perhaps the least emotionally laden of all his work. There is a certain beauty in the bleakness and simplicity of his beach-scapes. Some of them depict tiny, overburdened figures making their slow and tortuous way, mile after desolate mile. In those landscapes that are devoid of people, there are just the undulating lines and forms of dark green, blood red hills, and whitened dunes meeting the dark blue of water and sky. One feels that in contact with nature alone, Djoko can put the world of men behind him and experience a certain peace. It is not a sweet, idyllic peace or a romantic view of nature; it is a serenity which arises from an awareness of the relentlessness of life combined with an acknowledgement of the powerful forces of nature.

translation. The title of the work, though different from the one in J. Fischer (1990), was given by the artist in a letter in late 1989.

Both Kerton and Hendra have, in recent years, received a good deal of attention from private collectors, by art students, and through public exhibitions. On the other hand, Djoko Pekik, who must be placed with this group of painters in terms of subject-matter, originality, and expressive power, has had little exposure to the public. His first solo exhibition, planned for April or May 1989, was cancelled when the ghost of LEKRA was revived in connection with the Festival of Indonesia exhibition in the USA.[12] In the short perspective, the cancellation of the exhibition appeared disastrous, making Djoko the most recent example of artists censored for involvements a quarter of a century ago. However, after the debate died down, Djoko's exhibition, entitled 'Nature and Life', was opened the following year. Furthermore, in 1989, he was included for the first time in the National Painting Biennial, where his work received honourable mention.

Given the sensitive issues surrounding Djoko's solo exhibition, it is interesting to see what some of the Indonesian reactions to his work were. Since the article about Djoko published in the English daily, *Jakarta Post*, in early 1989 fuelled the debate surrounding the work of Indonesian painters who exhibit an active social conscience,[13] there seems to have been something of a normalization in the Indonesian attitude to work like this. Djoko's 1990 exhibition was opened by Ciputra, champion of Hendra's work. It received an unusual amount of attention, with write-ups in all the major media.[14] As could be expected, the reactions varied. After describing the works and quoting the artist about his work style and sources of inspiration, one reviewer concluded: 'Djokopekik [*sic*] is not exaggerating. His expression of reality which is poured on to the canvas, not only make us steal a glance at our fellow men who are in need, but makes us feel that need too' (Sinaga, 1990).

Another reviewer, in an article called 'Fascinating Indonesian Canvas Art', interpreted Djoko's paintings as 'nostalgic' presentations of 'ethnic characters'. He wrote: 'There is a longing for past times which suddenly is soothed' (Sri Warso Wahono, 1990). The romantic and positive tone of this reviewer is taken a step further by another writer, who not only finds humour and beauty in Djoko's work, but also finds implicit support for the government—and that in a work which strikes most people as among Djoko's most bleak and desperate paintings:

The painting 'Becak driver caring for child' is ... suitable to discuss at this time when Jakarta's *becak* are being condemned.... Probably Djokopekik [*sic*] is not aware of it himself, but the circle of white colour at the feet of the *becak* driver can be read as a symbol of the light of hope for the *becak* driver. This white light, which looks like it is revolving, symbolizes how the fate of the *becak* driver can be much better if he is given new work by the government (Francis H., 1990; author's translation).

Reading this, and then turning to the review in *TEMPO*, one can only wonder whether the writers are speaking of the same exhibition.[15] What is demonstrated

[12]See the discussion, in articles and letters, in *KOMPAS* and *TEMPO* from March to September 1989, and in *DIALOG Seni Rupa*, September 1990.

[13]In this article, after outlining a history of genre painting, the view was put forth that painting human suffering is not always, or necessarily, synonymous with adherence to a communist ideology (Wright, 1989c; see also Supangkat, 1989: 71).

[14]Some of the journalists only reported, but did not review the work in any qualitative way. See, for example, the article in *Harian Terbit*, Tuesday, 6 February 1990.

[15]It seems that such glossing over of the realities and sentiments expressed in Djoko's paintings must be rooted in a confusion about how to deal with such unfamiliar works of art, after twenty-five years

in all these examples of art journalism, however, is how different writers attempt to write about a sensitive issue in a way that will not cause repercussions, either to writer or to artist. In an essay entitled 'Suffering Seen from One Point of View', the reviewer writes: 'In a style of painting that has become rare we are shown an honest recording of the life of the common small people, presented with skilful workings of the brush' (Bambang Bujono, 1990).

According to Bambang, Djoko's work does this 'without falling to the level of protest posters or becoming decadent work'. Asking whether such works are not outdated, he answers: 'In as far as they are born out of an honest heart and from real problems that clearly exist in our society, these are works for the present.' The final conclusion, however, is that because Djoko lacks the sense of humour exhibited by other painters of social realities, his paintings become one-sided depictions of his own personal feelings. 'Djoko's world is like a world without hope. Maybe this is what causes even his best works to seem incomplete' (Bambang Bujono, 1990).

Statements like these indicate, on the one hand, how difficult it is for Djoko's work to be received in Indonesia, where the very idea of unadorned straight-forwardness goes so much against the grain of both cultural and official psychology. They also illustrate how far some critics will bend to present 'up-beat'

interpretations that are more acceptable from official hold.

As we have seen, feeling is an important element in the art of Hendra Gunawan, Sudjana Kerton, and Djoko Pekik. In each artist's work, feeling combines in different ways with visual sense impressions, elements of cultural knowledge, and personal memory. Djoko's art, rather than romantic, allegorical, or humouristically pointed like the work of the other two, is more in the vein of dramatic tragedy. His narratives are carried by a different sense of empathy than the work of Hendra and Kerton, and his bleak tone provides a stark contrast to theirs.

Djoko's paintings strike a deep note of realism in exhibition halls otherwise filled with resplendent colours and harmonious orchestrations of familiar forms—sweet dancers, cozy farm animals, benevolent nature, pretty women, and nostalgia-provoking mythological scenes. His paintings represent an undeniable but rarely depicted part of both life and art in Indonesia. The following lines by Rendra express the same kind of non-ideological simplicity and directness as Djoko's visual statements: 'People cannot live alone. They must mix with others. And relationships between people can be just or unjust. This is what we wish to talk about' (1979: 4).

Djoko's work completes a picture which otherwise would ring false. Not all Indonesians can while away their poverty cheerfully playing cards like Kerton's underemployed men, or forget their hunger in the intensity of a trance-dance, as in Hendra's work. The people Djoko paints are part of the backbone of Java, depicted in an idiosyncratic and expressive realism. Painting a mixture of what he sees and feels and how he thinks his subjects feel, Djoko's art represents a kind of communal rather than individual expressionism, a visual merging through empathy of the individual with the larger group.

of not seeing such things. Apparently, the official and cultural limitations imposed on painting, defining which are 'suitable' themes to put on canvas and which are not, differ from the expectations and demands placed on photography. Although there is much official pressure to make photographs which depict 'beautiful Indonesia', with all its happy ethnic and natural diversity, the fact that there is more leeway allowed in photography is illustrated by the presence of photographs depicting poor people (often women) carrying heavy loads to market and other themes similar to Djoko's in glossy Indonesian publications (see Joop Ave, 1986).

11 Challenging the Art Establishment

IN the first half of the 1970s, the wider dimensions of an agricultural crisis were becoming apparent, the increase in domestic prices triggered a sharp rise in inflation, and natural calamities on several islands contributed to worsening economic conditions. Although OPEC's rise in oil prices was beneficial to the Indonesian economy as a whole, the situation on the social level was not much improved (McDonald, 1980). In addition to the socio-economic problems, government marriage legislation caused strong public Muslim protests in 1972. The general disillusionment of intellectuals and artists with the new regime's development strategies and corruption was deepening, and in 1973 the student movement appeared on the national arena as a vocal public force. The large-scale demonstrations in January 1974, known as the Malari Affair, in which leading human rights figures were arrested, caused military crack-downs on several campuses.[1]

In the art world, too, authority was being questioned. A new chapter was being written in the East–West debate, which dates back to the Cultural Polemics (*Polemik Kebudayaan*), first appearing in print in 1935 (Holt, 1967: 211–54). At that time, questions were raised about what forms future

'Indonesian' culture should take: Was modernization synonymous with Westernization? How should an indigenous identity be preserved in the face of change, and, more fundamentally, what *is* Indonesian identity? When Claire Holt revisited Indonesia in the mid-1950s, Indonesian intellectuals were still involved in this debate, though in somewhat altered terms (1967: 211) as, again, in the 1970s.

The New Art Movement

In 1970, Soedjoko, a teacher in the Department of Fine Arts at ITB-Bandung, criticized the romanticism of modern Indonesian artists. He accused them of adopting an élitist, urban, Western definition of fine arts and forgetting, or relegating to the lower position of crafts, their own aesthetic heritage, represented by the art objects of traditional culture. In contrast to modern Indonesian art, Soedjoko pointed out, these craft objects were not isolated and élitist by nature; they could be understood by Indonesians from all classes (Supangkat, 1990: 160).

Soedjoko ... then took an extreme position: he argued that only traditional handicrafts were Indonesian art. He denied the existence of modern art and doubted its function. Soedjoko based his view on Javanese aesthetic and cultural concepts. In high Javanese language, art is known as *kagunan* or skill. More specifically, it was a special skill which

[1]This was repeated in 1978. See Rendra, 1979: 67 translator's n. 78.

expressed wisdom and beauty in the creation of utensils and ritual objects.... Soedjoko had practiced a sort of 'shock therapy'. His denial of modern art was only a theoretical denial. He attempted to place Indonesian art within the context of society by emphasizing its real function. He opened up a new channel in the search for the identity of Indonesian art. According to Soedjoko, art had an identity only if it was contextual. Modern art that developed in Indonesia had neglected the factors of society, communication and function. He argued that the societal theme which appears in Indonesian paintings was merely [an expression of] 'romantic agony' (1990: 60).

G. Sidharta, a sculptor and teacher at ITB, had also been moving away from the 'art for art's sake' philosophy characteristic of the Bandung school, which after 1965 had received tacit official sanction, removed as it was from any notions of the social involvement of artists. Sidharta's eye-opening experience happened in Bali, where he studied with Kakoel, a master dancer and mask carver. Sidharta feels he learned more from this traditionally trained and practising artist than from anyone else about the artistic life and the creative process. 'He taught me', Sidharta said in an interview, 'to unify my mind [here he pointed to his head] and my heart [pointing to his heart] in the centre of energy [pointing to his belly].'[2] This was one of the experiences which inspired him to search for ways to visualize a specifically Indonesian aesthetic. Having lived and taught in Bandung since late 1965, and become associated with the Bandung group, the encounter with Kakoel in Bali must have evoked memories of his student days in Yogyakarta, where he, among others, had studied with Hendra Gunawan.

[2]Pers. com. with artist, Bandung, March 1991. For a somewhat different narration of his encounter with Kakoel, see Supangkat and Sanento Yuliman, 1982: 34.

There, the students had lived and worked closely within the rhythms of everyday Indonesian life and thought, traditional and modern, and were far less involved with Western art theory than students were in the late 1960s and 1970s (Supangkat and Sanento Yuliman, 1982: 36).

Increasingly, Sidharta came to feel that Western ideas were 'inappropriate for Indonesian artists, and that the direction he wanted to follow was to draw upon the traditional arts not only for their forms, but also for their meanings, reintroducing the value of content into Indonesian modern art' (Miklouho-Maklai, 1991: 20). Experimenting with indigenous motifs and materials, Sidharta started to distance himself both from the Westernized middle-class Indonesian culture and the academic emphasis on the individual artist (1991: 21) (Colour Plate 57).

While at the same time remaining firmly planted in the modern world, I would like very much to re-establish my ties with the traditional world, which is to say that my desire is to abolish the gap between tradition and modernity. The approach I have chosen to this problem is a continual use at an intimate level of objects, forms, stories, streams of thought and anything else which is the result or expression of traditional patterns of culture and social intercourse (Supangkat and Sanento Yuliman, 1982: 1).

Inspired by Soedjoko's and Sidharta's challenges to the aesthetic values prescribed by art academies, senior artists, and critics, a group of young artists formed the New Art Movement (Gerakan Seni Rupa Baru) and held their first exhibition at Taman Ismail Marzuki (TIM) in 1975. This was the first focused statement by a number of younger artists who had, on several occasions in preceding years, shocked the art establishment with their actions (*TEMPO*, 1977b). Sharply criticized, even ridiculed, the group was defended by Sudarmadji, then head of the Jakarta Arts

Council. The group held their second and third exhibitions in 1977 and 1979. In 1979, a book was published which, in addition to the group's manifesto, also included essays by various members and observers.[3]

In the context of those eventful years marked by student activism and official crack-downs, arrests, and the banning of organizational and artistic activity, it is perhaps remarkable that the New Art Movement was allowed to continue exhibiting in the capital's major exhibition space. The answer must, in part, lie in the group's emphasis on aesthetics, and the fact that what social criticism could be read in the works was of a general nature.[4] 'The *Gerakan* was concerned not only with ideological *content* in art, as were the artists of PERSAGI and LEKRA, but also saw *form* as equally important' (Miklouho-Maklai, 1991: 26).

Form was perceived differently from what it had come to mean in the art academies of Bandung and Yogyakarta, which under the New Order increasingly emphasized aesthetic universalism. Sidharta, whose ideas both paralleled and inspired artists involved with the New Art Movement, asked:

Is there a kind of art which is universal? Is there a kind of art which denies personal identity? And is there an individual who is free from a connection with the environment? When universalism exists, and when individuals are free from links with the environment, is not this the result of *measures which are intentional and systematic? Is not this a kind of violence?* (Supangkat, 1979: 10; author's translation).

Ideas familiar in the West since the 1920s and the Dada movement, in Joseph Beuys' contemporary formulation of social sculpture and 'show your wounds' philosophy, in pop art and photo-realism, had become familiar to young Indonesian artists both through magazines and occasional first-hand involvement. Such inspirations, merged with their own visual imagination and life experiences, gave them a new language with which to express their dissatisfaction with the reigning values in artistic expression.[5] The Western idea of juxtaposing found objects and hyper-realism with symbolic or conceptual statements was Indonesianized through choosing objects from the Indonesian artists' urban environments to convey the particular messages they wanted to communicate to an audience living within the Indonesian context.

A few examples of works shown at several New Art Movement and related exhibitions should be noted. Satyagraha showed a lifelike sculpture of a woman seated on a toilet, concealing her face in her hand. Clearly, the situation flies in the face of what would be considered appropriate for public display. On the other hand, the woman's legs are crossed in a way one would sit publicly, on a chair; in addition to her despondent mood, this mixing of messages raises many questions in the mind of the viewer. Bonyong Munni Ardhi exhibited

[3] For the text of the manifesto in Indonesian, see Supangkat, 1979, or Miklouho-Maklai, 1991: 111–12; for an English translation, see Miklouho-Maklai, 1991: 113–14. The latter volume is a well-documented discussion in English of the New Art Movement.

[4] In contrast, an exhibition by some of the members of the New Art Movement called 'What Identity?' (Kepribadian Apa), in Yogyakarta in 1977, *was* closed by the police after two and a half days (Miklouho-Maklai, 1991: 70). One of the works regarded as offensive was by Bonyong Munni Ardhi entitled *Hotel Asian Tower*, which consisted of a wall enclosing a building area, against which a hyper-realist sculpture of a wounded and exhausted homeless person is leaning, surrounded by tattered fragments of the necessities of life. Pers. com. with an ex-member of GSRB, Jakarta, March 1991.

[5] Hardi, one of the group's original members, participated in a Joseph Beuys seminar at the Sixth Documenta international art event in Düsseldorf in 1977.

a table, set for two, including a cooked meal of chicken. As the seven days of the exhibition progressed, the food gradually rotted. Siti Adiyati Subangun turned two hopscotch grids into crucifixes, one white and one black, symbolizing the death to childhood games on neighbourhood roads—an image with simultaneous

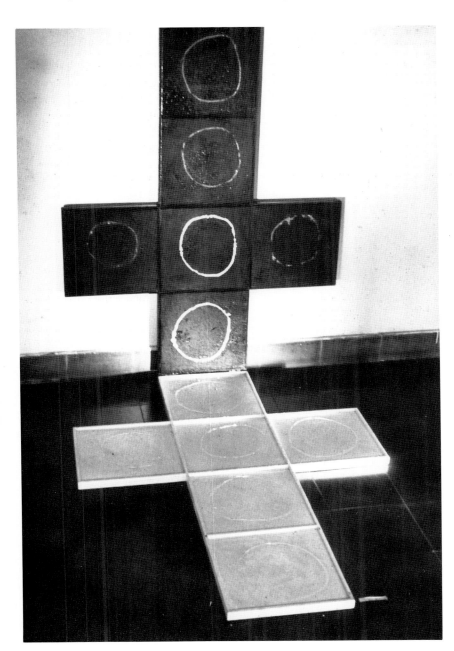

134. Siti Adiyati Subangun, *Children's Game*, 1977, painted hardboard. (Photograph courtesy of the artist.)

reference to wider aspects of cultural loss (Plate 134). Another of Siti Adiyati's works was a box filled with a type of water plant, common in Jakarta's rivers and canals, adorned with plastic flowers. These plants, polluted by humans and by factories, are often the only food available to the poor.

F. X. Harsono's work, entitled *Transmigration* (Plate 135), consisted of old clothes torn into narrow strips and hung in a kind of cat's cradle. From the strips dangled a common type of cracker (*krupuk*) shaped like figurines, brightly coloured with industrial dyes. These are sold for a pittance and eaten by the poor, who do not know that the dyes are poisonous. The title gives a second perspective to the work: the image of human forms suspended in torn webs of cloth refers to the largely unsuccessful government practice of transferring populations from Java to the outer islands, to alleviate overpopulation and facilitate development in areas far from the centre.

Dadang Christianto's *Ballad for Supardal* (Plate 136) made use of a part of the frame of a real *becak*, painted black and hung on the wall, with white cotton as both backdrop and runner. The cloth was the type in which corpses are wrapped. A white-painted stool, overturned on the cloth-covered floor, and a white plaster death mask suspended above the *becak* frame, complete the statement. Supardal was a *becak* driver from Bandung who was featured in the national news. He committed suicide by hanging when *becak* were outlawed as he saw no hope of other employment.

Several of the works exhibited during these years had an interactive dimension. In 1975, Harsono's *Pistol and Plastic Flower in Plastic Bag* invited the visitor to pick it up, play with it, and reflect on what she or he would do if this were a real pistol. A book placed nearby invited

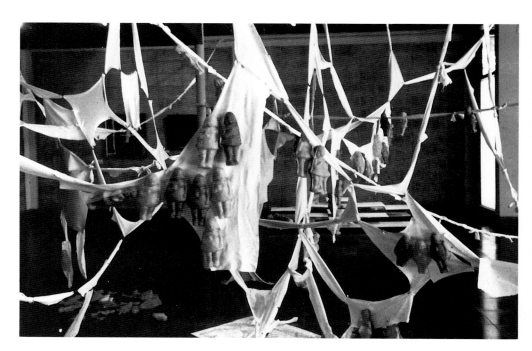

135. F. X. Harsono,
Transmigration, 1979, cloth
and commercial crackers.
(Photograph courtesy of the
artist.)

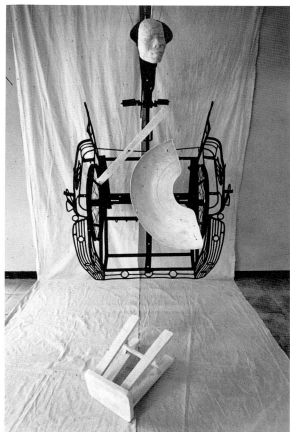

136. Dadang Christianto, *Ballad
for Supardal*, 1986,
multimedia installation.
(Photograph courtesy of the
artist.)

the visitors to write down their thoughts. Bambang Bujono, who reviewed the exhibition, said this work made his hair stand on end (1975). In 1979, Dede Eri Supria's large mirror, on which a sleeping beggar had been painted on the lower part, 'set up a confrontation between the viewer and the experience of poverty' (Miklouho-Maklai, 1991: 45). Another work at the same exhibition consisted of

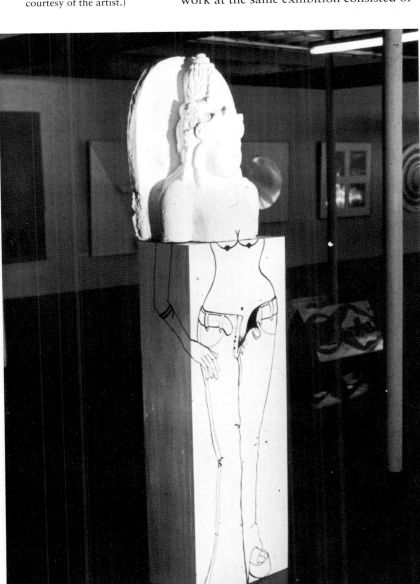

137. Jim Supangkat, *Ken Dedes*, 1975, plaster, hardboard, and paint. (Photograph courtesy of the artist.)

a real boxing ring inside of which a print-out of one of President Suharto's speeches was placed, challenging visitors to step inside and read the speech out loud (Bambang Bujono, 1979; Miklouho-Maklai, 1991: 73–4).

The most controversial work of the first New Art exhibition was Jim Supangkat's *Ken Dedes* (Plate 137). This sculpture consisted of a plaster cast of the head and shoulders of one of the most famous classical Javanese sculptures, celebrated for its beauty and workmanship. This cast of the Goddess of Transcendental Wisdom (Fontein, 1990: 160–1), believed to commemorate the early fourteenth-century East Javanese queen, Ken Dedes, was placed on top of a hardboard pedestal. On the pedestal had been painted the outline of a young woman's midriff, hips, and legs—topless, wearing jeans, with a few pubic hairs visible through the open zipper.

This sculpture gave rise to a heated debate between Indonesia's two most prolific writers on art.[6] Kusnadi dismissed the New Art Movement as a group of immature and frustrated art students who mistook immorality for creative freedom. Sudarmadji, on the other hand, referring to art movements based on similar ideas in the West, warned against drawing hasty conclusions and dismissing something just because it was new in Indonesia. He reminded critics of the initial reception of the European impressionists and later, the cubists, as well as the criticism of Indonesian artists working during the revolutionary period. Well-known artists and cultural figures like dramatist Putu Wijaya and writers Goenawan Mohamad and Umar Kayam joined in the debate.

[6] The series of articles by Kusnadi and Sudarmadji discussing the merits and the meaning of the New Art Movement, focusing on this sculpture in particular, first appeared in *Sinar Harapan*, and was reprinted in Supangkat, 1979: 21–42.

Most received the new art works with reservations but on the whole welcomed the creative freedom the approach signified (Putu Wijaya, 1977a).

Some artists and writers found a scathing critique of Westernization in the name of modernization in Supangkat's *Ken Dedes*:

Ken Dedes became the focus of the 1975 exhibition, not only because of its socalled pornographic elements and shock value, but also because it cleverly portrayed an image suggestive of the condition of contemporary urban Indonesia: classical Java grafted onto Western vulgarity, with no real point of contact or blending....

There is a sense of two cultures having nothing in common being merged to form something grotesque. Supangkat has

addressed constructs of social reality through the use of traditions of representation from two apparently disconnected and contradictory sets of cultural and aesthetic values. The result is an image of the merging of two cultures that have nothing in common. A transitional point of adaptation is missing. The Revolution and the values on which the Republic were founded, are absent (Miklouho-Maklai, 1991: 64).

Besides perceptions of history, culture, and aesthetics, the question of who is 'the artist' was addressed by the New Art Movement. In August 1976, a 'Concept Exhibition' was held at the Balai Budaya in Jakarta, based around the question: 'How serious is our art?' (Miklouho-Maklai, 1991: 67). The first part of the exhibition was named 'Action Sketching',

138. Priyanto, *The Artist*, 1976, cartoon created at interactive drawing workshop. (Photograph courtesy of the artist.) Clockwise from bottom left: (a) The Artist (*Seniman*); (b) Ears Closed (*Telinga Tutup*); (c) Brain (*Otak*); (d) Obligatory Thoughts (*Berpikir Harus*): strategical, political, opportunity, calculating, economically oriented; (e) The Artist (*Seniman*) = artisan, shaman, scientist, cultural observer, prophet; (f) Target of Taste (*Target Selera*): collectors, critics, government officials, the mass media, cultural observers, the élite; (g) Art Work (*Karya Seni*); (h) Topics of Conversation (*Topik Pembicaraan*): philosophy, politics, literature, technology, popular science; (i) Obligatory Day-to-day Attitude (*Sikap Sehari-hari Harus*): romantic, polite, cool, relaxed; (j) Dream/Ideal (*Cita-cita*): the Star of Artistic Merit.

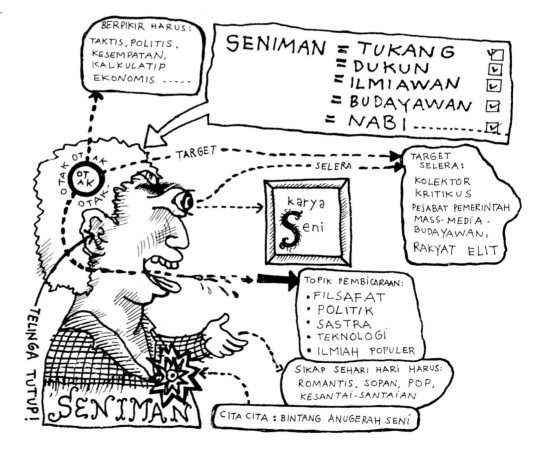

in which New Art artists and supporters held a marathon discussion on the issues facing contemporary Indonesian artists. Then followed a session where they collectively wrote and drew on large pieces of paper mounted on the walls of the gallery. Several cartoons satirizing contemporary 'traditional' Javanese culture, the role of the Indonesian artist, and the creative process were later included in the 1979 book (Plate 138) (Supangkat, 1979: 50–1).

Although the core group of the New Art Movement disbanded in 1979, announcing their third exhibition as their last, many of the original people came together again to create a collective installation, shown at Taman Ismail Marzuki in 1987 (Sanento Yuliman, 1987b). This 'situational work' was named *Fantasy World Shopping Mall* (*Pasaraya Dunia Fantasi*) and consisted of a walk-through space conceptually imitating and satirizing a Western-style Indonesian shopping mall, complete with mannequins modelling clothing, rows of canned and packaged foods, and advertising (Sanento Yuliman, 1987b; Dewan Kesenian Jakarta, 1987). On closer inspection, one encountered strangely distorted life-sized figures, and discovered that the large advertising posters and products had been manipulated, with the addition of verbal, visual, and contextual puns.

The billboard advertising Malioboro cigarettes, for example (Colour Plate 58), shows a muscular Western male model (your typical 'Marlboro Man'), confidently leaning back with a cigarette in his mouth. However, this Western-looking 'he-man' is dressed in a *lurik* jacket, batik wrap, and *blangkon* head-dress, traditional Javanese court attire. The wall he is leaning against is made of bamboo, and the cigarette in his mouth is the home-rolled, trumpet-shaped kind smoked by villagers. 'Malioboro', the brand name on the cigarette pack, is the name of the main thoroughfare in Yogyakarta, which runs north–south between Mount Merapi and the court. In recent decades, Malioboro has become the city's main tourist area, filled with cheap accommodation, restaurants, shops, and vendors offering foreign guests all kinds of goods and services, and attracting street musicians, itinerant performers, and other night-life. Finally, under the pack of cigarettes we read 'No. 1 ing Amriki', a play on the English 'No. 1 in America' and the Javanese *ing mriki*, meaning 'here'—erasing the boundary between 'here' and 'there'.

Interspersed with the manipulated commercial products in *Fantasy World Shopping Mall* were white, faceless, life-sized dolls, arranged in various, frequently painful positions. These dolls had become Jim Supangkat's hallmark since the first exhibition, symbolizing the alienation and anonymity of the individual in the midst of a mass-produced world, and of the Indonesian in this Western-style market place.

By the end of the 1970s and early 1980s, the novelty of the New Art Movement had begun to wear off. While some observers felt that large numbers of art students picked up the formal idiom of the New Art without any in-depth conceptual content or analytical framework (Bambang Bujono, 1979), others felt that some of the original members of the New Art Movement were becoming more establishment-oriented and were losing their critical edge.[7] The originators of the movement, once unified around a set of core ideas, began to grow apart and pursue their own careers. Some, like Supangkat, were drawn towards questions of aesthetics and freelance curatorship; some, like Agus Dermawan T., began to work closely with the media and the art market;

[7]Pers. com. with various ex-members, March 1991.

others, like Harsono and Moelyono, towards environmental and social issues.

Since the original New Art Movement group broke up in 1979, several of the artists have continued to exhibit as individuals or in smaller group shows. Some have become involved with non-government organizations (NGOs, called Lembaga Swadaya Masyarakat), such as Assosiasi Penelitian Indonesia (API or the Indonesian Association for Research), and others. Some have taken up the study of social sciences, especially ideas about social transformation (*ilmu sosial transformatif*), inspired by the writings of Paolo Freire, Alois Nugroho, Arief Budiman, and others.

The mark made by the New Art Movement on the Indonesian art world continues to be felt, however, both in the wider range of possibilities for artistic expression than what existed during the preceding decade, and in the livelier debate about culture and society that has followed. New Art Movement ideas and exhibitions reflected new directions in the field of literature, where the bases for what came to be known as 'contextual literature' were being laid (Foulcher, 1987; von der Borch, 1988). In Indonesia, sociologist and cultural critic Arief Budiman, anthropologist Parsudi Suparlan, and historian Kuntowidjojo have been in the forefront of the larger debate, with Sanento Yuliman acting as mediator within the art world.[8]

Looking back on the movement and its ideas sixteen years later, Supangkat wrote:

That art is a plural concept ... is not a new conclusion. However, it clarified the positions of contemporary and traditional art and helped diminish the overly long debate about East–West confrontation in developing countries. Syncretism, an attempt to fuse the two forms of art, is clearly possible. The New Art Movement calls it 'art engineering', that is, creating new expressions by mixing art elements from different contexts.

Present-day Indonesian modern art demonstrates that local characters, indigenous traditions and the outside world of abstraction and science are all valid attributes of both national and international contemporary art (1990: 162).

Art as Consciousness-raising

The New Art Movement inspired young artists to approach art-making as a socially engaged activity. Some chose the urban environment as the source for their images and ideas (see Chapter 12), others chose the rural environment. Moelyono (b. 1957, Tulungagung) is one whose interests focus on the task of developing a rural and locally rooted approach to art-making. A drawing teacher at the local school in an isolated coastal region in East Java, Moelyono attempts to address questions of humanity by working with a small number of isolated and marginalized individuals. Moelyono's concern is the material and psychological well-being of the inhabitants of two small hamlets, and how they are faring in the processes of national development. F. X. Harsono describes Moelyono as 'a social worker who happens to be a painter'.[9]

During his studies at ASRI in the early 1980s, Moelyono's work and ideas were not considered adequate to the school's standards. In 1985, when he submitted a conceptual work referring to the spaces, materials, and interactions of village life for his examination, it was failed on the grounds that it did not meet the school's aesthetic or academic requirements. The school stated that the work did not have any 'two-dimensional, painterly aspects'.[10] Furthermore, the faculty

[8]See, for example, Sanento Yuliman, 1987a, where the ideas of the above-mentioned are discussed as presented at a seminar entitled 'New Art and Modern Indonesian Culture', organized by *KOMPAS* on 8 June that year.

[9]Pers. com., March 1990.
[10]Pers. com. with the artist, April 1991.

reasoned, although the school on principle supported an experimental attitude, Moelyono had not discussed the work beforehand with his advisers (Butet Kartaredjasa, 1985).

The work was entitled *KUD—Kesenian Unit Desa* [Art of the Village Unit] and consisted of a small hut of bamboo, like the ones used to guard the rice-fields once the crop begins to ripen. This structure was surrounded by straw mats—the furnishings generally used at large gatherings, such as village meetings. In the centre of each mat was placed a leaf-adorned clump of soil on a banana leaf—a reference to the snacks offered to each person at formal gatherings, ritual or otherwise. A podium with a megaphone, through which broadcasts from national radio could be heard, completed the installation.[11]

Despite the lack of support from the school, Moelyono exhibited in Jakarta with four other young artists in October the same year. The 'Environmental Art Exhibit' at Ancol, sponsored by WALHI, an environmentalist NGO founded in 1980, had the support of the Minister of Population and Environment, Emil Salim, and Ciputra, the Director of Ancol, who both wrote welcoming remarks in the catalogue (Agus Dermawan T. and Wienarti, 1985).

Bonyong Munni Ardhi, Harsono, Gendut Riyanto, Harris Purnama, and Moelyono—all former ASRI students who had been involved in the New Art Movement—had been experimenting with approaches to collaborative art-making. They wanted to distance art from the subjective emotions and imagination of the individual artist, and narrow the gap between the artist and his or her themes and materials. The process of creating the exhibition was carried out in several stages, evoking the *sanggar* pattern of artists who shared similar views about life and art, living and working together (Agus Dermawan T., 1985: 5). The first stage consisted of research into environmental problems, both nationally and locally.

To gain a close-up perspective of the effects of environmental destruction, the group visited and photographed polluted sites in Jakarta. They were shocked to find out that 2,000 factories and 30,000 large and small businesses dump their unprocessed waste into Jakarta's seventeen rivers, some of which were found to contain mercury. Accompanied by a physician, Dr Meizar, they visited a village where children and adults were being crippled and killed by the Minamoto disease.[12] This agonizing encounter became one of the central themes of the exhibition, resulting in photographs, informational posters, poetry, and conceptual works. Gendut Riyanto's long poem, 'Bunga Rampai untuk Ida' (A Bouquet for Ida), was written as a eulogy for one of the children that died.

Not surprisingly, given the importance of the timber industry to the national economy, the destruction of the forests became one of the central themes of the exhibition.[13] To the shock of the gallery director, Bonyong's work, entitled *Logging*, consisted of a large fenced-in area filled with a ton of soil, on top of which the amputated trunk of a dead tree was placed. Two of Harsono's works speak to the same theme. Purchasing used hardboard destined for trash, he silk

[11]Although this work was refused by the school, Moelyono submitted another work a few months later which passed the examination requirements (Agus Dermawan T., 1985: 12)

[12]A discussion of the effects of pollution and the current situation in Jakarta, including government regulations, is found in Meizar, 'Pencemaran dan akibatnya pada manusia', in Agus Dermawan T., 1985: 19–22.

[13]A specialist essay printed in the catalogue addressed the destruction of the rain forests. See A. N. Hafild's 'Hutan dan Kehidupan Kita', in Agus Dermawan T., 1985: 23–4.

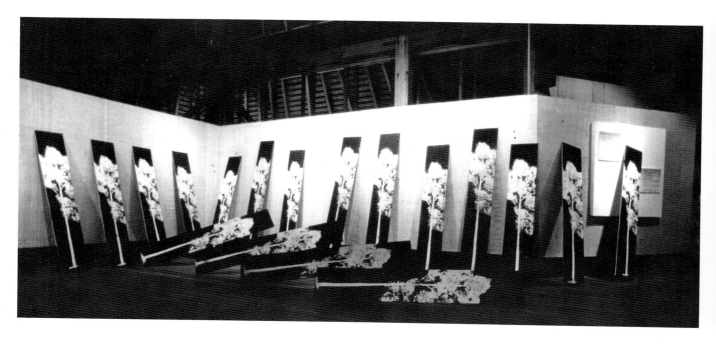

139. F. X. Harsono, *Logging*, 1985, silk screen on hardboard installation. (Photograph courtesy of the artist.)

screened in white the image of a slender, leafy tree on a black ground (Plate 139). Some of the slates were installed leaning tenuously against the walls, others were laid on the floor. A second work displayed dry branches on six low pedestals which lead the eye towards a vertically hung sack cloth. In front of this, reddish-brown dry leaves were suspended in thin threads, moving to the breezes in the room and throwing shadows on the backdrop.

Moelyono's works concerned the effect of environmental destruction on human lives. One of them consisted of a well surrounded by a spread of soil on which were placed a hoe, an upturned bucket, and bunches of wilting vegetables. This was a reference to the dual problem in the Tulungagung area of West Java of the erosion of land during annual flooding—the amount of arable land in the region has decreased from 15 000 to around 3 000 hectares (Agus Dermawan T., 1985: 12)—and a shortage of year-round supplies of water.

Although Moelyono's work was criticized for not expressing its message clearly enough, it illustrates how closely it is connected with the context of life in the mountain villages of his native region (Supangkat, 1985). This involvement, which deepened during annual visits home in the seven years he was a student at ASRI in Yogya, encouraged Moelyono to return to the area after graduating.[14] He now works as an art teacher, rotating between a Catholic high school in Tulungagung, IKIP (Teachers' Training College) in Kediri, an art institute in Surabaya, and the small elementary school in the tiny fishing villages of Brumbun and Nggerangan (Wahas Shofyan, 1989; letter from artist).

In August 1988, Moelyono returned to Jakarta with his first exhibition resulting from working with the village children.

[14]Apparently, after participating in the 'Environmental Art Exhibition' in Jakarta, Moelyono was approached by ASRI and offered the opportunity to retake the final examination. This time it was made clear that his submission would have to include two-dimensional painted works. Furthermore, these were to be installed inside rather than, as previously, outside the school building. Letter from Moelyono, May 1991.

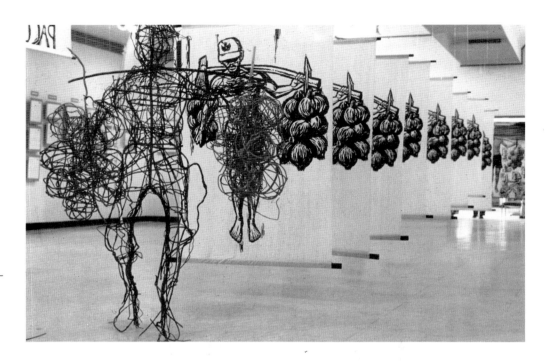

140. Moelyono, installation in 1989 exhibition, rattan and woodblock-printed cloth. (Photograph courtesy of the artist.)

Entitled 'Transformative Dialogue', it consisted of drawings on paper by twenty-six children aged between seven and twelve, as well as an installation. The catalogue, written by Moelyono, presents a geographical and social portrait of life in the region, complete with maps, statistics, and photographs. Words are also important in the children's drawings, where the name of each object or event depicted is written in large letters. In 1989, Moelyono organized a similar exhibition which travelled to Surabaya, Yogyakarta, and Salatiga. This time, there were 200 children's drawings and an installation of similar sculptures made of thin rattan roots. These, depicting a man carrying coconuts to market, were placed before a series of repeated woodblock-printed banners with the same theme, which ran the entire length of the room like a procession (Plate 140).

Moelyono not only works with children but gets involved in the problems of the village, using different techniques to address them. To help solve the problem of drinking water referred to above, he used money raised from sales of the children's work to build a well. When he creates his rattan sculptures, they are introduced into the village as interactive tools, and it is not only the children who play with them (Plate 141). 'The people identify with them—they say: this one is me! and put their own clothes on them.'[15]

Stating that his aims are to 'develop the life of the people' and create awareness through artistic activity, Moelyono starts out by teaching children how to observe their surroundings, the details of daily life, and the causes and effects of events. He asks questions about everyday matters: 'What do your fathers do?' ('They go fishing.') 'What do your mothers do?' ('They repair fishing nets, cook, wash.') 'What makes us sick from time to time?' ('Malaria.') 'What does malaria come from?' ('Mosquitoes.') 'Where do mosquitoes live?' ('In the still water puddles.') 'What can we do to prevent being bitten?' etc. Then the

[15]F. X. Harsono, pers. com., March 1991.

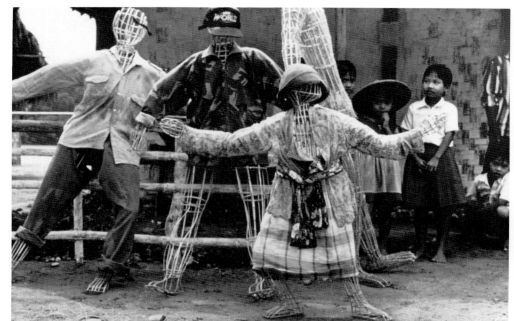

141. Moelyono, rattan sculptures dressed in Tulungagung villagers' clothes, 1987. (Photograph courtesy of the artist.)

142. Moelyono's student drawing in the sand. (Photograph courtesy of the artist.)

children are asked to draw these themes. When they have no money for supplies like paper, pencils, and colours, they draw on the sandy beach (Plate 142). Moelyono wants to break through habitual ways of seeing and selecting. Children, he says, draw what they have been told is worthy of depiction and according to how they have been shown such objects 'are supposed to be' drawn.[16] He asks the children what they dream about and then asks them to draw that. This way, he says, they soon develop the ability to express themselves imaginatively rather than merely reproduce (Wahas Shofyan, 1989). In this way, Moelyono hopes to contribute towards social change from below.

Conscience of the Poor

Semsar Siahaan (b. 1952, Medan) is a Batak and the son of the military founder of the People's Army of North Sumatra during the Revolution (Miklouho-Maklai, 1991: 76). Semsar is the only painter in Indonesia today who paints and draws images that point accusing fingers at Western-oriented capitalist economics and a militarized political system. One of six children, Semsar lived in Yugoslavia during his teens, studied at the San Francisco Art Institute in 1975, and at ITB-Bandung from 1977. After continuing his study of sculpture briefly in the Netherlands in 1985, Semsar has turned his attention to painting since his return to Indonesia.

Semsar is a dynamic and cosmopolitan man who is outspoken and committed to the struggle for social justice. Described as someone with a 'strong, hard attitude' (*Suara Pembaruan*, 1988), Semsar has shocked and angered the art establishment for more than a decade. In 1977, instead of submitting the life-sized human figure required of the sculpture students at ITB, he created a 'living sculpture' by rolling himself in a pool of mud in which he had placed sculpted fragments of body parts (Miklouho-Maklai, 1991: 75 n. 14). In 1981, he made newspaper headlines when, in a protest performance at the Bandung art academy, he publicly 'cremated' a sculpture by Sunaryo, a faculty member. Semsar saw this sculpture, entitled *West Irian in Torso*, as representative of the exploitation of ethnic minorities and their art by contemporary Indonesian artists, many of whom had become highly successful financially (1991: 75). He was suspended from the school.

In 1988, Semsar held an exhibition in Jakarta which then travelled to Yogyakarta, Salatiga, Solo, and Bandung, accompanied by discussions with local artists and audiences, and by a final 'happening'. The cover of the catalogue shows the self-portrait of a wounded artist, his head, and a volume entitled *Aesthetics* wrapped in banana leaves (Plate 143). One large eye looks out from the bandages, refusing to stop witnessing events; the artist's mouth is only partly covered, signalling that he is still able to speak out. In this catalogue, Semsar offers his own manifesto entitled 'My art is liberation art'.[17] The first lines read as follows:

It was as if I arrived and entered a garden, where everything was ordered/had to be, beautifully arranged/filled with elements

[16] A standardization of children's art has taken place in Indonesia over the last two decades, resulting in canons of 'correct' ways to depict things in a 'childlike' way. This is reflected in the school books, such as *Seni Rupa I, II, Bidang Studi Kesenian, Semester I, II, III, dan IV*, edited by M. Ariffin Pulangan et al., Jakarta: Penerbit Fa. Hasmar, 1977 (9th edition). This reflects the larger situation of education in Indonesia today, where learning is often by rote and independent or creative thinking is actively discouraged (Leigh, 1992).

[17] For the original text, see Dewan Kesenian Jakarta, 1988; for an English translation, see Miklouho-Maklai, 1991: 97–100.

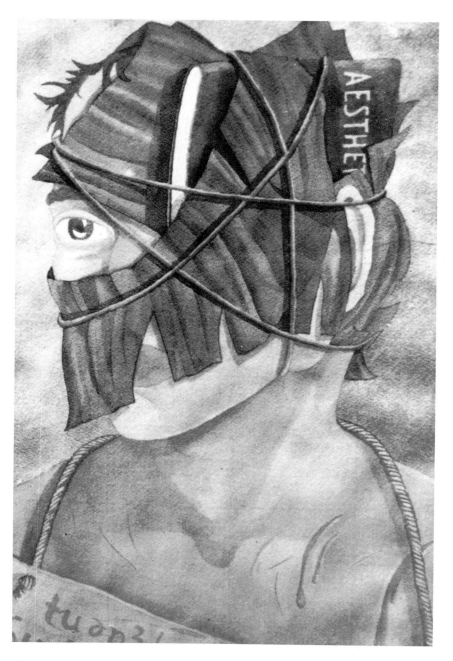

garden. I appear here with values of beauty which in the eyes of some civilized human beings (civilized clowns) are ridiculed as the beauty of tattered rags which lead one astray (Semsar, 1988; author's translation).

In this exhibition, Semsar showed four oil-paintings and about 240 black-and-white drawings, executed in a raw expressionist style related to that of Käthe Kollwitz, though lacking in her technical refinement.[18]

In Semsar's work, the enemy of the people is called MANUBLIS, an acronym which he invented in a 1982 short story from the words *manusia* (human being), *binatang* (animal), and *iblis* (demon). MANUBLIS is made up of three main attributes welded to form a single entity: 'Humanity as its body. Animal as its desires. And Demon as its deceit and corruption' (Miklouho-Maklai, 1991: 117). In Semsar's drawings, MANUBLIS is shown as a fat, pig-like composite of a capitalist and a dictator, enslaving and exploiting the people to death. The faces of the starving masses of half-naked people do not look particularly Indonesian; they are generalized into the faces of suffering humanity (Plate 144). Indeed, generalizing and polarizing are two of Semsar's main techniques, both in his writing and in his art. The use of black and white may in itself indicate the artist's choice of a framework of extremes.

One of Semsar's most astonishing paintings is entitled *Olympia, Identity with Mother and Child* (Colour Plate 59). In this work, a blond white woman reclines, nude except for her red high-heeled shoes, blue sun-glasses, and white

143. Semsar Siahaan, *Portrait of an Artist* [self-portrait], 1982, water-colour, collection of the artist. (Photograph courtesy of the artist.)

which all symbolized joy, coloured in pastel hues. That is what it was like when I stopped by my Indonesia's garden of contemporary art—art full of etiquette, sweet and refined.

I come, complete, equipped with all kinds of handicaps and carrying wounds. I emerge to exhibit/reveal the extensive suffering that clearly exists beyond the walls of this beautiful

[18]As his favourite Western artists, Semsar lists Goya, Courbet, Kollwitz, Orozco, and Rosa Luxembourg. As his favourite Indonesian artists, he lists Hendra Gunawan, Sudjojono, Affandi, and Basuki Resubowo (1988 research questionnaire). Since 1989, Semsar has been improving his drawing skills, without losing the expressive power of his style.

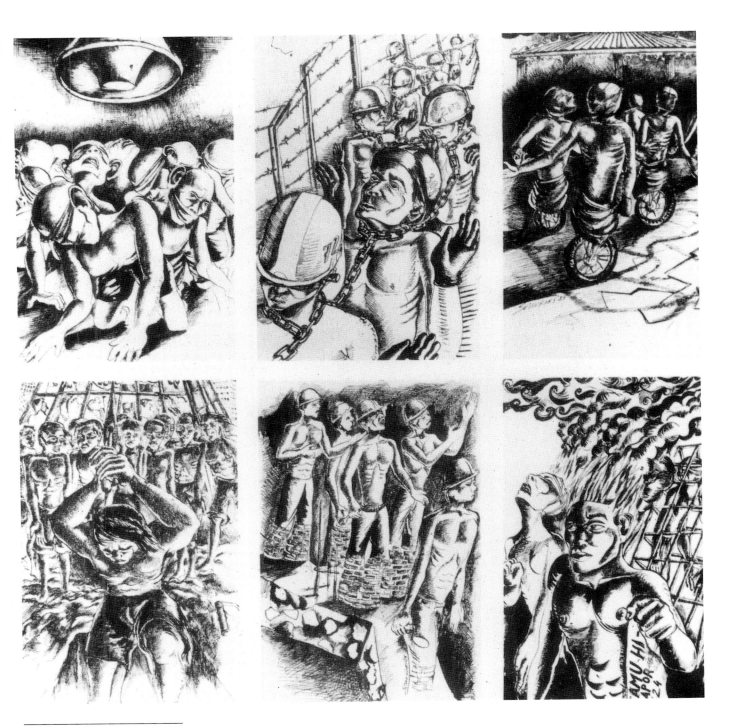

144. Semsar Siahaan, examples
of 'Liberation art', black-
and-white drawings, ink on
paper, each 60 × 40 cm.
(Photograph courtesy of the
artist.)

pearls, while an assortment of Indonesian characters surround her in different postures and contrasting attitudes. A Balinese dancer (emblem of Indonesian tourism) offers flowers to the foreign woman with a resentful look on her face. She is accompanied by an Indonesian man in shirt and tie (representing Indonesian technocrats and bureaucrats), with a breathless look on his face, next to an older man in traditional head-gear and jacket (representing Javanese tradition), wearing a look of surprise. Both of these men are folding their hands in front of their genitals: traditionally a posture of respect, it is used here with obvious sarcastic overtones. In the mid-foreground, a black mongrel barks at a group of people who, pushing aside luxurious curtains, are entering the scene from the right. With their dark-skinned and muscular naked torsos, the farmers and labourers provide an active contrast to the lazing tourist, her bikini marks signalling her leisured life. The wailing of the starving woman and child in the background, and the anger and resolve of the labourers contrast with the smug complacency on the white woman's face and the servitude, lust, and petty jealousy on the faces of the three Indonesians attending her. In the background, a blood red sky burns above a red ocean, starving people, and a tattered native fishing boat. From under the bed protrudes a dark foot; a red smear near by suggests blood. One artist suggested that this was the murdered body of the white woman's lover—symbolizing all the disposable native commodities of pleasure increasingly available to Westerners since the late 1960s.[19]

Semsar's critique of contemporary standards of beauty, which he claims are superficial, individualist, and market-oriented, and his vision of the role of the artist, bridge the gap between the late 1930s and the late 1980s, when Sudjojono first put forth similar views on the subject (see Holt, 1967: 195–6). Semsar writes:

My understanding of individual freedom is to lend my spirit to try to change the miserable state of human values resulting from injustice, through my works of art. This is also what I mean by social commitment, a component of art that has long been neglected. Individual freedom must merge to become one unified struggle to liberate humanity. Individual freedom can be attained to some extent through the style of the artist, yet he/she must be firmly grounded in the spirit of the struggle to free mankind. Artists! This is the moment for returning to reality and igniting the spirit of the renewal of humanity through the renewal of art, as well as expressing a new identity which is alive, strong and fresh. I call it 'Liberation Art'. Individual freedom for the liberation of the masses (Miklouho-Maklai, 1991: 117).

The police in Yogyakarta attempted to close the 1988 exhibition, bringing Semsar in for questioning on the charge that he was 'staging the exhibition there to humiliate the authorities'. He was released only after it was established that he had not himself printed and distributed the leaflet advertising the exhibition, the product of supportive local artists and activists (*Jakarta Post*, 1988: 3). In Bandung, the police also attempted to close the exhibition immediately after the opening, but when Semsar demanded a written order to that effect, nothing more happened during the three-day exhibit. After the exhibition had closed, Semsar again resorted to the use of fire and in a public 'happening' burned the 240-odd black-and-white drawings (1988: 3).

'This is not a burning,' Semsar told a reporter. In a statement circulated at the event, Semsar wrote that he saw it, rather, as the return to fire of works that

[19]For further discussion of this work as well as others in the exhibition, see Miklouho-Maklai, 1991: 77–81.

had been born in fire—the fire of the struggle for the liberation of the Indonesian people from injustice and suffering. After the drawings had been exhibited in five cities, with no intention of selling any, they must be returned to fire in the spirit of renewal. This was necessary to clear the way for the Liberation Art yet to be created (Foulcher, 1988; *Suara Pembaruan*, 1988).

It may seem remarkable that Semsar has been allowed to continue working as freely as he has. Not less remarkable is the fact that *Olympia* was bought and hangs, indeed dominates, the home environment of one of Indonesia's wealthy businessmen. All this shows that the guidelines for censorship in the visual arts are less clearly formulated by the state's security apparatus than in the case of literature. It illustrates, too, that contemporary painters can feel relatively safe as long as their work does not point a finger at any particular politician, leader, or policy.[20] There is no doubt that Semsar's dynamic presence and vocal works can exist due to a combination of his family background and the relative tolerance towards the visual arts that characterized the 1980s.

[20]That being too specific in this respect can be dangerous in the visual arts is illustrated by events in 1991. The cartoonist behind the satirical 1991 calendar, *Land for the People*, in which national leadership figures in both government and military were depicted living off the labour of the poor, who are increasingly being pushed off their land in the name of development without realistic compensation, was for a long time being sought by the police (*Jakarta-Jakarta*, 1991: No. 255, 99).

12 From Photo-realism to Cartoons

Urban Chronicles: Dede Eri Supria

DEDE ERI SUPRIA (b. 1956) (Plate 145), Indonesia's most important urban painter, takes photographic images of the metropolis apart and reassembles them into disconcerting but strangely familiar views, at times crossing the border to the surreal. In Dede's landscapes of urban construction, people are the main feature: not the cosmopolitan segments of Jakarta

145. Dede Eri Supria, 1992.
(Photograph courtesy of the artist.)

society, but *becak* drivers, *bajaj* drivers,[1] labourers, poor women with children, shoppers, lost children, and unemployed men—people of Javanese village and small-town life uprooted, hustling to and from their destinations (Colour Plate 60). They are isolated, hurried, and often obstructed in their progress by the machinations of the city—barriers of chrome, glass, and steel, a locomotive roaring by in a whirr of motion, or the never ending traffic which leaves no alternative but to cross the avenue on an overpass. These often harsh depictions of two contrasting modes of life—animate and inanimate, urban and rural, machine and human—reflect 'the peculiar personality of Jakarta, its sense of solidarity vis-à-vis the provinces and the brutal, commercial power-oriented and cynical character of its everyday life' (Anderson, 1990c: 142).

By concentrating a high proportion of elements familiar to urban Western eyes on his canvases, Dede ironically reverses the role of a Gauguin going to the tropics. Gauguin, a European uninspired by his own culture, gave to the world beautiful, mysterious images of exotic people blending into equally unfamiliar landscapes, filled with strange gods and

[1]A *bajaj* is a small three-wheel motorized taxi, with a metal body over a motor cycle engine.

primal forces repressed or forgotten in his European bourgeois background.

In Dede's paintings, Westerners can thrill to see their own world, the urban jungle, through the eyes of a tropical man come to 'civilization'. Westerners can see 'their' environment, celebrated by well-established painters from the early twentieth century on, never more sensationally than in the various movements following pop art, but in Dede's work populated with anachronistic and 'exotic' villagers. A tension is created between the familiar and the unfamiliar, which gives one of those little sensational thrills, the gratifying emotional experience of recognition which an encounter with the completely unknown fails to yield. In this way, Dede's work is deceptively accessible to Euro-Americans who, for the same reason, can more easily accept his work as modern than the work of many other Indonesian artists.

I was born and raised in Jakarta, a city which not only inspires my work but more than that. Jakarta offers all of life's possible problems and enjoyments, so I have a certain sentimental feeling about it. The situation in Jakarta is created by the thunder of traffic and the smoke from factories that never stop, the building of the city which continues ceaselessly, the increasing number of inhabitants, and its tumultuous daily life which has become extremely complex.[2]

Dressed in overalls, Dede wanders through construction sites, his leisure and his camera distinguishing him from the workers hauling, pushing, lifting, carrying, and hammering together yet another part of the city's scenography. Later, he secludes himself at home in his small loft-studio. Seated cross-legged on the floor, he sketches directly on a large canvas, either from an on-site sketch or from photographs, before starting to paint. He remains absorbed until his participation is demanded in the world down below. The greater part of the first floor is dedicated to a gallery where his works hang; dozens more, which find no place on the walls, are stacked against each other in a corner.

The seventh of eight children, Dede learned to be a photographic draftsman from primary school age, when he started helping his father do enlarged drawings of photographs on commission. Even at that age, he was closely involved with his family's economic survival in the city: his father, a teacher and one-time director of the Budi Utomo Technical School (STM), could not single-handedly support the large family (TEMPO, 1978). At first, Dede sold comic books and ice-cream in his spare time—something which, he admits, inspired him to take up cartoon drawing. Later, he took drawing lessons from Dukut Hendranoto ('Pak Ooq'), a local artist who, non-dogmatically, encouraged his students to get in touch with their own selves (Maksiani, 1988). By junior high school (SMP), Dede had already founded his first artist studio with three friends (TEMPO, 1978). Having decided he wanted to be a painter, he applied to the secondary school of fine arts (SSRI, Sekolah Seni Rupa Indonesia) in Yogyakarta.

Apart from informal studies with Pak Ooq, whom he remembers fondly, Dede considers himself a self-taught painter. He admits that he probably did learn something about painting technique in Yogya, but he dropped out of SSRI a year before graduating. His interest in realism elicited little encouragement or understanding from the teachers; the style was not deemed worthy of anything but a study tool, or as one of the preparatory stages to creating 'real art' which must be expressionistically or decoratively distorted. When a handful of students none the less persisted in pursuing it, they were mocked with statements like

[2]Letter from the artist, February 1990.

'realism is a dirty cooking-pot for rice' (Dede Eri Supria, 1979).

After returning to Jakarta, Goenawan Mohamad, Chief Editor of *TEMPO*, hired Dede to do cover illustrations for the news magazine.[3] Dede also did illustrations for calendars, some of them industrial. These two modes of working, in turn, influenced his painting. In order to be able to paint a relevant, visually catching, and communicative cover, he followed news events closely and did his own journalistic research. In this way, the idea that art was firmly connected to socio-political and economic affairs was solidly exercised. By painting industrial interiors and machinery, architecture and oil-rigs for calendars, he further trained his skill at depicting objects, materials, and textures of all types and on all scales. Both work methods involved drawing from photographs. Supporting himself in this manner, Dede continued to paint on the side, at his own rate, and in his own way, without interference.

In the mid-1970s, Dede became involved with the New Art Movement, which experimented with Western avant-garde art and ideas, applying them to Indonesian realities. He shared the New Art Movement's preoccupations with contextualizing art and bridging the gap between élitist definitions of fine art and popular images created by commercial, mass-producing technologies.

Dede received much attention in the context of the New Art Movement. In an article entitled 'Realism after Sudjojono', the reappearance of realism in the work of a handful of young artists, foremost of whom was Dede, was the main subject of discussion (*TEMPO*, 1978). The anonymous writer of this piece noted that the last time realism was popular in Indonesia, was under LEKRA's 'forceful' patronage.[4] The writer argued that ensuing generations, however, have benefited from the realization that 'social realism' depended on party guidance, and hence usually showed no imagination. Comparing the present neorealism with Sudjojono's, the writer notes that Sudjojono was 'rather too serious', whereas 'Dede's generation in contrast knows how to play, be ironic, be "just like normal" (*biasa-biasa saja*), with no deeper intent; they can also be dreamlike, skirting the boundary to surrealism' (*TEMPO*, 1978).

At the time of this exhibition, Dede's entire *oeuvre* consisted of eighteen paintings. Five of these were self-portraits—according to the artist, an exercise in how to paint skin, hair, and facial features. The photograph of Dede in the *TEMPO* article shows a young boy with long hair, leaning against a canvas depicting the bare legs of a girl in a

[3]*TEMPO* is Indonesia's 'TIME magazine'. An excellent example of one of Dede's covers is that of 18 February 1978. It is a close-up portrait of a Chinese-Indonesian, wearing a batik shirt and *pici* (a hat associated in various ways with nationalism, Islam, and Sukarno). The portrait of the Chinese-Indonesian, who is laughing jovially so all his nicotine-stained teeth show, is overlaid with the title 'The problem of the non-indigenous peoples' (*masalah non-pribumi*)—a term which generally refers to Chinese-Indonesians. This photo-realist portrait evokes the dual position of the Chinese in Indonesia—as both the owners of the majority of businesses, large and small, and as a politically oppressed and often persecuted minority. It is hard to tell whether this laugh is one of mirth or one that hides acute embarrassment or fear. At the top are four Chinese characters spelling 'Felicitations at the New Spring', a variation on the customary greeting at Chinese New Year. The presence of this inscription must be seen in light of the fact that the use of Chinese characters or any writings in Chinese has been banned since 1965.

[4]When the subject is LEKRA or LEKRA artists, articles are frequently anonymous. An article about Hendra, in which several bitter and frightening paintings were described, which could easily be read as allegories of the 1965–6 massacres, was also anonymous (*TEMPO*, 1979). Most of the articles on fine arts in *TEMPO* are signed, and during the late 1970s, the two major writers were Putu Wijaya and Bambang Bujono.

minimal miniskirt, staring at the photographer with a glum face. Dede is quoted as saying that he opposed the idea that a painter must specialize in a single mode. Consistent with the scandalized reporting of the New Art Movement's frankness, Dede was also quoted as saying that lust was the main obstacle to

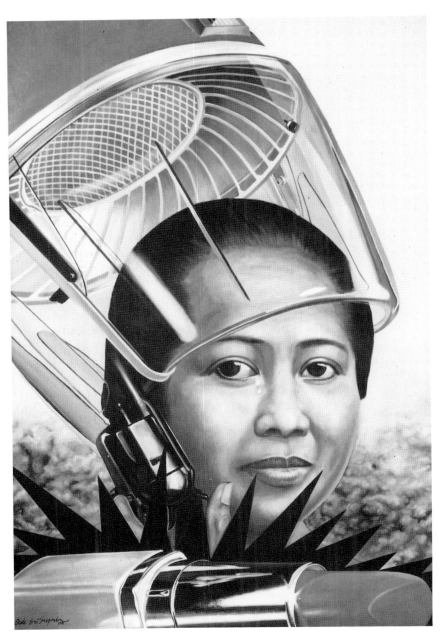

146. Dede Eri Supria, *Mother Crying*, 1980, oil on canvas, 200 × 100 cm, collection of John McGlynn. (Photograph Astri Wright.)

his work, while the most important inspiration came from music.

Dede held his first solo exhibition in 1979, and by 1989 had held three more. He had also participated in numerous national and international group exhibitions, such as the Indonesian and the ASEAN biennials. In the decade following his first solo exhibition, Dede has developed new ways of approaching the translation of subject-matter on to canvas. In the 1970s, he worked directly from slides, photographs, or images he clipped from magazines. These he projected with a slide projector directly on to the canvas before painting. His work thus consisted, to a greater degree, of straightforward 'painted photographs' (Bambang Bujono, 1985: 56).

In the early 1980s, Dede painted numerous studies of form and texture. This is evident in an enormous chrome and lacquer motor cycle set against the sky, and a series of paintings of a striped mattress (1981).[5] His colours here are low-key, understated, at times nearly monochrome; the themes are deliberately lacking in any narrative or human element. The presentation of the object being his main goal, Dede's connection both to a Western-style commercial art world and to leading abstract movements is here felt the most strongly. His interest at this time lies in form and texture as autonomous elements and not in communicating any immediately decipherable message.

A few of Dede's paintings from this period are figurative and conceptual, foreshadowing the more socially engaged, and allegorical work to follow in the mid-1980s. The large canvas entitled *Mother Crying* (Plate 146) shows Kartini, her hair dressed and face made up in traditional Javanese fashion, sitting under a hair-drier, a large phallic lipstick

[5] The latter works are in the collection of John McGlynn, Jakarta.

dominating the foreground.[6] As a large tear falls from her eye, Kartini holds a revolver to her head. This painting can support numerous readings—anti-consumerist, anti-capitalist, feminist, or general socio-political, any and all aiming at the nebulous space where tradition and modernization intersect.

In 1984, Dede visited the United States on an international visitors' programme sponsored by the United States Information Service. After three months in a new and artistically challenging environment, his palette changed. From his low-key earth tones and greys, he started working in stronger and more vibrant colours: brilliant blues, purples, and reds now mixed with his browns and whites. At this time, he stopped painting from slides projected on to the canvas. Although the separate pictorial elements are still painted photo-realistically, Dede's work increasingly employed fractured images, prismatically or chaotically rearranged across the canvas (see Colour Plate 62).

Despite his obvious involvement with his subjects, Dede paints with the emotional detachment of a photo-journalist:

Most of my paintings carry symbolic meanings with humanitarian themes or themes about the environment in which I live. My paintings are not at all meant as social criticism, because truly the themes I take from the life of the people are in themselves stark facts.... The way I paint is determined by what I think is artistic. Whatever I do, it is as

if I always have a feeling of moral responsibility towards life such as you find it here in Jakarta.... Maybe I hope that, besides the artistic quality and beauty of a specific painting, people will also be drawn into thinking about the fact that all around us there are many problems which need to be faced.[7]

In his writing and painting, Dede treads the fine line that separates reportage from social criticism. The fact that the visual riddles depicted in his photo-realist style do invite thought has earned him the criticism of being 'cold' and 'technical'. A 1985 review expresses disturbance at the lack of emotion in Dede's work. Discussing a particular painting, in which the inhumanely stressed and mechanical existence of factory workers is depicted in a surreal factory landscape where the walls consist of giant cardboard boxes and where oversized alarm clocks line the roads, the critic writes: 'Unfortunately, this story reached me, not through touching my emotions, but via my brain' (Bambang Bujono, 1985).

The tendency of modern Indonesian artists and critics to emphasize feeling and emotion, above all *positive* emotion, in romantic or lyrical visual styles, whether representational, decorative, or abstract, was one of the central criticisms levied at Indonesian art by the New Art Movement. This attitude may also explain Bambang's discomfort with what he calls a rational approach, one lacking feeling; an example of the lesser value traditionally given to *ratio* versus its opposite, *rasa* (intuitive or feeling-based insight) considered superior in Javanese thinking. This attitude may, in part, explain the difficulty that conceptual art, pioneered by the New Art Movement, has had in being accepted in the Indonesian art world.

[6]The portrait of Kartini, champion of women's education and officially designated a national hero, is engraved on one of the Indonesian rupiah bills. The engraving is based on a well-known photograph taken of Kartini when she was twenty-two (Nieuwenhuis, 1988: 100). The hyper-realism with which Kartini is depicted, as well as the image of the hair-drier, is a direct quotation (whether conscious or unconscious) of James Rosenquist's work, *F111* (1965), which it is likely Dede saw either in original or in reproduction during his 1984 visit to the USA.

[7]Research questionnaire, 1988.

In 1990, Dede wrote:

I am aware of the limitations of the media of the canvas, of space and time. These imprison one; I try to break through them with the use of symbols. With colours, nuances, and various techniques, such as arranging the composition, the one thing that I emphasize amidst all these methods or techniques is symbolism—a simple choice, but one nevertheless full of meanings and complex parables about the life around us which I record. For example, a narrow road which turns and bends, like a labyrinth—many ideas and problems arise in my mind from such a motif. I see people around me becoming apprehensive, anxious, frustrated, feeling a loss of identity. People become very lonely in the midst of the flow of life—therefore a work like 'Labyrinth' is born: a description of urban people who face a life situation which is bitter and tortuous.[8]

Dede Eri Supria's *Labyrinth* (Plate 147) shows the iron rails of a staircase descending into a maze of giant cardboard boxes, depicted as towering walls. Dede plays with the strange effect of greatly enlarging something small—a heritage of both surrealists and post-modernists, mixed with a touch of Indonesian sarcasm *vis-à-vis* spiritualist clichés about microcosm mirroring macrocosm. Again, he posits something fragile as an unbreakable barrier. In the distance, the shining, mirror-glassed boxes of corporate high-rise buildings dominate the horizon.

At first glance, the human element seems completely lacking in this picture. On second thought, the viewer realizes that he or she is incorporated into it by the illusion of being positioned at the top of the staircase, about to descend into the maze, in an attempt to reach the prosperous fortresses in the distance. The viewer is posed as a poor person, for in Jakarta only the poor embark on any quest on foot: those for whom the high-rises are built travel in cars. Hence, Dede is working with a symbolism of materials, where cardboard represents the lower classes and glass, chrome, and steel represent the élite. Confusion, the lack of overview (in opposition to the equation of Sight = Insight = Power), the idea of being packed into boxes like commodities, one's physical energy the only marketable commodity in this capitalist city, are feelings and associations that overwhelm a person ('You!' says Dede) trapped in this maze. The feeling of being helplessly caught and controlled is further strengthened by the severe consistency of the vanishing

147. Dede Eri Supria, *Labyrinth*, 1987, oil on canvas, collection of the artist. (Photograph courtesy of the artist.)

[8]Letter from the artist, February 1990; author's translation.

perspective; all the lines in the painting converge on the high-rise buildings.

Most of Dede's work of the last seven years concerns people caught in the midst of an unaware moment: crossing the street, waiting for a long-distance bus, pushing a heavy load on a bicycle through an urban maze. The occasional surreal elements are handled with greater sureness. A large number of his works depict people sitting or standing alone, waiting for a means of livelihood to appear, or lost in troubled thought (Colour Plate 61). Depicting a solitary figure in a culture where it is virtually impossible to be physically alone or separate, and where it frequently is considered suspect when one is, in itself amounts to significant commentary. Even where more than one person is shown, they are just coexisting, not relating; everyone is in the same isolated, desperate situation. Two *becak* drivers sleep in their pedicabs in the shelter of an imposing glossy wall which is really a bus, the modern threat to their existence (Plate 148). A *bajaj* driver swelters in the heat, waiting for a customer. A bus station is devoid of passengers; the only people present are the vendors of sweets, drinks, and cigarettes, waiting, impassive, in the heat. A solitary man in a sarong stands watch over his load of papayas, half-shaded from the noonday sun when the shops are closed and the streets empty. An ageing man stands, confused and aimless, in the midst of a blur of urban movement. Small and apparently insignificant dramas of underemployment

148. Dede Eri Supria, *Two Becak Drivers*, 1985, oil on canvas, 138 × 160 cm, collection of the artist. (Photograph courtesy of the artist.)

and severely limited livelihoods are played out in a context of concrete, steel, glass, and exhaust fumes.

Dede's style, choice of setting, and emphasis on working people recall the work of S. Sudjojono from the 1950s and 1960s (see Holt, 1967: 198, Pl. 160). One major difference lies in the relationship between the human figures and their environment. Dede's people are passive and powerless victims to the politics and economics of urban culture. Sudjojono's people, on the other hand, are people who feel as though they have the power to participate in the shaping of their world (Plate 149).[9] Dede says:

At this point we can see that 'development' is not a simple issue. Everything is being developed. Land is cleared, housing developments are built, factories are built, then crushed to bits, destroyed again. More things are built, then destroyed (*Zaman*, 1985: 26; author's translation).

These portraits of development truly leave a bundle of wrinkles on the brow. Up to the farthest reaches of the sky, you have only the impressions of high-rises, deserted. And in the empty alleyways, a man from the village pushes a heavy burden on his bicycle; who knows where he is going in this silence... (Plate 150) (source unknown; courtesy of the artist).

Dede Eri Supria is an example of an Indonesian artist who disclaims any connection with mysticism.[10] When contrasted with ancient Javanese ideas about man's power to attain some degree of psychological and spiritual harmony, Dede's work becomes all the more bleak with its depictions of man as powerless to improve either his material surroundings or his mental situation. His work proclaims how traditional modes of seeing are no longer relevant to urban Indonesian life. His art offers more questions than answers; the way he develops his visual language and contrasts may indicate that there are indeed no answers (Colour Plate 62).

In 1989, listing an estimated 250 paintings, Dede has increasingly caught the eye of Indonesians and foreigners alike, especially Japanese

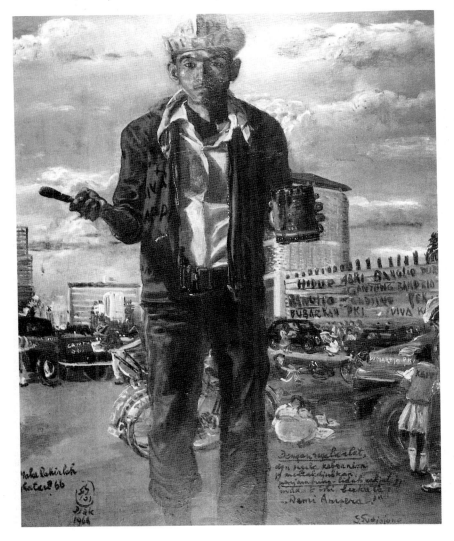

149. S. Sudjojono, *And So Was Born the Generation of '66*, 1966, oil on canvas, 100 × 85 cm, collection of the artist. (Photograph courtesy of the artist's estate.)

[9]This is one of the last works I have seen of Sudjojono's with a clear political and activist theme. In the 1970s and 1980s, his work, when not portraiture or still life, becomes richly allegorical (see reproductions in Liem Tjoe Ing, 1978: 30, and J. Fischer, 1990: 28, Pl. 16; 168, Pl. 109; 169, Pl. 111).

[10]Apart from my own communications with the artist, I am grateful to Umar Kayam for comments about Dede's work and attitudes in this respect.

150. Dede Eri Supria, *Pushing a Burden*, 1984, oil on canvas, 140 × 160 cm, collection of the artist. (Photograph courtesy of the artist.)

collectors. Highly respected among younger generations of artists and art students, he stands as something of a legendary rebel against the institution of the art school.[11] Many attempt to paint in the same style, but no one manages to copy successfully his powerful combination of stylistic and thematic elements and colour.

Experiments in Culture: Heri Dono

Heri Dono (b. 1960) (Plate 151) is among the most experimentally minded of the youngest generation of artists in Indonesia. Born too recently to be part of the New Art Movement, the ideas that

were considered radical in the mid- to late 1970s are today part of the modern Indonesian art heritage. Born in Jakarta, Heri was raised in a military family in Semarang, capital of Central Java. Wanting to be an artist since first grade, and painting since he was seventeen, he attended the art academy in Yogyakarta from 1980 to 1987, and has been active with the group of young artists around the CEMETI gallery.

Heri Dono's imaginary world seems to be the offspring of a community of images: Picasso's *Guernica*, Monty Python, New York graffiti, Western cartoons (both popular and avant-garde), New Order Indonesia, and his own laughter and nightmares. In his work, common human activities are contrasted with outrageous monster forms, often in the process of metamorphosis or

[11]Dede is the subject of at least one *skripsi*, the baccalaureate-level thesis written by students at the art academies.

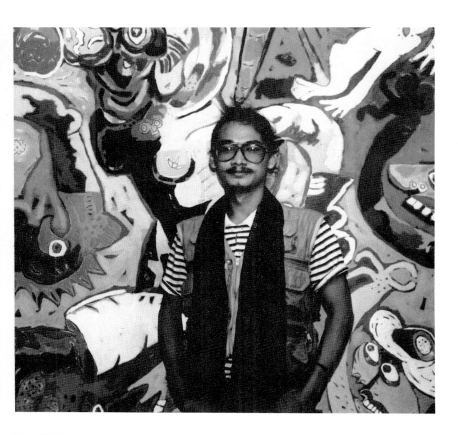

151. Heri Dono, 1988.
(Photograph Astri Wright.)

dismemberment, threatening each other with guns, teeth, and claws. The familiar and the fantastic, the ridiculous and the horrible, exist in a single medley of entwining forms in pictures which are sometimes absurd, sometimes cynical, and which range from the political to the erotic and the scatological. To respond to all of this with laughter, Heri says, is not merely the Javanese way of smoothing over potential social embarrassments. Laughter, he says, is an active healing agent in the therapy that everyone needs to deal with the realities of living. However, laughter can only be healing, if one learns to see things the way they are, including ugliness, around as well as within, and to acknowledge the absurdity of ourselves and others and the beasts with which we populate our internal and external worlds.[12]

Frequently collaborating with other young artists, Heri crosses boundaries between art forms and media, at times infuriating the traditionalists. He has done installations, environmental art, and multimedia performances which radically transform the *wayang* shadow puppet tradition. To Heri, nothing is sacrosanct. He feels that problems of culture are the responsibility of the artist. Interested, committed, and experimental are key words in his discourse. Artists, he says, should strive to realize the national motto 'Bhinneka Tunggal Ika' (In Diversity, Unity), albeit in a different way than the approach taken by national television: 'What you see on TV is only museumizing the old days, things which are not relevant anymore. Just preserving it so they can put it in the museum ... where the only response is: "Oh! Good" or "Oh, terrible!" That is not active involvement ... that is not culture.'

Heri admits to strong influence from Western artists, from hours of looking at their work in the library of the art academy. He mentions Picasso, Joan Miro, and Van Gogh as artists he has studied closely. He sees the process of seeking inspiration in other artists' work as a natural one, part of the creative dialogue. 'From these books I know that many of the artists in the West also tried to be influenced by something different than their own culture.' Now, however, Heri feels it is more important to look to 'everything that is in Indonesia' for his inspiration. This does not mean, however, that he will only be looking at traditional crafts or classical performing and visual arts.

Munni Ardhi's comment in the debate around the New Art Movement is illuminating here:

Older people always judge us by contrasting West and East. The understanding of [what is]

[12]Where nothing else is noted, all quotations are from interviews with Heri Dono, Yogyakarta, May–December 1988, and correspondence up to late 1992.

the East is their own. I suspect whether they themselves really know about the East, or if they only know via tourists. For example, [in my sculpture] I use mannequins—which are always called 'Western'. I use them as objects which I have seen here in Indonesia ever since I was little, until today (*TEMPO*, 1977a).

The year 1988 was a very prolific one for Heri. After his first solo exhibition at CEMETI in Yogyakarta in March, he held his second in June, this time in Jakarta. In August, he participated in an exhibition entitled 'Wayang Kreasi' (Creation Wayang) at the Purna Budaya in Yogyakarta, and travelled with the exhibition to Solo. In September, his 'Wayang Legenda' was performed in the Seni Sono building in Yogyakarta; he was producer, puppet-maker, writer, and chief narrator.

Heri's involvement with *wayang* started when he became acquainted with Sukasman, a local puppeteer (*dalang*) and puppet carver. He is popular with younger generations who find his slightly eccentric puppets, cast in traditional characters, and his incorporation of coloured shadows into his performances exciting (Wright, 1988f). Even his most conservative critics cannot deny Sukasman's wide knowledge of the history, symbolism, and methods of making *wayang* puppets. Combining knowledge of tradition with experimental freedom also characterizes Heri's work.[13]

I am not worried about Javanese culture disappearing because of the influence of Western culture.... In my opinion it is not possible for a culture to fade or disappear, as long as there are people there who are actively creating. If there are no such people, why then the culture is already dead! (Wright, 1988f).

[13]Other artists are also experimenting with the medium of *wayang*, both creatively reworking traditional characters and stories, and incorporating new material. This was demonstrated at the 'Wayang Festival' in Jakarta in August 1988. However, none cross over as completely as Heri to a modern idiom.

Rather than explore the psycho-cultural dimensions of his own regional or ethnic group, as many Indonesian artists do, Heri scans all of Indonesia for ideas and inspiration. Giving contemporary formulation to the long-standing nationalist search for an Indonesian identity, he draws on ideas from cultures ranging from Sumatra to Irian Jaya, mixing and merging them with Javanese traditions and his own idiosyncrasies. This approach is clearly illustrated in two self-portraits which he has produced as postcards. One shows him as the Buddha, seated in meditation posture, his shoulders draped with cloth, and his hair gathered into a bun. The other shows him prostrate on a mat, wearing a sarong, his loose hair and head on a level with three skulls—a reference to the indigenous practice among Asmat and other peoples of honouring the skulls of dead ancestors and enemies by sleeping with them. Such eclecticism also characterizes Heri's approach to the quintessentially Javanese form of *wayang kulit*.

To me, *wayang* is only a medium for expressing a story. And folk-tales, legends, and various types of folklore are widespread throughout Indonesia. Why do we only perform stories from the *Mahabharata*, *Ramayana*, and *Panji* epics? As an Indonesian, I feel the responsibility to make a contribution in the field of art. Say that each of twenty-seven provinces in Indonesia has five folk-tales. How many folk-tales could then be made into *wayang* performances? Wouldn't *wayang* then truly become the property of the Indonesian people?[14]

[14]*Kedaulatan Rakyat*, 1988; no date on clipping supplied by the artist; author's translation. The idea of expanding on the form and function of *wayang kulit* does not originate with Sukasman or Heri Dono. Possibly for centuries, *wayang* has been used as an allegorical vehicle to ridicule and criticize leading figures in the community. After Independence, many experiments were carried out attempting to employ *wayang* as a tool for both educational and political work. To some extent,

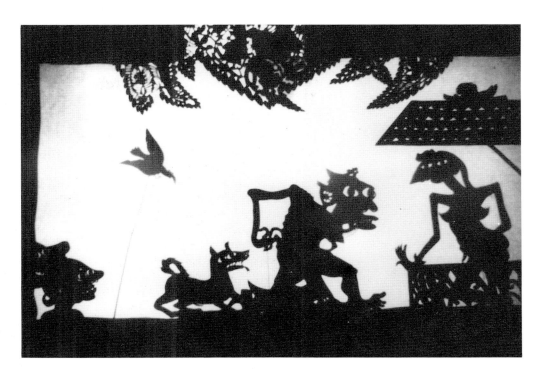

152. Heri Dono, scene from
 'Wayang Legenda', 1988.
 (Photograph courtesy of the
 artist.)

The idea of using a Batak folk-tale arose from Heri's feeling that the characters of the classical *wayang* repertoire were not immediately relevant to daily life. There were other characters and different moral and dramatic situations that could be equally or more relevant. Heri, whose conversation is studded with references both to Western and Asian art, culture, and history, therefore chose a story which revolves around the legend of incest which explains Batak regulations for marriage. He read several versions of the legend before allowing characters and plots to begin to take shape in his mind. He made the puppets of cardboard, with grotesque and hilarious deformations hinting at Picasso, cartoons, and the patterns on Batak carvings and textiles. The week before the opening date, he had to shut himself in his room in order to finish the

cutting and painting of the sixty-odd puppets, some of them still wet when the collaborative performance began. The use of two screens and two puppeteers rather than one, synthesized music rather than *gamelan*, and the highly original puppets, all combined to create a unique performance experience.

Besides retaining some of the timeless quality of the Batak legend, Heri's reformulation of it injects a sense of freshness, interspersed with both humour and melancholic poetry (Plate 152). The sensual and humorous puppet of the young woman is reminiscent of a primitive sculpture. The old shaman is as crooked and bent as only the full-time practice of magic can make one. The court dancers who perform for the lovelorn king have long arms and cowhorns but no legs, and the old woman who keeps asking the shaman to restore her youth and beauty so that she can find a young husband, is a delightful caricature of traditional female *wayang* servant characters.

puppeteers are still pressured to incorporate government propaganda into their performances, for example, in regard to family planning.

Picasso and the cubists liberated the elements of the face and body from realism and three-dimensionality, pioneering new expressive possibilities for later generations of artists. Classical *wayang* figures, depicted in profile with great stylization of the human form, usually employ a single large eye for expression.[15] In Solo, however, the convention is to show a part of the second eye on the other side of the nose bridge. As a modern artist, Heri Dono feels free to draw on all of these traditions: he blithely places two eyes on one side of a nose seen in profile, thereby adding more expressive power to the puppet's face.

In his paintings, Heri's concerns are, at the same time, more personal and more global. Reflecting such wide-ranging issues as the Chinese occupation of Tibet, hunger in Africa, the torture of political prisoners, unemployment and crime, the effects of gambling, drugs, and drinking, the state lottery, and violence in the media, his work exhibits an agenda beyond the purely aesthetic. One work Heri chose not to exhibit at his solo exhibitions was painted after hearing his friend tell how imprisoned student activists were forced to eat excreta. Other titles were *On Good Terms with Iron Hands*, *It's Probably Sir Corrupter*, *Shooting Hero*, *Pollution*, *Satan Looking for a Good Lottery Number*, *Face of Tibet*, *Kiss (War)*, and *Gifts from Bali*.

With his titles Heri seeks to add an important perspective to the reading of the work. Otherwise, he says, the work might not be perceived as speaking about something specific but only expressing his own feelings. 'An artist is someone who wants to serve art—but more important to me is, how can art serve humanity! That's what drove me to become an artist.' He admits, however, that the title may be more important to the artist than to the viewer, who will also bring his or her own experience to the work.

Stylistically, Heri's paintings are done in a zany, densely overlapping cartoonish style that does not suggest the subject directly, thereby demanding closer scrutiny. Indeed, the titles are frequently necessary to enable a reading out of chaos; this view posits that the artist, indeed, has the right to direct the viewer's mind in a certain direction through the employment of words. Often what looks funny at first glance has a nightmarish quality when studied more closely. Here is amputation, including castration imagery, a theme that would seem to warrant special investigation in a culture that has worshipped human potency in the form of the *lingga* and *yoni* for so long. There is surreal metamorphosis, and there are monsters and aliens who, through the titles, are connected directly with specific and real horrors occurring both locally and globally.

My obsessions are especially concerning problems of humanity. Before—I remember the problems of earlier times, such as political problems, social problems, etc. Since then I have matured and become more directed towards problems of humanity in general. I use humour in my work. Imagine, a person who doesn't look deeper into my paintings will laugh, see my work as an expression of hilariousness. But someone who enters into it might cry. . . . I am not only involved with problems of visual art. I am involved with tragedy.

Watching TV (Colour Plate 63) shows a small, illuminated square within a densely composed canvas, before which sits a group of three alien-like beings. Heri is here, among other things, playing with the image of E. T. from Spielberg's famous movie. The figures and their television are set against a ground of bright overlapping red, yellow, and orange areas. Two of the figures, monster

[15]Deformation (*Deformasi*) is the term usually used by Indonesian artists for what Western art writers call stylization.

versions of mother and child, are involved with each other, one reaching for a plate on which lie the remains of a meal. The biggest monster is glued to the screen, mesmerized. His eyes are bulging; in one eye is reflected a small gargoyle head and in the other, a skull. On the television screen, a spiked boot becomes a hand, then a snake, and finally a double-barrelled gun. The gun shoots a bullet down the throat of a screaming, terrified, and helpless being who is begging for food under a burning red sun. To the side lies a femur bone, indicating that this is not the first victim.

At first glance, one's impression is that of a science fiction cartoon. Then one starts reading the violence intruding into the domestic setting, where it is either not paid attention or not comprehended, the television functioning like a trance inducer. Neither the theme nor the style is entirely new. The interesting thing here is that this was not painted in Berlin or in New York. It was painted in Yogyakarta by an artist who had never been outside his native island and who was drawing on his own first-hand experience and general literacy.

Violence recurs in Heri's work, as in *Lebanon* or in *Killing Field*, and, more subtly, in *Campaign* (Colour Plate 64).

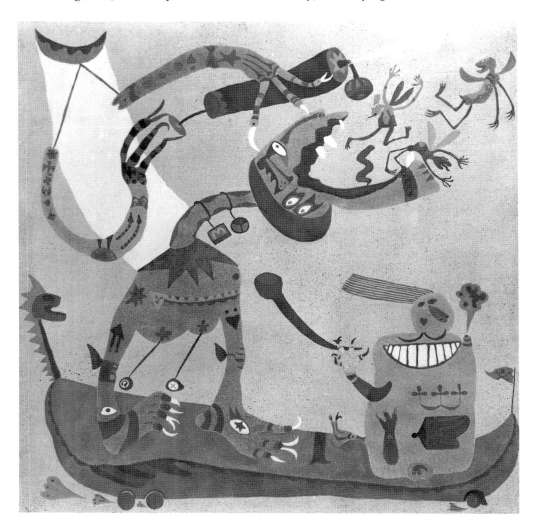

153. Heri Dono, *Spraying Mosquitoes and Smoking*, 1985, acrylic on canvas, 100 × 100 cm, collection of the artist. (Photograph Astri Wright.)

'I am not involved in political or social problems, if you will—but my paintings, maybe they are identical with politics or with society. The main thing is that the social structure must be turned around 180 degrees.'

Another style of Heri's in the period 1985–7 appears to be inspired by Miro. Working with flat colours, isolated forms, and no shading, the figures, which are more abstracted and less indebted to the international commercial cartoon monster genealogy, are set in a two-dimensional and evenly lit world. In *Spraying Mosquitoes and Smoking* (Plate 153), strange creatures with thick bodies and thin limbs appear in isolation against a grey ground. The theme establishes the moment before disaster. A hand coming out of nowhere turns out to be a toy. Linked to another toy hand by a

thread, it is holding a spray can which emits a little puff of poison, depicted as a 'cute' little cloud. Mosquito-like creatures fall down, choking. The poison wafts into the open mouth of a strange beast standing on a boat, where another creature is calmly lighting up its pipe in the highly inflammable atmosphere.

Heri's imaginative forms are never more deceptively playful than in this style, where the multitude of strange beings and interactions emerge more clearly than in the densely overlapping style of the works above. Combining the two styles is *Between the Desire for Good and Bad* (Plate 154), where a single winged figure dominates a symmetrically composed canvas. The figure is painted in the humorous manner of the cartoon style, but its outlines stand out clearly against a neutral rather than a busy, layered background. Over the figure's right shoulder a blue parrot-like demon emerges; over his left, a more feminine figure grasps a flower. The expression is one of hesitation before a choice. The creature stares out at us, lost in the confusion of the moment, as he clutches his chest just below a small heart emblem.

Regarding the future of Heri Dono and other experimentally minded artists, the question is whether they will be able to find patronage in the predominantly conservative Indonesian art world.[16] In

154. Heri Dono, *Between the Desire for Good and Bad*, 1988, acrylic on canvas, 100 × 100 cm, collection of the artist. (Photograph Astri Wright.)

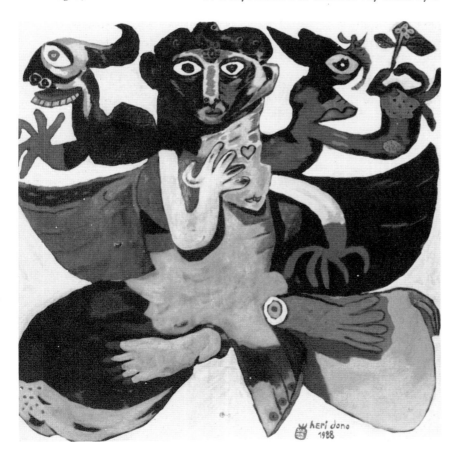

[16]Like people everywhere, most Indonesians do not tend to go to an exhibition unless the artist is well-known or some kind of sensation surrounds the work, such as in the case of the New Art Movement or Semsar. Similarly, the critics are not looking for new talent, even though the number of exhibitions in the 1980s was so small that anyone interested in art could easily make the rounds in a couple of hours a week. At Heri Dono's 1988 exhibition in Jakarta, attendance was fairly poor and no paintings were sold during the first six of seven days. No Indonesian critics reviewed it. On the sixth day, my review of the exhibition appeared in English in the *Jakarta Post*; on the last day of the exhibition, Heri sold ten paintings, nine to

1992, Heri returned from art and culture studies in Basel, Switzerland, and successful exhibitions there, in Holland, and in Germany. In late 1992, he was invited to Japan. If he can find patronage at home, it is clear that the Indonesian art world will continue to be enriched by the type of experimental creativity that Heri Dono's work represents.

Summary of Part II: Roles of the Artist

It remains for us to look at the roles perceived to be played by artists who participate in the perception of the mountain as an image of society, structured hierarchically, and who focus on that section of society that constitutes the largest part of the 'mountain'—the common people.

These artist roles are variations on the theme of what has been called the politically or socially engaged artist, although a widespread avoidance of the first formulation by Indonesian artists is well-ingrained. Traditionally, in the South-East Asian archipelago, overt and directed criticism has a tenuous place, always masked in humour and raucousness, as in, for example, the Javanese *wayang*'s *goro-goro* sections. Here, the clown-retainers traditionally performed a critical function, comparatively safely because they spoke in low Javanese and not in the deliberate, proper, and 'refined' syntax and vocabulary of high Javanese. The avoidance of the label 'political' for art in Indonesia has been encouraged since the beginning of the New Order, both from official hold and inspired by personal memories of the political battles that

foreigners and one to an Indonesian painter. The prices ranged from Rp 50,000 (*c.*US$28) for a 40 × 50 cm drawing, to Rp 4 million (*c.*US$2,273) for a 300 × 200 cm oil-painting. None of the larger paintings were sold.

took place during the last years of the Sukarno regime and the violent end to the Old Order out of which emerged the New.

None the less, the first generation of modern Indonesian painters, emerging within the nationalist movement's sustained challenge to the traditional avoidance of challenging authority, did see their roles as political and activist. They were charged with the new idea that art could be a tool in political awakening, mobilization, and in the shaping of a national identity. S. Sudjojono, Affandi, Hendra Gunawan, Sudjana Kerton, and many others were frontline artists, whether participating directly in armed struggle, sketching on the battlefield, or making posters for the resistance movement. Also after Independence, their sense of identification with the Indonesian people manifests itself in different ways in their art.

This is also evident in the work of Djoko Pekik, who, although too young to have participated directly in the war of Independence, is old enough to have clear memories of it and, through his experiences with life in the impoverished countryside, to partake in a similar perspective. Semsar, although of an even younger generation, is conceptually related to these artists. His art is self-consciously radical, employing an iconography of political caricature with links both to European expressionists and Western and Asian leftist movements of the 1930s, 1940s, and 1950s.

Many of the painters in their late thirties and early forties refer to themselves as 'socially engaged', an engagement which embraces social, political, and aesthetic dimensions. These artists are protesting against the older generation's definitions of art, aesthetics, and 'Indonesian-ness'. In their art they attempt to express reality as they see it rather than according to the idealist and romantic modes of representation they

see prevailing in the established modern Indonesian art world. With the New Order avoidance of overt social or political criticism, some of these painters find absurd and surrealist styles to be most appropriate to their message. Their work reflects contemporary life in Indonesia, with its commercialism, its urban–rural polarities, and what they experience as increasing social alienation.

The 'mountain' is here at its furthest remove from the traditional image of cosmic–terrestrial order and harmony. Art can now function as a form of protest, though it is not always clear at whom it is directed and what its agenda for social action, if any, would be. A few painters, such as Dede Eri Supria, concentrate on depicting the encroaching of an urban environment on an essentially rural culture. A few, like Heri Dono, approach the question of identity in novel forms, drawing on a pan-Indonesian catalogue of visual forms. Fewer still, like Moelyono, locate themselves in processes of change by creating collaborative works that speak to solidarity with those layers of Indonesian society who are felt to have no political representation.

Stylistically and conceptually, the younger artists are more in touch with the whole range of contemporary international styles than the first two generations of artists were. This has, since the 1970s, resulted in the inclusion also of conceptual art into the range of modern Indonesian expressions.

13 Conclusion

WITH the emergence of modern Indonesian painting in the twentieth century, a new chapter began to take shape, both in the history of Indonesian art and in the history of twentieth-century art in general. Indonesian artists of the early twentieth century inherited a panorama of images, ideas, and styles from modern Western art. New ideas involved the challenging of traditional interpretations, value systems, and styles, and the rewriting of established views of history and the present. At the same time, Indonesian artists began to draw consciously on a whole range of indigenous as well as foreign art styles from all periods of history, creating new syntheses which simultaneously echo of the past and comment on a changing present.

'Modern/–ism'

The use of terms like 'modern' or 'modernism', imprecise and much debated within the Western context, is especially problematic in discussions of non-Western cultures. For lack of a better term to distinguish peculiarly unprecedented developments that have taken place in the twentieth century from indigenous historical and traditional counterparts, writers continue to use the term 'modern' while awaiting an in-depth discussion of its range of meanings and uses in different contexts.

For reasons both cultural and political, modern Indonesian art does not explore the same range of ideas and styles as seen in modern art movements in the West. From the Western point of view, such differences in the modern art of non-Western cultures have been interpreted as signifying underdevelopment; from the Indonesian point of view, however, they reflect a different set of conditions, challenges, and preoccupations.[1] For example, modern Indonesian painters never exhibited the fascination with industry and technology evident in the works of Dadaists and Futurists.[2] They rarely showed a strong interest in complete formalist abstraction; the great majority of abstract paintings in Indonesia can, through titles or recognizable symbols, be connected with familiar themes, spiritual or secular.[3]

Finally, it is only in the last two decades

[1]This is not to say that areas of modern Indonesian art do not suffer from under-development or from a prevalence among some artists to copy modern Western art styles without creating a synthesis of their own. The point here is that the anatomy of such artistic underdevelopment needs to be examined from an Indonesian rather than a Western perspective, and that much of what has been labelled as such would, after re-examination, appear as autonomous contributions of inherent interest.

[2]Dede Eri Supria could be cited as a partial exception to this.

[3]Nunung W. S. and Nashar could be exceptions to this.

241

that Indonesian painters have produced works characterized by questioning, criticism, satire, or irony, and have shown an interest in dismantling the icons of traditional culture and reassembling them in new and startling ways. On the other hand, the repertoire of cultural icons with at least a residual social and spiritual dynamism available to Indonesian artists was staggering.

Instead of duplicating Western artistic developments and concerns, modern Indonesians were, after four centuries of increasing colonization, preoccupied with questions of nationalism and identity. In contrast to the relatively homogeneous sovereign nations of nineteenth-century Europe which gave birth to modern art, the Republic of Indonesia was characterized by cultural pluralism from the outset. The national motto, 'Bhinneka Tunggal Ika', is not merely invoked as a tool to create national unity across formidable cultural, ethnic, and geographic boundaries; it also reflects individual preoccupations with the plethora of Indonesian cultural forms, and the problem of how to reconcile them into a meaningful personal and national identity. Because of their history, the interest of modern Indonesian painters in comparing and contrasting Eastern and Western ideas was fuelled by a sense of urgency which far exceeded the interest of European painters in non-Western art. Emerging suddenly into a modern world based on industrial technology, twentieth-century Indonesians have always had an acute sense of the past existing alongside the present. This situation is reflected in the emphasis on continuity and change as parallel themes in so much scholarship pertaining to Indonesia.

The outlines of a discussion about what 'modern' means in modern Indonesian art could entail comparing and contrasting the conditions for the rise of 'modernism' in the West with those that gave rise to twentieth-century developments in Indonesia. If the Western modernist movement as a whole embodied anti-imperialist perspectives, as has been claimed, it was against different forms of imperialism than those remembered or encountered by modern Indonesian artists. If Western modernism opposed traditionalism, modern Indonesian artists were divided on this issue, some abandoning traditionalist outlooks as outmoded, and others seeking to integrate or renew them in a modern idiom.

In order to see what is 'modern' and what is 'Indonesian' about it, modern Indonesian art must be seen within its context. To many younger Indonesian artists, it is as important that their art be genuinely rooted in their own lives as that it be modern. Furthermore, since the anatomy of Indonesian society in the 1980s differs from that of earlier decades, a chronological and thematic history of modern Indonesian art needs to be established more carefully than has hitherto been done.

Indonesian art, in particular painting, is at the most basic level called 'modern' because it utilizes techniques, media, and ideas which in large part, or in their peculiar combinations, are new to the practice of the arts in the country. It is presented in individual stylistic and conceptual syntheses unprecedented in this part of the South-East Asian archipelago. Moreover, modern artists were recruited from different social strata and trained in ways unlike those of the social and educational institutions within which traditional Indonesian arts were produced. Modern artists constituted a new type and class of artist in Indonesia, who since their emergence have coexisted with traditional art makers. Although many art traditions are slowly dying out or undergoing modern transformations, many instances are recounted of how modern painters have learned from traditional masters.

Under the force of modernizing and

Westernizing influences, older views of society have changed towards a more secular one, based on ideas less synthesized with magical or religious world-views than in the past. From the 1930s to the 1970s, new themes and aspects of society began to be represented in art. In some cases, this happened because new segments of society, such as village people, urban people, and women, began to represent themselves. In the last two decades, international currents manifested themselves more quickly than previously in Indonesian art. Besides reflecting better access to international media and publications, this development was facilitated by the greater availability of art education in Indonesia, and the numbers of second- and third-generation artists (active, respectively, from the 1960s and mid-1970s on) who studied abroad, going to the United States as well as to the old centres in the Netherlands, France, and Germany.

At the same time, Western artists, without the colonial baggage of Dutch artists of the late nineteenth and early twentieth centuries, have been coming to Indonesia to study or to gather inspiration for their work, some of them settling permanently and playing active roles in the Indonesian art world. Apart from this increase in artist exchange, there was also, in the 1980s, an increase in the numbers of foreign exhibitions shown in Indonesia compared to the 1960s and 1970s.[4] While the connections with modern art movements in Europe and the United States became more evident in the work of the younger generation, a self-conscious attempt was made to reinterpret, in contemporary form, an indigenous, 'Indonesian' aesthetic—the most recent round in the long-standing debate about what 'Indonesian' means.

The Indonesian Modern Art Debate

Among Indonesian artists themselves, there is little consensus about what modern Indonesian art is and is not: whether it is 'modern', whether it is 'Indonesian', whether it is 'art'. The situation illustrates changing patterns of cultural pluralism in Indonesia, and reflects both the fact that modern art in Indonesia is a recent phenomenon with a short history and that this history has been of a dynamic nature.

One group among Indonesian artists and art watchers argues that modern Indonesian art does not yet exist as an integral cultural product. The mentality of the artists is still colonial, emulating Western models and ideas.[5] These critics may concede that there have been artists in the twentieth century who have achieved high artistic standards as individuals, but point to the absence of identifiable elements beyond narrative content that can be called 'Indonesian' in style and feeling.

Other critics and/or artists maintain that modern Indonesian art has not been a slave to Western models but has found its sources of inspiration, both formally and in content, as much if not more in indigenous artistic traditions.

Abstract forms as vehicles for symbolic meaning have been processed for centuries in Indonesia. Such motifs emerge, for example, as a result of *pamor* casting techniques on the *keris* blade, a weapon and social attribute in the Majapahit Era and after. Why have we created abstract arrangements? Because these exist so abundantly around us in nature. Let us become aware of the subtle colors and forms in the world of flora and fauna and

[4]Based on the numbers of reviews in newspapers of the time and in *TEMPO* since its inception in the mid-1970s, this appears to be the case. It is also corroborated by oral reports of artists and art officials.

[5]The discourse about art in Indonesia resembles discourses about politics, history, and tradition, which have received more attention in the field of Indonesian studies.

notice the ever-changing positions of the stars in the galaxies.

Geometrical elements helped create traditional Batak and Toradja ornaments; the leather puppets of the shadow play in Java present imaginative scenes illustrating the behavior of individuals, depicted in profile and in two-dimensional stylization. All these phenomena, directly or indirectly, influence the creative mind of the contemporary artist, carrying the idea of the wide variety of styles achieved by the nation in the past. The contemporary painter is applying, above all, elements of line, color, space and texture as basic components in an individual composition containing a particular message of a poetic character rather than a merely visual one (Kusnadi, 1984).

A third group of critics and/or artists maintain that, increasingly in the course of the twentieth century, distinctions between different cultures and nations no longer apply in the realm of art—that ideas and concerns, and hence art works, belong to an international, universal culture. Within this group, some complain that many Indonesian artists remain too concerned with being 'Indonesian'. This renders them provincial-minded producers of works which are not relevant to contemporary society, local or global.

Roles of the Artist

Modern artists appeared on the conceptual horizon of the South-East Asian archipelago with no time-sanctioned roles or meanings. It was up to the artists, through their choices of lifestyles and roles, to create specific places for their work within the evolving networks of patronage and meaning. At first, with no existing categories or institutions within which modern painting made sense, the works by the early generations of modern Indonesian painters were often left to rot, in storage spaces either in the artist's or a chance collector's home. In the case of those

artists who, through their family backgrounds or through personal patronage, managed to create a space for themselves in the upper echelons of the social hierarchy (itself undergoing evolution, spawning a new group which is often referred to as middle class), the paintings have acquired high value as status symbols, often with overtones of traditional objects that are believed to reflect the owner's power.

In the case of painters who, for one reason or another, did not have access to social mobility, remaining marginal seemed the only option, unless this marginality could be rephrased as the spiritually potent role of the hermit sage (*ajar*) who 'withdrew from society to cultivate clairvoyance, study the secrets of the cosmos, and prepare himself for death'. Because the *ajar* was withdrawn from society, his judgement could not be affected by self-interest, and so his insights were regarded as deeper and closer to the truth than those of other people, including the ruler (Anderson, 1990b: 63–7). It is in the light of this role that a painter, cultivating a pose informed, for example, by Islam or by Javanese mysticism, can borrow from the aura of traditional persons and objects of power and attempt to cast himself and his work in it.[6]

Modern Indonesian artists who find their inspiration in spiritual ideas and practices are those whose roles and preoccupations represent the clearest continuity with pre-modern arts and the idea of the artist as a spiritual interpreter.[7] As we have seen, some of

[6]Although the *ajar* is no longer a formally recognized institution in Indonesia, the image of such a person lives on in people's imagination, partly through the *wayang*, partly through new mutations of it, such as the role Rendra perceives himself as playing (see Rendra's speech to the Jakarta Academy in which he describes himself as the poet cum critic, 'living in the wind', withdrawn from rather than *in* the 'body of society' (1979).

[7]The artists discussed in Part I are only a small

these artists work in abstract styles, frequently labelled 'Western' by Indonesian writers. Others work in traditional styles, translating familiar mythological imagery directly into a new medium. Another type of modern artist, whose role has direct ties to art-makers of the past, is one whose art functions to maintain and celebrate the *status quo* and social harmony, depicting the social élite and idealized village life as emblems of cosmic and microcosmic harmony.[8]

Indonesian artists whose work is inspired by social realities, whether urban or rural, who work in various representational styles ranging from expressionist and symbolist to conceptual, and whose preoccupations tie in with ideas that do not have a long genealogy in this part of the South-East Asian archipelago, represent the clearest break with traditional ideas about art and art-makers. Hence, it is this latter group which, from a Western perspective, appears most modern. These artists draw on the social and intellectual ferment out of which arose nationalism, revolution, and the Indonesian nation-state. In their work, they show concern for the dynamics of a society undergoing rapid change under the forces of Western-capitalist modernization. Whereas the painters in the spiritually inspired group continue to develop ideas and forms that are stylistically related to modernism, but may lack other elements in the West associated with the concept of modernism, the younger generation of artists in the socially inspired group participates in the wide range of cultural concerns central to modernism, some in forms analogous to what in the last two

decades have been called post-modern.

Comparing Indonesian society in 1955 with what she knew during her previous stays in Indonesia, Holt noted that there were

... more combinations: communists can be individualists and mystics. Mystics can be scientific. Barbers can be painters. Officials can be dancers and vice versa. Technicians and engineers can lead cultural institutes. Presidents can be bigamists. Leaders of inter-religious movements can be teachers of *pentjak*.[9] Military police can patronize the arts. A *golek* dancer plays Chopin; a public works official is a *dalang* (24 December 1955).

This pattern of overlapping roles and involvements still obtains in the Indonesian art world of the 1980s, as well as in society at large, although a greater degree of specialization in the direction of Western categories is taking place among younger generations.

The Life and Role of Art Works

On the level of how a work of art is viewed and its life and function defined, traditionally two views prevail: one which sees art as a uniquely constituted mirror of reality (whether defined in terms of the spiritual or the social) and another which perceives art as having the power to actively foster the conditions depicted. It is the second view that is most relevant to pre-modern insular South-East Asia, and, interestingly, resonates with the ideas of twentieth-century artists who believe art to be an active tool in promoting socio-political change.

The traditional view of art works in Indonesia posits them as empowered objects, symbolic vehicles of transition covered with patterns and motifs which are meant to be 'read'. From the religious point of view, such objects mediate

selection of those who could be categorized in this group.

[8]An example of the first type is Basuki Abdullah; an example of the latter type is Suhadi, whose naïve paintings depict a world of ordered fertility, in ways that can be interpreted as a reference to the Garden of Paradise theme.

[9]*Pentjak* is an Indonesian form of martial art, influenced by Chinese and indigenous traditions.

between this world and spiritual and divine dimensions. From the sociological point of view, they mediate between the individual and a network of social relationships, signalling relative status, with the potential of conferring social status and power.

Even these powerful objects, however, have their own natural life cycle, depending on the materials with which they were produced. Although the physical objects were kept and often handed down for generations as *pusaka* (highly prized inheritance objects), the power in them maintained by rituals and offerings, it seems that efforts were not taken to repair these objects extensively or to isolate them from their socio-religious context for better safe keeping, as is the practice of modern museums.[10] Thus, the idea that objects can be powerful appears to be counterbalanced with the idea that they can lose their power through ceremonial neglect, through material decay, and through changes in ownership and function.[11] Some objects are carefully kept and venerated as powerful as long as its

maker is still alive, and then allowed slowly to 'expire'.[12]

With the appearance of modern painting, the variety of ways of viewing traditional art works needed to be stretched, adapted, or negated before the new medium of paint and canvas could be 'seen'. The problem of fitting such works into traditional frameworks accounts, in part, for the difficulty modern painting has had in gaining broad acceptance and interest throughout Indonesian society. Although it passionately engages a small group of mostly urban-based artists and art lovers, the great majority of Indonesian people patronize an entirely different spectrum of traditional, folk, and popular arts (Geertz, 1990: 77–94).

Portraits and Self-portraits

Individual portraiture was an unprecedented development in Indonesian art during the late nineteenth century.[13] This development was indebted to the advent of photography in the archipelago, when family and individual portraits of local aristocracies and wealthy Chinese became status symbols.[14] After the development of

[10]A great degree of simplification is at work in the above statement, where I do not distinguish between different types of powerful objects. There may be a certain hierarchy among such objects as well, where powerful textiles, due to the nature of their less durable materials and possibly their gender connotations (usually made by women) would rank lower within a given society than the powerful objects made by men of more durable materials, such as ceramics, or metal, such as a keris. The higher in the hierarchy of powerful objects, the more effort might be made to refurnish, say, an old keris blade with a new handle and sheath, to prolong its 'life'. What remains true in this case, however, is that the keris, in order to continue bringing power or blessings to its owner, must remain in context and not be put in a museum.

[11]The practice of letting something decay versus preserving it at all cost, in isolation from the flow of life, as in modern museumizing, can be seen in the prevalence of decaying Thai temples, Balinese temples, and textiles throughout South-East Asia.

[12]Pers. com. with Barbara Leigh about Acehnese textiles, January 1991.

[13]Raden Saleh painted portraits of indigenous aristocracy and Dutch Indies officials. It is possible that a tradition of portraiture existed in the archipelago in earlier centuries. Holt refers to C. C. Berg's translation of *Kidung Sunda*, where it is recounted that a painter was dispatched from the Majapahit court to West Java to paint the likeness of a Sundanese princess whose hand was being sought in marriage. There is no indication, however, of the style of this portrait, and no known examples of individual portraits in the Western sense have been found (1967: 191).

[14]The photographers were for the most part foreigners, working on a freelance basis. The Sultan of Yogyakarta, however, had his own court photographer by the name of Cephas [sic] (Nieuwenhuis, 1988: 7).

modern painting in the 1930s and 1940s, painters no longer depicted only members of the royalty or upper class. Besides depicting ordinary men and women, they also began to paint themselves.

In a society where drastic change has occurred in the last fifty years, ideas of the self located in traditional social values and symbolic systems are challenged and demand adaptation. Looking at self-portraits can illuminate the artist's perception of self. Although the self-portrait entered the history of Indonesian art as a category in the twentieth century, it rarely acquired the popularity and the dimensions of psychological probing of Western individual portraiture with its roots in the Renaissance. Many Indonesian artists who did not paint self-portraits would, however, participate in group portraits. The examples of such group portraits show each artist painting and, in turn, being painted by another. Such group portraits are often large,[15] at times including so many people that the individual disappears completely in the mass (see Colour Plate 45).[16]

The majority of first-generation Indonesian artists searched for an answer to who they were by looking at their immediate social group and close involvements—whether revolutionary comrades, fellow villagers, their family-based or traditional lives, and rituals. They sought to depict themselves within the context of those relationships that engaged them the deepest, and through focusing on 'their' part of the 'mountain'—the order of the world as they knew it most intimately. The need to single out individual minds, features, and emotional complexes, and to place them in the spotlight, was not felt as strongly as in Euro-America.

In the late 1970s and 1980s, the search for self emerges as a theme of greater importance in Indonesian painting than in earlier decades. In some self-portraits, the artist presents him- or herself as a generic type, one among a finite number of combinations of personality characteristics, similar to the character cast offered by the *wayang*.[17] Some self-portraits by the current generation of artists show the painters playing with traditional notions of artist roles, as spiritual seeker, seer, someone in touch with the cosmic order and nature, and so forth (see Plates 50, 64, and 93). Some paint self-portraits that are more caricaturistic, stylized, allegorical, or symbolic (see Colour Plate 12 and Plates 143 and 154).

With the exception of a few self-portraits done by women (see Chapter 6), expressions of the self in modern Indonesian art have never become as self-consciously probing or revealing of the personally painful, or as deliberately shocking as modern art on occasion has in the West. The spiritual, the community, and relationships between individuals are still important elements in the way

[15]One such example is *Three Artists with Ciputra* in the Ciputra collection (Wright, 1991e: 81, Pl. 5). Many examples exist in the Sukarno Collection, such as S. Sudjojono's *Friends of the Revolution* (1947) (see Dullah, 1956: Vol. II, Pl. 88).

[16]Self-portraits of thirty-one artists teaching at ASRI, Yogya, painted in the mid-1950s and photographed by Claire Holt, is 1.7 metres long. A work which takes this genre of mass portraiture to its extreme is Djoko Pekik's painting of Sultan Hamengkubuwono IX's funeral, where the masses of people lining both sides of the road are depicted as a sea of round shapes (J. Fischer, 1990: 36, Pls. 30, 31). Another interesting painting of this type is Widayat's work entitled *Indonesian Painters*, which was shown at the National Painting Biennial in 1987: here, each painter is represented by a mask, no body; a hundred masks cover the canvas. In 1990, after Affandi's death in late May, Widayat painted several pieces entitled *Portrait of Affandi* (see Chapter 4), where the latter's face is repeated in stylized form across the canvas, some fifty times.

[17]For an exposition of the types and their place in day-to-day Javanese perceptions of psychology, see Anderson, 1965.

modern Indonesian artists see the world. Nevertheless, in challenging older concepts relating to self and society, modern Indonesian artists are bringing about a secularization of the idea of self from an older idea emphasizing the 'soul' or 'spirit' to a more sociologically, if not psychologically defined individual in society. In some cases, a humanistic philosophical approach has come to replace older religious views of the self in the world (see Affandi's self-portraits, Chapter 5).

Preoccupations of the Emerging Generation of Painters

The artists of the generation now in their early thirties, who have emerged to play prominent roles in exhibitions and art debates, are on the whole less concerned with realism or social expressionism. Born a decade or more after Independence, they are not concerned with depicting national heroes or revolutionary struggle; their use of symbolism is different than that of preceding generations, and their approaches to history range from nostalgic and romantic to sarcastic. History, represented by traditional symbols, is in the work of some artists presented as a golden era, but more often it is presented as a cracking artifice (see Plate 55). Alternatively, as seen in the work of the surrealist school in Yogyakarta, history and tradition can be interpreted as strait-jackets imposed on the living organism of human society (Chapter 5).

The younger generation paints relatively few straightforward images of society. The absence of overt social and political commentary in contemporary Indonesian art reflects several things. First, the upcoming generation are not politicized in the same way as the first two generations who experienced the hardship and sacrifice of occupation, war, and nation-building. They have not experienced the early experiments of a multi-party system during Sukarno's early years, complete with polarized public debates. Even those whose world-view is essentially political for the most part practise self-censorship or work in veiled, allegorical, or symbolic styles (see Chapter 11).

While the first generations of modern artists searched for forms and media which could represent 'Indonesia', many among the younger generations in the last two decades seek to locate themselves within an international context. Although many Indonesian artists still remain preoccupied with themes and symbols which can only be fully understood in the context of Indonesian cultures and the ways these are changing, others of the more talented young artists are no longer preoccupied solely with their own ethnic backgrounds. Some extend their focus to include Indonesian cultures beyond their own, which in some ways are as foreign to them as those of other nations (see Chapter 12).

The younger generations of artists are more diverse and appear to be at once more in touch with international currents and less artistically dependent on the West. Since the advent of modern print technology and accessible travel, they know both their Western art history and the diversity of Indonesian cultural forms better than their elders did. Whereas the first generation were either self-taught or had studied with foreign teachers, the younger generations have had greater access to formal art education and have studied mostly with Indonesian teachers. Thus, in addition to Western and other Asian artists of the past and present who are internationally recognized as masters, Indonesian artists of the last two generations also have Indonesian masters to look to.

Can One Speak of an Indonesian Aesthetic?

In the same way that it would be difficult to define an American aesthetic without either becoming hopelessly complex or sacrificing the variety of contributions for the sake of clarity, a simple definition of an Indonesian aesthetic is hard to formulate. Any discussion of an Indonesian aesthetic must treat it as a pluralistic phenomenon which includes elements around issues of Indonesian identity, local and ethnic cultures, and the variety of existing and potential solutions to form and content within the context of life in Indonesia.

A sociology of themes in Indonesian art reveals that art world institutions and officials posit a hierarchy of themes or motifs considered worthy of being celebrated in art. Emphasis is on the refined, the conventionally beautiful, the recognizably spiritual, and the divinely inspired, whereas the everyday, low-class, raucous, or vulgar are considered inappropriate as aesthetic subjects.[18] In stylistic terms, appropriately artistic themes are acceptably depicted in more or less expressionist and decorative styles, with extensive repetition of formal elements. Rather than the sense of 'ennui' associated with repetition in modern Western life, repetition is perceived as a method of increasing power—a device which in itself confirms meaning and creates power, like the repetition of a *mantra*. If the style is abstract, there is none the less usually some reference to a conventional formulation of nature or spirituality.

It appears that official Indonesian definitions of modern art to a large degree cluster around the old Javanese philosophical values, *halus* and *kasar*.

As discussed earlier, *halus* refers to things of refinement and spirit, while *kasar* refers to things of matter and coarseness. This division of the world into complementary opposites is an old one; traditional arts often express both *halus* and *kasar* qualities within one and the same text (for example, the Borobudur or a *wayang* performance). What can be observed in modern Indonesian art world institutions— guided by the Department of Education and Culture, the Directorate-General of Culture, and state-run art academies, art collections, and newspapers—is a ranking of subject-matters and styles into a hierarchy which places *halus* art at the top and *kasar* at the bottom.

Although such a system of evaluation is rarely spelled out, it can be seen to operate in the discourse surrounding modern art and specific artists and works. According to how the established art world might apply the terms, then, *halus* would represent 'fine art'. The not-*halus*, then, is 'not-fine art'; at best, it is 'crafts', often it is 'immature', at worst it is subversive.[19]

The discussions which rage between different factions in the modern Indonesian art world could be defined as a battle between those who do and those who do not support the official definition of 'fine art' as being *more* true, *more* moral, *more* politically correct than any other. It is possible that such a pattern of conflict has always been present in art worlds of earlier eras but has been written out of neo-traditionalist presentations of the past. However, in modern times, and more particularly in the last three decades, a movement away from the old view where opposite poles were seen as complementary, indeed necessary to the balance of the universe, has been perceived by certain authors,

[18]The remark about realism being 'like a dirty cooking-pot for rice' springs from this set of attitudes. See Chapter 12.

[19]The last two accusations were heard about the work of the New Art Movement. See Chapter 11.

who analyse the ideological development of a more black-and-white, either–or attitude, which lends itself to apolitical and simplistic moral interpretations (see Anderson, 1965; Resink, 1975).

Halus, if used in the arena of modern Indonesian painting from the perspective of art world officials, would refer to the 'universalist' aesthetics adhered to by many senior artists. This aesthetic aims to speak of timeless truths, in forms which, albeit new, still reverberate with the sanction of tradition. Art, according to the universalist aestheticists, is like a mask through which worldly phenomena are not perceived directly but are translated into a formula representing a higher truth. The truth itself is unchanging; the dynamic dimension lies in the individual artist's search for a form with which to depict it. This is the aesthetic adhered to by traditionalists and neo-traditionalists in Indonesia. To this category belong several of the artists discussed in Part II, as well as artists whose work serves to legitimize the holders of power.

Conversely, *kasar* would refer to the 'contextualist' formulation of aesthetics, which seeks to reveal the mutable face behind the mask, claiming that here lies the truth which is only falsified by theatrical props. The artists and thinkers involved in this category are in search of ever new perspectives on a situation which is in constant flux. They seek to see society as a whole from an ant's perspective, and take this as their legitimate working material. They struggle against what they perceive as pressure from the art world institutions to limit their artistic vision only to the view from the top of either the spiritual or social mountain; they feel the implicit and explicit demand to ignore the less refined, hence more chaotic and disturbing, images that are located down along the slopes and around the base of the mountain.

It is this perspective of a hierarchy of themes and a preference for the abstracted (or stylized), decorative, and repetitive which must be kept in mind when discussing the work of painters who persist in depicting aspects of life that are not refined or pretty in expressive-realistic styles. The sheer weight of the conventionally established aesthetic predilections, along with the New Order's political agenda, combine to prevent such painters from gaining wide acceptance in the modern Indonesian art world. The fact that some of them none the less do, illustrates that there is much more operating under the surface of established definitions of what is appropriate to art. It also illustrates that such criteria of taste and aesthetic quality are losing their grip, themselves caught in the throes of change.

Expressions of 'Indonesian-ness' that appear contradictory are none the less rooted in traditional aesthetic systems, some of which have not always been recognized by the 'centre'. The younger generations of artists, reacting to the value judgements implied in the *halus–kasar* distinction as it is used in modern Indonesia, seek to define Indonesia's present aesthetic systems historically or sociologically, locating values within the context of era and social class. They would claim that rather than a polarity of opposites, which is the perception of duality, reality could be seen as supporting more than two main parts (factions, levels, or primary qualities). Each of these several parts would provide a link to a different aspect of the past as well as result in a new synthesis in individual works of modern art.

With the recent boom in the Indonesian modern art market and concomitant developments in the structure of the art world, the perception of modern paintings—and by extension, other art objects—will change. With their

now comparatively high monetary value and the greater availability of modern preservation technologies, the accession of modern art by museums may be said to have truly started, with the positives (such as public access) and negatives (such as being isolated from the flow of life) that this process entails.

Modern Indonesian painters are, for the most part, painting *about* something, whether it is the nature of God, the journey of the soul, man in his environment, woman in hers, social intercourse, history, poverty, or the relation between symbols or eras. There is little, if any, art for art's sake in modern Indonesia, establishing the purely formal qualities of the work itself as the parameters of its existence and meaning. In modern Indonesian art we see, I believe, a parallel to what Bernet Kempers says about the geometric motifs of the prehistoric kettledrums of South-East Asia:

… the word 'abstract' actually calls for the inverted commas, expressing the caveat 'so called'. Instead of 'non concrete' (one of the meanings for 'abstract' given by the dictionaries) geometric designs or tokens should be characterized as 'highly concrete', 'utterly compact'…. This applies to both categories of geometric symbolism, notwithstanding the very different token values attributed to either. It is an interesting point that geometric designs need have no physical resemblance to the subjects they represent and to which they are referring. The subjects themselves (say, Cosmic Order or Life) may have no physical appearance themselves…. In the context of religious art, therefore, geometric designs developed into a kind of spiritual shorthand, which being visually manifest could be understood by all those who were aware of their meaning (1988: 102, 105).

Like any landscape, the contours of the phenomenon of modern Indonesian painting change when seen from different perspectives: from up close, a great number of involved and involving points of departure and results are evident. From a more distant perspective, it becomes clear that modern Indonesian painting is not deeply rooted in Indonesian society and culture: compared to the entire population of Indonesia and the way its various histories have been written, modern Indonesian painting has engaged the creative imagination of a few people, the craftsmanship of more, and in recent years the imaginations and purses of greater numbers of wealthy Indonesians. To the general populus outside the major urban centres, however, modern Indonesian painting remains without great meaning or interest and will continue to do so until affordable mass-produced reproductions, easier access to more exhibitions in public spaces, with themes relating to people's lives, and better art education become available.

On the other hand, one of the crucial questions of the twentieth century has been how to unify ethnically, culturally, geographically, and temperamentally divergent populations assembled under the heading of individual nations. Once the goal of uniformity is abandoned and the concept of pluralism adapted— and this happened much earlier in Indonesia than in North America—it is no longer paramount that a single group of artists or a single art form reach an entire population. Modern Indonesian art and artists are highly relevant, meaningful, and interesting within the contexts they spring out of and, in turn, re-create for themselves.

As with all artistic production, what varies in the work of modern Indonesian artists is where, along the continuum from concreteness to abstraction, and from obviousness to subtlety, each individual painter's message or intent is located, and the character and strength of the form created around it. It seems evident, as generally throughout the

history of painting, that the more the painter's conscious intent is subsumed in the intensity of the process of painting itself, the more integrity the result has as a work of art. Painters in Indonesia, as elsewhere, are influenced by their culture, environment, individual personality, past and present experiences, and sense perceptions, the sum of which triggers their rational, conscious interest to focus in certain directions. It is in the elusive mind space located somewhere between the dimension of their outer, conscious lives and the hidden workings of the creative process, that Indonesian painters choose (or are chosen by) their subjects and then enter into a state of rational, emotional, and sensual immersion in paint and canvas, colour, form, and texture, where the separation between consciousness and unconsciousness and between subject and process ceases to exist.

Appendices

Appendix 1
Exhibition Spaces and Galleries[1]

In Jakarta, the Municipal Collection of Fine Arts (Balai Seni Rupa) holds the largest permanent body of modern painting accessible to the public. The arts centre, Taman Ismail Marzuki (TIM, opened in 1969), home of the Jakarta Arts Council (Dewan Kesenian Jakarta, DKJ) and the Jakarta Art Institute (Institut Kesenian Jakarta, IKJ), regularly hosts exhibitions.[2] The Department of Education and Culture's Art Exhibition House (Gedung Pameran Seni Rupa) opened near Gambir Station in late 1988.

Galleries run by private foundations include the Balai Budaya, Mitra Budaya, and Bentara Budaya. All run by private foundations (the latter is owned by Kompas), they hold regular exhibitions.

By the late 1980s, the majority of group and solo exhibitions were sponsored by private foundations, individuals, banks, or corporations in private or corporate gallery spaces; many of these were arranged by groups of artists.

Among the private galleries, the most established and professionally run is DUTA Fine Arts Gallery in South Jakarta. DUTA has hosted a number of large-scale solo exhibitions of young, less-known artists as well as of established artists in the latter half of the 1980s. Other galleries of importance are Oet's Fine Arts Gallery in Blok M and the new gallery (as of spring 1991) in Kemang in South Jakarta, near DUTA. In Blok M can also be found Hadiprana's Art Gallery, which, besides Balinese and Javanese traditional arts, also carries modern painting. Of more recent date are Edwin's Gallery in Kemang, Mon Decor in Central Jakarta, and Tony's Gallery in South Jakarta. New galleries with a more commercial orientation have opened up in the last two years. Among individual artists who have exhibition space at their residences for their own work are S. Sudjojono, Basuki Abdullah, and Dede Eri Supria.

In Bandung, which until 1988 mainly had exhibitions at the Faculty of Fine Arts and Design's gallery, at the DECENTA gallery, and occasionally at a local hotel, new galleries have been opening up: by December 1990, five galleries were reported, among them one owned by Prawira. Artists like Popo Iskandar and Sudjana Kerton have built galleries for their work in their homes.

In Yogyakarta, the provincial branch of the Department of Education and Culture organizes exhibitions at Purna Budaya; the small Kompas-owned Bentara Budaya and the Dutch cultural centre both host occasional exhibitions. CEMETI, run by a young artist couple, offers eleven exhibitions annually; a new gallery in artist Nyoman Gunarsa's home also hosts exhibitions of other artists. In addition, many painters living in Yogyakarta have built exhibition wings in their homes for their own work: Affandi's is the oldest and most notable of these, in which also Kartika's and Maryati's work is displayed, and in 1988 it was accorded museum status. Other home

[1]This is not an exhaustive list of developments in the last two years. Apart from a few updated items, it reflects the situation during the period of my fieldwork.

[2]Holt, 1970b: 165.

253

galleries are those of Widayat, Amri Yahya, Bagong Kussudiardja, and Saptohudoyo.

In Solo, Museum Dullah, opened in August 1988, shows Dullah's work spanning half a century along with work by a few of his contemporaries; in Surabaya, apart from the local governmental Arts Council, there is also Gallery Nikko.

In Bali must be noted, first and foremost, Puri Lukisan, the Ubud Museum of Modern Art formally opened in 1956, founded by Cokorda Gede Agung Sukawati and Rudolf Bonnet. High-quality complementary collections can be found in both the commercial and private collections of Museum and Gallery Neka, Ubud; Agung Rai, Peliatan, Ubud; and Rudana, Tegal, Mas, in addition to the Denpasar Art Centre's permanent collection and occasional exhibitions. Despite the rapid developments in the art world in Jakarta in the last year or two, the Balinese collections are still the best place to orient oneself to modern Indonesian painting (Wright, 1989d). Finally, numerous Indonesian artists living in Bali exhibit their work in their homes.

Appendix 2
National Exhibitions

The holding of regular national exhibitions dates back to 1974, when the first National Painting Biennial was held, arranged by the government-sponsored Jakarta Arts Council. A Biennial for Young Indonesian Painters was arranged separately for artists under thirty-five; in 1987, these two Biennials were combined into one. The Eighth Biennial was held in 1989. These are usually the occasion for a competition in which the three best paintings are awarded.

The First Exhibition of Indonesian Sculpture, also arranged by the Jakarta Arts Council, was held in Jakarta in 1973; the Second Exhibition was held in 1986. In 1987, the First Biennial of Indonesian Graphic Art was held in Bandung; the Second Biennial of graphic art was held in Jakarta in 1989. In 1988, the Yogyakarta Painting Biennial was arranged by the regional government-sponsored Arts Council; the second one was held in 1990. The first Bali Triennial was also held in 1988, sponsored by the regional

government-sponsored Arts Council. The national Art Academies and Institutes hold annual Student and Faculty Art Exhibitions, often accompanied by competitions with awards.

In addition, the regional branches of the Department of Education and Culture and regional Arts Councils arrange exhibitions and competitions for a broader range of cultural activities.

Appendix 3
The International Network

Various exhibitions sponsored by ASEAN receive government funding. The most recent ones include the first ASEAN art exhibition, held in all the ASEAN capitals in 1974, co-ordinated by a Malaysian committee. The first ASEAN exhibition of Painting and Photography was held in Manila in 1978. In 1980, Indonesia hosted the second ASEAN Exhibition of Painting and Photography, mounted in Jakarta and in Bali. In 1981, Thailand hosted a version of this exhibition which travelled to all the capitals concerned. The exhibition in this format was renamed the First ASEAN Exhibition of Painting and Photography. In 1982, Malaysia co-ordinated the Second; in 1984, the Philippines co-ordinated the Third; and in 1985, Singapore co-ordinated the Fourth. In 1988, Indonesia co-ordinated this exhibition in yet another format.[3]

Furthermore, there is the Annual Asian Arts Festival in Hong Kong. The Fukuoka Art Museum in Japan has also hosted two exhibitions of Asian art. Other international art activities are channelled through international agencies like UNESCO and SEAMEO (Southeast Asian Ministers of Education Organization).

[3]ASEAN Art Exhibition: Third ASEAN Exhibition of Painting and Photography, Manila, Singapore, Kuala Lumpur, Jakarta, Bangkok, 1984; Fourth ASEAN Exhibition of Painting and Photography, Singapore, 1985; The First ASEAN Travelling Exhibition of Painting, Photography, and Children's Art, 1988, with Brunei Darussalam added to the original participants (Indonesia, Malaysia, the Philippines, Singapore, and Thailand).

Appendix 4
Art Publications

The lack of a regular and high-quality art magazine or journal in Indonesia has been noted by artists and art writers for years. Such a magazine has been attempted several times, unfortunately with little regularity or lasting success.

Seni Rupa is published by the Fine Arts Committee of the Jakarta Arts Council on an irregular basis, sometimes monthly; sixteen issues were published between June 1982 and February 1987.

DIALOG Seni Rupa is a quarterly published privately by a group of younger artists and writers, some of them previously involved with the New Art Movement. Launched in May 1990, the second issue appeared in August 1990. The third and fourth issues were published on schedule. With good layout and fairly high-quality writing, the first issues have concentrated on reporting on recent developments in the art market, interviews with collectors and gallery owners, and a discussion of the issues surrounding the selection and exhibition of modern Indonesian art in the USA in connection with the Festival of Indonesia, September 1990–December 1991.

For art news, daily newspapers such as *KOMPAS* and *Sinar Harapan*, and the regional newspapers are the place to look. The weekly news media, like *TEMPO* and *EDITOR*, have in the last couple of years standardized their format to include articles on art in almost every issue. Among the monthly magazines, *Asri* (architecture and interior design) has regular articles on artists and art world events. Popular weekly magazines like *Sarinah* and *FEMINA* (for women), *GADIS* (for teenage girls), and *MATRA* (for men) all carry occasional articles on collectors and artists and their work, some better reported than others.

Bibliography

Achdiat K. Mihardja (1950), *Berkelana ke Alam Keindahan*, Jakarta: Balai Pustaka.

Adams, Cindy (1965), *Sukarno, An Autobiography, As told to Cindy Adams*, New York: Bobbs-Merrill Company, Inc.

Agus Dermawan T. (1985), *R. Basuki Abdullah RA: Duta Seni Lukis Indonesia*, Jakarta: Gramedia.

Agus Dermawan T. and Wienarti, eds. (1985), *Pameran Seni Rupa Lingkungan, Proses 85*, Exhibition catalogue (October).

Alisjahbana, Margaret, ed. (1978), *Art and the Future: Collected Papers of the First International Conference on Art and the Future*, Toyabungkah, Bali: The International Association for Art and the Future.

Alliance Française de Yogyakarta (1986), *Pameran Lukisan Berlima: Agus Kamal, Boyke Aditya, Effendi, Hening Swasono, Ivan Sagito, 25–31 July 1986*, Alliance Française de Yogyakarta, A l'occasion de la Fête Nationale du 14 Juillet.

Anderson, Benedict R. O'G. (1965), *Mythology and the Tolerance of the Javanese*, Ithaca, NY: Cornell Modern Indonesia Project, Monograph Series No. 37.

———— (1972), *Java in a Time of Revolution: Occupation and Resistance 1944–1946*, Ithaca: Cornell University Press.

———— (1990a), 'Cartoons and Monuments', in *Language and Power: Exploring Political Cultures in Indonesia*, Ithaca: Cornell University Press, pp. 152–93.

———— (1990b), 'The Idea of Power in Javanese Culture', in *Language and Power: Exploring Political Cultures in Indonesia*, Ithaca: Cornell University Press, pp. 17–77.

———— (1990c), 'The Languages of Indonesian Politics', in *Language and Power: Exploring Political Cultures in Indonesia*, Ithaca: Cornell University Press, pp. 123–51.

———— (1990d), 'Old State, New Society: Indonesia's New Order in Comparative Historical Perspective', in *Language and Power: Exploring Political Cultures in Indonesia*, Ithaca: Cornell University Press, pp. 94–120.

Apinan Poshyananda (1990), 'Modern Art in Thailand in the Nineteenth and Twentieth Centuries', Ph.D. dissertation, Cornell University.

———— (1992), *Modern Art in Thailand: Nineteenth and Twentieth Centuries*, Singapore: Oxford University Press.

Arsip Nasional (1989), *Di Bawah Pendudukan Jepang: Kenangan Empat Puluh Dua Orang yang Mengalaminya*, Jakarta: Arsip Nasional.

Ashton, Dore (1990), 'Mexican Art of the Twentieth Century', in John P. O'Neill, ed., *Mexico: Splendors of Thirty Centuries*, New York: Metropolitan Museum of Art, pp. 553–694.

Atkinson, Jane and Errington, Shelly, eds. (1990), *Power and Difference: The Construction of Gender in Insular Southeast Asia*, Stanford, Stanford University Press.

Balai Seni Lukis Negara (1984), *Pameran Tamaddun Islam: Pameran Seni Lukis dan Seni Khat*, Exhibition catalogue, Kuala Lumpur.

Bambang Bujono (1975), 'Laporan dari Seni Rupa Baru 1975', *TEMPO* (13 September).

_____ (1979), 'Serabi yang Terakhir (?)', *TEMPO* (27 October), p. 33.

_____ (1985), 'Kontras tanpa Keharuan', *TEMPO* (10 August), pp. 56–7.

_____ (1990), 'Penderitaan dari Satu Sisi', *TEMPO* (17 February), p. 67.

Barbier, Jean Paul and Newton, Douglas, eds. (1988), *Islands and Ancestors: Indigenous Styles of Southeast Asia*, New York: Metropolitan Museum of Art and Geneva: Barbier-Mueller Museum.

Barnett, Milton (1979), 'Livestock, Rice and Culture', paper presented at Rockefeller Foundation conference on International Agriculture, Bellagio, Italy.

Barrett Jones, Antoinette M. (1984), *Early Tenth Century Java from the Inscriptions: A Study of Economic, Social and Administrative Conditions in the First Quarter of the Century*, Dordrecht: Foris Publications.

Baxandall, Michael (1972), *Painting and Experience in Fifteenth Century Italy: A Primer in the Social History of Pictorial Style*, Oxford: Oxford University Press.

_____ (1989), *Patterns of Intention: On the Historical Explanation of Pictures*, New Haven: Yale University Press; first published 1985.

Becker, Howard S. (1982), *Art Worlds*, Berkeley: University of California Press.

Berenson, Bernard (1953), *Aesthetics and History*, Glasgow: Pantheon.

Berger, John (1972), 'The Moment of Cubism', in *The Look of Things: Selected Essays and Articles*, New York: Penguin Books.

Berman, Marshall (1988), *All That Is Solid Melts Into Air: The Experience of Modernity*, New York: Penguin Books; first published 1982.

Bernet Kempers, A. J. (1959), *Ancient Indonesian Art*, Amsterdam: van der Peet.

_____ (1988), *The Kettledrums of Southeast Asia: A Bronze Age World and Its Aftermath*, Rotterdam: A. A. Balkema.

Birth, Kevin K. (1990), 'Reading and the Righting of Writing Ethnographies', *American Ethnologist*, Vol. 17, No. 3 (August), pp. 549–57.

Butet Kartaredjasa (1985), 'Kesenian Unit Desa Ditolak', *Sinar Harapan* (4 March).

Buurman, Peter (1988), *Wayang Golek: The Entrancing World of Classical Javanese Puppet Theatre*, Singapore: Oxford University Press.

Carey, Peter and Wild, C., eds. (1986a), *Born in Fire: The Indonesian Struggle for Independence*, Athens: Ohio University Press.

_____ (1986b), 'Myths, Heroes and War', in *Born in Fire: The Indonesian Struggle for Independence*, Athens: Ohio University Press.

Carey, Peter and Houben, Vincent (1987), 'Spirited Srikandis and Sly Sumbadras: The Social, Political and Economic Role of Women at the Central Javanese Courts in the 18th and 19th Centuries', in Elsbeth Locher-Scholten and Anke Niehof, eds., *Indonesian Women in Focus: Past and Present Notions*, Dordrecht: Foris Publications, pp. 12–42.

Chipp, Herschel B., ed. (1968), *Theories of Modern Art*, Berkeley: University of California Press.

Choy, Peggy (1984), 'Texts Through Time: The Golek Dance of Java', in Stephanie Morgan and Laurie Jo Sears, eds., *Aesthetic Tradition and Cultural Transition in Java and Bali*, Madison: University of Wisconsin, Center for Southeast Asian Studies, Monograph 2, pp. 51–81.

Chudori, Leila et al. (1990), 'Angin Sejuk untuk Seniman', *TEMPO* (22 December), pp. 84–5.

Clifford, J. C. and Marcus, G. E., eds. (1986), *Writing Cultures: The Poetics and Politics of Ethnography*, Berkeley: University of California Press.

Couteau, Jean (1990), *Wianta*, Denpasar, Bali: C. V. Buratwangi.

Danto, Arthur C. (1979), 'Pictorial Representation and Works of Art: Distinguishing Artworks from Artifacts', in Calvin F. Nodine et al., eds., *Perception and Pictorial Representation*, New York: Praeger.

_____ (1990), 'Introduction: Artphilohistocritisophory Today', in *Encounters and Reflections: Art in the Historical Present*, New York: Farrar Straus Giroux, pp. 3–11.

Dede Eri Supria (1979), 'Realisme, Gaya Seni Lukis yang Nyaris Bangkrut', in Jim Supangkat, ed., *Gerakan Seni Rupa Baru Indonesia*, Jakarta: Gramedia, pp. 88–9.

Departemen Pendidikan dan Kebudayaan (1979), *Sejarah Seni Rupa Indonesia*, Jakarta: Proyek Penelitian dan Pencatatan Kebudayaan Daerah.

————— (1988), *Katalogus Lukisan Wisma Seni Nasional, Seniman dan Karyanya*, Jakarta: Dir-Jen Kebudayaan, Proyek Wisma Seni Nasional.

Dewan Kesenian Jakarta (1987), *Seni Rupa Baru Proyek 1: Pasaraya Dunia Fantasi*, Jakarta: Exhibition catalogue, 15–30 June.

————— (1988), *Semsar S.*, Exhibition catalogue, Jakarta: Cipta.

————— (1989), *BIENNALE '89: Pameran dan Kompetisi Seni Indonesia Lukis ke VIII*, Biennale ke VIII, Taman Ismail Marzuki, 24 July–24 August 1989, Jakarta: PT Multi Setco Stupa.

Dhakidae, Daniel (1991), 'The State, the Rise of Capital and the Fall of Political Journalism: Political Economy of Indonesian News Industry', Ph.D. dissertation, Cornell University.

Dillenberger, Jane (1990), *Image and Spirit in Sacred and Secular Art*, New York: Crossroad.

Djoko Pekik (1987), *Pameran Lurik Tenun Gendong*, Jakarta: Dewan Kesenian Jakarta.

Doniger O'Flaherty, Wendy (1980), *Women, Androgynes and Other Mythical Beasts*, Chicago: University of Chicago Press.

Dowson, John (1973), *A Classical Dictionary of Hindu Mythology*, New Delhi: Oriental Books Reprint Corporation.

Drake, Christine (1989), *National Integration in Indonesia: Patterns and Policies*, Honolulu: University of Hawaii Press.

Dullah (1982a), 'Bung Karno Pemimpin, Presiden, Seniman', *Merdeka* (4 July), p. 2.

————— (1982b), *Karya dalam Peperangan dan Revolusi/Paintings in War and Revolution*, Jakarta: Bumiputera 1912.

————— (1988), 'Museum Dullah: Buku Petunjuk dan Pengantar Tamu', Unpublished typescript.

—————, ed. (1956, 1959), *Lukisan-lukisan Koleksi Ir. Dr. Sukarno, Presiden Republik Indonesia*, 4 vols., Peking: Center for People's Culture, text in Indonesian, Chinese, Russian, and English.

Elliot, Inger McCabe (1984), *Batik: Fabled Cloth of Java*, New York: Clarkson N. Potter.

Erlanger, Steven (1990), 'For Suharto, His Heirs are Key to Life after '93', *New York Times* (11 November).

Fischer, Clare B. (1991), 'Hendra's Women's Bodies', Unpublished conference paper, American Association of Religion (November).

Fischer, Joseph, ed. (1990), *Modern Indonesian Art: Three Generations of Tradition and Change, 1945–1990*, Jakarta: Panitia Pameran KIAS and New York: Festival of Indonesia.

Florida, Nancy K. (1987), 'Reading the Unread in Traditional Javanese Literature', *Indonesia*, No. 44 (October), pp. 1–15.

Focillon, Henri (1989), *The Life of Forms in Art*, New York: Zone Books; first published as *La Vie des Formes*, Paris, 1934.

Foley, Kathy (1979), 'The Sundanese Wayang Golek: The Rod Puppet Theatre of West Java', Ph.D. dissertation, University of Hawaii.

Fontein, Jan, ed. (1990), *The Sculpture of Indonesia*, Washington: National Gallery of Art and New York: Harry N. Abrams.

Foulcher, Keith (1986), *Social Commitment in Literature and the Arts: The Indonesian 'Institute of People's Culture' 1950–65*, Monash University: Centre for Southeast Asian Studies.

————— (1987), 'Sastra Kontekstual: Recent Developments in Indonesian Literary Politics', *Review of Indonesian and Malaysian Affairs*, Vol. 21, No. 1, pp. 6–28.

————— (1988), 'Liberating Art, Liberating Society: The Art of Semsar Siahaan', *Inside Indonesia*, No. 16 (October).

Francis H. (1990), 'Sederhana Tetapi Menyentuh Nurani', *Suara Karya* (18 February).

Furnivall, J. S. (1944), *Netherlands India: A Study of Plural Economy*, New York: Macmillan.

Gallop, Annabel Teh and Arps, Bernard (1991), *Golden Letters: Writing Traditions of Indonesia/Surat Emas: Budaya Tulis di Indonesia*, London: British Library and Jakarta: Yayasan Lontar.

Geertz, Clifford (1960), *The Religion of Java*, Chicago, University of Chicago Press.

————— (1963), *Agricultural Involution: The Process of Ecological Change in Indonesia*, Berkeley: University of California Press.

_____ (1968), *Islam Observed: Religious Development in Morocco and Indonesia*, Chicago: Chicago University Press.

_____ (1973), 'Person, Time, and Conduct in Bali', *The Interpretation of Cultures*, New York: Basic Books, pp. 360–411.

_____ (1990), '"Popular Art" and the Javanese Tradition', *Indonesia*, No. 50 (October), pp. 77–94.

Gerbrands, A. A. (1962), *The Art of the Asmat, New Guinea*, New York: New York City Museum of Primitive Art.

Gittinger, Mattiebelle (1979), *Splendid Symbols: Textiles and Tradition in Indonesia*, Exhibition catalogue, Washington, DC: Textile Museum.

_____, ed. (1980), *Indonesian Textiles: Irene Emery Roundtable on Museum Textiles, 1979 Proceedings*, Washington, DC: Textile Museum.

Gombrich, E. H. (1984), *The Story of Art*, Oxford: Phaidon Press.

Hanna, Willard A. (1967), *The Magical–Mystical Syndrome in the Indonesian Mentality*, American Universities Field Staff Reports Service, Southeast Asia Series, Vol. XV, Nos. 5–9.

Harsono, F. X. (forthcoming), 'Tema Kerakyatan dalam Seni Lukis Indonesia, Sejak Persagi hingga Kini', MA thesis, Jakarta Art Institute.

Hart, Gillian (1986), *Power, Labor and Livelihood: Processes of Change in Rural Java*, Berkeley: University of California Press.

Haryati Soebadio (1985), *Cultural Policy in Indonesia*, Paris: UNESCO, Studies and Documents on Cultural Policy.

Hendra Gunawan (1958), 'Pekerdja Kebudajaan dan Hak Azaşi', *Zaman Baru*, Nos. 6–7 (28 February–10 March), pp. 1, 3, 4, 8.

Holt, Claire (1930s–1970), Claire Holt Collection, New York Public Library, Performing Arts Research Center at Lincoln Center, the Dance Collection, unpublished notes, papers, catalogues, newspaper clippings, photographs and slides.

_____ (1955), Notebook from research trip to Indonesia; entries by date.

_____ (1967), *Art in Indonesia: Continuities and Change*, Ithaca: Cornell University Press.

_____ (1970a), List of Claire Holt's Slide Collection, Ithaca: Southeast Asia Program, Cornell University.

_____ (1970b), 'Indonesia Revisited', *Indonesia*, No. 9 (April), pp. 162–88.

Huntington, John C. (forthcoming), 'Encyclopedia of Buddhist Iconography'.

Hull, Valerie L. (1982), 'Women in Java's Rural Middle Class: Progress or Regress', in Penny Van Esterik, ed., *Women of Southeast Asia*, Northern Illinois University, Center for Southeast Asian Studies, Occasional Paper No. 9, pp. 100–23.

Hurgronje, Christian Snouck (1906), *The Acehnese*, Vol. II, translated by A. W. S. O'Sullivan, Leiden: E. J. Brill.

Hyde, W. Lewis (1979), *The Gift: Imagination and the Erotic Life of Property*, New York: Vintage Books.

Ihromi, T. O. (1973), *The Status of Women and Family Planning in Indonesia, Preliminary Findings*, Jakarta.

Institut Seni Indonesia (1988), *Buku Petunjuk: Institut Seni Indonesia, Yogyakarta, 1985–88*.

Jairazbhoy, R. A. (1965), *Oriental Influences in Western Art*, New York: Asia Publishing House.

Jakarta-Jakarta (1991), 'Katanya Ia Subversif', No. 255 (18–24 May), p. 99.

Jakarta Post (1988), 'Artist Sets Fire to 250 Drawings after Exhibition' (11 April), p. 3.

Jencks, Charles (1987), *Post-Modernism: The New Classicism in Art and Architecture*, New York: Rizzoli.

Jessup, Helen Ibbitson (1990), *Court Arts of Indonesia*, New York: Asia Society Galleries and Harry N. Abrams.

Joop Ave (1986), *Bunga Bangsa Indonesia*, Jakarta: Joop Ave.

Kahin, G. McT. (1952), *Nationalism and Revolution in Indonesia*, Ithaca: Cornell University Press.

Kandinsky, Wassily (1947), *On the Spiritual in Art and Painting in Particular*, New York: Wittenborn, Schultz, Inc.; first published in German, 1912.

Keeler, Ward (1987), *Javanese Shadow Plays, Javanese Selves*, Princeton: Princeton University Press.

Kerton, Sudjana and Kerton, Louise (1990), *Tanah Airku: My Country—Paintings by Sudjana Kerton*, Bandung: Sanggar Luhur.

KOMPAS (1983a), 'Pelukis Hendra Meninggal' (18 July), pp. 1, 12.

_____ (1983b), 'Almarhum Hendra Konsekven dengan Tema Indonesia' (19 July), pp. 1, 12.

_____ (1983c), 'Hendra Gunawan dimakamkan di Purwakarta' (20 July), p. 6.

_____ (1990), 'Affandi, Sisi Lain Seniman Besar' (26 May), p. 16.

Kramrisch, Stella (1946), *The Hindu Temple*, 2 vols., Calcutta: University of Calcutta.

Krom, N. J. (1926), *L'Art Javanaise dans les musées de Hollande et de Java*, Ars Asiatica VIII, Paris: Libraire Nationale d'art et d'histoire.

Kusnadi (1984), 'Basic Foundations of Contemporary Indonesian Art', *ASEAN Art Exhibition: Third ASEAN Exhibition of Painting and Photography*, Manila.

_____ (1987), *Sketsa Widayat dan Nyoman Gunarsa/Sketches of Widayat and Nyoman Gunarsa*, Ubud: Rudana Art Gallery.

Lane, Max (1979), 'Translater's Introduction', in Rendra, *The Struggle of the Naga Tribe*, St Lucia: University of Queensland Press, pp. xvii–xxi.

Leigh, Barbara (1988), 'The Garden of Paradise in Acehnese Embroidered Cloths', paper presented to the Asian Studies of Australia Bicentennial Conference, Canberra, 11–15 February.

_____ (1989), *Tangan-tangan Trampil: Seni Kerajinan Aceh/Hands of Time: The Crafts of Aceh*, Jakarta: Penerbit Djambatan.

_____ (1992), 'Education and the Making of the State: A Case-study in Aceh, Indonesia', Ph.D. dissertation, University of Sydney.

Legge, J. D. (1972), *Sukarno: A Political Biography*, New York: Praeger Publishers.

Lie, Iliana (1990), 'Tema Djokopekik, Kerakyatan', *Mutiara* (3 February).

Liem Tjoe Ing (1978), *Lukisan-lukisan Koleksi Adam Malik, Wakil Presiden Republik Indonesia/ Paintings from the Collection of Adam Malik, Vice President of the Republic of Indonesia*, Jakarta: PT Intermasa.

Locher-Scholten, Elsbeth and Niehof, Anke, eds. (1987), *Indonesian Women in Focus: Past and Present Notions*, Dordrecht: Foris Publications.

Loofs, H. H. E. (1975), 'Dongson Drums and Heavenly Bodies', in Noel Barnard, ed., *The Proceedings of a Symposium on Scientific Methods of Research in the Study of Ancient Chinese Bronzes and Southeast Asian Metal and Other Archaeological Artifacts*, Melbourne: National Gallery of Victoria, pp. 441–67.

M. Ariffin Pulangan et al. (1977), *Seni Rupa I, II, Bidang Studi Kesenian, Semester I, II, III, dan IV*, 9th edn., Jakarta: Penerbit Fa. Hasmar.

McDonald, Hamish (1980), *Suharto's Indonesia*, Sydney: Fontana/Collins.

McIntyre, Angus (forthcoming), 'Sukarno as Artist-Politician'.

Machmud Buchari and Sanento Yuliman (1985), *A. D. Pirous: Lukisan, Etsa dan Cetak Saring/ Painting, Etching and Serigraphy, Retrospective Exhibition 1960–85*, Bandung: Gallery DECENTA.

Maksiani D. Mulyantari (1988), 'Dede Eri Supria's Jakarta: A New Wave in Indonesian Painting', *Indonesia Magazine*, 03/XVIII (June–July), p. 70.

Mangkunegara VII (1957), *On the Wayang Kulit and Its Symbolic and Mystical Elements*, translated by Claire Holt, Ithaca: Cornell University.

Masjkuri, ed. (1979/80), *Tokoh Nasional I Gusti Nyoman Lempad*, Jakarta: Pusat Penelitian Sejarah dan Budaya, Proyek Inventarisasi dan Dokumentasi Sejarah Nasional.

MATRA (1990), 'Apresiasi, Investasi atau Gengsi: Sketsa Mutakhir Kolektor Lukisan Kita', No. 46 (May), pp. 59–66.

Maxwell, Robyn (1987), 'The Tree of Life in Indonesian Textiles: Ancient Iconography or Imported Chinoiseries?', in *Indonesian Textiles: Reports and Conclusions*, Köln: Rautenstrauch-Joest Museum fur Volkenkunde.

_____ (1990), *Textiles of Southeast Asia: Tradition, Trade, and Transformation*,

Melbourne: Oxford University Press.

May, Brian (1978), *The Indonesian Tragedy*, London: Routledge and Kegan Paul.

Merriam, Alan P. (1977), 'Anthropology and the Arts', in Sol Tax and Leslie G. Freeman, eds., *Horizons of Anthropology*, 2nd edn., Chicago: Aldine Press, pp. 332–43.

Miklouho-Maklai, Brita L. (1989), 'The Silent World: Indonesia's New Art Movement Visits Australia with an Exhibition on AIDS', *Inside Indonesia* (December), pp. 31–3.

_____ (1991), *Exposing Society's Wounds: Some Aspects of Contemporary Indonesian Art since 1966*, Adelaide: Flinders University Asian Studies Monograph.

Miller, James Innes (1969), *The Spice Trade of the Roman Empire, 29 BC–AD 641*, Oxford: Clarendon Press.

Mirwan Yusuf (1986), *A. D. Pirous, un Peintre Contemporain Indonésien*, Paris: École des Hautes Études en Sciences Sociales.

Mochtar Lubis (1969), 'Mysticism in Indonesian Politics', in Robert O. Tilman, ed., *Man, State and Society in Contemporary Southeast Asia*, New York: Praeger, pp. 179–86.

Moerdowo (1963), *Reflections on Indonesian Arts and Culture*, 2nd edn., Soerabaya: Permata Publishing House; first published 1958.

Montias, J. M. (1982), *Artists and Artisans in Delft: A Socio-economic Study of the Seventeenth Century*, Princeton: Princeton University Press.

Morgan, Stephanie and Sears, Laurie Jo, eds. (1984), *Aesthetic Tradition and Cultural Transition in Java and Bali*, Madison: University of Wisconsin, Center for Southeast Asian Studies, Monograph 2.

Mulder, Niels (1978), *Mysticism and Everyday Life in Contemporary Java: Cultural Persistence and Change*, Singapore: Singapore University Press.

Museum Negeri Banda Aceh (1981), *Pameran Lukisan, Kaligrafi dan Mesjid di Aceh*, Exhibition catalogue.

Mustika (1983), *Percakapan dari Hati ke Hati Pelukis Indonesia*, Jakarta: Sanggar Krida Jakarta.

Naniel K. (1988), 'Lukisan Kerton Mencerminkan Wajah Indonesia Sehari-hari', *Suara Pembaruan* (18 June), p. 2.

Narasimhan (1965), *The Mahabharata*, New York: Columbia University Press.

Neka Museum (1988), *Art of Bali: Paintings from the Neka Museum, Ubud, Bali, Indonesia*, Honolulu: Institute of Culture and Communication, East–West Center.

Nieuwenhuis, Rob (1988), *Met Vreemde Ogen. Tempoe Doeloe—een Verzonken Wereld. Fotografische Documenten uit het oude Indië, 1870–1920*, Amsterdam: Em. Querido.

Noranto, Norbertus (1990), 'The Evolution of Chinese Business Under the New Order in Indonesia: Four Case Studies', MA thesis, Cornell University.

Nyoman Arsana (1990), *Wianta: His Art and Balinese Culture*, translated and edited by Dorothea A. Markakis and Putu Suasta, Denpasar, Bali: C. V. Buratwangi.

O'Connor, Stanley J. (1975), 'Iron Working as Spiritual Inquiry in the Indonesian Archipelago', *History of Religions*, Vol. 14, No. 3 (February), pp. 173–90.

_____ (1983), 'Art Critics, Connoisseurs and Collectors in the Southeast Asian Rain Forest: A Study in Cross-cultural Art Theory', *Journal of Southeast Asian Studies*, Vol. XIV, No. 2 (September), pp. 400–8.

_____ (1985), 'Metallurgy and Immortality at Candi Sukuh, Central Java', *Indonesia*, No. 39 (April), pp. 52–70.

Peluso, Nancy L. (1980), 'Survival Strategies of Rural Women Traders or a Woman's Place is in the Market: Four Case-studies from North-west Sleman in the Special Region of Yogyakarta', paper presented to the ILO, for use by the Department of Manpower, Jakarta.

Pemberton, John (1989), 'The Appearance of Order: A Politics of Culture in Colonial and Post-Colonial Java', Ph.D. dissertation, Cornell University.

Pigeaud, Theodore G. Th. (1962), *Java in the Fourteenth Century: A Study in Cultural History. Nagarakertagama by Rakawi Prapanca of Majapahit, 1365 A.D.*, Vols. III–IV, The Hague: Martinus Nijhoff.

Popo Iskandar (1977), *Affandi*, Jakarta: Akademi Jakarta.

Pramoedya Ananta Toer (1983), '*Perburuan* 1950 and *Keluarga Gerilya* 1950', translated by
 Ben Anderson, *Indonesia*, No. 36 (October) pp. 24–48; excerpts published in *World Authors
 1975–80*, New York: H. W. Wilson Co., 1985.
Pudjiwati Sajogyo et al. (1980), 'The Role of Women in Different Perspectives', Project on Rural
 Household Economics and the Role of Women, in co-operation with the FAO/SIDA project on
 Promoting Women's Participation in Rural Development, Bogor.
Puri Lukisan (1984), *Puri Lukisan, Museum Kesenian Bali Modern/The Museum of Modern
 Balinese Art*, Jakarta: Penerbit Djambatan.
Putu Wijaya (1977a), 'Bukan hanya Sex atau Protes', *TEMPO* (12 March), pp. 16–18.
_____ (1977b), 'Wanita Macam Kuda', *TEMPO* (14 May).
Rawson, Philip (1990), *The Art of Southeast Asia*, London: Thames and Hudson; first published
 1967.
Rendra (1979), *The Struggle of the Naga Tribe*, translated and introduced by Max Lane,
 St Lucia: University of Queensland Press.
Resink, G. J. (1975), 'From the Old Mahabharata to the New Ramayana Order', *Bijdragen van
 heet Koninklijk Instituut voor Taal-, Land- en Volkenkunde*, Vol. 131, pp. 214–35.
Rhodius, Hans and Darling, John (1980), *Walter Spies and Balinese Art*, Amsterdam: Tropical
 Museum.
Rudi Isbandi (1975), *Perkembangan Seni Lukis di Surabaya*, Surabaya: Dewan Kesenian
 Surabaya.
Said, Edward (1979), *Orientalism*, New York: Vintage Books.
Saiff Bakham (n.d.), 'Perihal 30 Tahun Pelukis O. H. Supono', typescript for *TEMPO*.
Sanento Yuliman (1976), *Seni Lukis Indonesia Baru: Sebuah Pengantar*, Jakarta: Dewan
 Kesenian Jakarta.
_____ (1981), 'Genèse de la Peinture Indonésienne Contemporaine: le Rôle de S. Sudjojono',
 Ph.D. dissertation, Paris: École des Hautes Études en Sciences Sociales.
_____ (1987a), 'Dari Pluralisme Estetik ke Estetika Pluralis', *TEMPO* (27 June), pp. 37–8.
_____ (1987b), 'Parodi Pasaraya', *TEMPO* (27 June), pp. 35–8.
_____ (1988), 'Wanita dan Seni Rupa di Indonesia', in Taman Ismail Marzuki, Ruang Pamer
 Lama, *Nuansa Indonesia III*, Exhibition Catalogue, Jakarta: Cipta Publishers.
Santoso, Lourdes P. (1988), 'Sudjana Kerton Takes Look at Life in RI', *Jakarta Post* (15 June).
Scheper, Dirk (1985), *Oskar Schlemmer: The Triadic Ballet*, translated by Leanore Ickstadt,
 Berlin: Akademie der Künste.
Semsar (1988), 'Seniku Seni Pembebasan', in *Pameran Tunggul Semsar Siahaan*, Exhibition
 catalogue, Taman Ismail Marzuki, 5–14 January.
Shiraishi Takahashi (1990), *An Age in Motion: Popular Radicalism in Java, 1912–1926*, Ithaca:
 Cornell University Press.
Sinaga, Martha (1990), 'Akrab dengan Kehidupan Rakyat Jelata', *Suara Pembaruan* (12 February).
Smail, John R. W. (1964), *Bandung in the Early Revolution, 1945–46: A Study in the Social
 History of the Indonesian Revolution*, Ithaca: Modern Indonesia Project Monograph Series,
 Cornell University.
Snodgrass, Adrian (1985), *The Symbolism of the Stupa*, Ithaca: Cornell Southeast Asia Program.
Soedarmadji, J. H. Damais (1979), *Bung Karno dan Seni*, Jakarta: Yayasan Bung Karno.
Spanjaard, Helena (1987), *Nindityo Adipurnama and Mella Jaarsma*, Exhibition catalogue, The
 Netherlands: Gerardus van der Leeuw Ethnographic Museum in Groningen.
_____ (1988), 'Free Art: Academic Painters in Indonesia', in Paul Faber et al., *Art from
 Another World*, Rotterdam: Museum voor Volkenkunde Rotterdam, pp. 103–32.
_____ (1990), 'Bandung, the Laboratory of the West?', in Joseph Fischer, ed., *Modern
 Indonesian Art: Three Generations of Tradition and Change, 1945–1990*, Jakarta: Panitia
 Pameran KIAS and New York: Festival of Indonesia, pp. 54–77.
_____ (forthcoming), 'Moderne Indonesische Schilderkunst (1938–1988): De functie van de
 moderne schilderkunst voor de ontwikkeling van een Indonesische identiteit',
 Ph.D. dissertation, University of Amsterdam.
Sri Soejatmi Satari (1981), 'Mountains and Caves in Art: New Finds of Terracotta Miniatures in

Kudus, Central Java', *Bulletin of the Research Center of Archaeology of Indonesia*, No. 15 (January).

Sri Warso Wahono (1990), 'Keasyikan Seni Kanvas Indonesia', *KOMPAS* (17 February).

Stange, Paul (1975), *Sumarah: Javanese Mysticism in the Revolutionary Period*, Madison: University of Wisconsin Press.

_____ (1980), 'The Sumarah Movement in Javanese Mysticism', Ph.D. dissertation, University of Wisconsin.

_____ (1984), 'The Logic of Rasa in Java', *Indonesia*, No. 38 (October), pp. 113–34.

Stutterheim, W. S. (1935), *Indian Influences in Old Balinese Art*, London: Asia Society.

_____ (1956), 'An Ancient Javanese Bhima Cult', *Studies in Indonesian Archaeology*, Koninklijk Instituut, translation series, The Hague: Martinus Nijhoff, pp. 105–43.

Suara Pembaruan (1988), 'Semsar Bakar Lukisannya Seharga 24 Juta Rupiah' (11 April).

Subroto, S. M. and Surisman Marah, eds. (1988), *Widayat, Pendidik dan Pelukis—Educator and Painter*, Yogyakarta: Institut Seni Indonesia.

Sudarmadji (1974), *Seni Lukis Jakarta dalam Sorotan*, Jakarta: Pemerintah Daerah Khusus Ibukota Jakarta.

_____ (1975), *Dari Saleh Sampai Aming: Seni Lukis Indonesia Baru dalam Sejarah dan Apresiasi*, Yogyakarta: Sekolah Tinggi Seni Rupa Indonesia.

_____ (1978), *Affandi 70 Tahun*, Jakarta: Dewan Kesenian Jakarta.

_____ (1979), *Dasar-dasar Kritik Seni Rupa*, Jakarta: Pemerintah Daerah Khusus Ibukota Jakarta, Dinas Museum dan Sejarah/Balai Seni Rupa.

_____ (1985), *Widayat—Pelukis Dekora Magis Indonesia*, Jakarta: Anwar Widayat, Lisa A.

_____ (1988), *Dullah: Raja Realisme Indonesia*, Bali: Sanggar Pejeng.

Sudarta, G. M. (1975), *Seni Lukis Bali dalam Tiga Generasi*, Jakarta: Penerbit Gramedia (Kompas).

Sudjojono, S. (1946), *Seni Lukis, Kesenian dan Seniman*, Yogyakarta: Indonesia Sekarang.

Sukasman (1985), 'Segi Seni Rupa Wayang Kulit Purwa dan Perkembangannya', in Soedarsono, ed., *Kesenian, Bahasa dan Folklor Jawa*, Jakarta: Departemen Pendidikan dan Kebudayaan, pp. 159–95.

Sumaatmadja, Nugroho, ed. (1975), *Affandi*, Yogyakarta: Penerbitan Yayasan Kanisius.

Supangkat, Jim (1985), 'Kampanye di Ruang Pameran', *TEMPO* (26 October), pp. 77–8.

_____ (1989), 'Affandi, Astri dan Amerika', *TEMPO* (22 April), p. 71.

_____ (1990), 'Two Forms of Indonesian Art', in Joseph Fischer, ed., *Modern Indonesian Art: Three Generations of Tradition and Change*, Jakarta: Panitia Pameran KIAS and New York: Festival of Indonesia, pp. 158–62.

_____, ed. (1979), *Gerakan Seni Rupa Baru Indonesia*, Jakarta: PT Gramedia.

Supangkat, Jim and Sanento Yuliman (1982), *Gregorius Sidharta: Ditengah Seni Rupa Indonesia/Gregorius Sidharta: In the Center of Indonesian Art*, Jakarta: PT Gramedia.

Supangkat, Jim and Wright, Astri (1990), 'Affandi: The Man and the Artist', *Budaya*, Vol. 1, No. 1 (October), pp. 54–68.

Sutedja Neka, P. W. (1984), 'Beberapa Pengalaman Sebagai Kolektor Seni Lukis', *Seni Rupa*, No. 9 (July), Jakarta: Dewan Kesenian Jakarta, pp. 42–57.

Sutedja Neka, P. W. and Edelson, Mary Jane (1986), *Neka Museum: Guide to the Painting Collection*, Ubud, Bali: Yayasan Dharma Seni Museum Neka.

Szu, Mai-mai (1956), *The Tao of Painting: A Study of the Ritual Disposition of Chinese Painting, with a Translation of the Mustard Seed Garden Manual of Painting, 1679–1701*, New York: Pantheon Books; 2nd edn., 1963.

Taman Ismail Marzuki (1988), *Nuansa Indonesia III*, Exhibition catalogue, Jakarta: Cipta Publishers.

TEMPO (1977a), 'Ada yang Suka, Ada yang Kurang Suka' (12 March), p. 18.

_____ (1977b), 'Pemberontakan Tengah Malam' (3 December), pp. 40–1.

_____ (1978), 'Realisme Setelah Sudjojono' (14 January), p. 21.

_____ (1979), 'Cerita di Balik Lukisan' (14 July), p. 23.

_____ (1983), 'Hendra, dari Revolusi ke Bali' (23 July), p. 18.

_____ (1985), *Apa dan Siapa, 1983–84*, and *Apa dan Siapa, 1985–86*, Jakarta: Graffiti Pers.

Thomson Zainu'ddin, Ailsa, ed. (1980), *Kartini Centenary: Indonesian Women Then and Now*, Melbourne: Monash University, Centre for Southeast Asian Studies.

Threadgold, Terry (1986), *Language, Semiotics, Ideology*, Sydney: University of Sydney, Studies in Society and Culture, No. 3.

Tirtaamidjaja SH, N. (n.d.), *BATIK, Pola dan Tjorak/Pattern and Motif*, translated by Ben Anderson, Jakarta: Penerbit Djambatan.

Tuti Indra Malaon (1987), 'Sebuah Masjid Kokoh dan Ramah', *MATRA* (October), pp. 95–100.

UKSW (1989), *Pameran Senirupa Penyadaran*, proceedings from seminar, Balairung Universitas Kristen Satya Wacana (UKSW), Salatiga, 13–15 December.

Umar Kayam and Raka Sumichan (1987), *Affandi*, Jakarta: Yayasan Bina Lestari Budaya.

Van Rijk, Bruce (1986), 'Raden Saleh, 1810–1880, De beginfase en Europese periode van de Javaanse schilder Raden Saleh Sjarif Bustaman', MA thesis, University of Leiden.

Vogelsanger, Cornelia (1980), 'A Sight for the Gods: Notes on the Social and Religious Meaning of Iban Ritual Fabrics', in Mattiebelle Gittinger, ed., *Indonesian Textiles: Irene Emery Roundtable on Museum Textiles, 1979 Proceedings*, Washington, DC: Textile Museum, pp. 115–26.

Von der Borch, Rosslyn (1988), *Art and Activism: Some Examples from Contemporary Central Java*, Adelaide: Flinders University Asian Studies Monograph Series No. 4.

Vreede-de Stuers, Cora (1960), *The Indonesian Woman: Struggles and Achievements*, 's-Gravenhage: Mouton and Co.

Wagner, Fritz A. (1988), *Art of Indonesia*, Singapore: Graham Brash; first published London: Methuen, 1959.

Wahas Shofyan (1989), 'Ini Potret Anak-anak Nelayan Brumbun', *Jawa Post*.

Weisberger, Edward, ed. (1986), *The Spiritual in Art: Abstract Painting 1890–1985*, New York: Abbeville Press and Los Angeles: Los Angeles County Museum.

Wieringa, Saskia (1985), *The Perfumed Nightmare: Some Notes on the Indonesian Women's Movement*, The Hague: Institute of Social Studies.

Wölfflin, Heinrich (1932), *Principles of Art History: The Problem of the Development of Style in Later Art*, translated by M. D. Hottinger, New York: Dover Publications.

Wolters, Oliver (1967), *Early Indonesian Commerce*, Ithaca: Cornell University Press.

Wright, Astri (1988a), 'Travels, Loneliness Made Kartika a Painter in Her Own Right', *Jakarta Post* (18 April).

_____ (1988b), 'Artist Espouses Laughter and Humor', *Jakarta Post* (16 June).

_____ (1988c), 'Young Painter Synthesizes Tradition and Modernism', *Jakarta Post* (16 July).

_____ (1988d), 'Bagong Translates Rhythm into Line and Color', *Jakarta Post* (25 August).

_____ (1988e), 'Yogyakarta's Art World Bustles with Activity', *Jakarta Post* (1 September).

_____ (1988f), 'Dono Tries to Expand the Use of "Wayang" Puppets', *Jakarta Post* (6 October), p. 6.

_____ (1988g), 'Nuansa Indonesia Moves Towards Professionalism', *Jakarta Post* (30 November).

_____ (1988h), 'Nuansa Indonesia Enriches Local Art Scene', *Jakarta Post* (1 December).

_____ (1989a), 'Sudjana Kerton Fills Canvases with Scenes of Daily Life', *Jakarta Post* (20 January).

_____ (1989b), 'Sulebar Paints the Spirituality of Dualism', *Jakarta Post* (24 January).

_____ (1989c), 'Djoko Pekik: A Painter of Expressive Empathy', *Jakarta Post* (24 February), p. 6.

_____ (1989d), 'Bali Offers Access to Indonesia's Modern Art', *Jakarta Post* (17 April).

_____ (1990a), 'Affandi (1907–1990): The Setting of a Warming Sun', *Jakarta Post* (25 May).

_____ (1990b), 'Dancing Towards Spirituality = Art', Exhibition catalogue essay in *Nindityo*, Yogyakarta.

_____ (1990c), 'Challenging Modern Nihilism', Exhibition catalogue essay in *Mella Jaarsma: Into-Extro Variform II*, Yogyakarta.

_____ (1990d), 'Painting the People (Hendra Gunawan, Sudjana Kerton and Djoko Pekik)', in Joseph Fischer, ed., *Modern Indonesian Art: Three Generations of Tradition and Change 1945–1990*, Jakarta: Panitia Pameran KIAS/New York: Festival of Indonesia, pp. 106–57.

_____ (1991a), 'Painting Refigured (Collecting Modern Art in Indonesia)', *Budaya*, Vol. 2, No. 1 (January) pp. 64–77.

_____ (1991b), 'Indonesia in the 1980s', *Art Monthly (Australia)*, Asian Special Issue, Pt. 2, No. 41 (June), pp. 8–10.

_____ (1991c), 'Javanese Mysticism and Art: A Case of Iconography and Healing', *Indonesia*, No. 52 (October), pp. 85–104.

_____ (1991d), 'Bali: Showcase of Indonesian Art', *Asian Art News*, Vol. 1, No. 3 (November/December), pp. 22–7.

_____ (1991e), 'Soul, Spirit and Mountain: Preoccupations of Contemporary Indonesian Painters', Ph.D. dissertation, Cornell University.

Yogi, Olga (1980), 'Lurik, a Traditional Textile in Central Java', in Mattiebelle Gittinger, ed., *Indonesian Textiles: Irene Emery Roundtable on Museum Textiles, 1979 Proceedings*, Washington, DC: Textile Museum, pp. 282–5.

Zaman (1985), 'Dede Eri Supria, Yang Penting Menggaet Kebenaran' (3 August), pp. 26–9.

Zaman Baru (1958), 'Bentjana Bom Atom' (20–30 June), p. 4.

Zeri, Federico (1987), *Behind the Image: The Art of Reading Paintings*, translated by Nina Rootes, New York: St Martin's Press.

Zoetmulder (1974), *Kalangwan: A Survey of Old Javanese Literature*, The Hague: Martinus Nijhoff.

Index

Numbers in brackets refer to Colour Plates.